RENAISSANCE ART

RENAISSANCE
ART A Topical Dictionary

IRENE EARLS

Greenwood Press

NEW YORK • WESTPORT, CONNECTICUT • LONDON

Library of Congress Cataloging-in-Publication Data

Earls, Irene.
 Renaissance art.

 Bibliography: p.
 Includes indexes.
 1. Art, Renaissance—Italy—Dictionaries. 2. Art,
Renaissance—Europe, Northern—Dictionaries.
3. Artists—Biography—Dictionaries. I. Title.
N6370.E27 1987 709'.02'4 87-250
ISBN 0-313-24658-0 (lib. bdg. : alk. paper)

British Library Cataloguing in Publication Data is available.

Library of Congress Catalog Card Number: 87-250
ISBN: 0-313-24658-0

First published in 1987

Greenwood Press, Inc.
88 Post Road West, Westport, Connecticut 06881

Printed in the United States of America

∞

The paper used in this book complies with the
Permanent Paper Standard issued by the National
Information Standards Organization (Z39.48-1984).

10 9 8 7 6 5 4 3 2 1

Contents

Preface

This dictionary is intended to serve as a quick reference source for identifying and understanding Renaissance art of Italy and northern Europe. It contains basic information about topics that were common subjects of painting, sculpture, and decorative arts of the period. Additionally, entries on characteristic schools, techniques, media, and other terminology have been included as background information and to provide an art history vocabulary necessary for comprehending or clarifying certain topics. Readers can also supplement information contained in each article by a system of internal cross-references. When a person, topic, or other special term appears in an entry for which there is a separate entry, it is indicated on the first occasion by the use of an asterisk placed before the entry. ''See'' references and a subject index provide readers with an even more complete location of topics and other entries. The subject index is a general index that includes the names of other persons mentioned in the text plus other key words and phrases that will enable the reader to identify and understand a topic or a special term. As an aid to further study, a list of Northern and Italian Renaissance artists and their life dates and nationalities has been included. It has been compiled from the example lines found at the end of topical entries and from artists specifically named in certain entries. It is not a complete list of all Northern and Italian Renaissance artists, but rather an index of those mentioned in this dictionary. A bibliography is also provided for further reference.

Arranged in one alphabetical sequence, the more than 800 entries concentrate on topics related to those works of art created between 1305 and 1576, respectively, the date of Giotto's frescoes in the Arena Chapel in Padua and the date of Titian's death. During this time artists frequently illustrated stories from the Bible, the lives and legends of the Christian saints as told in the *Golden Legend* and other sources, mythological subjects, certain historical events, and important

or influential individuals. Artists chose topics for a variety of reasons, and an understanding of the resulting works of art presupposes some knowledge of the sources from which they and their patrons drew. It may be true that many biblical, mythological, historical, and other references or allusions in Renaissance art are incomprehensible to the present generation. In the belief that such gaps exist, this book has been designed to help fill them.

The purpose is to foster an art history literacy and help those who are interested to enjoy works of art more fully. Certainly a knowledge of the meaning of a work of art opens new realms of enjoyment and experience. Also, it is important to note that this knowledge is not confined to the Renaissance. Because some of the topics appear in various periods from late antiquity to the nineteenth century, one could, by extension, say that this book is not limited entirely to Renaissance art. Long after the Renaissance, many of the same topics, such as the Crucifixion, appear over and over in works of art. Such topical art can be enjoyed more fully if the content is understood.

Certainly a book about topics can only be selective, especially within the confines of one volume. With increasing specialization in the history of art, Renaissance art is being analyzed in ever finer focus. Such scholarly application is good, but in order that the gallery visitor, student, researcher, or any interested person exploring new territory can find an unbiased view of Renaissance topics, the entries here have been written according to generally accepted judgments and traditional emphasis, not individual interpretations. For this same reason, the guiding principle of selection has been to center on the mainstream. A topic painted but one time on the wall of a remote church in the south of France, for example, will probably not be found here. On the other hand, a few topics have been included that were painted or sculpted by only one artist. These deal with the topical content of certain works that are commonly found, although not always explained, in general art history survey and picture books.

All entries, those explaining topical content and those providing an art history context, are brief and essentially definitional. Most often a topical article is entered in the form of the title of a painting or a piece of sculpture. Alternate titles may be entered as cross-references. For example, there is an entry for "Multiplication of the Loaves and Fishes." This same topic is sometimes titled "Feeding of the Five Thousand," which appears as a cross-reference. Each topic is discussed, usually in the form of giving an account of the legend or story, and, if pertinent, identifying attributes and symbols are included (although not necessarily at the end of each article). Cross-references may lead to topics, terms, media, and so forth in other entries. For example, under the entry for "Abduction of Helen" will be found a cross-reference to Jupiter, Helen's father, the Trojan War, and a type of painting popular during the Renaissance known as fresco. Besides cross-references there are also "see" references. For example, under the entry, "Abduction of Helen," the reader will find "(see LEDA AND THE SWAN)," and thus be directed to further information on Helen's mother, Leda. These articles will lead the reader to a deeper understanding of not only

the original topic, but in this case, of a method of wall painting practiced in Italy beginning in the thirteenth century and perfected in the sixteenth century (fresco). At the end of every topical entry, an example of the work is given. When the title of the work is the same as that of the entry itself, for example "Last Supper," this title is not repeated. A typical example illustrating an entry takes the following form: The artist's name is provided, then the title of the work (if different from the entry title), the date the work was executed (with as much precision as possible), in some cases the media, when rare, and finally the location of the work (be reminded that works of art do move about). Some examples provide an alternate title as an extension of the entry title. Finally, some examples and artists' names have been incorporated into certain articles to provide a more complete definition. No special mode was used in selecting the examples. An effort was made, however, to include many different artists, both from northern Europe and from Italy.

I should like to thank my husband, Ed Earls, for his encouragement, help with the manuscript, and patience. I thank my never-ending source of inspiration and help, Edward DeZurko, Professor Emeritus of Art at the University of Georgia in Athens, and the many other professors there who provided unique intellectual stimulation. Special recognition is due to Marilyn Brownstein, my editor at Greenwood Press, who, over the phone and in letters, commented and made many valuable suggestions. The original concept of a topical dictionary was hers. I thank my colleagues who have helped me with ideas and criticism, especially Roger Barrows. Finally, I thank the Orlando Public Library and Toni Ribley; my typist, Julie Rosario, at the University of Central Florida; and my many students who, in and out of the classroom, always seem to teach as much as they learn.

Introduction

This book focuses on a period from the fourteenth to the sixteenth century when the world was several hundred years younger. Then, although not quite suddenly, a moment in history surged as a great wave across Italian soil and slowly began to wash away the mouldering Gothic layers of religion and philosophy as they were known in the Middle Ages. Old institutions and ideas were challenged and to a degree discredited. While today it may be impossible to fathom the common person's ignorant mind and indifference to all except a day by day existence, it is true that despite stubborn resistance many voices spoke then and cleared the air of that medieval decay and gradually began to supplant superstition with science and the progress of ideas. This moment in history, signifying the revival of the knowledge of Greek and Roman civilizations, was first termed "Renaissance," the French translation of the Italian word *rinacita*, meaning rebirth. It was first used in the preface Giorgio Vasari (1511–1574) wrote to his *Lives of the Most Excellent Italian Architects, Painters, and Sculptors from Cimabue to Our Own Day* (Florence, 1550).

Geographically the Renaissance occurred both north and south of the Alps. In Italy it had emerged by the fourteenth century and reached its height in the fifteenth and sixteenth centuries. In northern Europe it is sometimes dated from the fifteenth to the mid-seventeenth centuries. Indeed, a change of profound and lasting importance occurred in both locations in the visual arts during these centuries. The transition from the medieval to an epoch that became entirely different stretched over a long period of time. Italians brought new importance to the individual, and artists began to feel that the times encouraged experimentation in many new directions. Northern painters, evolving out of the illuminator (one who decorates manuscripts), also found a new place and prestige and began their own experiments. While in Italy the painters Giotto, Masaccio,

and Raphael took steps never before taken, Jan van Eyck, Dürer, and Bosch in the lands north of the Alps helped take artists away from the Gothic and develop a distinctive expression. In a unique way, along with many others, they helped fashion a brilliant path that miraculously wound its way through the deepest pits of a retarded world. Together, they helped produce a powerful humanistic lift up and out of a mysterious, misunderstood structure of thousands of false formalities, of fierce religion blanketed in blatant and blinding display, condemnation, fear, and awesome dignity of ritual. Simultaneously a new class emerged made up of persons with a different culture that was uniquely their own, a culture which was sometimes close to the church, sometimes hostile to it, but always distinctly apart from it. Both the Northern and the Italian Renaissance gradually brought important and lasting cultural as well as social changes that moved their societies from barbarism to rebirth, from obscurity to brightness. By the end of the fourteenth century, the Gothic world had run its course.

Art informs life and produces changes. It has recorded history and enriched the lives of millions. The Renaissance was special in this way. The new changes were so profound they produced a culture and an environment that required a different approach to the explaining and understanding of God and nature. This was the hour of St. Francis of Assisi, who appeared seemingly at the right moment and made religion a matter of intense personal experience. His was a new approach that fit cultural and social changes. Before Francis, religion had been a matter of condemnation and fear. Medieval theologians had claimed that individuals were worthless in the eyes of God. Pointing out the beauty of nature for the first time, Francis called it the handiwork of God. He proclaimed that everyone should love, not fear God. While the medieval person found the world filthy with vices, St. Francis, c. 1250 found beauty in the humblest objects. By the turn of the century the painter Giotto felt that each individual should do what was necessary for saving one's soul. Thus Francis and others helped create an environment that allowed and even encouraged the individual artist to break with formal traditions a thousand years old. Now the body, nude or otherwise, was seen again as a beautiful work of art. The face was viewed again as individual and lovely. Human intelligence was recognized again as the miracle it is. A new question arose in a previously unchallenged world: Did God create man or did man create God?

The new emphasis upon a freedom of will and not a dependence upon God was accompanied by other interests. Scientific perspective developed early in the fifteenth century in Italy and opened entirely new avenues to artists. For the first time they painted and carved the optical world, that infinitely complex and shifting optical reticulum that, because of the lack of knowledge of perspective, had eluded all predecessors. The staunch opinion of the Gothic world was that it was impossible to suggest the tactile quality of material objects on a flat surface. No previous civilization had unlocked the key to scientific perspective. The Renaissance represented a new space-concept never even contemplated by the ancients. The world was gradually viewed and rendered in a way never before

imagined by the Greeks or Romans. Of course, a single generation of artists did not do this, but each artist in his own way added to the process.

With perspective as a new tool, artists began to observe and analyze the monuments of classical times still visible on the ground in Italy. Early Renaissance Italians saw themselves as descendants of the ancient Romans. It is no wonder that the memory of former Roman grandeur stirred them to wondrous accomplishments, the products and consequences of which are with us yet.

Inspired, painters carried painting to a peak of perfection unknown to the ancients, who had neither the variety of colors used by the Italians, nor the knowledge of the art of perspective or of chiaroscuro. The Renaissance artists gave us the first believable pictures of the world in which we live. Very soon, of course, it was impossible that this new manner of seeing things and of painting and sculpting things should confine itself to Italy. By the middle of the fifteenth century artists in both geographic locations sought the new illusionistic space and the pictorialization of form. One must not believe, however, that Northern and Italian art reached that peak of perfection at the same time or was painted and sculpted in the same fashion. Even though art changed radically in both locations, no exact parallels can be drawn between the two.

During the fifteenth century Flemish painters found ideas in nature that, when rendered in their unique way, stirred not only their Northern contemporaries, but those in Italy as well. Their outlook was different. Northern artists created a space for forms with minute detail, powerful realism, and the deep, rich colors never seen before that were startling and awesome to all who saw them. They approached naturalistic lighting and occasionally they painted real shadows. But above all, they used paint with oil. Jan van Eyck is traditionally credited with the invention of oil paint a hundred years before Titian, even though the early history of its use is still a mystery. Nevertheless, Flemish painters used oil paint in translucent layers, called ''glazes,'' on surfaces of opaque monochrome underpainting that had been carefully produced on panels of wood prepared with white ground. The binding for their pigments had oil as a base, which, even though used by certain artists in the late Middle Ages, enabled painters to create colors unlike any ever seen before. The oil color seemed to be lit from within. Northern painting of the fifteenth century has a glowing light with intense tonality, and the dried oil paint is hard and enamellike on the surface. This was an astonishing and revolutionary change from the dull matte surfaces of Italian painters still using tempera and fresco. Soon the Italians looked upon Northern painting with open-mouthed wonder, many of them traveling north in the fifteenth century to learn the Flemish way.

While the Italians were preoccupied with the structure of what appeared to the eye—perspective, illusion, anatomy, composition, *contrapposto*, and the body in motion and proportion—the Northern painters focused on the appearances of surfaces when touched by light. Rather than produce the volume of form, as did the Italians, they followed their own tradition of stained glass and miniatures and created a realism of decorative, glowing color. When oil painting spread to

Italy, the new differences did not affect the Italian form; rather Italian painting became richer, especially in Venice, where oil painting replaced tempera. Overall, however, artistic communication between Northern and Italian painters was probably limited to a relatively few individuals, and both areas tended to develop independently of each other.

The topics represented in works of art by Northern and Italian Renaissance artists are the subject of this book. After centuries of painting, sculpture, and architecture created to elevate and glorify the church and manage the minds of the ignorant, Renaissance artists saw, for the first time in nearly a thousand years, the topics of classical antiquity. Handsome gods and voluptuous goddesses emerged as individuals, especially in painting, and reenacted their ancient conflicts, loves, and revelries. The nude, seen very little since antiquity, and then as an Eve with her hands covering herself, made a dramatic and stimulating appearance as the beautiful woman. Stories, from the Old and New Testaments, that had been used from the time the first Christian artists painted on the walls of the catacombs to illustrate and promulgate Christian doctrine, appeared once more in a new way. Christ, the Christian saints, and the Virgin Mary, previously shown symbolically on a field of gold or elevated beyond reach, became human against a sky of blue. It wasn't long before *mandorlas* and even halos were removed. Artists took the new figures into environments with trees and buildings and surrounded them with beautifully costumed secular figures. The figures themselves, previously flat and patterned, acquired volume and became sensuously full and human. At the same time, the topics of martyrdoms, miracles, and triumphs, presented more forcefully than ever before, came alive. Saint Lawrence, a third-century Christian martyr who actually died for his beliefs by being roasted alive on a gridiron, was, for the believer, a real person who suffered a horrible death for what he believed. Previously the saint had been shown in such an unrealistic way, that is, with flat body features on a flat background, that it was nearly impossible for the worshipper to feel any real sorrow or be moved beyond a dutiful prayer. Renaissance artists portrayed Lawrence as a person, not a symbol. Religious devotion had become an act based on love rather than fear.

For nearly three hundred years Renaissance artists drew, painted, and sculpted subjects and placed them in increasingly more elaborate and complicated settings. It is true, however, that, a rebirth cannot continue forever, and by the time of Titian's death in 1576, most of what had been uplifting and illuminating had lost its luster and was, itself, destined for change. That is why 1576 was selected as the date for ending this book. It is, however, impossible to assign positively certain limits and dates to a period. Some historians believe that in many senses we are still in mid-Renaissance—that the evolution has not been completed.

It is true the word Renaissance has lately received a more extended significance and that the student of art will see in it different truths than, for example, the student of literature. But as one remembers that it was, overall, the emancipation of the individual, one must be reminded that the work achieved during the Middle

Ages cannot be depreciated. History must move on and does. By the end of the eighteenth century the Renaissance had burned itself out. The works of Titian and Raphael and other painters of the High Renaissance continued to inspire such great baroque artists as Rubens, and the seemingly already overused topics found still further expression. Indeed, the same topics used during the Renaissance continued to inspire artists through the nineteenth century and today remain a landmark of the endless search for elegance and beauty.

RENAISSANCE ART

A

ABDUCTION OF HELEN (Rape of Helen). In Greek mythology, Helen was the daughter of Leda and *Jupiter (Zeus), who had assumed the form of a swan and was hatched from an egg (see LEDA AND THE SWAN). The wife of Menelaus, king of Sparta, she is usually remembered for her great beauty, which Homer likened to that of the immortal goddesses. Paris, a Trojan prince, loved Helen and took her to Troy while her husband was gone. Some legends say she was forcibly abducted; others that she went willingly. The *Trojan War began when the Greeks tried to recover her. Artists usually depict a rocky seashore or harbor where Trojan boats may be seen in the background. Paris may hold Helen in his arms while his companions fight the Greeks with their swords and Helen's handmaidens look about helplessly. Even though Helen must have been painted in many lost *frescoes of the Troy saga, little of Helen exists in art.

Example: Follower of Fra Angelico, *Rape of Helen by Paris*, c. 1450, National Gallery, London.

ABEL. See CAIN KILLING ABEL.

ABIAD AND ELIAKIM. Abiad, the son of Zerubbabe (Zorobabel), was one of the ancestors of *Christ in Saint *Matthew's geneology (Matt. 1:13). Eliakim, also an ancestor of Christ and king of Judah, appears in Matthew's and Saint Luke's geneologies (Matt. 1:13; Luke 3:30). On the Sistine Chapel Ceiling, Abiad and Eliakim are placed in compartments just below Zorobabel. Abiad, which means "he is my father," is shown looking up at his father. Eliakim, which means "Resurrection of God" or "God lifting up," is lifted up by his

mother. Both names refer to salvation in Christ's body, which is symbolized by the Ark.

Example: Michelangelo, 1511–1512, Sistine Chapel Ceiling, Vatican, Rome.

ABIMELECH SPYING ON ISAAC AND REBECCA. Abimelech was the king of Gerara in the country of the Philistines, where Isaac took his wife during a famine. When asked about his wife, Isaac said, "She is my sister," for he feared the men of Gerara would kill Rebecca if it were known she was his wife. One day, after Isaac had been there a long time, Abimelech looked out a window and saw Isaac and Rebecca making love (Gen. 26:1–11). Isaac and Rebecca are usually shown embracing in a courtyard while Abimelech stands watching them through a window.

Example: Raphael, 1518–1519, Loggia, Vatican, Rome.

ABNER BEFORE DAVID. Abner was a relative of Saul (see SAUL AND DAVID) and commander in chief of his army. Abner's story is told in Samuel 1 and 2. His death, shortly after his meeting with *David, was probably caused by jealousy and revenge. During the time of fighting between King David's forces and the forces loyal to Saul's family, Abner decided to join David. He met the king at Hebron, and David gave a feast for him and twenty of his men. At this time Abner promised to win all Israel over to David. He said the people would accept him as king and then he would rule over the whole land. David gave Abner a guarantee of safety and sent him on his way. Abner is usually shown kneeling before David, the letter in his right hand, his hat and sword in his left. David sits on his throne and listens as a court official tells him of Abner's deception (2 Sam. 3:20–21).

Example: Master of the St. Barbara Legend, *Adoration of the Magi Triptych*, c. 1490, Metropolitan Museum of Art, New York.

ABRAHAM (A'bram). The first great Hebrew patriarch of the Old Testament, Abraham left his birthplace, Ur of the Chaldees, with his nephew, Lot, and his wife, Sarah, to go to Canaan (Chanaan) after being called by God. He is shown with a flowing beard and white hair. Usually he carries a knife with which he meant to sacrifice his son Isaac (see SACRIFICE OF ISAAC) to demonstrate his faith and obedience to God.

Example: Jacopo Tintoretto, 1580s, Scuola di S. Rocco, Venice.

ABRAHAM AND LOT SEPARATE. See PARTING OF LOT AND ABRAHAM.

ABRAHAM AND MELCHIZEDEK (Gen. 14:18–24; Ps. 110; Heb. 7). After staying in Egypt to escape the famine, Abraham and Lot traveled north and then separated with Abraham returning to Canaan and Lot going to Sodom. Later, Lot was captured when raiders attacked the Cities of the Plain. When news was

brought to Abraham, he armed over three hundred men and set off in pursuit. He defeated the foe, released Lot, and recovered the stolen possessions. Abraham returned, and at Salem (Jerusalem) in the vale of Save, he was welcomed by Melchizedek, the king and high priest, who offered bread and wine and blessed him. Melchizedek is usually shown wearing magnificent robes and a crown. He carries a *chalice and bread, since the event was looked upon in the Middle Ages as a prefiguration of the *Last Supper. In Renaissance *painting, Abraham frequently stands or kneels before Melchizedek.

Example: Dirk Bouts, *Last Supper Altarpiece*, 1464–1467, Church of Saint Pierre, Louvain.

ABRAHAM VISITED BY THE ANGELS. When he was very old, Abraham received a visit from God, who announced that Abraham and Sarah at last would be blessed with a son. Abraham refused to believe this at first, thinking that both he and his wife were too old. Some time later, three men appeared at Abraham's tent in the vale of Mambre, and he offered them hospitality. While they were eating, Abraham perceived them as *angels, and one of them prophesized that a son would be born to Sarah. Sarah laughed at the prophecy because she and Abraham were both ''old and well striken with age'' (Gen 18:1–16). The prophecy was fulfilled when she bore Isaac. The three men are usually depicted as angels, with wings and sometimes halos. Abraham may be shown kneeling before them, washing their feet, or preparing food. His dwelling, contrary to the text, is sometimes a building or a tent. The three angels were seen as a symbol of the *Trinity, and their prophecy was considered a prefiguration of the *Annunciation.

Example: School of Raphael, early sixteenth century, Loggia, Vatican, Rome.

ABSORBENT GROUND. A chalk surface applied to a panel or canvas without oil so that it will absorb the oil from the paint is absorbent ground.

ABUNDANCE. The allegorical figure of Abundance is meant to symbolize ample supplies of food, the basis of man's needs, issued from good *government, *justice, and peace. Abundance is shown with other *virtues as well, praising the end of war or depicted on a tomb in allusion to the bounty bestowed by the dead man while he was alive. The figure of Abundance, found mainly in Italian art, has the cornucopia as her principal attribute. She may be accompanied by children, and she may hold a sheaf of corn in her hand, since her classical prototype was the goddess of agriculture, *Ceres. Renaissance artists also continued the idea of the rudder as an attribute of Abundance. The rudder, an idea associated with good government, dates from ancient Rome and derives from the annual fetes associated with the grain harvest that came to the city by boat. The rudder, together with the cornucopia and terrestrial globe, suggests that the rule of Rome brought *prosperity* for everyone.

Example: Paolo Veronese, *Abundance, Fortitude and Envy*, ceiling fresco, c. 1561, Villa Barbaro, Maser.

ACADEMY. The word "Academy" has been taken from the olive grove outside Athens named for the new academies where Plato and his successors discussed and taught philosophy. His school of thought was known as "The Academy." Academy was used in Italy in the fifteenth century by groups of humanists gathering together for discussion. In the Italian Renaissance, the word was applied to nearly any literary philosophical circle. During the sixteenth century, academies became extremely formal, established rules of procedure, and started to engage in a greater range of activities. During the Renaissance, however, the word was often applied to groups of artists who gathered to discuss theoretical and practical problems. About 1500, it was used to describe Botticelli's studio. Leonardo da Vinci, in his Milanese period, gathered about him a group of men who discussed artistic and scientific problems, and the "Accademia Leonardi Vinci" is well known. Lorenzo de' *Medici (Il Magnifico) organized another so-called academy under the direction of the sculptor Giovanni di Bertoldo, who had the distinction of helping the young Michelangelo. There was no organized body of any kind, according to Giorgio Vasari, but Lorenzo allowed painters and others access to his statues and sculpture school in the Medici Garden. The first official Academy of Fine Arts, the Accademia del Disegno, was founded in Florence in 1561 by Vasari with the Grand Duke Cosimo de' Medici (see COSIMO I) as head and eighty-eight-year-old Michelangelo, who had done more than anyone, by his personal prestige, to raise the fine arts from the level of the mechanical to the equal of the liberal arts. The main purpose of Vasari's Accademia del Disegno was always to raise the social status of the artist, but though nearly all artists of reputation in Italy became members, its program was abandoned.

ACADEMY FIGURE. The academy figure is a drawing, statue, or painting, usually about half life size, of a nude figure executed solely as an exercise or for purposes of instruction and not as a work of art. There is a tradition of suitable poses and the proper treatment of figures that goes back to the fifteenth century.

ACEDIA. See SEVEN DEADLY SINS.

ACIS. In Ovid (*Metamorphoses* 13:750–897), Acis was the son of Faunus and a river-nymph, and lover of the beautiful sea-nymph *Galatea. He was killed by the Cyclops Polyphemus, who also loved Galatea, and turned into the river that still bears his name at the foot of Mount Etna. This story was first mentioned by Theocritus and was well known throughout Renaissance, although Acis may be absent.

Example: Raphael, *Galatea*, 1513, Villa Farnesina, Rome.

ACTAEON, DEATH OF. Described by Ovid (*Metamorphoses* 3:138–253), Actaeon, a legendary huntsman and grandson of Cadmus, king of Thebes, was killed by *Diana, the huntress (Artemis). Hunting with his dogs one day, the young man came upon the pool where Diana and her *nymphs were bathing naked. Although he only wanted water for himself and his dogs, he saw the goddess, and to punish him for his glimpse of her beauty, Diana turned the young prince into a stag. His hounds turned upon him immediately and tore him to pieces. Various scenes are depicted. One version shows Actaeon stumbling innocently upon the grotto, his dogs panting at his heels, and his hands raised in astonishment at the scene before his eyes. Diana's companions try to protect their mistress from the young man's gaze and at the same time retreat in disorder. Other versions depict Actaeon staggering backward under the weight of his dogs as they attack and pull him down. Diana may be dressed as a huntress aiming her bow. Actaeon may also be shown as a stag on the ground, his hoofs flying in the air as his hounds tear his body apart.

Example: Titian, *Death of Actaeon*, known also as *Actaeon Torn by His Hounds*, mid-seventeenth century, London (on deposit in the National Gallery, London).

ADAM. Adam was the first man created by God (Gen. 1:26–27). Since Adam in Hebrew means ''red,'' it is supposed that he was so named because of the red earth of which he was made. The name also indicated man in general. God breathed the breath of life into his nostrils and placed him in a paradise, the Garden of Eden, where he was given dominion over all animals, which he named. God had planted the tree of knowledge of good and evil in the garden and warned Adam under penalty of death not to eat the fruit of this tree. Then God created Eve from one of Adam's ribs (Gen. 2:21–24). Although in direct communication with God and in a state of perfection, Adam and Eve ate the forbidden fruit. They felt at once their nakedness, covered themselves with fig leaves, and tried to hide from God. Adam blamed Eve, who confessed, ''The serpent deceived me and I did eat'' (Gen. 3:1–7). Adam and Eve were then cast out of paradise. Because of Eve's sin, God decreed that thereafter all women would bear their children in pain and should be subject to man. Because of Adam's sin, God decreed thereafter man would earn his bread by the sweat of his brow. And he told Adam, ''dust thou art, and unto dust shalt thou return'' (Gen. 3:19). Adam lived to the age of 930, having begotten Cain (see CAIN KILLING ABEL), Abel, Seth, and other sons and daughters. Renaissance artists depicted Adam and Eve in different scenes as they interpreted the story of the creation from the Bible. In the first scene, the creation of Adam, God creates Adam by breathing life into his nostrils or by reaching out his hand to transmit life by his touch. Eve may emerge from Adam's body as he sleeps, or she may stand before God fully formed. The *Temptation depicts Adam and Eve standing by a tree, usually an apple or a fig; Eve either holds the fruit or is plucking it, or having eaten a part, offers the rest to Adam. A serpent is twined round the tree's trunk. In the Expulsion Adam and Eve, ashamed and naked, are being driven out of the

garden. God may be present, handing them clothing, and Death (see MEMENTO MEI) may stand by as a symbol of their lost immortality.

Examples: All the above were painted by Michelangelo on the ceiling of the Sistine Chapel, 1508–1512, Vatican, Rome; Masaccio, *Expulsion*, c. 1414–1415, Brancacci Chapel, Sta. Maria del Carmine, Florence.

ADONIS TAKING LEAVE FROM VENUS. The beautiful youth Adonis was the son of Cinyras, the king of Cyprus, by an incestuous union with Myrrah, his daughter. Overcome with the shame of her pregnancy, Myrrah invoked the gods to change her into a myrrh tree. After a time, the tree trunk split, and the baby, Adonis, was born (Ovid, *Metamorphoses* 10:298–599, 708–39). He was loved passionately by Aphrodite (*Venus), who had been accidentally grazed by *Cupid's arrow. Aphrodite hid the infant in a box and left it with Persephone, who raised him and made him her lover. She was unwilling to return him when Aphrodite demanded him for herself. Zeus (*Jupiter) settled the dispute by agreeing that Adonis should spend part of each year (the summer months) on earth with Aphrodite and part in the underworld with Persephone. While hunting one day he was gored to death by a wild boar, or, according to some sources, killed by the jealous Hephaestus (*Vulcan) or by Ares (Mars) disguised as a boar. He was a god of vegetation and fertility, and his disappearance marks the harvesting of crops. His death and *resurrection, symbolic of the yearly cycle of vegetation, were popular and celebrated in ancient Greece. The Adonia is a mid-summer festival. Part of his worship during this time included the "garden of Adonis," beds of short-lived flowers and herbs planted for the occasion. Artists usually depict Venus trying to hold Adonis back from the hunt while he is impatient to be off, his hunting dogs straining at the leash.

Example: Titian, c. 1553, Prado, Madrid.

ADORATION OF THE CHILD. This is a common subject in Renaissance painting. The Virgin Mary (see MARY, SAINT) kneels and adores her Child, who may be placed on the ground. Saint *John the Baptist may be present, shown as a child of five or six, although he was actually only six months older than his cousin, Jesus. Any of the following may be present: God the Father, the Dove of the *Holy Spirit, and an ax jammed into a tree trunk. The ax is taken from Saint *Matthew: "And now also the ax is laid of the root of the trees; therefore every tree which bringeth not forth good fruit is hewn down, and cast into the fire" (3:10). Hills, roads, streams, castles, three *cherub heads (symbol of the *Trinity), and the Star of Bethlehem may be included.

Example: Fra Filippo Lippi, *Madonna Adoring Her Child*, late 1450s, Picture Gallery, Dahlem Museum, Berlin.

ADORATION OF THE LAMB. An Apocalyptic theme, it was possibly inspired by the liturgical office for the Feast of All Saints or taken directly from Revelation 7:9–17 (*Apocalypse 9) and 14:1. The Apocalyptic lamb is depicted

standing upon an altar with a *chalice catching the blood pouring from its breast; *angels kneel about the altar holding instruments of the *Passion. Included in an adoration are usually long processions of virgins, prophets, popes, pilgrims, knights, hermits, and judges. The lamb, sheep, or ram was the sacrificial animal in ancient Near Eastern religious rites. The early Christians adopted the lamb as a symbol to depict *Christ in his sacrificial role. In the *Sacrifice of Isaac by *Abraham, the substitution of a ram illustrates the historical change from human to animal sacrifice in earlier societies and was seen as a foreshadowing of Christ's death as a sacrificial substitute for man. The All Saints Picture is a related theme.

 Example: Hubert and Jan van Eyck, *Ghent Altarpiece* (open) lower panels, c. 1425–1432, Cathedral of Saint Bavon, Ghent.

ADORATION OF THE MAGI. Although the *Gospels give few details of this subject sometimes known as "Adoration of the Kings" (Matt. 2:1–11), it acquired great significance as the first act of homage paid to the Baby Jesus by the pagan world. The Gospels do not mention the number of the Wise Men, although three soon became the figure because of the number of their gifts. Only two are shown on a third-century *fresco in the Petrus and Marcellinus catacomb, and four appear in the Cemetery of Domitilla of the fourth century. According to tradition, the Magi had come from the east, following a star, to seek the king of the Jews and were told by Herod's officials to go to Bethlehem. Herod instructed them to report back to him, under the pretext of paying homage himself, but really because he feared usurpation. Historically, the kings were astrologers of the Persian court, the priests of Mithraism, which became popular in the Roman empire in the early Christian era. In the Roman catacombs and in some Byzantine *mosaics, the kings wear Mithraic robes. Tertullian (c. 160–230), a Christian writer, was the first to name them as kings. Historically, their names may have originated in a ninth-century pontifical at Ravenna, but they do not appear in art as kings until the tenth century, when their Phrygian caps, pointed hats having the top folded forward, were gradually replaced by crowns. From the twelfth century onward, they were almost always crowned. Early Renaissance painting shows them dressed in the court fashions of the day. One king may be drawn in the likeness of the artist's patron as an indication of his devotion to Christianity. Occasionally, the kings are depicted meeting during their travels or traveling together, with their retinues, led by the star. The adoration itself depicts Caspar (also called Jasper) the oldest, kneeling before the Baby Jesus in the Virgin's lap, offering his gift of gold. Present also are Balthazar, a Negro, and Melchior, the youngest. Signs of their eastern origin are obvious: leopards, camels, turbans, or perhaps the star and crescent of the Saracens. Usually Joseph is present. The *Annunciation to the Shepherds may be seen in the background. Bede, the English historian (c. 673–735), explained the symbolism of their gifts. Frankincense was in homage to Christ's divinity; gold represented his kingship; myrrh, used in embalming, was a foreshadowing of his crucifixion. In the late Middle Ages and early Renaissance, the Magi came

to personify the three parts of the known world (Asia, Africa, and Europe) paying homage to *Christ, which explains the traditional portrayal of Balthazar as a Negro (Africa). However, the theme was also meant to symbolize the submission of the temporal powers to the authority of the church. The feast of the Epiphany (January 6) celebrates certain manifestations of Christ to mankind, particularly that of the Adoration of the Magi. Giotto's fresco in the Arena Chapel at Padua, 1305, depicts the first of the Magi kneeling and kissing the Infant's feet. Later artists, including Leonardo da Vinci, added large numbers of attendants and followers. Benozzo Gozzoli introduced most of the *Medici family into the train of the Magi in his 1459 painting located in the Palazzo Riccardi in Florence.

Example: Sandro Botticelli, 1470s, Uffizi Gallery, Florence.

ADORATION OF THE SHEPHERDS. Although the announcement in the fields of the birth of Jesus by the *angel *Gabriel appears in Byzantine art, the scene of the Adoration is not found until the Renaissance. The shepherds, usually rough and tattered, are shown kneeling or standing near the Baby Jesus in various attitudes of adoration. Sometimes three men are shown with gifts, which are not mentioned by Luke (2:8), and were possibly created by analogy with those of the three kings. The shepherds may hold a sheep, symbolizing the Christian sacrificial lamb, a bagpipe, or some other rustic gift. Other shepherds may be seen lingering behind. Through an open doorway, there may be a landscape with an angel announcing the birth to those shepherds still attending their flocks.

Example: Antonio Correggio, *Holy Night*, 1522, Gemäldegalerie, Dresden.

ADORATION OF THE TRINITY. The *Trinity (from the Latin for ''three-foldness'') is the fundamental doctrine in Christianity that God is of one nature yet three persons, Father, Son, and Holy Ghost. The doctrine was defined very early and takes its authority from Matthew 28:19. It was expounded by Augustine in the *De Trinitate* and received amplification at the first ecumenical councils. Most Christian teachers consider the Trinity to be a mystery, that is, human intelligence cannot fully understand or know its nature. For this reason, it is called a ''truth of revelation.'' In Renaissance painting, God may be depicted in two ways. The Unity of the Godhead may be stressed, or the Three Persons of the Trinity may be shown. For the latter, the Father, Son, and Holy Ghost may be represented separately or together. The most usual form of the Trinity in Renaissance art depicts God the Father as an old man, usually with a long beard and patriarchal in appearance, sometimes with a triangular halo (a reference to the Trinity), or with a papal tiara, especially in Northern Renaissance painting. He may hold a globe or a book. He is behind and above *Christ on the cross and may hold in his hands each end of the crosspiece or *patibulum*. A dove, the symbol of the Holy Ghost, hovers above the head of God the Father or at Christ's feet. All people and classes of society, including kings, popes, cardinals, bishops, virgin martyrs, and even angels may participate in the adoration.

Example: Jacopo Tintoretto, *The Trinity Adored by the Heavenly Choir*, late 1500s, Columbia Museum of Art, Columbia, South Carolina.

AERIAL PERSPECTIVE. This type of *perspective first created by Leonardo da Vinci was termed ''aerial'' because the word ''perspective'' was already in use. Leonardo introduced the term ''aerial perspective'' for the means of producing pictorial depth when dealing with changes in tone and color values that are seen in objects receding from the observer. Atmosphere, because of its density, creates mute colors that tend toward blue in proportion to their distance from the observer. This is due, according to modern analysis, to the presence of dust and large moisture particles in the atmosphere, which causes some scattering of light as it passes through it. Scattering depends on the color of the light. Blue, for example, is scattered most and red is scattered least. Hence, the sky appears blue and distant, dark objects appear to lie behind a mist of blue. Bright objects tend to seem redder in the distance because some blue is lost from the light by which we see them. Leonardo discusses aerial in relation to linear perspective in the *Trattato*. He stated: ''The diminution or loss of colours is in proportion to their distance from the eye that sees them. But this happens only with colours that are at an equal elevation; those which are at unequal elevations do not observe the same rule because they are in airs of different densities which absorb these colors differently'' (Sect. 231). Great differences between the atmospheres of northern Europe and the Mediterranean account for the greater interest in aerial perspective to be found in the north.

AGES OF MAN. The doctrine of the Three Ages of Man may be divided into twelve units. The most usual numbers are three or seven, but four, five, and six are also found. The theme is that earthly things such as youth and beauty are transient and must eventually pass away, and in the end we must all face death. Children, young lovers, and an old man perhaps holding a skull usually represent three of the ages in art. The fourth, shown after youth, is a warrior, an adult who may be dressed in armor or possibly holding a compass to show he is knowledgeable in his craft. The ages of human life may be connected with the progress of the year, for example, four ages with the four seasons; twelve, in which case each age lasts six years, with the twelve months. Prudence (see VIRTUES) is sometimes glorified as a wise employer of the Three Forms of Time. The present learns from the past and is therefore able to act for the future. These Three Forms of Time appear equated with the Three Ages of Man.

Example: Titian, *The Three Ages of Man*, c. 1520, National Gallery of Scotland, Edinburgh.

AGNES, SAINT (Lat. *agnus* **''lamb'').** According to the *Golden Legend*, Agnes (Inez) was a Christian saint and virgin martyr who died in A.D. 309 during the time of the persecutions under Constantine the Great. She met her martyrdom when she was only thirteen, having declared herself to be the Bride

of *Christ. Her story began when she refused to marry the son of the Prefect of
Rome who had fallen in love with her after seeing her on her way home from
school. He promised her great riches and diamonds if she would marry him.
Even his father could not persuade her when he called upon her in his son's
behalf. When she would not be persuaded into marriage, the Prefect decided to
shame her by having her taken to a brothel, stripped and violated. As this
happened Agnes prayed so hard for her body to be kept pure that miraculously
her hair grew down to the floor. Then an *angel brought her a white robe from
heaven and cast a supernatural light around her body so that when the Prefect's
son arrived to ravish her he was struck dead by a demon. Agnes' prayers,
however, brought him back to life. The Prefect, at the sight of this miracle,
turned her over to a lieutenant named Aspasius. He had her thrown into a fire
where she stood unharmed. A nearby soldier stuck his dagger in her throat and
killed her. Agnes' parents and other Christians barely escaped stoning when they
buried her. Her sister, Emerentiana, was stoned to death at the tomb. Eight days
later Agnes appeared to Christians who came to her burial sight; she stood before
them holding a white lamb and accompanied by a choir of virgins. Agnes is
usually shown holding a white lamb and she may stand in flames. Some artists
show her covered by long hair or a long robe.

Example: Pietro Lorenzetti, *Carmelite Altarpiece*, 1329, Pinacoteca, Siena.

AGONY IN THE GARDEN. "Agony" is from the Greek *agon*, a contest. In
this case the agony is the struggle between the two natures of *Christ, the divine
and the human. His divine nature gave him the strength he would need for the
suffering soon to come and was in conflict with his human nature, which feared
the imminent suffering and would try to avoid it. Immediately before his arrest
Christ went to the Mount of Olives to pray with Peter (see PETER APOSTLE
AND SAINT), *James the Greater, and Saint *John the Evangelist. Saint Luke
wrote: "There appeared to him an *angel from heaven bringing him strength,
and in anguish of spirit he prayed the more urgently" (22:39–46). Christ is
usually shown a little apart from his disciples. In early examples (the theme is
rare before the thirteenth century) the head of God the Father or his symbol, the
right hand pointing down out of a cloud, may be depicted instead of the angel.
Other early examples show Christ either kneeling (Luke) or lying with his face
downward in great humility (Matt. 26:36–46; Mark 14:32–42). Christ may be
alone or with all eleven disciples in various positions of sleep. During the
Renaissance Christ was most often depicted kneeling on a raised and rocky
surface. On the ground below him are the three disciples: James, who is shown
with dark hair and a beard; John, the youngest, with long hair usually down his
shoulders; Peter, grey-haired with a beard and sometimes a sword (for cutting
off the servant's ear). The landscape usually has a group of approaching figures,
the soldiers led by *Judas; in the distance is Jerusalem. The angel brings Christ
the *chalice and *host. Less often an angel or angels may appear before him
bearing the instruments of the *Passion. The representation of Christ as if he

were about to receive communion has no textural support and could have come from the *Gospels' metaphorical reference to a cup.

Example: Giovanni Bellini, c. 1465–70, National Gallery, London.

AGOSTINO NOVELLO. The holy man Agostino was actually an Augustinian monk whose original name was Matthew of Termini (Taormina, Sicily). His story is as follows: After a career at Bologna, Agostino studied and taught law and later became chancellor to King Manfred of Sicily. At the Battle of Benevento, 1266, he was wounded and left for dead. At this time he promised that if he lived, he would devote the rest of his life to God. He survived, entered the Order of the Hermits of Saint Augustine, and took the name Agostino to conceal his identity. Soon afterward Agostino offered to defend the community when it became involved in a law suit. His work was so astonishing that the advocate of the opposition is said to have exclaimed: "This must be the work of an *angel or of the devil—or of Matthew of Termini, but he perished at Benevento." Agostino requested to see the author of the statement and immediately the lawyer recognized him. Agostino accompanied Clement of Osimo to Rome where together they wrote out the new constitution of their order. Pope Nicholas IV appointed him plenipotentiary for the papal court of *Boniface VIII and sent him as a lawyer to Siena. Agostino was elected Prior General in 1298 but left the office two years later when he decided to retire to the hermitage of Saint Leonard near Siena where he died May 19, 1309. The designation "Novello" (Lat. *Novellus*) was added in the fifteenth century. His relics are preserved in a church dedicated to him, Saint Agostino, Siena. In painting, the saint is usually shown with representations of his miracles which he performed in posthumous appearances.

Example: Simone Martini, *The Blessed Agostino Novello and Four of His Miracles*, c. 1330, Saint Agostino, Siena.

AHASUERUS. See ESTHER AND AHASUERUS.

ALABASTER. Alabaster is a fine-grained, translucent stone. It is either pure white, yellowish, pink, and sometimes streaked with reddish brown. It is soft enough to be scratched or bruised easily and is most suitable for works that will remain indoors. After 1330 alabaster began to take the place of other types of stone and wood for tomb effigies. It was popular during the Renaissance because its surface will take paint without a coat of *gesso and was thus used extensively for *retables and tomb effigies. It is quarried chiefly in England.

ALLEGORY OF GOOD GOVERNMENT. See GOVERNMENT, GOOD.

ALLEGORY OF HATE. This topic depicts two brothers playing in the grass and brush. A snake is coiled around the legs of one, and snakes are coiled around the body of the other. Both writhe on the ground. A Latin inscription flows in

the air that, when translated, says "There is no worse plague than family enmity."

Example: Filippino Lippi, c. 1485–1490, Uffizi Gallery, Florence.

ALLEGORY OF HUMAN VANITY. See THREE AGES OF WOMAN AND DEATH.

ALLEGORY OF MUSIC. See ERATO.

ALLEGORY OF SPRING. See PRIMAVERA.

ALL SAINTS PICTURE (Ger. *Allerheiligenbild*). The phrase "All Saints" is similar to "Church Triumphant" and indicates those men and women who have dedicated their lives for Christianity and thus after death, whether by martyrdom or natural causes, have entered heaven. Depicting all the saints together, sometimes holding their instruments of martyrdom, is an established way to represent heaven in art. This presentation is widely seen in Renaissance *altarpieces. During the Renaissance, the rows of saints and concerts of angels are usually depicted as turned in adoration to either the *Trinity or God (who signifies the Trinity) and also the Virgin, who might be enthroned beside the godhead. The Feast of All Saints, known also as All Hallows, was instituted in 835 to commemorate the dedication of a Roman temple. It is celebrated every year on November 1.

Example: Nardo di Cione, *Paradise*, mid-fourteenth-century (1350s), Strozzi Chapel, Sta. Maria Novella, Florence.

ALTARPIECE. A term in Christian church architecture for a painted, sculptured, or decorated screen that stands as a religious image upon, behind, or above an altar, sometimes called *retable, rededos, *ancona, and in Italian, *pala d'altare*. The altar may represent in visual symbols the underlying doctrine of the *Mass or depict a saint to whom the church or altar is dedicated, usually with scenes from his or her life. Altarpieces may include scenes and persons of general importance—*apostles, doctors of the church, the *Crucifixion, and other important events from the New Testament. When a *donor is portrayed, he is generally presented by his patron or name-saint. An example of this is *Étienne Chevalier, Treasurer of Charles VII*, presented by Saint Steven in an altarpiece by Jean Fouquet, c. 1450 Gemäldegalerie, Staatliche Museen, Berlin-Dahlem. Scenes from the *Passion may be represented, as in Duccio's altarpiece in Sienna.

The decoration and various motifs of the altarpiece took a different course in different parts of Europe. Italy, for example, favored an elaborately decorated gilt frame, which eventually became more complex with twisted columns, pinnacles, and cusped arches. More complex pictorial themes led to an increase in the number of compartments and resulted in the *polyptych type, where each

saint was represented in a separate arch and the lives of saints and scenes from the *Gospels were placed apart on the *predella below.

During the Renaissance the increasing predominance of pictorial values in art led to the reduction of the frame and unification of picture space, so that the number of compartments decreased and the narrative scenes blended into a single composition. The *Sacra Conversazione, in which the Madonna and saints are depicted in direct and increasingly informal conversation with each other, often formed the central panel of an altar-painting.

The Northern Renaissance saw, especially in Germany and the Low Countries, a different type of altarpiece evolve in the fourteenth century. The winged altar had a central panel flanked by hinged leaves painted on both sides that could be kept open or closed. This altarpiece had its origin in the reliquary-retable, where relics were preserved behind locked doors, and even in the absence of relics, the wings were generally kept closed on all but feast days. Many times a second pair of wings was used, painted on the outside in *grisaille for use on penitence days such as Lent. Multiple wings had the advantage of providing more space for the pictorial program. The altar of Conrad von Soest, 1403, at Wildungen, Westphalia, shows a Crucifixion with scenes from the life of *Christ and the Virgin on either side, with saints on the back sides of the wings. The Ghent Altarpiece, 1432, by Jan and Hubert van Eyck, presents an extensive program illustrating a procession of saints and patriarchs on the wings adoring the Sacrificial Lamb in the center panel. God the Father, the Virgin, and Saint *John the Baptist are shown in a separate section, while the back of the wings is painted with the *Annunciation, donors, and their patron saints. In time the altarpiece differed little in form from other easel paintings.

Examples: Ancona of Bernardo Daddi, Uffizi Gallery, Florence, and Andrea Orcagna in Sta. Maria Novella, Florence, both of the fourteenth century. Flemish altar, in the Petrikirche at Dortmund, c. 1500; sixteenth century retable with Coronation of the Virgin, Breisach Münster. Nicolas Froment, *Altarpiece of the Burning Bush*, 1476, Cathedral of Saint-Sauveur, Aix-en-Provence.

AMALTHEA. As one of the nurses of Zeus (see JUPITER) when he was a child, Amalthea is variously described as a *nymph, a she-goat, or possibly a theriomorphic (conceived of as having the form of an animal) goddess. Her legend describes her as a she-goat and tells of her wonderful horns flowing with nectar and ambrosia. When one broke off, it was filled with fruits and given to Zeus. After her death she was placed in the heavens as the inconspicuous southern constellation Capricornus (Lat. for the ''goat horn'').

Example: Rohan Master, *Amalthea* from the *Boccaccio of Philip the Bold*, illumination, c. 1402, Bibliothéque Nationale, Paris.

AMBASSADORS, THE. See FRENCH AMBASSADORS.

AMBER. A fossil resin known as amber is taken from different trees and found primarily on the southern shores of the Baltic. In painting, amber can be used as an ingredient of some oil mixtures. Actually, it is a hard resin that is difficult

to dissolve and is not suitable for varnishing pictures painted with linseed oil and turpentine, since cracks are caused by rapid hardening over the soft layers of oil pigment underneath. In time it may turn yellow and become cloudy and can only be removed by the strongest solvents.

AMORINO. Italian for "little love," an *amorino* is a *putto or a *cupid.
 Example: Raphael and Giovanni da Udine, *Amorino with Lion and Sea Horse*, 1515–1516, Villa Farnesina, Loggia of Psyche, Rome.

AMOUR GIVES THE KING'S HEART TO DESIRE. See BOOK OF THE HEART TAKEN BY LOVE.

AMPHITRITE. See NEPTUNE AND AMPHITRITE.

ANAMORPHOSIS. The term refers to a painting or a drawing that is so executed as to give a distorted image of the object being rendered, but which, if reflected in a curved mirror or viewed from a certain point, shows the image in true proportion. Although the word first appears in the seventeenth century, the earliest examples appear in Leonardo da Vinci's notes. Anamorphoses are included in some sixteenth century manuals dealing with perspective.
 Example: Radically elongated skull stretched diagonally across the lower center of Hans Holbein the Younger's *French Ambassadors*, 1533, National Gallery, London.

ANANIAS AND SAPPHIRA. See DISTRIBUTION OF THE GOODS OF THE CHURCH.

ANATOMY. The study of the human anatomy formed a large part of the education of an art student during the Renaissance. The artists, especially Leonardo da Vinci and Antonio Pollaiuolo, worked diligently with anatomical studies and perhaps anticipated the work of the physicians in this specialized area of science. Examples of human skeletons are depicted in the *engravings of Baccio Bandinelli. In 1584 G. P. Lomazzo gave a minute account of the structure of the body in his *Trattato*. The Renaissance interest in the examination of the human form led artists and students to a thorough examination of anatomy in an attempt to arrive at the ideal form.

ANCONA. *Ancona* is the Italian word for a large *altarpiece consisting of more than one compartment made in one piece with a frame. See PALA and POLYPTYCH.

ANDREW, SAINT. Andrew (Greek for "manly") was one of the twelve disciples, brother of Simon Peter, a fisherman of Bethsaida in Galilee and the first to follow *Christ (John 1:40–42). Traditionally Andrew was a missionary in Asia Minor, Macedonia, and the country to the north as far as Scythian Russia.

His preaching and many acts of healing converted so many people to Christianity
that the Roman governor of Patras in the Peloponnese feared an uprising.
Maximilla, the governor's wife, became a Christian when Andrew cured her of
a terrible illness and was persuaded by him to deny her husband his marital
rights. Because of this the governor had Andrew arrested, imprisoned, scourged,
and subjected to numerous tortures before having him crucified by being tied to
a cross. His cross is believed to have been in the shape of an X, or saltire,
although the earliest Renaissance representations show the saint tied to the Latin
cross or to one in the shape of a Y. (The X-shaped cross is sometimes known
as the Saint Andrew's cross.) Usually Andrew is portrayed as an old man with
white hair and a long beard. He may carry a net containing a fish, an X-shaped
cross, or a piece of rope. Andrew is the patron saint of Greece, Russia, and
Scotland.

 Example: Pupil of Pietro Lorenzetti, *Saint Andrew the Apostle*, fourteenth century,
Bridgeport Museum of Art, Science, and Industry, Bridgeport, Connecticut.

ANDRIANS. See BACCHANAL OF THE ANDRIANS.

ANDROMEDA. See PERSEUS.

ANGEL (Gk. angelos "messenger"). The angel plays a vital role in many
Renaissance topics and has a complicated lineage as the messenger of the gods,
the agent of the divine will, and its execution on earth, which may be traced
back to the winged messenger-spirits of Assyrian sculpture and the Cherubim
of Jewish art. Descriptions of angels appear in apocalyptic and prophetic literature
and were a formative influence in medieval and Proto-Renaissance art. The Old
Testament has many references to angels whose function is to convey God's
will to mankind. In some works of art they are the topic while in other works
they are necessary supports for the primary topic. Their most important roles
include annunciator, both to *Abraham and the Virgin (see MARY, SAINT)
and punishers of wrong-doers (*Adam and Eve). Also they surround and support
figures, play musical instruments, float about in various attitudes, and adore holy
figures. They predominate in such themes as the *Coronation of the Virgin, the
*Assumption, and *Last Judgment scenes. See SERAPH AND CHERUB.

 Example: Luca della Robbia, *Angels Making Music*, 1431–38, Cathedral Museum,
Florence.

ANGELS HOLDING THE SUDARIUM. See SUDARIUM.

ANGER. See SEVEN DEADLY SINS.

ANIANUS. See MARK, SAINT.

ANNE, SAINT. Saint Anne (Anna) is traditionally the mother of the Virgin
Mary (see MARY, SAINT) and wife of Saint Joachim. She is not mentioned in
Scripture, although her cult is very old. She has been especially popular since

the Middle Ages and appears in many Renaissance works of art. She is shown in scenes of the life of the Virgin such as the *Presentation of the Virgin in the Temple, teaching her child to read, and the *Meeting at the Golden Gate. She appears frequently in paintings of the *Holy Family with the *Christ Child. Usually she is portrayed as an elderly, veiled woman in a green mantle and red dress, symbols of immortality and divine love. She is also shown holding a book. Scenes depicting Anne's death show the Virgin Mary placing a candle in her hand as Christ gives her his blessing. She is the patroness of Quebec province and Brittany and is evoked by women in childbirth.

Example: Michelangelo, *Saint Anne with Madonna and Child*, chalk and pen sixteenth century, Louvre, Paris.

ANNUNCIATION. The Annunciation to the Virgin Mary (see MARY, SAINT) by the *Angel *Gabriel is one of the most important events from the entire Christian cycle and was painted by Leonardo da Vinci and by most of the great artists of the Renaissance. According to Saint *Luke, the Angel Gabriel brought tidings to the Virgin Mary of her miraculous maternity, ''You shall conceive and bear a Son, and you shall give Him the name Jesus'' (1:26–38). In art the subject has three essential elements: the angel, the Virgin, and the dove of the *Holy Spirit usually descending toward Mary's breast. It is seldom depicted without other symbolic features. Present are usually a lily, symbol of the Virgin's purity, and a distaff or basket of wool, which alludes to the legend of the Virgin's upbringing in the Temple at Jerusalem, where she made priests' vestments. She is always shown with a book from which she is reading the prophecy of *Isaiah, ''A young woman is with child, and she will bear a son'' (7:14). Some artists chose the closed book, held in her hand, which alludes also to Isaiah, ''All prophetic vision has become for you like a sealed book'' (29:11–12). The angel speaks to Mary, especially in early Netherlandish painting, ''Ave Maria,'' or ''*Ave gratia plena Dominus tecum*,'' ''Greetings most favored one. The Lord is with you'' (Luke 1:28). The Virgin may speak in return. ''I am the Lord's servant. May it happen to me as you said'' (Luke 1:38). These inscriptions may sometimes be painted upside down so that they can be more easily read by God. The Virgin may stand, sit, or kneel, generally at a *prie-dieu*. In some versions she turns away from the angel or raises her hands. The Angel Gabriel is usually in white and has wings. He stands or kneels before her, but may be shown descending. Italian Renaissance painting from c. 1500 places Gabriel on a bed of clouds to imply that he descended from heaven. In some early examples Gabriel holds a sceptre tipped with a fleur-de-lis, his attribute, but just as often he holds a lily. In Simone Martini's *Annunciation*, 1333, Uffizi Gallery, Florence, Gabriel holds an olive branch (the symbol of peace), which was an indication of the enmity that existed between Florence and Siena, since the lily was the civic emblem of Florence. The entire image is meant to imply the exact moment that the Virgin conceived the human body of Christ. God the Father is

sometimes shown above as the spiritual light, and the dove descends on a slanting ray of light that reaches the Virgin's breast or hand.

Luke does not mention a setting for the Annunciation, merely that "God sent the Angel Gabriel to a town in Galilee named Nazareth" (1:26). However, a distinct difference is shown between Northern and Italian Renaissance depictions. Northern painters usually display ecclesiastical architecture that has a symbolic meaning. The ogive arch and very slender columns of the Gothic style, which to northern painters was modern and symbolized the church and Christianity, were usually shown. Within the same painting the round arch with plain heavy columns, a type of the old Romanesque, was shown in contrast and is symbolic of Judaism. The Virgin may be seated or standing within the building or standing at a doorway. The Gothic building is new and bright while the Romanesque construction is dark and in decay. Some artists introduced a walled garden (the *hortus conclusus*) and a tower. Both are symbols of the Virgin's purity.

Example: Fra Angelico, 1438–1445, Monastery of S. Marco, Florence. (There are two different versions, same artist and location.)

ANNUNCIATION OF THE VIRGIN'S DEATH. In painting, this topic may resemble the Annunciation of Christ's Incarnation. The *angel, however, offers the "Palm of Paradise" instead of holding a lily or sceptre. Traditionally the angel has been identified with Michael (see MICHAEL, SAINT), but is not necessarily so depicted. See DEATH OF THE VIRGIN.

Example: Duccio, *The Annunciation of the Death of Mary*, detail of the *Maestá Altarpiece*, 1309–1311, Opera del Duomo, Siena.

ANNUNCIATION TO ANNE. This topic is a scene that resembles the *Annunciation to the Virgin Mary (see MARY, SAINT). An *angel told Anne that she would conceive and that the child would be the mother of *Christ. The setting is usually a garden, and Anne sits under a laurel tree in which some sparrows are nesting. She had seen the nest and remarked upon her own barrenness after twenty years of marriage. The scene, however, can be different, as in the version by Giotto, where Anne is in a house in Jerusalem when she is visited by an angel, who flies in through a window and announces to her that she will conceive and bear a child. A servant sits in a side room apparently unaware of Anne's good fortune. The term "Immaculate Conception" is used in reference to the conception of Mary in the womb of her mother. The story of Anne and her husband Joachim is told in the thirteenth-century *Golden Legend*, which took it from the apocryphal New Testament literature.

Example: Giotto, *Vision of Anna*, 1305, Arena Chapel, Padua.

ANNUNCIATION TO JOACHIM. Joachim, the father of the Virgin Mary (see MARY, SAINT), is shown in a remote and rocky place with perhaps a shepherd's enclosure with shepherds and sheep in the background when he receives the news that his wife, Anne (see ANNE, SAINT), will have a child.

He kneels before *Gabriel, the Annunciation *angel, identifiable by the fleur-de-lis on the tip of his wand. He tells Joachim that Anne will conceive, and that the child will be the mother of Jesus. The story of Joachim and Anne is told in the *Golden Legend* written in the thirteenth century and taken from the apocryphal New Testament literature.

 Example: Quinten Metsys, *Saint Anne Altarpiece,* left wing, 1507–1509, Musée Royaux des Beaux-Arts, Brussels.

ANNUNCIATION TO THE SHEPHERDS. The symbolism of Christians, *Christ, sheep, and shepherd is supported by the parables in *John (10:1–18) and Luke (15:3–7) and to a degree by Ezekiel (34), Isaiah (40:11), and Psalm 23. During the Annunciation, when the shepherds are being told that Jesus had been born, they are depicted as young and beardless, usually seated among their flocks and either playing syrinxes or lyres or holding shepherds' staffs. This image was derived from Orpheus (see ORPHEUS AND EURYDICE) charming the animals in classical literature. Shepherds are usually present at Christ's *Nativity, having already been called in from the fields or the Annunciation is in process. The latter scene may show an *angel hovering overhead, casting a spiritual light where the shepherds are guarding their sheep. One may lift a hand in recognition and another may shield his eyes from the intense spiritual light. Some Annunciation to the Shepherd scenes depict the shepherds around the edge of the Nativity; their sheep may have arrived ahead of them.

 Example: Taddeo Gaddi, 1332–1338, Baroncelli Chapel, Sta. Croce, Florence.

ANSANUS, SAINT. Saint Ansanus was a Christian martyred for his beliefs in 303, when he was twenty years old. He was a nobleman of Siena who, after becoming a Christian at the early age of twelve, preached the faith until he was denounced by his father to the emperor Diocletian. According to legend, he was boiled in oil before his execution and may be shown standing in a vat of oil while a fire is lighted underneath. He may also be shown baptizing converts or being led to prison. Sometimes he is dressed as a warrior, holding the banner of *Resurrection with a heart inscribed with the letters IHS (the abbreviation of the name "Jesus" in Greek) and a martyr's palm with a bunch of dates. (The fruit of the date palm was picked by Joseph during the rest on the *Flight into Egypt.) Since he is the patron saint of Siena, Ansanus appears primarily in paintings of the Sienese school.

 Example: Simone Martini, *Annunciation with Saints Ansanus and Margaret,* 1333, Uffizi Gallery, Florence.

ANTAEUS (Antaios). See HERCULES AND ANTAEUS.

ANTHONY OF PADUA. A Portuguese Franciscan and doctor of the church, Anthony of Padua was born in Lisbon in 1195 and educated in the cathedral school of that city. He died in Padua in 1231. At first he joined the Order of

Saint Augustine, but after hearing of the holiness of Saint *Francis of Assisi, he sought out the founder of the Franciscans. At first Francis thought Anthony merely a well-meaning youth, but after hearing Anthony preach, Francis commended the young man's speaking ability and put him in charge of much of the educational work of the order. Soon Anthony was the close friend and favorite disciple of Saint Francis. Several legends exist about Anthony. One is the story of the heretic of Toulouse, who would not believe in the presence of *Christ in the *Eucharist unless his donkey came out of its stable and knelt down before the Sacrament. Some time later, as Anthony was carrying the Eucharist to a dying man, the donkey met him at the steps of the church and knelt before the Sacrament. Because of this legend, a donkey is sometimes seen with Saint Anthony. Usually the saint wears the robe of the *Franciscan order and may carry a lily, the flowered cross, a book, a fish, or fire. Traditionally, in a vision he held the Child Jesus in his arms and is usually thus depicted in art. He is the patron saint of Padua and has the reputation of a miracle worker. He is invoked by Roman Catholics to find lost articles. See MIRACLE OF THE IRASCIBLE SON.

Example: Vincenzo Foppa, *St. Anthony of Padua*, late fifteenth century, National Gallery of Art, Washington.

ANTHONY THE GREAT. Anthony Abbott or Saint Anthony of Egypt (251?–c. 350) is one of the figures most frequently portrayed in Renaissance paintings. A Christian saint and hermit, he was born in Upper Egypt of noble and wealthy Christian parents. When Anthony was eighteen, his parents died and he distributed his inheritance among the poor, felt his spirit suddenly awaken, and at the age of thirty-five retired into the Egyptian desert with a band of hermits, where he remained for twenty years in a ruin near the Nile. He devoted his life to self-denial and spiritual growth, striving to overcome all weakness of the flesh and to live for God alone. His struggles with temptations, which he called his ''demons'' (every temptation the devil could devise) during his ascetic life in the desert have inspired numerous works of art. His temptations assume two forms in art, erotic visions and assaults by monsters. They flee when God appears to him in a blinding light. When Anthony left the desert he had such spiritual strength that a colony of hermits grew up around him in order to be under his guidance. He ruled them in a community, and the monks lived in solitude except for communal worship and meals. When he was ninety he believed he was the only person to have lived so long in solitude and self-denial, but a voice told him that Paul the Hermit also had served God in solitude and penance for ninety years and was a holier man. Anthony went in search of the Hermit Paul. When he reached the cave where Paul was living (after many temptations, all dispelled with the sign of the cross), Paul told him how a raven had brought him a half a loaf of bread each day for sixty years. When the two men began to live together in the desert, the raven brought a whole loaf of bread every day. When Paul died, Anthony returned to his own dwelling and lived there until his own death at the age of 105. Saint Anthony was the father of Christian monasticism; his

community became a model, particularly in the East. He is the patron of herdsmen. Artists show him as old, bearded, and dressed in a monk's robe and hood. He holds a stick with a *tau*-shaped (T) handle; the *tau* is also depicted on the left shoulder of his cloak in blue or white. The origin of the *tau* is uncertain, although some sources say the T was originally a theta, the first letter of the word *Theos*, which means "God" in Greek. He carries a crutch, an indication of his advanced age, and a bell is in his hand or hanging on his crutch. The significance of this attribute is that it symbolizes the ability of the saint to exorcize evil spirits and demons. A hog may accompany Anthony; the hog represents the demon of gluttony and sensuality and indicates his triumph over sin. Anthony may also be depicted with flames under his feet, a reminder that a vision of the flames of hell killed in the saint the desires of the flesh. In early Renaissance painting women included in the work are usually clothed, but may have horns to remind one of their satanic origin.

Example: Matthias Grünewald, *Temptation of Saint Anthony, Isenheim Altarpiece* (completed 1515), Musée d'Unterlinden, Colmar.

ANTICHRIST. In Christian belief, the Antichrist is a person whose appearance on earth will precede the Second Coming of *Christ and will represent the powers of evil by opposing Christ, glorifying himself, and causing many to leave the faith. At the time of the Second Coming he will be destroyed by Christ. The Antichrist is described in Revelation:

Then I saw a beast coming up out of the sea. It had ten horns and seven heads; on each of its horns there was a crown, and on each of its heads there was a name that was insulting to God. . . . The beast was allowed to make proud claims which were insulting to God. . . . It was allowed to fight against God's people and to defeat them. . . . Whoever is intelligent can figure out the meaning of the number of the beast, because the number stands for a man's name. It is 666 (13).

The destruction of the beast is also described in Revelation: "Then the Devil, who deceived them, was thrown into the lake of fire and sulfur, where the beast had already been thrown" (20:10). See PREACHING OF THE ANTICHRIST.

Example: Luca Signorelli, *Preaching of the Antichrist* 1499–1504, S. Brixio Chapel, Cathedral, Orvieto.

ANTIOPE. In Greek mythology Antiope was a Theban princess, or according to various sources, a *nymph, the wife of a king of Thebes, the daughter of the river Asopus or Nycteus, king of Boeotia. Her story, now lost, has come down mainly through Euripides' *Antiope*. She was approached by Zeus (*Jupiter) in the form of a *satyr while she was asleep and seduced by him (Ovid, *Metamorphoses* 6:110–111; Hyginus, *Fabulae* 8). She bore twin sons, Zethus and Amphion, then fled to Sicyon to escape the wrath of her father, who cast the infants out to die on Mt. Cithaeron, or she abandoned them there, where they were raised by shepherds. Later Amphion was given a lyre by Hermes (Mercury) and helped Zethus to erect a wall around Thebes by causing stones

to move of their own will with his music. Antiope was captured by her uncle Lycus, then king of Thebes, and his wife Dirce, who kept her in prison and treated her cruelly. She escaped and was avenged by her sons. They dethroned Lycus and tied Dirce to the horns of a bull so that she was dragged to her death. Antiope is usually shown asleep in a forest while Zeus, in the shape of a satyr, horned and goat-footed, lifts her robe.

Example: Antonio Correggio, c. 1520, Louvre, Paris.

ANTIPOPE. A person elected pope in opposition to a canonically chosen legitimate pontiff is known as an antipope. The word refers generally to the popes elected at Avignon in opposition to those elected at Rome between 1378 and 1417, the time of the Great Schism. A series of antipopes were also elected at Pisa as well as at Basel. Important antipopes were Novatian; Clement III; Nicholas V; Clement VII; Benedict XIII; John XXIII; and Felix V, who was the last antipope.

ANTONINE OF FLORENCE, SAINT. Antonine (1389–1459) was a saint who was born Antoninus Pierozzi and entered the *Dominican order at the early age of sixteen and in 1446 was consecrated archbishop of Florence. He ruled well and was admired and beloved for his untiring devotion and support for victims of the plague and earthquake of 1448 and 1453. His *Summa moralis* is a well-known work in theology. It is of special interest because of its treatment of the morality of banking and of commercial ethics. It is an accurate record of the effect the new economics were having on everyday life. In 1523 he was canonized by Pope Adrian VI. His feast day is May 10.

Example: Giovanni da Bologna, *Miracle of Saint Antoninus*, bas relief, sixteenth century, San Marco, Florence.

ANTWERP MANNERISTS. A term used to indicate a group of Antwerp painters working in the early sixteenth century whose style is characterized by affected poses. Most are unidentified and have nothing to do with *mannerism. Adriaen Isenbrandt (Ysenbrandt) is related to this group.

APELLES AND THE COBBLER. Apelles was a Greek painter born at Colothon on the island of Cos who worked in the late fourth century B.C. He was the most celebrated of Greek painters, though none of his work remains. He was court painter to Alexander the Great. Technical treatises written by him are lost and little useful information about him survives. He remains important as a part of the movement by Renaissance scholars to revive classical antiquity. See CALUMNY OF APELLES.

Example: Giorgio Vasari, c. 1570, Sala delle Arti, Casa Vasari, Arezzo.

APHRODITE. See VENUS.

APOCALYPSE. The last book of the New Testament is the book of Revelation, often called the Apocalypse (from Greek for "uncovering"), a type of ancient Hebrew and Christian literature narrating the visions of the future experienced by Saint John on the island of Patmos (see JOHN THE EVANGELIST AND APOSTLE, SAINT). It is known in the Authorized or King James Version as "The Revelation of Saint John the Divine." It also deals with the end of the world. The writing is characterized by rich imagery and obscure symbols mostly in the form of visions. No early Christian manuscripts of the Revelation have survived. The earliest examples date from the fourth century and occur in the West only. The Eastern church doubted the authenticity of the Apocalypse. During the Renaissance Albrecht Dürer published his *Apocalypse* (1498). Here he condensed the visions of the Apocalypse into a number of powerful and dramatic *woodcuts. See FOUR HORSEMEN OF THE APOCALYPSE.

APOCRYPHA. The apocrypha (from Greek for "hidden things") is the appendix to the Authorized or King James Version of the Old Testament included at one time in authorized Christian versions of the Bible, although now mostly omitted from Protestant versions.

APOLLO. One of the twelve Greek gods of Olympus, Apollo was a symbol of ideal, youthful, masculine beauty; of light; and of the rational and civilized side of man's nature. He is also associated with archery, medicine, music, prophecy, and the care of flocks and herds. Numerous legends deal with his many functions. In Greek myth he was born on the island of Delos, the son of Zeus (*Jupiter) and Leto, and the twin brother of Artemis (*Diana). Leto was on Delos, where she had fled from the jealousy of Zeus' wife, Hera (Juno). Later Apollo came to be identified with the sun-god Helios (Sol), who daily drove his chariot pulled by horses (depicted as white after the fifteenth century) across the sky. Artists portrayed Apollo as a beardless young man with delicate, even effeminate, features. He is usually depicted nude. As the patron of archery he may hold a bow, arrow, and quiver. During the Renaissance, mythographers compared the sun god's arrows to the sun's rays; they also gave him a twined serpent—a monster with three heads, those of a dog, lion, and wolf. This creature was taken from the Egyptian sun-god Serapis.
 Example: Michelangelo, c. 1530, Bargello, Florence.

APOLLO AND DAPHNE. Daphne, whose name means "bay" or "laurel," was the mountain-nymph daughter of the river god Peneus and was the first of Apollo's loves. The cause was, according to Ovid, *Cupid, who one day in a spiteful mood shot *Apollo with the golden arrow that enflames love and Daphne with the leaden arrow that causes one to flee. Apollo pursued Daphne until she became exhausted, and when she had no more strength she prayed to Peneus to

save her. The river god immediately changed her into a laurel tree (*Metamorphoses* 1:452ff; Hyginus 203). In painting and sculpture the transformation usually takes place at the moment Apollo touches Daphne. Apollo is depicted as a beautiful young man with bow and quiver and perhaps a crown. (For consolation Apollo made himself a laurel crown.) Daphne is shown as a lovely *nymph with laurel leaves and roots sprouting from parts of her body. The theme symbolizes the victory of Chastity over Love.

Example: Antonio Pollaiuolo, 1433–1498, National Gallery, London.

APOLLO AND MARSYAS. Marsyas, a *satyr and sometimes called a silenus because he represented man's beastly nature, was a follower of *Bacchus and a skillful flute-player in Phrygia. Athena (Minerva) (see PALLAS AND THE CENTAUR) had invented the flute, but she threw it away because in order to play it she had to puff out her cheeks and disfigure her face, and the other gods laughed at the sight of her face when she played. Before she threw the flute away she laid a curse on it. Marsyas, who found the flute, played so beautifully upon it that he challenged the lyre-playing *Apollo to a contest to be judged by the muses. The winner was supposed to be able to do as he pleased with the vanquished. The muses, of course, declared Apollo the winner. Apollo tied Marsyas to a pine tree and flayed him alive (*Metamorphoses* 6:382–400; Ovid, *Fasti* 6:703–708; Philostratus the Younger, *Imagines* 2). The original myth possibly echoed an ancient fertility rite from Phrygia that involved human sacrifice. The victim was hanged under a pine tree. The river Marsyas, according to myth, sprang from his blood or from the tears shed by the other satyrs at his death. During the Renaissance, when the story gained in significance, symbolic meanings were attached to the two classes of instruments. It was felt that the soothing sound of strings had a spiritually uplifting quality, while the reed pipe with its coarse notes stirred primitive passions, and the pipe was already a recognized phallic symbol. In this way the theme was seen as an allegory in musical terms of the intellect in contest with the emotions, a symbol of divine harmony triumphing over earthly (uncontrollable) passion. While baroque artists in the seventeenth century tended to dwell on the cruel aspects of the flaying itself, Renaissance artists show a quiet scene with possibly an attendant of Apollo with the laurel crown of victory. The contest is also known as a separate work. Marsyas innocently plays his flute while Apollo regards him with cool confidence. The latter's lyre and sometimes also bow and quiver lie nearby.

Example: Raphael, early sixteenth century, part of a series in the Vatican, Rome.

APOLLONIA. A virgin martyr and Christian saint of Alexandria, Apollonia was executed in 249. According to legend, a magician lived in Alexandria who was held in high esteem by the pagan population. Because the Christians who lived there despised and even destroyed the gods he worshiped, he ordered a persecution. Many Christians fled to avoid death, but Apollonia, a deaconess of the Christian church there, remained to comfort those who stayed. She was even

able to preach and make many converts while she awaited her martyrdom. When arrested, she was ordered to sacrifice to the pagan gods of the city, but instead she made the sign of the cross before the idols and the statues fell into fragments. For this she was bound to a stake and her teeth were pulled out with pincers. She was then taken to a huge fire outside the city where she was to be burned alive. Ready for her martyrdom, she threw herself into the fire. Apollonia is usually depicted as a beautiful young woman who holds a pair of pincers containing a tooth. Other scenes show her martyrdom with one executioner holding her by the hair while another pulls out her teeth. She is the patron saint of dentists.

Example: Piero della Francesca, *Saint Apollonia*, mid-fifteenth century, National Gallery of Art, Washington.

APOSTLES. In art the apostles represent the Disciples of *Christ sent out to preach the *Gospel, with the addition of Saint *Paul. The number is always twelve even though the *Evangelists Mark and John may be included (see MARK, SAINT, and JOHN THE EVANGELIST AND APOSTLE, SAINT). In Renaissance works they appear in scenes such as the *Ascension and the *Last Supper. Their physical types are fairly constant, and they are easily recognized. For example, Saint John is a beardless youth; Saint Paul has a long face, large brow, and dark hair and beard; Saint Peter (see PETER, APOSTLE AND SAINT) is old with white hair and beard; and Saint *Andrew has unruly white hair. They usually wear long tunics with mantles thrown across one shoulder, although in the Renaissance and later they may be shown naked as in Michelangelo's *Last Judgment* in the Sistine Chapel at the Vatican in Rome. They have also been depicted in several portrait-series, as in the work of Jan van Eyck, fifteenth century drawings, Albertina, Vienna.

APPARITION AT ARLES. See FRANCIS OF ASSISI, SAINT.

APRIL. April was the fourth month of the calendars that appeared in northern European illuminated manuscripts and Italian *fresco cycles during the Renaissance. Sometimes each page or scene depicted the triumphal car of the deity who presided over a particular month, while below or above it, the usual signs of the zodiac appeared and the labors and activities associated with the month were often represented. The triumphal vehicle of April, usually ridden by a robed *Venus is usually a decorated barge pulled through low waves by graceful harnessed swans, or through clouds by two horses. On the banks of a serene water inlet are elegantly dressed men and women charmingly represented in social intercourse, enjoying themselves in the midst of abundant flowers and rich green fields. Two women may court one man. Numerous loving couples of rabbits, a byword for fecundity, symbol of lust and attribute of Venus, may be placed here and there. The *Three Graces, often the handmaidens of Venus, may be shown typically grouped so that the two outer figures face the spectator

with the one in the middle facing away. This was their antique form that was known and used during the Renaissance.

Example: Francesco del Cossa, early 1470s, Sala dei Mesi, Palazzo Schifonoia, Ferrara.

ARIADNE. See BACCHUS AND ARIADNE.

ARISTOTLE AND PHYLLIS. This is a "classical" story, which is actually medieval. It depicts the philosopher Aristotle in the unusual position of being ridden like a horse by his mistress, Phyllis. The pair are discovered by two curious figures who peer at them over a wall.

Example: Housebook Master, drypoint c. 1475–1480, Rijksmuseum, Amsterdam.

ARNOLFINI WEDDING. This marriage group is a wedding portrait of Giovanni Arnolfini and his wife. The double portrait of Giovanni Arnolfini and his wife, Giovanna Cenani, by Jan van Eyck, considered a marriage portrait by some and a pictorial marriage certificate by others, features Arnolfini, a financier of Lucca who had established himself in Bruges, wearing a purple velvet tunic, and his Paris-born Italian wife, in a blue dress and green mantle, taking the matrimonial vow in the privacy of the bridal chamber. The merchant holds his wife's hand and looks ahead and down as he raises his right hand. To the right of the pair the curtains of the marriage bed have been opened. His shoes are to his right and hers are at the back of the room, having been removed because the couple stands on holy ground. The dog standing between the couple is a symbol of fidelity (the origin of the common canine name, Fido). Also, dogs were usually represented at the feet of women in earlier tomb sculpture. The chandelier above and between the couple contains a single burning candle, symbol of the all-seeing presence of *Christ, whose *Passion is placed in the ten small medallions around a larger circular convex mirror at the back of the room. Jan van Eyck can be seen (according to some sources) in the mirror entering the room with a companion. The bride and groom are reflected from the back. The single burning candle is also reflected, causing the omnivoyant eye of God to be referred to twice. On the top right of the finial of the chair (some sources indicate a bedpost) at the back of the room Saint *Margaret, patron saint of childbirth, is carved. From the same finial hangs a whisk broom, the symbol of domestic care. The light for the room comes from a window at the left and illuminates oranges on the window sill, which may refer to the golden apples of the Hesperides, representing the conquest of death. The atmosphere is calm and mystic. Jan van Eyck has dated his work with an unusual inscription, using the calligraphic flourishes of a legal signature of the day, on the back wall above the round mirror: "Johannes de eyck fuit hic, 1434," "Jan van Eyck was here, 1434," announcing that he was present at the wedding. The painting is located in the National Gallery, London.

ARREST OF CHRIST. See BETRAYAL.

ARRICCIATO (Arriccio). *Arricciato* is a term used in mural painting. It is the rough layer of sand plaster and lime to which the *intonaco*, the final layer of plaster, is applied. See FRESCO.

ARRIVAL OF THE AMBASSADORS OF BRITAIN AT THE COURT OF BRITTANY. The ''arrival'' is part of the narrative cycle of the legend of Saint *Ursula. The story appeared in several versions during the Middle Ages and occurs frequently in Renaissance art. Many episodes from this long narrative have been illustrated and are not always consistent because they are drawn from different versions of the legend. Basically, Ursula's father, a Christian king of Brittany, received ambassadors from a pagan king of England whose son Conon wanted to marry Ursula. In the cycle, reading from left to right, the ''arrival'' scene usually shows the ambassadors kneeling before the king flanked by four of his counselors. On the right the king is shown sitting at the edge of a bed (as if he is in Ursula's room) and listening while Ursula counts off the conditions of her future marriage.

Example: Vittore Carpaccio, c. 1495, Accademia, Venice.

ARTEMIS. See DIANA.

ASA. Asa was a king of Judah, the son and successor of Abijah. He was known as a good king who ruled for forty-one years in Jerusalem. During his rule he expelled all the male and female prostitutes from the country, and he removed all the idols his predecessors had made. He was known for being faithful to God all his life. His life is recorded in *The History of the Kings of Judah*. When he died he was buried in the royal tombs in David's City, and his son Jehoshaphat succeeded him as king (Kings 15:8–24).

Example: Michelangelo, 1508–1512, Sistine Chapel Ceiling, Vatican, Rome.

ASCENSION. The Ascension is the name usually given to the departure of *Christ from earth as related in the *Gospels according to Mark (16) and Luke (24) and in Acts (1:9–12). This was the last appearance of Christ to the apostles. He was taken up to heaven forty days after his *Resurrection while he was with the apostles on the Mount of Olives. ''As they watched, He was lifted up, and a cloud removed him from their sight. As he was going, and as they were gazing intently into the sky, all at once there stood beside them two men in white who said, 'Men of Galilee, why stand there looking up into the sky? This Jesus, who has been taken away from you up to heaven will come in the same way as you have seen him go' '' (Acts). Different depictions of the Ascension are found in Renaissance painting. Christ may be portrayed full face, framed within the almond-shaped *mandorla*, which may be carried by *angels. He may be shown in profile, as if climbing to heaven, usually framed in a *mandorla*, or he may

be shown literally disappearing into a cloud with only his feet visible below. Usually a complete Ascension is divided into an upper and lower zone representing heaven and earth, or the spiritual and the physical. In the heavenly zone Christ is in the center, his feet on a small cloud mass, surrounded by angels who form a *mandorla*. Sometimes he holds the banner of Resurrection, and makes the sign of benediction with his right hand. Angels may play musical instruments on either side of him. The apostles (by now only eleven) on earth either kneel in prayer or gaze up in awe. Christ's mother, as a symbol of the Mother Church that Christ has left behind on earth, is usually present. Peter (see PETER, APOSTLE AND SAINT), holding the keys, and Saint *Paul, holding his sword, represent the Jews and the Gentiles to whom the Christian message was brought. The annual commemoration of the Ascension is one of the principal feasts in most Christian churches. Ascension Day occurs on the fortieth day after Easter. This festival was known as Holy Thursday in early English usage.

Christ's was not the only Ascension represented in art. Also, the idea is not confined to Christian belief. For example, deification was bestowed in his lifetime to Alexander the Great and among the Romans, Julius Caesar was officially recognized after death as a god. In art they were depicted as being received in heaven into the presence of the deity. Saint *John the Evangelist and Apostle, the son of Zebedee and brother of James, also "ascended" into heaven. See ASCENSION OF SAINT JOHN.

Example: Andrea Mantegna, *The Ascension of Christ, Uffizi Triptych*, 1464, Uffizi Gallery, Florence.

ASCENSION OF SAINT JOHN. According to the *Golden Legend*, by the time Saint *John the Evangelist and Apostle had reached the age of ninety-nine years, the sixty-seventh year of the *Passion of *Christ, Jesus appeared to him and said, "Come to me, my well beloved, for the time has come when thou shalt sit at table with me and with thy brethren." John rose to go but Jesus said, "No, thou shalt come to me on Sunday." The following Sunday, everyone gathered at the church. John preached telling them to be strong in the faith and carry out faithfully the commands of Christ. After this he dug a square grave near the altar (some sources say the altar was in the shape of a cross), carried the earth outside the church, and went down into the grave. He raised his hands to heaven and said, "Thou hast invited me to Thy table, Lord; and behold I come, thanking Thee for having invited me, for Thou knowest that I have desired it with all my heart." When he finished his prayer, a radiant light surrounded him. When the light vanished, the saint had faded away, and the grave was filled with manna. The *Golden Legend* tells that even today this manna issues from the grave, as if it were a spring. John may be depicted descending into his grave, watched by his disciples. He is met at his *Ascension by Christ, the Virgin, and Saint Peter (see PETER, APOSTLE AND SAINT) and Saint *Paul. The saint may also be shown moving upward through the ceiling of the church

from his tomb on the floor, to be received into Heaven by Christ (who may give him a helping hand) and other saints.

Example: Giotto, after 1317, Peruzzi Chapel, Sta. Croce, Florence.

ASCRIPTION. See ATTRIBUTION.

ASSASSINATION OF SAINT PETER MARTYR. Peter is translated as "one who takes off his shoes," or as "one who knows." The word comes from *petros*, meaning "strong." Peter Martyr (c. 1205–1252), also called Peter the New, was born at Verona, and became a Dominican (see DOMINICAN ORDER) friar. He is remembered for his pursuit of heretics. Both his father and his mother belonged to a heretical sect. Peter spent his days preaching against the poisonous doctrines of the heretics and the temptations of the world. During his life he heard confessions and also performed many miracles. Some heretics began to plot the saint's death so they could be left in peace. Pope Innocent told his tale, which is in the *Golden Legend*. From the city of Como, where he was the prior of the brethren of his order, Peter was on his way to Milan to carry out the office of judge, which had been bestowed upon him by the Apostolic See. One of the heretics, egged on by pleas and gifts from his fellow believers (some sources say he was hired by two Venetian noblemen), set upon the saint, as Peter himself had foretold in one of his sermons. Peter did not run from his assassin, but offered himself a willing victim, patiently sustaining the attack, although his soul was already mounting toward heaven, and the murderer left him for dead. Peter died of his wounds a few days later. He was canonized in the following year. He is usually depicted as wearing the habit of the order and has a knife, hatchet, or sword embedded in the back of his skull. He kneels on the ground, a hand raised to his head. Peter was said to have died writing the Apostle's Creed on the ground with his blood or reciting it. The first words may be included in the work, "Credo . . . " or "Credo in Deum. . . . "

Example: Gentile da Fabriano, from the *Valle Romita Polyptych*, c. 1420, Brera Gallery, Milan.

ASSUMPTION. Assumption is a term used to indicate the ascent of the body and soul of the Virgin Mary (see MARY, SAINT) to heaven three days after her death. The term, from the Latin *adsumere*, "to take up," suggests that she was taken up to heaven. The Assumption, celebrated as a church festival for centuries, was in 1950 declared an article of faith by Pius XII's bull *Munificentissimus Deus*. The belief, which rests on the apocryphal literature of the third and fourth centuries and the tradition of the Catholic church, has no scriptural foundation. As a topic in Renaissance art, it continues the narrative of the *Death of the Virgin*. A Renaissance Assumption usually consists of two or three elements, one above the other. The Virgin is typically depicted in mid-air, being raised by choirs of *angels who sometimes play musical instruments.

Example: Titian, *Assunta*, 1516–1518, Sta. Maria Gloriosa dei Frari, Venice.

ASSUNTA. See ASSUMPTION.

ATHENA. See PALLAS AND THE CENTAUR.

ATLAS. In Greek mythology Atlas was a Titan condemned to stand in the west and support the heavens on his head and hands, except for a short time when *Hercules took over the task while Atlas got him the golden apples of the Hesperides. This punishment was for taking part in the revolt of the Titans against Zeus (see JUPITER). In another legend Atlas was visited by Perseus, to whom he refused hospitality, was turned into stone by the Gorgon's head, and is identified with the range of mountains in northwestern Africa that bear the name Mount Atlas. These legends were supported as explanations of why the sky does not fall. In architecture an atlas (pl. atlantes) is the male counterpart of the *caryatid; both are figures that function as a supporting column. In the *Cinquecento* the word *prigione* meant an atlas or a caryatid.

Example: Michelangelo, marble, c. 1520–1523, Galleria dell' Accademia, Florence.

ATTILA. See EXPULSION OF ATTILA.

ATTRIBUTION. The term "attribution" is used in art history and criticism for the assignment to an artist of a work whose authorship is in question. If a painting is signed or recorded in a document, little doubt exists that it is by the painter to whom it is attributed. "Attribution," however, usually means crediting a painter with a picture on grounds of its likeness to works known to be his. Attributions can be made either on style alone or on the evidence of documents. Some attributions have been based on minor "graphological" mannerism, such as the way in which an artist paints fingernails or earlobes. This, which centers about style criticism, can move from complete certainty to mere guesswork. Other attributions have been made when an artist's "handwriting" has been determined—his nonfigurative background strokes and shading technique, for example. The enormous financial consequences that the assignment of a work to a famous master must have creates an enormous responsibility for the conscientious cataloguer. For this reason, it is desirable to resort to such phrases as "Ascribed to," "Attributed to," "Studio of," or "Circle of." Three panels from the Saint Francis cycle in the upper church at Assisi have been attributed to Giotto. These panels depict scenes from the saint's life and span a bay in the upper church. Flanking the window are episodes done in *fresco from the life of the biblical patriarch Isaac (see SACRIFICE OF ISAAC). Some historians believe that Giotto painted the Isaac frescoes; others attribute them to an unknown artist, the "Isaac Master." No document has been found to solve the mystery.

AUGUST. The word "August" derives from Augustus, which in Latin means "to increase." August is one of the twelve months in the cycle of the months, also known as Labors of the Months, and represents the harvest. Each month

has its corresponding sign of the zodiac. The sign for August is Virgo (Latin, for virgin). Virgo is usually depicted as a maiden holding a sheaf of grain to indicate the harvest. She has been identified with *Ceres, Isis, Ishtar, and Rhea.

Example: Pieter Bruegel, *August Wheat Harvest*, 1565, Metropolitan Museum of Art, New York.

AUGUSTINE AND THE CHILD WITH THE SPOON. See VISION OF SAINT AUGUSTINE.

AUGUSTINE GIVEN TO THE GRAMMAR MASTER. The Christian Saint Augustine of Hippo was given early religious instruction by his mother, Saint Monica. When he was old enough his mother took him to school for further education. Artists usually show the pair arriving and the grammar master comes out to greet them. Augustine is shown as a child of five or six years and a little distrustful of his new teacher. The picture may contain children of all ages obediently following the grammar master, reading, playing, and talking in the background.

Example: Benozzo Gozzoli, 1465, San Agostino, San Gimignano.

AUGUSTINE IN HIS STUDY. See VISION OF SAINT AUGUSTINE.

AUGUSTUS AND THE TIBURTINE SIBYL. Also known as the Tiburtina *sibyl, she was famous as the prophetess of *Christ. Her connection with Augustus is as follows: When the Roman senate decreed the deification of the Emperor Augustus (63 B.C.-A.D. 14), according to Christian legend, he consulted the sibyl, and she told him of the coming of a child greater than all the Roman gods. At this time the heavens opened and Mary (see MARY, SAINT) holding the Baby Jesus, appeared in the sky. Augustus is sometimes shown removing his crown, or the crown may already be on the ground along with his sceptre, a sign of acceptance and adoration. The legend has been viewed as a prefiguration of the coming of the Magi (see ADORATION OF THE MAGI).

Example: Baldassare Peruzzi, 1528, Fontegiusta Church, Siena.

AVARICE (*Avaricia*). See SEVEN DEADLY SINS.

B

BABEL. See TOWER OF BABEL.

BACCHANAL OF THE ANDRIANS. The Bacchanalia (the Latin name of the Dionysiac *orgia*) in Roman religion was originally a religious ceremony in honor of *Bacchus (Dionysus), god of wine. However, it gradually became an occasion for drunken, lusty excesses and was eventually forbidden by the Roman senate in 186 B.C. Livy (*History of Rome* 39:8–18) gives a long account of the episode. Bacchantes or bacchae were also called "maenads," who in Greek and Roman mythology were female devotees of Bacchus. Widespread in southern Italy, they adorned themselves with animal skins and ivy and roamed forests and mountains waving the thyrsus (a staff tipped with a pine cone and sometimes entwined with ivy or vine leaves). They often danced in groups and many times worked themselves into an ecstatic frenzy during which they tore live wild animals to pieces with their bare hands. The Andrians lived on the Aegean island of Andros, famous for its wine, and the center of the worship of Bacchus in antiquity. According to legend, the god visited Andros annually when a fountain of water turned into wine. A river of wine beside which the Andrians drank, described by Philostratus the Elder (*Imagines* 1:25), became the scene for dancing, drinking, and singing. Philostratus was known to Renaissance Italy, and Titian's *Bacchanal* especially reveals the variety of ways in which wine can be enjoyed. Silent brooding, loquaciousness, complete indolence, recklessness, and anger are all carefully described and analyzed according to the amount of wine already consumed. Special emphasis is placed upon the aphrodisiac effect of wine. The participants are young adults enjoying life enhanced by the gift of Bacchus except for two cases: the child in the foreground, the only remnant of Philostratus' "multitude," who lifts his shirt and relieves himself on the legs

of a beautifully stretched out maenad; and the old man in the background in a vinous torpor, who has withdrawn from the group to seek silence on a hill. He sleeps the sleep of impotence and lethargy and seems to form a contrast to the lovely maenad in the righthand foreground, asleep in sated exhaustion. Her pose is later imitated by Poussin and Goya.

Example: Titian, c. 1520, Prado, Madrid.

BACCHUS. Bacchus is the Roman name for the Greek or pre-Greek god associated with wine, the release of emotion, and fertility cults. (The Greeks used the Latin form Dionysus.) Bacchus was originally a fertility god worshipped in the form of a goat or a bull whose celebrations were often delirious orgies that culminated in the ritual killing of an animal or even a human victim, which was torn apart and eaten raw, a symbolic eating of the god himself. Bacchus was also the god of vegetation. The controlled orgiastic ritual in his honor was at one time considered a necessary catharsis. The celebrations, orgies, and rituals were closely guarded mysteries. He was said to have been born from the thigh of *Jupiter after he had been sewn into it by Mercury. Semele, his mother, had been consumed by one of Jupiter's thunderbolts while she was pregnant. The infant was taken from her dead body by Mercury and handed over to maenads who lived in a grotto on Mount Nysa in India. He was brought up by the *nymphs and taught the use of the vine by *satyrs and Silenus. They also taught him the use of ivy, which when chewed is pleasantly intoxicating. When older, Bacchus led his maenads across Asia to Greece. There his cult seems to have had great attraction for women; the bacchante, or maenad, is Bacchus' female companion. She usually expresses pleasurable abandonment and beats a tambourine. Bacchus himself is usually shown drunk and sensuously naked, his head wreathed by bunches of grapes and vine leaves. In Renaissance art a hint of Christian content may exist in that *Christ, like Bacchus, was a god of wine (the *Eucharist), and the mystery of intoxication was comparable to that of death.

Example: Michelangelo, marble, 1496–1497, Bargello, Florence.

BACCHUS AND ARIADNE. In Greek mythology, Ariadne was a Cretan princess, the daughter of King Minos of Crete and his queen, Pasiphaë. Because of her love for Theseus, she guided him through the labyrinth with a ball of thread after he had killed the Minotaur. All she had in return was to be taken away, betrayed, and abandoned on the island of Dia (later identified with Naxos). Here Bacchus (Dionysus) found her asleep on the shore. He gave her a jeweled diadem of seven stars, then flung it into the heavens where it became the constellation known as Corona (the Cnossian Crown). Then, he, too, left her, journeyed east, and conquered India. She wished only to die. However, Bacchus, having returned from his triumph, appeared to her for a second and final encounter. She died in his arms and shared his immortality. Bacchus' first and second meeting with Ariadne is obscure as far as the marriage is concerned. But he told her that the Cnossian Crown would forever direct ''the doubtful ship''

at sea. For the Renaissance artist Ariadne became more a symbol of life through death because she was brought into the divine realm by Bacchus. In art Bacchus may be seen arriving on his chariot or swiftly bounding to the ground to rescue Ariadne (who may show fear of his spotted cheetahs) and lifting her up on to the chariot. He may be in the process of taking the diadem from her head or it is already placed in the heavens as an elliptical arrangement of seven stars. Bacchus' maenads and *satyrs are drunk, celebrating their rites, brandishing thyrsi (staffs tipped with pine cones), beating cymbals, and tambourines, and throwing the limbs of a dismembered heifer.

Example: Titian, 1522–1523, National Gallery, London.

BANQUET OF HEROD. See FEAST OF HEROD.

BANQUET OF THE GODS. See FEAST OF THE GODS.

BAPTISM OF CHRIST. Baptism is a rite of initiation into the Christian church by sprinkling with or immersion into water. From the earliest Christian times baptism was the first of the three essential acts of the Christian initiation. In doctrine baptism represented both a mystical union with *Christ and an acceptance into Christian society. It was at once a rebirth and a purification in which the baptismal font was the symbol of the immaculate womb of the Virgin Mary (see MARY, SAINT) from which the initiate was born again. It was preceded by a lengthy period of probation, the catechumenate. Baptism is the first of the cycle of the seven sacraments. Considering the importance of the ceremony, the scene of Christ's own baptism was frequently depicted in art, being thought of as a ''type'' or precedent of baptism in the church. Accordingly, Saint *John the Baptist was preaching of baptism in the church in the wilderness of Judea, prophesying the coming of the Savior. A multitude of people came to him from Jerusalem and other places in Judea and were baptized by him in the river Jordan. Jesus, too, came from Galilee to be baptized (Matt. 3:13–17; Mark 1:9–11; Luke 3:21, 22; John 1:29–34). Scenes of the baptism changed from a catacomb painting of John the Baptist helping Christ out of the water to the time of the Renaissance, both Northern and Italian. During this period, Christ is shown wearing a loincloth, standing ankle-deep in the Jordan; from a shallow cup, shell, pitcher, or merely cupped hands John the Baptist is on the bank pouring water over the Savior's head (baptism by ''affusion''). The dove of the *Holy Spirit hovers above Christ's head, and above that, God the Father, with possibly only head and shoulders shown or perhaps only his hands, makes the sign of blessing. Some Renaissance artists added to the scene a number of other naked or undressing figures, thereby combining the Baptism of Christ with the Baptism of the Multitude. The Baptism of Christ was a popular subject during the High Renaissance, but from the seventeenth century onward, it was rarely done.

Example: Piero della Francesca, c. 1450, National Gallery, London.

BAPTISM OF CONSTANTINE. Constantine was the Roman emperor (288?–337) who issued the Edict of Milan in 313, which made Christianity a lawful religion. Historically, Constantine I or Constantine the Great was baptized by Eusebius of Nicomedia when the emperor was dying. Legend says he was baptized by Pope Sylvester (see SYLVESTER RESUSCITATING TWO DECEASED ROMANS), (314–335). Some say Constantine had leprosy, and the only cure was to soak in the blood of innocent children. Saints Peter (see PETER, APOSTLE AND SAINT) and *Paul appeared to him in a dream and told him to send for Sylvester, who could end his suffering. The saint was summoned, and after the baptism, the emperor was cured of his disease. During the baptism, Constantine wears only a loincloth. He usually kneels while Sylvester pours holy water over his head. Roman soldiers may watch in consternation. Constantine's weapons and armor are in a pile on the ground.

Example: Raphael, c. 1500, Vatican, Sala di Costantino, Rome.

BAPTISM OF HERMOGENES. Hermogenes was a magician who was converted and baptized by Saint *James the Greater. James had just completed a pilgrimage to Compostella in Spain and met Hermogenes as he was returning to Jerusalem. According to the *Golden Legend*, Hermogenes became a devout Christian when he and James tested each other and James' way proved to be the best. Hermogenes, an old man, is shown kneeling before James, who pours the baptismal water over his bowed head.

Example: Andrea Mantegna, 1454–1457, Ovetari Chapel, Eremitani Church, (destroyed 1944) Padua.

BARBARA, SAINT. A virgin martyr of the third or fourth century, Barbara lived in Asia Minor. Her life is shrouded in contradictory legends. According to one, Dioscurus, a heathen nobleman who was Barbara's father, locked her in a tower to discourage her suitors. The tower had only two windows, but Barbara persuaded workmen to add a third in her father's absence. She also succeeded in letting in a priest disguised as a physician, who later baptized her a Christian. When Dioscurus returned, Barbara told him of her conversion. This enraged her father, and Barbara fled from the tower. She hid in the crack of a rock, but was betrayed by a shepherd. Dioscurus brought her to the Roman authorities, but when she refused to recant, she was tortured. Finally, Dioscurus cut her head off and was immediately struck down by lightning. By extended analogy, Barbara has become the patroness of makers and users of armor and firearms. Barbara's attribute is a tower with three windows to represent the *Trinity. She may hold a *host and a *chalice, implying the giving of the last sacrament. A peacock's feather, the symbol of immortality, may be in her hand. The relationship of sudden death to her is usually represented by a cannon at her feet. This symbol also signifies her patronage of armor and firearms. Narrative scenes include the building of her third window in the tower, running from her father, and her betrayal by the shepherd (his act of betrayal was punished by

the transformation of his sheep into locusts). The most common scene is her execution by her father, who usually wears a turban and wields a scimitar. Saint Barbara is invoked for a happy death and against sudden death by storm and lightning.

Example: Master Francke, *Saint Barbara Altarpiece*, c. 1415, National Museum, Helsinki.

BARTHOLOMEW, SAINT. Little is known of Bartholomew, one of *Christ's twelve *apostles. The New Testament only mentions his name. Source for his activities is the **Golden Legend*, which tells of his travels as far east as India and of his martyrdom in Armenia, where on his return journey he was seized by heathens. Tradition says he was martyred by being flayed alive and then crucified, but there are also accounts of his *death by beheading. He is usually shown as a middle-aged man with dark hair and a beard. He holds a large knife of peculiar shape, the instrument of his martyrdom, and sometimes the flayed skin hangs over his arm or is held in his hand. His inscription from the Apostles' Creed is *Credo in Spiritum Sanctum*. Common themes from Renaissance art show him preaching, baptizing, exorcising demons, and being brought before the authorities for refusing to worship pagan idols. The most common scene is his flaying.

Example: Master of Wittingau, *Saints James the Less, Bartholomew, and Philip*, panel c. 1380–1440, National Gallery, Prague.

BARTOLOMMEO. See COLLEONI, BARTOLOMMEO.

BARUCH. Baruch was a seventh century Jewish prince and faithful friend and scribe of *Jeremiah the prophet. He was also editor of the Old Testament of the Western Canon book of Baruch. Critics disagree sharply over the dates of Baruch, and many see the book as a collection of texts by several authors.

Example: Giotto, 1305, Arena Chapel, Padua.

BATHSHEBA. Bathsheba was the wife of Uriah the Hittite. In biblical accounts (2 Samuel 11:2–17; 12:16–25) she was the mistress and then the wife of the shepherd boy *David, who became king of Israel. King David first coveted Bathsheba one evening as he walked on the roof of his palace and saw her naked in her bath. Since her husband was away on service in his army, he ordered that she be brought to his palace, and when she arrived he made love to her. David, upon learning that Bathsheba had become pregnant during this encounter, wrote to Uriah's military commander and ordered that the man be put in the front line of the worst battle so that he might be killed. This was done. Uriah was killed and David married Bathsheba. As punishment for causing the death of Bathsheba's husband and for marrying his widow, God caused their first born child to fall mortally ill. Repenting, David subsequently admitted he had sinned. He was forgiven, but the child died a few days later. Artists show Bathsheba

nude or partially clothed. Some early Renaissance artists depict her fully clothed, helped by attendants, and merely washing her hands and feet. Although the Bible does not record a letter (David sent messengers to get her), some artists chose to include one. The medieval church drew this typological parallel: David prefigured *Christ and Bathsheba, the church. Bathsheba in her bath was interpreted as an image of the church cleansed by baptism and saved from the Devil (David) by Christ. From the Renaissance onward into the nineteenth century, Bathsheba was a favorite pretext for painting the nude.

Example: Hans Memling, 1484, Staatsgalerie, Stuttgart.

BATTISTA SFORZA. See SFORZA, BATTISTA.

BATTLE OF ALEXANDER. In 333 B.C. Darius III of Persia was defeated by Alexander the Great at Issus, located in what is present-day Turkey. Darius underestimated Alexander's strength, used the wrong battle tactics, and was forced to flee to Bactria, where he was murdered by the Satrap (governor) of Bactria, Bessus. Artists usually depict vast hordes of armies from both sides upon a narrow plain that rises to an alpine landscape. In the center of these swarms of warriors, Darius, in his chariot pulled by three white horses, flees the battle and Alexander on horseback chases him.

Example: Albrecht Altdorfer, *Battle of Issus*, 1529, Alte Pinakothek, Munich.

BATTLE OF ANGHIARI. One of the most celebrated military encounters of the Renaissance occurred at Anghiari in 1440 in which Florentine and Venetian forces in alliance defeated Milanese Duke Filippo Maria Visconti, who was endorsed by the treachery of Rinaodo delgi Albizzi and other Florentine exiles. The *catàsto*, the taxation reform of 1427 supported by the Medici, was replaced by a progressive income tax designed to lighten the burdens of the poor. Cosimo de Medici supported Francesco Sforza's (see SFORZA DYNASTY) contest for the duchy of Milan and aided him in this battle. For commercial reasons he favored France, but backed Ferrante of Naples against the Angevin claims. He was thus the real creator of the Triple Alliance of Florence, Milan, and Naples in the interest of Italian equilibrium and security. In the days when the Republic had to fight the invading forces of Cesare Borgia, it is conceivable that the government would want to see this scene painted, to visually revive this triumph over a long-time enemy, on the walls of the Sala del Cinquecento (Hall of the Five Hundred), a new addition to the rear of the Palazzo Vecchio by Guiliano da Sangallo to provide room for the Council of the Republic. The battle scene depicts the brutal contest of four horsemen for the possession of the standard of the Republic. Smoke rises from the battlefield and the dust on the ground is covered with blood. The faces of the victors reveal exultation and rage and those of the defeated reveal pain and despair.

Example: Leonardo da Vinci, 1503–6 (destroyed). A copy of the central section exists executed by Peter Paul Rubens in pen, ink, and chalk, c. 1615, today in the Louvre, Paris.

BATTLE OF CASCINA. One of Michelangelo's most famous compositions is the *cartoon, now destroyed, for the *Battle of Cascina*. It is well known from studies and copies. The battle scene was meant to be a large *fresco for the Palazzo Vecchio, to face the *Battle of Anghiari*, a commission given to Leonardo da Vinci in 1503 for what might have been the greatest of all his mural paintings, if it had ever been completed. Michelangelo's section of the wall was to be the same size as Leonardo's, and it can be assumed that both artists planned subordinate scenes near the ends of the large space as well as the central scene. Since the cartoon was destroyed and because the fresco itself was never executed, only a copy probably done by Aristotile da Sangallo in the sixteenth century exists. The subject Michelangelo chose for the center section of the mural does not depict an actual fighting scene; rather, he chose a minor, more human incident that happened the day before the battle. The Florentine soldiers were camped by the Arno and had taken off their armor and clothes to swim in the river while their leader lay bandaged and ill in the sweltering heat. Manno Donati, the hero of the battle, became suddenly aware that the soldiers were totally naked and unprepared for combat. He called out a false alarm, screaming that the Pisans were attacking. The web of twisting, turning, crouching, tugging boots over wet feet was Michelangelo's way of revealing the momentary weakness of the Florentine army. The Florentine soldiers are shown leaping out of the water and hastily putting clothes on their wet bodies. The probable leader, Galeotto Malatesta, can be seen in the exact center, taking a bandage from his head.

Examples: Michelangelo, figure study, black chalk heightened with white, c. 1504, Albertina, Vienna; Michelangelo, figure study, pen and brush heightened with white, c. 1504, British Museum, London; Aristotile da Sangallo made a copy of the central section in 1542 located today at Holkham Hall, Courtauld Institute of Art, London.

BATTLE OF CONSTANTINE AND MAXENTIUS. Constantine I or Constantine the Great, the son of Constantius I and Saint Helena, was born in Naissua (present-day Nis, Yugoslavia). His full name was Flavius Valerius Constantinus. As a child he was left at the court of the emperor Diocletian after his father was made caesar (subemperor). Constantius and Galerius became emperors when Diocletian and Maximian resigned in A.D. 305. Galerius sent Constantine to Constantius in Britain. When Constantius died at York the next year, his soldiers proclaimed Constantine emperor. However, much rivalry for the vacated office followed. Maxentius, in Italy, supported by the Romans, competed with Galerius and Severus. Constantine accepted the lesser title of caesar while Maxentius and Maximian defeated Galerius and Severus. Constantine married Maximian's daughter (executed in 320 on adultry charges), creating an alliance with Maximian and recognizing Maxentius.

Constantine sheltered Maximian during a dispute until the latter undertook a revolt in 310 against Constantine's rule in Gaul. Unsuccessful in his attempt, Maximian committed suicide, and Constantine considered himself emperor. When Galerius died in 310, Maximin, still another opportunist who allied himself with Maxentius, tried to claim the throne. Constantine moved against Maxentius, and they met in 312 at the Milvian or Mulvian Bridge over the Tiber near Rome. This encounter is the scene usually chosen by artists. Constantine is usually shown riding a white horse and the standards of his soldiers may carry a cross or the chi-rho monogram (the first two letters of Christ's name in Greek). Constantine may wear a sharp visored hat as he confronts Maxentius among a crowd of soldiers. There may be dead or dying soldiers trampled under horses' hoofs or falling into the river. The Battle of Constantine is an event traditionally looked upon as the turning point in the establishment of Christianity within the empire.

Example: Piero della Francesca, from the *Legend of the True Cross*, probably 1453–1454, San Francesco, Arezzo.

BATTLE OF HERACLIUS AND CHOSROES. This battle story of Heraclius and Chosroes is from the *Golden Legend*, ''Exaltation of the Cross.'' Chosroes I, king of the Persians during the seventh century, took with him when he left Jerusalem a part of the Holy Cross that Saint Helena had left there. He handed over his kingdom to his son, Chosroes II, and with the wood of the cross at his side, commanded that he be called ''God the Father.'' The emperor Heraclius, seeing an opportunity, gathered his army and advanced to meet the son of Chosroes. It was agreed before the battle that the princes would fight alone in the middle of a bridge and that the victorious prince would take over the other's empire and neither army would be damaged. A decree was issued that anyone who came to the aid of his prince would have his arms and legs cut off. Heraclius was victorious. Artists usually depict a battle scene so crowded with soldiers on foot and on horses that no landscape is visible. The idea of two princes fighting alone in the middle of a bridge is ignored. Standards and swords wave against the sky while closer observation reveals several brutal situations such as one finds when men are crowded together for the purpose of murdering each other.

Example: Piero della Francesca, from the *Legend of the True Cross*, c. 1453–1454, San Francesco, Arezzo.

BATTLE OF ISSUS. See BATTLE OF ALEXANDER.

BATTLE OF LAPITHS AND CENTAURS. See LAPITHS AND CENTAURS.

BATTLE OF SAN ROMANO. This battle took place between the Florentines and the Sienese in 1432 near San Romano in the Arno Valley close to Pisa, Italy. Men are shown in heavy armor on horseback and on foot engaged in

combat with long lances. Dead horses and men, broken lances, and pieces of armor are trampled underfoot. Fields of crops and more fighting men form the background.

Example: Paolo Uccello, three panels, 1445, National Gallery, London; Uffizi, Florence; and the Louvre, Paris.

BATTLE OF TEN NAKED MEN (Battle of the Ten Nudes). This battle, so called for lack of any knowledge of its real topic, is a mastery display of the nude body in action that places man on a level with wild beasts. Ten nude men armed with swords, bow, and ax attempt to slaughter each other against a background of dark, dense vegetation. The scene seems nearly medieval in its savagery. During the last half of the fifteenth century the nude body moving and twisting was still a problem to artists. This *line engraving by Antonio del Pollaiuolo displays in a variety of difficult poses a new interest and management of the contour line and reveals the expert knowledge of *anatomy necessary for a full understanding of bodily movement. The medium of line engraving, known before the Renaissance as a means of decorating suits of armor, was used at first by relatively few artists. This is an early prototype.

Example: Antonio del Pollaiuolo, c. 1465–1470, Metropolitan Museum of Art, New York.

BEARING OF THE BODY OF CHRIST. See PIETÁ.

BEARING OF THE CROSS (Carrying of the Cross). Christ is depicted bearing the cross on the road to Calvary. The Procession or Ascent to Calvary, better known as the Road to Calvary, is found in John 19:17. It is only John the Evangelist (see JOHN THE EVANGELIST AND APOSTLE, SAINT) who says that Christ was made to bear his own cross. Following this version of Saint John, artists show Christ bearing his cross on his shoulders from the house of Pilate (see CHRIST BEFORE PILATE) to the hill of *Golgotha, where he was crucified. He is usually shown in great pain, sometimes on his knees struggling to regain his footing under the enormous weight of the wood. Sometimes Saint *Veronica is near him holding her veil (see SUDARIUM).

Example: Albrecht Dürer, woodcut from the *Great Passion*, c. 1489–99.

BEATA VIRGO MARIA. A phrase meaning "Blessed Virgin Mary"; abbreviated B.V.M.

BEATING OF SAINT SEBASTIAN. According to the legend of Saint Sebastian, which is without historical or scriptural foundation, after the saint was shot full of arrows and left for dead by his executioners, he was nursed back to health by a widow named Irene. When completely well, he returned to confront the emperor with a renewed faith. The emperor had him arrested and beaten to death with clubs. His body was thrown into the Cloaca Maxima, the

main sewer of Rome. Artists show Sebastian as a fragile young boy surrendering helplessly to his fatal beating. He is usually partially nude and his slight figure is a strong contrast to the malicious executioners.

Example: Albrecht Altdorfer, c. 1518, Monastery of Sankt-Florian, near Linz.

BEATITUDES. The eight declarations from Matthew 5:3–11 that were spoken by Jesus at the opening of the Sermon on the Mount and which begin, "Blessed are the poor in spirit," are known as the Beatitudes. Beatitude means perfect blessedness or happiness.

BEATO (fem., *beata*). *Beato* is an Italian word meaning "blessed." More specifically, beatification is a papal decree that announces publicly that a deceased person has reached the highest form of heavenly bliss (*beatus*) and declares a type of veneration to him or her.

BEHEADING OF SAINT GEORGE. George of Cappadocia in Asia Minor was born of Christian parents before the reign of Constantine (see CONSTANTINE AND SAINT HELENA), during which Christianity was legalized. He met martydom at Diospolis in Palestine. When he defied the edict of Diocletian against the Christians, he was, after being forced to drink a poisoned cup, put in a boiling cauldron, stretched on the wheel, and finally beheaded. The beheading scene is rare in art and is mainly seen in churches of which he is a patron. See MARTYRDOM OF SAINT GEORGE.

Example: Altichiero, 1380–1384, Oratory of S. Giorgio, Padua.

BEHEADING OF SAINT JAMES. James, son of Zebedee, is known as *James the Greater because he was called earlier by *Christ and was martyred sooner than the other *apostle, *James the Less. James the Greater's martyrdom happened when the high priest of the year, Abiathar, dragged him to Herod Agrippa, where he was condemned to death by beheading. This was in Jerusalem in the year A.D. 44. As James walked to his death, he met a paraplegic whom he healed. Josias, the scribe who was leading James, saw this healing and was converted. He was executed with James, who baptized him before the beheading. Most often he is depicted on the ground, the executioner with ax poised above him. The day was March 25, the day of the *Annunciation to the Virgin Mary (see MARY, SAINT). James' relics are at Santiago de Compostella, Spain.

Example: Andrea Mantegna, c. 1455, Ovetari Chapel, Church of the Eremitani (destroyed 1944), Padua.

BEHEADING OF SAINTS COSMAS AND DAMIAN. According to the *Golden Legend*, Cosmas and Damian were twin brothers who were martyred by beheading for their beliefs. They became Christian martyrs at Cyrrhus in northern Syria under the third-century Christian persecution of the emperor Diocletian. Before being beheaded they were tortured on the hands and feet,

bound with chains, and thrown into the sea, cast into a fire, stretched on a rack, crucified, and stoned. None of these torments killed Cosmas and Damian, and the authorities were only successful in killing the brothers when they ordered their heads cut off. The saints are usually shown with their heads severed, still wearing haloes, their necks spouting blood. The expressions of the executioners range from remorseful to showing calm brutality as they discuss the execution and possibly even other events of the day.

Example: Fra Angelico, predella of the *Saint Marco Altarpiece*, c. 1438–1440, Louvre, Paris.

BEMO, PIETRO. Bemo (1470–1547) was a cardinal of the Roman Catholic church and an Italian humanist. He was secretary to Pope *Leo X but made cardinal by *Paul III. A favorite of the *Medici, Bemo insisted that classical traditions be preserved. He was responsible for helping to establish the language of Tuscany as the standard literary Italian.

Example: Raphael, c. 1500, Budapest Museum of Fine Arts.

BENEDICT. Saint Benedict was an Italian monk born near Spolete in the province of Nursia in Umbria, c. 480. He died in 547. After studying in Rome he withdrew to become a hermit at an early age and lived near Subiaco, where he attracted many followers because of his holiness. He was able to overcome his sexual feelings by throwing himself into thorn bushes. Later he founded twelve monasteries, each with a superior in charge so that his followers would have rules and discipline. At Monte Cassino he changed a Temple of Apollo, an old pagan holy place, into a church dedicated to Saint *John the Baptist. When a monk was crushed to death by a stone, Benedict restored his life. Here he established the first Benedictine monastery and wrote the Rule of the *Benedictine order (13 chapters in Latin), which became the foundation for Western monastic law. Benedict is usually shown as an old man with a white beard, though occasionally he is shown clean-shaven. He either wears the black habit of the original Order of Benedictines or the white of the Reformed order. Scenes of Benedict healing the sick are common as he was remembered especially for his miraculous acts of healing and the curing of mental illness.

Example: Taddeo Gaddi, *Saint Benedict in the Desert*, from the *Tree of Life*, c. 1340–1350, Refectory, Sta. Croce, Florence.

BENEDICTINE ORDER. A monastic order founded by and based on the teachings of the Italian monk Saint *Benedict of Nursia (c. 480–543) at Subiaco near Rome. The rules governing life in Benedictine monasteries, known as the Benedictine rule, spread to England and much of Western Europe in the next two centuries. The order was noted for its liturgical worship and its scholarly activities.

BERNABO. See VISCONTI, BERNABO.

BERNARD, SAINT. Bernard of Clairvaux (1090–1153) was a Cistercian monk. He founded the monastery at Clairvaux in France and remained its abbot until he died. He was known for his devotion to the Virgin Mary (see MARY, SAINT) and his restrictions against art in holy places because he thought it out of keeping with the monk's vow of poverty. In art he is usually depicted as young and beardless, wearing the white habit of the *Cistercian order, holding a pastoral staff, and sometimes standing on a chained dragon or monster, which symbolizes his putting down of heresy. He holds a pen and a book like the early Doctors of the church. There may be three *mitres on the ground, symbolic of his three refusals of the episcopate. See VISION OF SAINT BERNARD.

Example: Dirk Bouts, *Martyrdom of Saint Erasmus with Saints Jerome and Bernard,* c. 1460, Church of St. Pierre, Louvain.

BERTIN, SAINT. Bertin, also known as Bertinus, was an eighth-century abbot, one of three men (the others were Saint Mommolinus and Saint Bertrand) sent to assist Saint Omer in civilizing the half-heathen Morini in what is now called Pas-de-Calais in France. The three missionaries built a monastery known as the "Old Monastery," which became too small and they soon built another at the estate of Sithiu. Saint Bertin and his companions brought the knowledge of the *Gospel to this backward area. In art he is usually shown founding the monastery and preaching. His emblem is a boat which refers to his self-imposed task as a ferryman.

Example: Simon Marmion, *Saint Bertin Altarpiece*, 1454–1459, Gemäldegalerie, Staatliche Museen, Berlin-Dahlem.

BETRAYAL. The Betrayal is from the story of the *Passion and is also known as the Arrest and the kiss of Judas (see PACT OF JUDAS). It follows chronologically the *Agony in the Garden. All four *Gospels describe the scene (Matt. 26:47–56; Mark 14:43–52; Luke 22:47–53; John 18:1–12). John, however, does not mention the kiss of Judas described in the first three. He says *Christ identified himself to the soldiers by saying, "I am He." The soldiers "drew back and fell upon the ground." Early artists of the Renaissance may depict the soldiers on the ground and the kiss in the same scene. The most popular scene, however, is the kiss. Judas purses his lips for the treacherous kiss. The classic beauty of Christ's profile may be contrasted with the bestial features of Judas. The two men are surrounded by Jewish elders and soldiers armed with spears and holding lanterns and torches. Judas is usually depicted as shorter than Christ. This convention may be taken from the account given in the fourteenth century by Bridget of Sweden in her *Revelations* (see REVELATIONS OF SAINT BRIDGET). All four Gospels mention cutting off the servant's ear, and this incident, required by iconographic tradition, is rarely omitted in art. "Thereupon Simon Peter drew the sword he was wearing and

struck at the High Priest's servant, cutting off his right ear.'' The servant, Malchus, is shown in early Renaissance paintings facing Peter (see PETER, APOSTLE AND SAINT), while the latter formally cuts his ear off. Later Renaissance works show a struggle on the ground. Sometimes the later healing of Malchus' ear by Christ is depicted. The same scene may also show the disciples deserting Christ. ''Then the disciples all deserted him and ran away. Among those following was a young man with nothing on but a linen cloth. They tried to seize him, but he slipped out of the linen cloth and ran away naked'' (Mark 14:51–52). Most often the young man is identified as Mark the Evangelist (see MARK, SAINT).

Example: Giotto, 1305, Arena Chapel, Padua.

BETROTHAL OF THE VIRGIN. See MARRIAGE OF THE VIRGIN.

BIBBIENA. Bernardo Dovizi da Bibbiena was a cardinal of the Roman Catholic church under *Leo X (pope 1513–1521), and a scholarly member of Leo's literary circle. Bibbiena wrote the risque play *Calandra*, known for its subtle double entendres, c. 1508. It is the oldest of Italian prose comedies. The play was performed before the pope. When Bibbiena was sent to France, he fell in love with *Francis I and had to be recalled. Raphael's portrait covers his baldness with a red hat and his gaiety with deep gravity; it reveals his sharp nose and sly eyes.

Example: Raphael, c. 1516, Galleria Palatina, Florence.

BIBLIA PAUPERUM. Also known as the *Biblia Picta* (poor man's Bible), this was the first textbook of Christian typology, showing by way of illustrations how the main events from the life of *Christ were prefigured in the Old Testament. No historical or secular subjects among its type exist. The *Biblia Pauperum* was copied and adapted in sculpture, tapestries, and easel paintings. Published as a block book in 1465, the earliest existing manuscript dates from c. 1300.

Example: Pseudo-Blesius altarpiece, Prado, Madrid.

BINDER. A binder is a liquid vehicle in which pigments are mixed to make *paint. It is also the substance used to hold pigment (dry powder) together, such as linseed oil for oil paint. See MEDIUM.

BIOMORPHIC. In the visual arts, imagery that is taken from, but not necessarily an imitation of, the forms of living things is ''biomorphic.''

BIRETTA. A biretta (also berretta or beretta) is a square cap worn by ecclesiastics that has three or four projections above the crown, sometimes with a tassel at the top. Those of cardinals are red, of bishops purple, and of priests black.

BIRTH OF SAINT JOHN THE BAPTIST (Nativity of Saint John the Baptist). John was born of Elizabeth (see ELIZABETH, SAINT) and Zacharias (Zachary), A.D. 28, and is considered to be the last of the prophets of the Old Testament and the first of the saints of the New Testament. His birth was announced by *Gabriel, the same angel who announced the birth of *Christ, and at this time it was said that his name would be John (Luke 1:57–64). In Renaissance art the scene of his birth is a bed chamber. Elizabeth is in her bed, neighbors and relatives enter the room, and midwives are in attendance. According to the *Golden Legend*, the Virgin Mary (see MARY, SAINT), who had cared for Elizabeth in her waiting, was one of the midwives. She received the newborn child in her hands. John was "lifted from the ground by the Mother of God."

Example: Jan van Eyck and Shop, Turin-Milan *Book of Hours*, illumination, 1433–1435, Museo Civico, Turin.

BIRTH OF THE VIRGIN. The Virgin Mary's (see MARY, SAINT) origins are the tribe of Judah and the royal house of David. The *Gospels hold no mention of Mary before the *Annunciation. (Early writers described the descendance of males, never females.) According to the *Golden Legend*, Anne of Bethlehem (see ANNE, SAINT), the mother of the Virgin, had three husbands, namely Joachim of Galilee, Cleophas, and Salome. She had one daughter by Joachim and named her Mary, whom she later gave in marriage to Joseph. Saint *Jerome tells us that when he was young he read the history of the nativity of the Virgin and wrote it down as he remembered it: Joachim was reproached for offering a sacrifice to God because he had no sons. Instead of returning home he went away and stayed for some time among his shepherds. One day an *angel appeared to him and told him that his wife Anne would bear him a daughter who would be called Mary. "And as she will be born of a barren mother, so will she herself, beget the Son of the Most High, whose name will be called Jesus" (*Golden Legend,* 522). Joachim was told he would meet Anne at the Golden Gate in Jerusalem (see MEETING AT THE GOLDEN GATE). Meanwhile the same angel appeared to Anne and revealed the same things, adding that as a sign she was to go to the Golden Gate of Jerusalem to meet her husband. Thus, following the angel's command, they came face to face and shared their joy over the certainty that they were to have offspring. "Then they adored God and set out for their home, awaiting the Lord's promise" (*Golden Legend*, 523). The birth of Mary, which is seldom depicted before the fourteenth century, usually shows Anne on her bed while neighbors and friends arrive bearing gifts. The baby Mary is being bathed or being prepared for a bath in the foreground. Joachim was a wealthy man, and artists may show an unusually luxurious bedchamber. Angels may look down from above.

Example: Pietro Lorenzetti, 1342, Museo dell' Opera del Duomo, Siena.

BIRTH OF VENUS. *Venus (Gr. Aphrodite) was worshipped for love, beauty, and reproduction. According to one legend she was born of the sea-foam and washed ashore on a scallop shell at Paphos in Cyprus, after the castration of Cronus' father Uranus. His member was thrown into the sea, where from the surrounding foam it begot Venus. Other versions tell that she was the daughter of Zeus (see JUPITER) and Dione, a Titaness. Her Greek name was believed to be derived from *aphros*, foam. She went to Cythera and then Cyprus, but both claimed her, and Hesoid's *Theogony* (188–200) is contradictory about her birth place. In the Middle Ages Venus was shown as Anadyomene (rising from the sea); during the Renaissance she was pictured naked and still in the sea (see VENUS ANADYOMENE).

Example: Sandro Botticelli, c. 1480, Uffizi Gallery, Florence.

BLAISE, SAINT. Blaise was a third-century Christian saint and martyr reputed to have been the bishop of Sebaste in Armenia. He was a physician by profession, but retired to a cave after being moved by divine inspiration. Here he lived a life of contemplation surrounded by savage animals who instead of attacking him welcomed and fawned over him and came to be cured when they were wounded or sick. One day he was discovered in the woods by the huntsmen of the emperor Licinius. They thought he was a sorcerer and took him prisoner. When brought before Licinius, the emperor ordered him executed and thrown into a lake. Before undergoing the sentence, Blaise was tortured by having his flesh torn with iron combs. Through divine help, though, his wounds were healed and he walked upon the water and away from the lake. Finally, he was beheaded. During the Renaissance Saint Blaise is shown as an old man with a white beard. He is dressed in bishop's robes and a *mitre and holds a spiked comb with a handle (it resembles the combs used for carding wool). Blaise is the patron saint of wool combers. He is also invoked against sore throats because of the legend that he miraculously saved the life of a boy who had swallowed a fish bone and was choking to death. He may hold a lighted candle in memory of his dying wish that the sick be healed. He may also have crossed candles for an attribute in reference to the French custom of placing a pair of crossed candles, blessed previously, at the throat of sufferers who called on Saint Blaise to cure them.

Example: Roman Painter, fifteenth century, E. G. Crocker Art Gallery, Sacramento, California.

BLESSED AGOSTINO NOVELLO. See AGOSTINO NOVELLO.

BLIND LEADING THE BLIND. *Christ likened the Pharisees to blind men when he said, "They are blind leaders of the blind. If one blind man guides another they will both fall into the ditch" (Matt. 15:14; Luke 6:39). Artists illustrate this by showing blind beggars, each holding onto the next to find the way, each poking about with a stick. The leader is falling into a ditch and there is no doubt that the others will fall in also.

Example: Pieter Bruegel the Elder, *Parable of the Blind,* 1568, Museo-Gallerie Nazionale di Capodimonte, Naples.

BLOCK BOOK. A block book is a type of illustrated book in which the illustrations and text were cut together from the same wooden block, with one block for each page. Some sources say the method was developed by the ninth century in China; others that the earliest block books date from c. 1460, after the invention of printing from movable types. These would be printed from movable type and illustrated with separately engraved wooden blocks. The best-known example is the *Biblia Pauperum,* 1465.

BLOT DRAWING. A blot drawing is a composition evolved from forms created by allowing ink to form blobs of color or ink. This practice was known to Leonardo da Vinci during the Renaissance, but was named in the eighteenth century by Alexander Cozens.

BLUE CLOAK. Blue commonly symbolized lying or deceit in sixteenth century Flanders. In Bruegel's painting *The Blue Cloak,* an adulterous wife hides her infidelities from her cuckold husband by covering him with a large blue cloak, hood and all. She hangs a blue cloak, the symbol of lies, around her husband.
 Example: Pieter Bruegel, *The Blue Cloak,* 1559, Gemäldegalerie, Staatliche Museen, Berlin-Dahlem.

BOAZ. See RUTH, OBED, AND BOAZ.

BOLSENA. See MASS OF BOLSENA.

BONIFACE VIII. Boniface (1235–1303) was an Italian named Benedetto Caetani. He was pope from 1294 to 1303. Elected after the abdication of Celestine V, he was the first to establish a holy year (1300) in order to mark the new centenary of Christ's birth.
 Example: Fresco ascribed to Giotto, *Pope Boniface VIII Proclaiming the Jubilee Year,* 1300, Instituto Centrale del Restauro, Rome.

BOOK OF HOURS. The *Book of Hours* was a prayer book used by laymen for devotion in their homes. It was popular during the Renaissance and noted for gorgeous illumination. The book was formed over the years as prayers were added by monks and priests. The *horae,* or canonical hours, are individual parts of the day set aside for special devotions consisting of the hymns, readings, prayers, and psalms that make up the Divine Office, the *liturgy of the church.
 Example: Limbourg Brothers, *Book of Hours (Les Très Riches Heures) of the Duke of Berry,* 1416, Musée Conde, Chantilly.

BOOK OF THE HEART TAKEN BY LOVE (*Livre de Cuer d'Amours Espris*). This book is the illustration of the allegorical romance by Duke René. One scene, *Amour Gives the King's Heart to Desire,* depicts the love-sick monarch Cuer in his bed. Love, a youth with wings, takes the heart (shown in the shape of a heart) from his chest and gives it to Desire, another youth dressed as a page in white whose costume is decorated with flames.

Example: Master of René of Anjou, illumination completed 1457, Osterreichische Nationalbibliothek, Vienna.

BOTTEGA. The word *bottega* is Italian for shop and is the studio or workshop of an artist, especially that section designated to assistants and pupils who worked on productions commissioned from, and sometimes signed by, the master.

BOY CHRIST DISPUTING WITH THE ELDERS IN THE TEMPLE. See DISPUTE.

BOZZETTO. *Bozzetto* (It. "sketch"), sometimes known as *modello* or *maquette,* is usually applied to models for sculpture, but is also used for painted sketches.

BRAZEN SERPENT. The Brazen Serpent is a scene from the Old Testament that prefigured the coming of *Christ through violence and death. The story is from Numbers 21:4–9. When the Israelites left the desert they spoke out against God and *Moses. They complained of miserable food and a lack of water. They were punished when the Lord sent a plague of poisonous snakes, and many Israelites were bitten and died. The people repented and Moses prayed for them. God told Moses to make a metal snake and put it on a pole so that anyone who was bitten could look at it and be healed. Moses made a serpent of bronze and put it on a pole. The bronze snake proved to have a miraculous curative effect. Artists depict the Israelites in a fantastic tangle of writhing bodies, their limbs entwined by snakes. Moses may be lifting a woman's hand to the thaumaturgic image.

Example: Michelangelo, 1511, spandrel of the Sistine Chapel Ceiling, Vatican, Rome.

BREVIARY. A breviary is a book that contains the offices to be said at the canonical hours by the clergy. Breviaries designed for use by kings, nobles, or church dignitaries were sumptuously illustrated; for example, the *Grimani Breviary,* c. 1500, Venice, contains 110 pictures, including scenes from the New Testament, Old Testament, calendar illustrations, and the lives of the saints.

BRIDGET, SAINT. See REVELATIONS OF SAINT BRIDGET.

BROAD MANNER. See FINE MANNER.

BRONZE. An alloy of copper and tin known as bronze was used as a material for sculpture in ancient Greece and Rome. The earliest figures were cast solid. One of the earliest bronze figures cast on a large scale was the Saint Peter (see PETER, APOSTLE AND SAINT) attributed to Arnolfo di Cambio; this was executed in the late thirteenth century and is located in Saint Peter's in Rome today. By the Renaissance the craft was well established and large projects were undertaken by masters like the Florentine sculptor Lorenzo Ghiberti. Bronzes then and today are made by the *cire perdue* (lost wax) process or sand-casting. Both are very old techniques of hollow casting. Of the two techniques the *cire perdue* is the least expensive because it uses the least amount of bronze. It consists of a model that is some millimeters smaller in all directions than the surrounding mould. The area between is filled with wax. Vent pipes are located at bottom and top. The outside of the wax is what the artist desires as the final product, and when molten bronze is poured through the top vent, it takes the place of the wax that has been melted out. The amount of bronze needed can be gauged by the amount of wax that runs out. An indefinite number of casts can be taken. During the Renaissance artists worked on the casts with chasers and files, *engraving and polishing the surface. Bronze, over a period of time, develops a greenish tint and matt surface known as patina.

BRUNI, LEONARDO (1369–1444). Born in Arezzo, Italy, secretary to four popes and then (1427–1444) to the Florentine signory, Leonardo Bruni is known for his excellent translations of several dialogues of Plato into Latin and his *Latin History of Florence*. The latter was so highly regarded that the Republic exempted him and his children from taxation. When Bruni died, after being given a public funeral in the manner of the ancients, he was buried with his *History* on his breast in the church of Santa Croce. His marble tomb, c. 1445–1450, was designed by Bernardo Rossellino.

BRUSH DRAWING. A brush can be used as an instrument of drawing as well as painting. During the Renaissance the brush was used many times instead of the pen, charcoal, or *metal point for drawing, and for the underdrawing or *lay-in for paintings. A well-known example is Albrecht Dürer's *Praying Hands,* an early sixteenth-century study for an *altarpiece.

BURIN (Graver). The burin is the main tool used in *engraving on wood or metal to draw the lines through the surface of the block or plate. It is a short, steel rod, usually lozenge-shaped in section, cut obliquely at the end to furnish a fine point for the artist. It is made with a short, rounded handle that is pushed by the palm of the hand while the fingers guide the point.

BURNING BUSH. The theme of the bush that burned but was not consumed was likened by the early church fathers to the Immaculate Conception, whereby the Virgin conceived without being consumed by the flames of concupiscence. *Moses' vision may also be seen as a prohecy of the *Nativity. According to Exodus (3:1–10). God called Moses while he was tending the sheep and goats of his father-in-law Jethro (see MOSES AND JETHRO'S DAUGHTERS). Moses led the flock across the desert and came to Sinai, where he had a vision of a bush that burned but was not consumed. God spoke to him from the bush and told him to take off his sandals because he was standing on holy ground and that he was destined to deliver the Israelites out of the hands of their oppressors, the Egyptians, and to lead them to Canaan. Artists depict Moses with his flock as he watches the bush burn. An *angel appears to him as a flame coming from the middle of the bush. He may be in the process of removing his shoes. Because of the theme's connection with the Immaculate Conception, the Virgin and her Child may be enthroned in the flames.

 Example: Nicholas Froment, *Altarpiece of the Burning Bush,* 1476, Cathedral of Saint-Sauveur, Aix-en-Provence.

BURNING OF THE BONES OF JOHN THE BAPTIST. According to the *Golden Legend,* Julian the Apostate ordered Saint John's bones to be scattered, but when the Baptist's miracles did not cease, he ordered the bones gathered together, burned and the ashes thrown to the winds. Bede and the *Scholastic History* tell that monks from Jerusalem mingled with the pagans as the bones were being collected for the fire. They took a great part of the relics and carried them to Philip, the bishop of Jerusalem, who afterward sent them to Arthanasius, the bishop of Alexandria. Theophilus, a later bishop of the same city, enshrined the bones in a temple of Serapis, which he had consecrated as a basilica of Saint *John the Baptist. The participants are usually shown shoveling the bones into a fire. In the background the holy men stand before an open sarcophagus; some hold bones and others pray. Julian and his entourage oversee the situation.

 Example: Geertgen Tot Sint Jans, after 1484, Kunsthistorisches Museum, Vienna.

BURR. In metal *engraving the burr is the ridge of rough metal left on either side of the ploughed furrow. In drypoint the ridge is left because it produces a rich, soft quality to the resulting line, but in *line engraving it is removed.

C

CADUCEUS. A Greek or Roman herald's staff, and an attribute of the god Mercury. The staff has two snakes curled around it and two wings on the top.

CAIAPHAS. See CHRIST BEFORE CAIAPHAS.

CAIN KILLING ABEL. Cain and Abel were the children of *Adam and Eve; Cain was a farmer and Abel a shepherd. When both made offerings to God—Cain, a sheaf of corn, Abel, a sacrificial lamb—God refused Cain's offering but accepted Abel's. Cain was so angry that when they were alone in the fields he attacked Abel and killed him (Genesis 4:1–8). Cain is usually shown beating Abel to death with a club. Abel is surprised and defenseless.
 Example: Titian, 1542, Sacristy, Sta. Maria della Salute, Venice.

CAJETAN, SAINT. Born in Vicenza, Gaetano da Thiene (1480–1547) was canonized as Saint Cajetan by Pope Innocent XII in 1691. He became an important Renaissance figure by helping to lay the foundations of sixteenth-century Catholic reform in Italy. He joined the *Oratory of Divine Love in Rome in 1516, but after it was dissolved, he helped expand its original work in the *Theatine order. Many of his improvements influenced artists' presentations of a particular topic. For example, the Theatines under Saint Cajetan instituted the perpetual adoration of the Sacrament. The real topic of Pontormo's *Entombment* is the Sacrament which is directly influenced by the Theatines.
 Example: Jacopo Pontormo, *Entombment,* 1525–28, Capponi Chapel, Sta. Felicita, Florence.

CALLING OF PETER AND ANDREW. Peter (see PETER, APOSTLE AND SAINT) and Andrew (see ANDREW, SAINT) were brothers. Peter was leader of the twelve *apostles and one of the closest to *Christ, while Andrew was the first of the apostles to follow Christ. Their calling to Christ's Ministry is recorded by Mark (1:16–18). As Jesus walked along the shore of Lake Galilee, he saw two fishermen, Simon (Peter) and his brother Andrew, catching fish with a net. Jesus said to them, "Come with me, and I will make you fishers of men." At once they left their nets and went with him. The brothers are shown in their boat, pulling in a net, or they kneel on the shore at the feet of Christ, who consecrates them in their mission, the foundation of the church.

Example: Domenico del Ghirlandaio, 1481, Sistine Chapel, Vatican, Rome.

CALLISTO. See DIANA.

CALUMNY OF APELLES. Apelles was a celebrated painter of ancient Greece in the fourth century B.C. (dated 332 B.C. by Pliny because of his portrait of Alexander). A native of Colophon near Smyrna, Apelles became official painter at the Macedonian court and was the only artist allowed to portray Alexander the Great. Nothing of his work survives, only descriptions from ancient writers, who thought him the greatest painter of his age. The allegory on the subject of Calumny was the work of the Greek author Lucian and known to Renaissance artists through Italian translations as early as 1408. They attempted to reconstruct Apelles' painting of Calumny, which no longer existed, from Lucian's description. Lucian describes Calumny as a beautiful woman who is beside herself with passion and nearly ready to explode with rage. In her left hand she carries a long, flaming torch; with her right hand she drags a nearly naked young man by his hair. He seems to pray to heaven, pleading with the gods to witness the scene. He is the personification of Innocence, falsely accused. Envy (see SEVEN DEADLY SINS) (Hatred) may lead Calumny, already standing before a judge, ugly and in ragged clothes while two women representing Deceit and Fraud attend Calumny. Deceit weaves flowers into her hair so that she will appear even more beautiful to the judge she approaches. The judge sits on an elevated throne and has ass's ears, signifying his stupidity. Two women beside him represent Ignorance and Suspicion. Truth, depicted as a naked youth, points to heaven, while Penitence, an old woman, rends her garments. They have arrived too late to save Innocence.

Example: Sandro Botticelli, c. 1497–1498, Uffizi Gallery, Florence.

CALVARY. Calvary, the Latin word for "skull," is the place where Jesus was crucified, outside the wall of Jerusalem. It is also known as *Golgotha, which means "Place of the Skull." Its exact location is not known (Matt. 27:33; Mark 15:22; Luke 23:33; John 19:17–20). The identification of the place known as Calvary was made by Saint Helena (the mother of Constantine I) when in 327 she found what she thought to be a relic of the cross. Artists usually depict Jesus

on the cross (the two thieves are not present), holy women, Veronica (see VERONICA, SAINT) and her veil (see SUDARIUM), and a multitude of viewers. Some Renaissance artists show the cross with a skull and crossbones at its foot, referring to the cross on Golgotha, "the place of the skull." According to legend the cross rested upon the skull and bones of *Adam, which suggests that through the cross all men will rise to eternal life.

Example: Jacob Cornelisz van Oostsanen, c. 1510, Rijksmuseum, Amsterdam.

CAMAÏEU (Fr.). For paintings *en camaïeu,* see GRISAILLE, and for *engravings, see CHIAROSCURO WOODCUT.

CAMALDOLITE ORDER. The Camaldolite order is an independent branch of the *Benedictine order founded in southern Italy in 1012 by Saint Romuald (c. 950–1027), which established the Eastern eremitic form of monasticism in the West. Members of this barefooted order of hermit Benedictines are known as camaldolese.

CAMBYSES. See JUSTICE OF CAMBYSES.

CAMERA OBSCURA. A dark box that can be large enough for the viewer to stand inside containing a hole or aperture on one side is known as a camera obscura (*camera obscura* is Latin for "dark chamber"). It can be used as a mechanical means of securing accuracy in a drawing when an inverted image of a scene is formed on an interior sheet of paper or screen. This can then be traced by a draughtsman. The first drawing of this apparatus appeared in a manuscript by Leonardo da Vinci in 1519, but he did not claim the idea.

CANTICLES. The Canticles is another name for the Song of Songs, called in the King James Bible, the Song of Solomon.

CARD PLAYERS. In the fifteenth century, card playing was even more popular than dancing and became a mania in all classes, often involving heavy gambling. Pope *Leo X was addicted to card games. It is also said that Cardinal Raffaello Riario won over 14,000 ducats in two games with *Innocent VIII's son. Gambling ruined so many noble families in Venice that the Council of Ten twice prohibited the sale of cards, and even requested servants to report masters in violation of their ordinances. Gamblers are usually shown holding cards and betting. There may be piles of coins on the table. Some gamblers have crafty faces while others appear innocent. Sometimes cheating is obvious.

Example: Lucas van Leyden, c. 1514, Wilton House Collection, Salisbury, England.

CARMELITE ORDER. The Carmelite order was a Roman Catholic mendicant order of our Lady of Mount Carmel founded in Syria in the mid-twelfth century by a crusader named Berthold and his followers. During the initial founding,

the Carmelites led lives of seclusion, silence, and abstinence, but about 1240 they moved to western Europe, the rule was changed, and the order became a mendicant one, similar to the *Franciscan and *Dominican orders.

CARRYING OF THE CROSS. See BEARING OF THE CROSS.

CARTELLINO. *Cartellino* is the Italian word for a "little paper." It is a small piece of paper or scroll painted on a picture to seem like a real scroll set in the background or set on a foreground parapet (small balustrade) that can be introduced to limit the foreground. The parapet provides a structure for the *cartellino* to be placed on. Usually a *cartellino* is provided for the artist's signature, as in the works of Giovanni Bellini and Antonello da Messina; however, it may hold a religious expression or the motto of the sitter in a portrait.

CARTHUSIAN ORDER. The Carthusian order was founded in 1084 by Saint Bruno (c. 1030–1101) in the mountainous region of southwest France at Chartreuse near Grenoble. The order was and still is eremitic and life for a Carthusian is that of a religious recluse with an emphasis on silence, extreme austerity, and prayer. Each monk lives by himself with a small cell and garden and, except for brief communal worship, hardly ever meets the others. It is the most austere order in existence. The monks have been unchanging in their rule and their original way of life.
 Example: Petrus Christus, *Portrait of a Carthusian,* c. 1446, Metropolitan Museum of Art, New York.

CARTOON. The word "cartoon" is from the Italian *cartone,* meaning "cardboard." Actually a cartoon is a full-scale preparatory drawing, usually worked out in complete detail on heavy paper or light cardboard, made for the purpose of transferring the work to a tapestry, wall, canvas, or panel. Early *fresco painters sketched on the wall, but a cartoon was indispensable for the design on stained glass, and it was possibly from this *medium that the painters borrowed it. Early fifteenth-century frescoes show that their designs have been traced from cartoons, for their contour lines are either marked with pin-pricks or indented. The procedure for fresco (more complex but essentially the same) was described by Giorgio Vasari. A drawing was made on heavy paper with chalk or charcoal, high-lighted with white or colored with water-colors, and rubbed on the back with chalk. Then, it was cut into sections for day-to-day painting. The section used for a particular day was laid against the freshly prepared plaster of the wall and a stylus was used to press the lines into place, or pin-pricks were made at intervals and dark charcoal powder was pushed into the holes, although not on the cartoon itself. A *spolvero* was used under the cartoon to receive the holes, and the charcoal powder was rubbed over this, thus preserving the cartoon itself. The procedure is known as "pouncing." Cartoons were employed for easel paintings also. The entire painting was not always

represented in the cartoon and might represent only a group or a head, and it was sometimes used more than once. It could also be turned over and placed in reverse. Michelangelo's frescoes in the supporting cornice of the Sistine Chapel feature a mirror-image of each couple of *putti* (see PUTTO). Several cartoons from the Renaissance still survive and one can determine which were used for transfer from the existing prick-points or the indentation of the lines. Raphael's cartoons for tapestries are the most famous of all. Some cartoons were famous in their day. According to Giorgio Vasari, when Leonardo da Vinci completed his cartoon of the *Virgin and Saint Anne*, it was placed on display and visited for two days by crowds of admirers.

CARYATID. A caryatid is a sculptured female figure that functions as an architectural support. The male figure that functions as a column is the *atlas (pl. atlantes).

Example: Jean Goujon, 1550–1551, Louvre, Paris.

CASSANDRA. In mythology Cassandra was one of the daughters of King Priam of Troy and Hecuba. In Homer she is mentioned (Iliad 2:13–365) as being the most beautiful woman of them all. Nothing is said of her being a prophetess in Homer, and her father knew nothing of her power to foretell the future. In surviving literature her prophetic gifts appear and are taken for granted by the time of Pindar and Aeschylus. *Apollo had given her the power of prophecy to win her love; however, she refused his love and, because he could not revoke a divine favor, he turned the blessing into a curse by making it of no count. No one believed her. In Virgil's *Aeneid II* when Cassandra tried to warn the Trojans about the wooden horse, it was in vain. They would not listen to her. During the Trojan War, while seeking refuge from the Greeks, she was dragged from the temple of Athena and violated by the Locrian Ajax. When the sack of Troy was over, she was brought home as a slave by Agamemnon and murdered there with him by his wife Clytemnestra. She had prophesized her own death. Her awareness and helplessness add to the mounting tragedy of Aeschylus' *Agamemnon*. It was always her fate to know the disaster that was coming and be unable to avert it. "Cassandra-like warnings" are well known. Artists usually show Cassandra's moment right before death, that instant before the sword struck.

Example: Master of 1402, illumination, (Ms. fr. 598, fol. 48v) c. 1402, Bibliothèque Nationale, Paris.

CASSONE. A *cassone* is an Italian word for a special kind of coffer used as a marriage-chest. Often richly decorated, *cassoni* were carved and had gilt moldings with painted panels at the front, sides, and sometimes inside and outside the lid. Many panels of the fronts of *cassoni* are hung today as Old Masters, although most of the original painters were regarded by their contemporaries as mere craftsmen. One exception is Paolo Uccello. A *cassoni* panel is usually recognizable because of its shape: usually 4 to 6 feet wide by approximately a

foot or 18 inches in height. Major artists such as Sandro Botticelli, Paolo Uccello, and Domenico Veneziano decorated *cassoni* occasionally. Toward the end of the fifteenth century, painted *cassoni* went out of fashion when carved oaken chests became popular.

CASTIGLIONE, BALDASSARE, CONTE. Baldassare Castiglione (1478–1529) was an Italian author, statesman, and soldier associated with the court of Lodovico, the duke of Milan. Later, while in the service of the duke of Urbino (1504–1516), he wrote his famous *Libro del Cortegiano,* or *The Courtier,* published by the Aldine Press in Venice in 1528. The treatise, one of the great books of its time, is an extended dialogue on social problems, etiquette, and intellectual accomplishments. It gives an accurate and elegant view of fifteenth- and sixteenth-century court life. A true aristocrat, Castiglione was a person of profound learning, possessing many physical and martial skills.
 Example: Raphael, 1515–1516, Louvre, Paris.

CASTING. Casting is a procedure for reproducing a three-dimensional *relief or object by forcing a molten metal or hardening liquid into a cast or mold bearing its impression. Most Renaissance pieces were cast from originals modelled in a plastic medium such as clay. See BRONZE.

CATÀSTO. The *catàsto* was a graduated tax on income and property begun in Florence in 1427 to pay for the city's defense.

CATHERINE OF ALEXANDRIA, SAINT. Catherine was born at Alexandria in Egypt of a noble family, possibly of royal blood. She showed great erudition from an early age and was known for her great beauty. According to legend Catherine had a dream before she was baptized. In it she saw Mary (see MARY, SAINT) holding Jesus in her arms. Mary asked the *Christ Child to take Catherine as a servant, but he said she was not beautiful enough. When she awoke, Catherine began to wonder how she could please the Christ Child and decided to be baptized a Christian. Early in the fourth century she was executed by the Roman emperor Maxentius, who had offered to make Catherine his wife and empress of the world. He tried to undermine her faith. When he could not, he sent 50 famous philosophers to refute her beliefs. She converted them to her faith. Maxentius ordered Catherine to be bound between four wheels, rimmed with spikes, and torn apart; a thunderbolt destroyed the wheels as the sentence was being carried out. She was then beheaded (see MARTYRDOM OF SAINT CATHERINE). *Angels carried her body to a monastery on Mt. Sinai, which still holds her relics. Catherine is nearly always shown with a broken, spiked wheel. Other attributes are the ring of her marriage to Christ, the martyr's palm, and the sword of her execution. She may wear a crown to signify her noble birth. Sometimes she holds a book which bears the inscription: "Ego me Christo sponsam tradidi," "I have offered myself as a bride to Christ." The book may

also be a reference to her great learning. As the patron saint of girls and the spouse of Christ, Saint Catherine was one of the favorite subjects in Renaissance painting.

Example: Master of the Ovile Madonna (the so-called Ugolino Lorenzetti), *St. Catherine of Alexandria,* early fourteenth century, National Gallery of Art, Washington D.C.

CATHERINE OF SIENA, SAINT. Catherine of Siena was a fourteenth-century Italian mystic and diplomat. She was born in 1347 and died in 1380. Catherine was the daughter and youngest child of the large family of Giacomo Benincasa, a Sienese dyer. As a young girl, she dedicated herself to a religious life and had mystic visions as early as age seven. She prayed that like Saint *Catherine of Alexandria she would have *Christ as her Heavenly Bridegroom. Epidemics of the plague killed many of her brothers and sisters and because of this she devoted herself, from the age of about nineteen, to the poor and sick, even though her own health was frail. Her total devotion was, in the beginning, opposed by her family, but one day when her father saw her kneeling in prayer, he saw a white dove perched upon her head. Thereafter he allowed her to become a member of the *Dominican order where she lived in the convent for three years. It was following this period of seclusion that her mystical marriage is reputed to have occurred. The accounts of Catherine's biographers vary as to whether she was married to the infant or the adult Christ. During the Renaissance both versions are depicted. In response to a vision, Catherine left the convent to become active in public life and to help the poor and needy. She interceded for the people of Florence when they were excommunicated by Pope Gregory XI and went to Avignon and exerted influence in convincing him to end the Babylonian Captivity. Many believe that because of Catherine, the pope returned to Rome in 1376. She was instrumental in bringing about peace between Florence and the Holy See. In 1375 Catherine received the *stigmata, which only she could see until her death. Although Catherine never learned to write, she dictated letters and a mystic work known in English as *The Dialogue of Saint Catherine of Siena* or *A Treatise on Divine Providence.* She is the patroness of Siena and is featured in the painting of that school. She usually wears the white tunic and veil and the black cloak of the Dominican Tertiary (the third order in a monastic system). She may hold a cross with a lily (for purity). Some artists show her trampling a dragon. As an allusion to her writings, she may hold a book or she may be shown dictating. Sometimes she holds a rosary, thought to have been instituted by Saint *Dominic, and may be in the company of other Dominicans and even Dominic himself. See COMMUNION OF SAINT CATHERINE, MYSTICAL MARRIAGE OF SAINT CATHERINE OF SIENA, and STIGMATIZATION OF SAINT CATHERINE.

Example: Domenico Beccafumi, *Saint Catherine Altarpiece,* c. 1518, Pinacoteca, Siena.

CECILIA, SAINT. Cecilia was a Christian saint and Roman virgin martyr who met her death in A.D. 223. According to the *Golden Legend* and an ancient account of Cecilia's life, which existed in the sixth century but cannot be reckoned as history, her story is as follows: Cecilia was brought up as a devout Christian and because of a vow of chastity her marriage to a Roman nobleman named Valerius was never consummated. (On her nuptial day she wore a hair shirt and prayed continually for God to preserve her virginity.) Her husband agreed to sexual abstinence if she would allow him to see the *angel who guarded her. Later the angel appeared to them and placed a crown of roses and lilies upon their heads. (Thus both flowers are Cecilia's attribute.) The result was that Valerius was baptized a Christian and later beheaded by the Roman governor. Cecilia too was condemned to a slow death by suffocation in a steam bath. When she survived this she was immersed in a cauldron of boiling oil. She lived through this ordeal also. An executioner then chopped her neck three times and could not sever her head. She died, however, in three days. During her last three days, she distributed her wealth to the poor. Renaissance painters drew many themes from the legend of Saint Cecilia. She is sometimes shown in her pot of boiling oil praying to God while executioners stoke the fire. Artists show the angel appearing to Cecilia and her husband and most of the stories of her life.

Example: Master of Saint Cecilia, *Enthroned Saint Cecilia and Scenes From Her Life,* early fourteenth century, Uffizi Gallery, Florence.

CEFALO. See CEPHALUS AND PROCRIS.

CENACOLO. *Cenacolo* is the Italian word for "refectory" or "dining room." The word is also used to indicate representations of the *Last Supper or of the room where it took place.

CEPHALUS AND PROCRIS. Cephalus, an Attic hero, was the husband of Procris and one of the loves of Aurora, the Dawn. His story, told by Hesoid, is found in greater detail in Ovid's version (*Metamorphoses* 7:795–866). The major source for Renaissance artists was the play *Cefalo* by Niccolo da Correggio. This play, performed at wedding celebrations, warned newly married couples against jealousy and mistrust of each other. *Cefalo* tells the story of Aurora, who fell in love with Cephalus. When he rejected her, she had her revenge by planting the seeds of suspicion in him concerning his wife's faithfulness. Disguised, he set out to test his wife by attempting to seduce her. Since he was almost successful (some accounts say he succeeded in obtaining her favors), Procris felt great shame, ran away, and joined the virgin goddess of hunting, *Diana (Artemis). Eventually they returned to each other's arms. Procris brought a hunting dog and magic spear that never missed its mark and gave them to Cephalus. Later a mischievous faun told Procris that he had overheard Cephalus talking to a lover. Jealous because he had spent so much time hunting, Procris followed her husband into the forest one day when he was hunting. She heard

him praying for a breeze and supposed this was his new love. She came closer and Cephalus, hearing the rustling of leaves, threw the spear that never missed. Procris was killed. Artists usually depict Procris dead while Cephalus mourns over her body. His hunting dogs are nearby.

Example: Piero di Cosimo, c. 1510, National Gallery, London.

CERES. The ancient Italian corn-goddess, known as Demeter in Greek mythology, Ceres is better known as the goddess of agriculture. Sometimes she was worshipped as the earth mother, the prime source of fertility, with games in her honor and an annual spring festival of the *Cerialia.* Worshipped in a temple on the Aventine Hill, she became the personification of earth's abundance. Thus she is frequently shown carrying a corn-sheaf, or she may wear a crown of ears of corn. Somewhere close by may be a cornucopia overflowing with vegetables and fruits. Also, she may be shown supervising the cutting of grain with a sickle.

Example: Francesco Primaticcio, Drawing for Ballroom, 1552–1556, Fontainebleau, Chantilly.

CERTOSA. The word *certosa* is Italian for "Carthusian monastery." See CARTHUSIAN ORDER.

CERTOSINA. Certosina is an Italian Renaissance style of elaborate inlay of ivory, metal, bone, light-colored wood, or other material in designs against a dark background.

CHALICE. A chalice is a goblet. Generally, it is a drinking cup; more specifically the chalice is the cup used in the sacrament of the Lord's Supper to hold the consecrated wine of the *Eucharist.

CHARLES THE BOLD (1433–1477). As the last reigning duke of Burgundy (1467–1477), Charles the Bold was the son and successor of Philip the Good. Charles allied himself with England by marrying Margaret of York (1468), the sister of King Edward IV. He earned his surname by his impetuous gallantry. A capable though harsh ruler, most of his achievements were short-lived. In Renaissance painting he is young and seems to have an aura of intelligence.

Example: Roger van der Weyden, fifteenth century, Staatliche Museum, Berlin.

CHARLES VII (Charles the Well Served) (1403–1461). King of France from 1422 to 1461, Charles VII was the son and successor of Charles VI. During his reign the Hundred Years' War came to an end. Charles VII was easily influenced by corrupt court favorites, and his air of vacillation and even sadness is present in Jean Fouquet's unidealized portrait of him.

Example: Jean Fouquet, c. 1445, Louvre, Paris.

CHARON CROSSING THE STYX (Passage to the Infernal Regions). In Greek mythology Charon was the boatman who ferried the newly arrived dead from the land of the living to the far west beyond the regions inhabited by man. These two areas were separated by the rivers Styx (hateful), Lethe (forgetfulness), Acheron (woeful), Phlegethon (fiery), and Cocytus (wailing). Charon was known to be avaricious, old, and dirty. For his work he was paid a coin that was left in the mouths of the dead when they were buried. He is usually shown drifting across the Styx, slowly pushing his skiff with a long pole. One or more small, naked, and sometimes winged figures are seated around him. On the bank he has just left, souls escorted by *angels wait their turn. The side of the Styx representing *Hell usually shows a great, dark cavern. Smoke and fire may be seen along with dragons and other infernal monsters.

Example: Joachim Patinir, c. 1520–1524, Prado, Madrid.

CHASING. Chasing is a process of ornamenting metal by *engraving or embossing.

CHASSE. A chasse is a reliquary or shrine of a saint.

Example: Hans Memling, *Chasse of Saint Ursula,* 1489, Hospital of Saint John, Bruges.

CHASUBLE. A chasuble is an ecclesiastical vestment in the form of a long, oval, sleeveless cloak or mantle that slips over the wearer's head, but remains open at the sides. It is worn over all other vestments by the celebrant of the *Mass.

CHERUB. A cherub (pl. cherubs, cherubim, cherubims), blue or sometimes golden yellow, possibly with a book, is one of an order of *angels placed in the heavenly hierarchy below the seraphim. See SERAPH.

CHEVALIER, ÉTIENNE. Étienne Chevalier was the finance minister for King Charles VII.

Example: Jean Fouquet, *Melun Diptych, Etienne Chevalier and Saint Steven,* c. 1450, Gemäldegalerie, Staatliche Museen, Berlin-Dahlem.

CHIAROSCURO. From the Italian *chiaro* (light) and *oscuro* (dark), the term chiaroscuro was used in the seventeenth century by Filippo Baldinucci to describe monochrome paintings, such as *grisailles,* which rely on the balance of light and shadow for their effect. The French *clair-obscur* also means a balance of light and shade in a picture, and the expertise shown by the painter in the management of shadows. *Claro* is designated for anything exposed to a direct light; *obscuro* implies all the colors that are naturally brown and keep their obscurity in any light.

CHIAROSCURO WOODCUT. The chiaroscuro *woodcut is a printing method that dates from the early sixteenth century (the earliest being 1508). In this process a three-dimensional effect is obtained when several blocks in light and dark tones are used in printing. One block is necessary for each tone. Raphael used the chiaroscuro woodcut, and Francesco Parmigianino became a prolific designer using the process.

CHOICE OF HERCULES. See HERCULES AT THE CROSSROADS.

CHOSROES. See BATTLE OF HERACLIUS AND CHOSROES.

CHRIST. The Italian Renaissance artists painted and sculpted a gentle, beautiful, and dignified image of Christ both on and off the cross. Much greater stress was laid on his suffering in the north; that is, in Spain, England, and especially Germany. Northern Renaissance artists depict Christ in agony, showing horrible wounds and blood trickling down his torn body. Many times the crown of thorns is a crown of long spikes.
Example: Melozzo da Forlì, *Christ in Glory,* 1477–1480, Quirinal Palace, Rome.

CHRIST AND THE WOMAN OF SAMARIA. This is a scene portrayed in art in which *Christ is recognized as the Messiah. It derives from the *Gospel of Saint John (4:5–27): When Christ was traveling from Judea to Galilee, he came to the city of Samaria and stopped at a well for water. A woman of the city came to draw water, and Jesus asked her for a drink. The woman asked him why a Jew would want water from a Samarian. (Jews would not use the same cups and bowls that Samarians used.) At this point she recognized him and brought many Samaritans from the city to see him. He remained there for two days, and many of the citizens were converted. Artists show the woman of Samaria at the well with Christ, who may sit on the side of the well or stand beside it. He offers her the "living water," the eternal life.
Example: Duccio, 1308–1311, from the back predella of the *Maestà,* Thyssen-Bornemisza Collection, Lugano.

CHRIST APPEARING TO HIS MOTHER. The *Gospels hold no account of *Christ appearing to his mother; however, the event is accepted as having taken place. In the fourteenth century Saint Ambrose wrote in his *Liber de Virginitate,* "Therefore Mary [see MARY, SAINT] saw the *Resurrection of the Lord: she was the first to see him and she believed." Pseudo-Bonoventura gave a later account (c. 1300) in his *The Meditations of the Life of Christ.* He tells how on the morning of the Resurrection when the three Maries went to the tomb with ointments, the Virgin Mary had decided to stay at home and pray. She prayed that her Son might come and comfort her. He appeared shortly thereafter dressed in white and she knelt down before him. They embraced and exchanged greetings. Artists usually depict Christ standing beside the Virgin

while she sits. He holds his hands out and open so that she may see the wounds and know that he is her Son. She may be shown kneeling before him, or at a *prie-dieu. Christ may also be shown with a retinue of the redeemed prophets and patriarchs of the Old Testament, led by *Adam and Eve. This scene is based on the assumption that Christ had just returned from Hell (see DESCENT INTO HELL). It is during the early Renaissance (early fourteenth century) that this subject first occurs.

Example: Roger van der Weyden, from the *Mary Altarpiece* ("Granada Altarpiece"), right panel, c. 1440–1444, Metropolitan Museum of Art, New York (Bequest of Michael Dreicer).

CHRIST AT SUPPER WITH SIMON THE PHARISEE. See SUPPER IN THE HOUSE OF THE PHARISEE.

CHRIST AT THE COLUMN. See FLAGELLATION.

CHRIST BEARING THE CROSS. See BEARING OF THE CROSS.

CHRIST BEFORE CAIAPHAS. Caiaphas was a high priest of the Jews, a Sadduce, and son-in-law of Annas. He presided at the council that condemned Jesus to death. When questioned, *Christ told Caiaphas that he was the Son of God and the awaited Messiah. This statement constituted blasphemy under Jewish law and was punishable by death. According to Matthew 26:65, Caiaphas tore his clothes and shouted, "Blasphemy! We don't need any more witnesses. You have just heard his blasphemy. The Jewish court said he is guilty and he must die." Thus Christ was condemned and handed over to the civil authorities for trial. Artists usually depict Caiaphus tearing his clothes and baring his breast. Christ stands quietly to the side surrounded by soldiers, his hands tied. One of the soldiers may be about to strike him. Annas, a second high priest, may be shown beside Caiaphas. Luke (3:1–2) says they were both high priests in the fifteenth year of the rule of Tiberius.

Example: Giotto, 1305, Arena Chapel, Padua.

CHRIST BEFORE PILATE. Pontius Pilate was the Roman procurator of Judea in A.D. 26. Supposedly he was a ruthless governor, but his attempt to avoid responsibility at the trial of Jesus was caused by his fear of the high priests' power. He would have released Jesus if not for the clamor of the Jews that he be crucified. Pilate's wife told him to have nothing to do with an innocent man. The custom at the Passover was to release one prisoner chosen by the people. Pilate offered them the choice of Barabbas, a murderer, or *Christ. The people, now a mob, shouted for Christ to be crucified. The fear of a riot caused Pilate to free Barabbas. He then washed his hands before everyone to indicate his refusal to be morally implicated in the decision. According to tradition he later committed suicide in Rome. (Matt. 27:11–26; Mark 15:2–15; Luke 23:13–25;

John 18:28–40). Christ is usually shown standing before Pilate in an open courtyard or judgment hall outside Pilate's house. Pilate is seated high above everyone else on his throne of judgment. It is very rare for Barabbas to be shown. Some artists include Pilate's wife.

Example: Jacopo Bellini, *Drawing of Christ before Pilate*, no date, Louvre Sketchbook, fol. 58, Louvre, Paris.

CHRIST CARRYING THE CROSS. See BEARING OF THE CROSS.

CHRIST DELIVERING THE KEYS TO PETER. See GIVING OF THE KEYS TO SAINT PETER.

CHRIST DISPUTING WITH THE ELDERS. See DISPUTE.

CHRIST DRIVING THE MONEY-CHANGERS FROM THE TEMPLE. See EXPULSION OF THE MONEY-CHANGERS FROM THE TEMPLE.

CHRISTINA OF DENMARK. Christina was the sister of Charles V and the widow of the duke of Milan, Francesco Sforza (see SFORZA DYNASTY). Henry VIII of England considered her for his fourth wife and she was painted full length as a prospective bride.

Example: Hans Holbein the Younger, *Christina of Denmark, Duchess of Milan,* 1538, National Gallery, London.

CHRIST IN GLORY. *Christ is depicted in heaven and seems to float in space. He is surrounded by ranks of child *angels in perpetual adoration. The *apostles and music-making angels move about Christ in his glory as if the winds of heaven are blowing freely.

Example: Antonio Correggio, 1520–1523, S. Giovanni Evangelista, Parma.

CHRIST IN THE HOUSE OF LEVI. See FEAST IN THE HOUSE OF LEVI.

CHRISTMAS AT GRECCIO. The Christmas at Greccio is a Christmas legend, one of the many miracles associated with Saint *Francis of Assisi, that occurred in the year 1223. According to this legend the saint was on a journey from Rome to Assisi when he stopped to rest in the town of Greccio. Here he decided to celebrate the *Nativity, his favorite holy day. When he finished saying *Mass, Francis prayed before a tiny manger in the center of the town. In front of the local priests and townspeople, the small figurine of the *Christ Child, which Francis had asked for, came alive and smiled at the saint. The legend describes the scene as taking place in the mountains. The Christmas crib as we know it today originated with this thirteenth century Nativity scene at Greccio. During the Renaissance, paintings of Saint Francis, mostly confined to Italy, usually consisted of narrative scenes from his real life, or others of legendary origin,

such as the Christmas scene, which is one of the best known. Saint Francis is easily recognized by the *stigmata. He wears a grey or brown habit fastened with a rope distinguished by three knots representing the religious vows of chastity, obedience, and poverty. In the Christmas scene he is shown kneeling as the Christ Child smiles at him. The townspeople look on in disbelief.

 Example: Attributed to Giotto, early fourteenth century, San Francesco, Assisi.

CHRIST NAILED TO THE CROSS (The Nailing of Christ to the Cross). Christ's death on the cross is the central image in Christian art and artists recognize the importance of its portrayal by depicting all of the events that led up to the *crucifixion as well as the crucifixion itself, the actual nailing of the hands and feet. Nails are always used in crucifixion scenes even though the Romans did tie as well as nail condemned persons to the cross. Only one reference to the nails is made in the *Gospels, and artists base their work on this: *Doubting Thomas said, "Unless I see the scars of the nails in his hands . . . I will not believe" (John 20:25). Jesus is most often shown stretched out on the ground on top of a Latin-shaped cross while Roman soldiers hammer nails, which are usually large and spikelike, into his hands and feet. The number of nails used during the Renaissance was generally three (one foot was shown nailed over the other). Before the Renaissance the usual number used by artists was four, which included one for each foot.

 Example: Gerard David, c. 1480–1485, National Gallery, London.

CHRIST ON THE MOUNT OF OLIVES. The Mount of Olives or Olivet ridge lies east of Jerusalem and is mentioned in the New Testament as a frequent resting place of Jesus and the place of his *Ascension. The primary hill of the mount is sometimes called "the Ascension." The Garden of Gethsemane is on the western slope, and Bethamy and Bethphage lie near its foot. Bethphage at the Mount of Olives is where Jesus waited while two of his disciples went ahead to find a donkey for his *Entry into Jerusalem (Matt. 21:1–2). During the Renaissance Christ is depicted as an ordinary man, ready for the pain and sorrow that he knows will follow his final visit to Jerusalem. He is usually shown praying while his disciples sleep. A single *angel appears holding a *chalice. See AGONY IN THE GARDEN.

 Example: Albrecht Altdorfer, c. 1518, Monastery of Sankt-Florian, near Linz.

CHRISTOPHER, SAINT. Christopher was a saint and third-century martyr of Asia Minor. According to the *Golden Legend,* Christopher was a Canaanite who wanted to serve only the most powerful person possible. The first person he served was a king. He left when he discovered the king feared Satan. Christopher then turned to serve Satan. He left Satan too when he discovered that Satan trembled before *Christ. From then on Christopher served Christ and devoted himself to carrying the weak and poor across a stream. One day when Christopher carried a little child across the river, he found that the child grew

heavier and heavier with each step until his weight became almost too much to bear. Later the child revealed that he was Christ and told Christopher he was carrying the world in his hand. Artists nearly always depict Christopher as a very large man crossing a stream with the Infant Christ on his shoulders. The Catholic church removed his name from the liturgical calendar in 1969 because of his doubtful historicity.

Example: Lucas Cranach the Elder, chiaroscuro woodcut, 1509.

CHRIST'S CHARGE TO PETER. See GIVING OF THE KEYS TO SAINT PETER.

CHRIST TAKING LEAVE OF HIS MOTHER. According to Giovanni de Caulibus' (Pseudo-Bonaventura) *Meditations on the Life of Christ,* *Christ said a last farewell to his mother in Bethany at the foot of the Mount of Olives before his last *Entry into Jerusalem. Mary (see MARY, SAINT) is shown kneeling before her Son. Sometimes Holy Women surround her. Saint Peter (see PETER, APOSTLE AND SAINT) may also be present.

Example: Albrecht Dürer, woodcut, c. 1505.

CHRISTUS MORTUUS. *Christus Mortuus* is a Latin phrase for "dead *Christ." Christ is shown as quietly and absolutely dead. The Christ of the liturgical crosses of the late twelfth and early thirteenth centuries was shown as alive and triumphant over death. Renaissance artists cause one to feel the actual weight of the dead body suspended from the arms of the Cross.

Example: Giotto, *Crucifixion*, 1305, Arena Chapel, Padua.

CHRISTUS PATIENS. *Christus Patiens* is a Latin phrase for "suffering *Christ." He is shown as dead on the Cross.

CHRISTUS TRIUMPHANS. *Christus Triumphans* is a Latin phrase for "triumphant *Christ." Christ is depicted on the Cross with his eyes open, alive, and triumphant over death. He is shown standing on, rather than hanging from, the Cross.

Example: Bonaventura Berlinghiero, *Cross,* Early thirteenth century, Pinacoteca, Lucca.

CHRIST WALKING ON THE WATER (Christ Walking on the Waves). According to the *Gospels, Jesus told the disciples to get into their boat and go to the other side of the Sea of Galilee while he went up into the hills to pray. By the time they were far out on the water, a storm arose that threatened to swamp the boat. Between three and six o'clock in the morning they saw the figure of *Christ walking toward them on the water. They were afraid and thought he was a ghost. Peter (see PETER, APOSTLE AND SAINT) asked Christ to order him out onto the water but soon after stepping on the water he lost courage

and began to sink. Jesus grabbed him and they both got into the boat. When Jesus came into the boat the wind ceased. The disciples in the boat said, "Truly you are the Son of God" (Matt. 14:22–33; Mark 6:45–52; John 6:15–21). Christ is depicted standing on the water reaching out for Peter, who is sinking. The other disciples in the boat look on in amazement. The scene is occasionally called the "Navicella" or the "Little Boat."

Example: Konrad Witz, *Altarpiece of Saint Peter*, 1444, Musée d'Art et d'histoire, Geneva.

CINQUECENTO. *Cinquecento* is the Italian word for "five hundred" and is used to indicate the sixteenth century or the 1500s.

CIRCE. In Homer, Circe is the daughter of the Sun, a sorceress and goddess encountered by Ulysses (Odysseus) (see ULYSSES AND PENELOPE) in his wanderings. She lived on the island of Aeaea with her wild beasts, men who had been changed into animals by her magic potions. Some of Ulysses' men were turned into pigs after they feasted at her table. Ulysses, though, had been warned by Mercury (Hermes) and ate the herbal antidote "moly." Afterward he forced Circe to restore his men to their normal shape. He lived with her for a year. Artists show Circe in her palace surrounded by various animals. Maidens may be waiting on her or driving the pigs to their sties. Some men, half-transformed, may recline on the floor. Ulysses may stand with Mercury at his elbow holding a cup or taking a bowl from Circe. Ulysses may also be forcing her to submission with a sword.

Example: Dosso Dossi, early sixteenth century, Borghese Gallery, Rome.

CIRCUMCISION. After the Infant *Christ was born, all the requirements of the law of *Moses as a token of the Covenant with respect to an infant son were fulfilled. A week after his birth the Baby had to be circumcised and at that time he was given the name of Jesus, the name which the *angel had given him before he had been conceived. Artists usually show Jesus in the arms of his mother, the circumcision about to take place, while beside her the priest of the temple stands with a knife in his hands. A young boy usually holds a plate with a roll of bandages and a bottle of water. Joseph may be included in the scene (Luke 2:21). Luke (see LUKE, SAINT) does not describe the surroundings but artists show the event in a temple of great architectural beauty.

Example: Andrea Mantegna, triptych, c. 1464, Uffizi Gallery, Florence.

CIRE PERDUE. See BRONZE.

CISTERCIAN ORDER. The Cistercian order is an austere order that was founded by Robert de Molesme at Citeaux, France. It was meant to establish a reform movement in the Benedictine order. The Cistercians main purpose was

to follow a more strictly interpreted rule of the Benedictines by living lives of severe simplicity.

CLARE, SAINT (It. *Chiara*). Saint Clare of Assisi (c. 1194–1253), early dedicated herself to a religious life. Her parents were nobles, and in the year 1212 she went without their consent to the mother church of the *Franciscan order where she was received into the Order of Saint *Francis of Assisi. Later she established an order of her own, the order of Poor Clares. Her major concern was the care and education of poor girls. The *Golden Legend* tells that once when Assisi was attacked by Saracens, she rose from her sick bed in the convent of San Damiano and placed the pyx (container for the *Host) on the threshold. She began to pray and sing and, seeing the Host, the invaders threw down their weapons and fled, falling from their ladders while Clare and her nuns watched. Saint Clare's attribute in art is a *monstrance (instead of the pyx), the sacred vessel for the consecrated wafer in the Roman Catholic church. She usually wears a grey habit with a white coif covered by a black veil and the cord of Saint Francis. She may hold a lily or a cross. When accompanying the Virgin she may have Saint Francis, Saint *Mary Magdalene, or Saint *Catherine of Alexandria at her side symbolizing, respectively, piety, piety and penitence, and wisdom.

Example: Master of Flémalle (Robert Campin), exterior panel of the *Betrothal of the Virgin*, c. 1420, Prado, Madrid.

CLAUSURA. *Clausura* is a Latin word for "closure," used to indicate the enclosure of certain classes of nuns in designated areas of their convents and their restriction from speaking to lay persons.

CLEANSING OF THE TEMPLE. See EXPULSION OF THE MONEY-CHANGERS FROM THE TEMPLE.

CLEOPATRA. See DEATH OF CLEOPATRA.

CLOSED DOOR. The *porta clausa* is the closed door of *Ezekiel's vision in which the gate of the sanctuary of the temple was closed because only God could enter it. (Ezekiel 44:1–4). In art it has been used as a symbol of the Virgin Mary's (see MARY, SAINT) purity.

CLOSED GARDEN (Lat. *Hortus Conclusus*). A symbol of the Virgin Mary's (see MARY, SAINT) purity, the closed garden is a walled or fenced enclosure. The notion of this enclosure, within which is fruitfulness, was used to represent the Immaculate Conception.

COLLAPSE OF THE TEMPLE OF EPHESUS. See TEMPLE OF EPHESUS.

COLLEONI, BARTOLOMMEO. Colleoni (1400–1475) was an Italian soldier of fortune from Gergamo. He was a *condottiere* who fought in the wars between Milan and Venice and was distrusted by both because he changed sides often. He deserted the Milan side in 1454 for the last time and became generalissimo of Venice, a position he kept until his death. Before he died, he left a considerable sum of money to the Venetian Republic, providing that an equestrian monument to him in *bronze be set up. He is shown as a general, standing erect in the stirrups, helmeted and armed with a mace, riding his giant charger into battle.

Example: Andrea del Verrocchio, c. 1481–1496, Campo SS. Giovanni e Paolo, Venice.

COLUMBA, SAINT (Saint Columcille). Saint Columba (521–597) was an Irish missionary to Scotland known as the Apostle of Caledonia. He founded the monastery schools of Derry (545), Durrow (553), and Kells. Saint Columba ranks with Saint Bridget and Saint Patrick as one of the three patron saints of the Irish. In Renaissance painting Saint Columba is depicted as an old man, slightly bald, dressed in a light-colored habit with a scapular (a length of cloth placed over the shoulders and extending to the hem of the garment, which is symbolic of the yoke of *Christ). He carries a crutch to signify his age and feebleness. A bell is sometimes suspended from the crutch to symbolize his power to exorcize evil spirits.

Example: Roger van der Weyden, *Saint Columba Altarpiece,* Central panel, late 1450s, Alte Pinakothek, Munich.

COMBAT BETWEEN THE ISRAELITES AND PHILISTINES. See SAUL AND DAVID.

COMMUNION OF SAINT CATHERINE. Catherine Benicasa of Siena (c. 1347–1380) was a Christian mystic and member of the *Dominican order. Her intense devotion to her faith is illustrated when she took Communion. At her Communion Catherine refused to approach the altar because of her conviction of unworthiness. She was given Communion by an *angel, while other saints, including Saint *Cajetan, witnessed the miracle. She wears a white tunic and veil and the black cloak of the Dominican order. She may hold a cross surmounted by a lily or a heart. She may trample a demon under her feet, hold a rosary, and show the marks of her *stigmata. See STIGMATIZATION OF SAINT CATHERINE, and CATHERINE OF SIENA, SAINT.

Example: Domenico Beccafumi, c. 1518, on the predella of the *Saint Catherine Altarpiece,* Pinacoteca, Siena.

COMMUNION OF THE APOSTLE. See LAST SUPPER.

CONDOTTIERE (*Condottiero* [pl., *condottieri*]). *Condottiere* is the Italian word for the leader of a band of mercenary professional soldiers during the fourteenth, fifteenth, and sixteenth centuries.

CONSTANTINE AND SAINT HELENA. Constantine, known as Constantine the Great (c. 280–337), was the Roman emperor who issued the Edict of Milan in 313 which stated that Christianity would be tolerated throughout the empire. Artists depict him dressed as a soldier or Roman emperor holding a sword and the labarum (calvary standard carried before the Roman emperors in war). His mother, Saint Helena, devoted the latter part of her life to Christianity after 313. According to legend, she visited the Holy Land and there discovered the cross on which *Christ was crucified. She is depicted as elderly by some artists and extremely young by others, regally dressed, and wearing a crown. She carries the cross and sometimes three nails and a hammer. As a devotional figure she is shown standing beside her son. See BATTLE OF CONSTANTINE AND MAXENTIUS, BATTLE OF HERACLIUS AND CHOSROES, and DISCOVERY OF THE TRUE CROSS.
 Example: Cornelis Engelbrechtsz, c. 1510–1520, Alte Pinakothek, Munich.

CONTINUOUS REPRESENTATION. In some Renaissance pictures, the artist depicts several successive incidents in the story, shown as taking place in different areas of the same picture. The martyrdom of a saint, for example, may show the martyrdom in the foreground and have the miracles he performed scattered about in the background. Masaccio's *Tribute Money* depicts Peter (see PETER, APOSTLE AND SAINT) in three different places. Standing near Christ and the tax collector, he is being told to go the lake where he will find a silver coin to pay the tax. He is shown kneeling (far left of the picture) at the shore taking the coin from the mouth of a fish. Finally, he is shown standing at the far right handing the coin to the tax collector, who is also shown again.
 Example: Masaccio, *Tribute Money,* c. 1425, Brancacci Chapel, Sta. Maria del Carmine, Florence.

CONTRAPPOSTO. *Contrapposto* is an Italian word for "set against." It was one of the great achievements of Greek art so-named during the Renaissance. The human figure is shown in such a way as to set parts of the body in opposition to each other around a central vertical axis. The artist usually achieves this by twisting the hips and legs in one way and the chest and shoulders in the opposite direction. With this new freedom, Renaissance sculptors could suggest an indefinite number of situations, from the figure standing quietly at ease to poses of greater tension and emotion. The theory of *contrapposto* was first described in a fifth-century treatise (now lost), the *Canon* of Polykleitos. During the

Renaissance Michelangelo's fantastically twisted torsos led artists in the sixteenth century to a contest of sorts to see who could devise the most astonishing and remarkable *contrapposto* for a figure engaged only in a simple exercise. See PONDERATION.

Example: Michelangelo, *David,* marble, 1501–1504, Accademia, Florence.

CONVERSATIO MYSTICA. See SACRA CONVERSAZIONE.

CONVERSION OF SAINT PAUL. Paul (see PAUL, SAINT) was first called Saulus after King Saul, and after his conversion to Christianity he was called Paul, meaning the small one, because of his humility. He was a tentmaker by trade and became an *apostle, though not one of the original twelve. He was born in Tarsus in Asia Minor c. A.D. 10 and died in A.D. 64 or 67, and although Jewish, he inherited Roman citizenship from his father. The sources for Paul's life are the Acts of the Apostles. The church celebrates Paul's conversion and not that of other saints because God showed by it that he could convert his cruellest persecutor and make of him his most loyal apostle. The conversion occurred on the road to Damascus in A.D. 33 when Paul was on his way to obtain authorization from the synagogue to arrest Christians. Paul was struck to the ground by a sudden blinding, divine light. When he fell from his horse he became blind and was led into Damascus, where he was found (on God's direction) by the disciple Ananias. When he regained his sight, he was baptized and began preaching (Acts 9:1–19). Paul is usually shown on the ground, his horse standing by, and he may be wearing Roman armor. *Christ accompanied by *angels may look down from the heavens.

Example: Michelangelo, 1542–1550, Pauline Chapel, Vatican, Rome.

COPE. A cope is a long semicircular cloak or cape open in front except at the top where it is joined by a band or clasp that is worn by ecclesiastics in processions or other ceremonial occasions.

CORONATION OF THE VIRGIN. The Coronation is the final glorification of the Virgin as *Regina Coeli, Queen of Heaven, in the narrative cycle of her life. It is also a portrayal of the Virgin as a devotional, nonnarrative figure, the personification of the church itself. The Coronation is an imaginary scene first developed in north-west France in a twelfth-century *relief at Senlis Cathedral. The subject was adopted by Italian artists in the thirteenth century and formed the center of a series of scenes from her life. The Virgin is usually shown seated to the right of *Christ, who is in the process of placing a crown on her head. She may also be depicted kneeling before him. She usually wears a white robe and clasps her hands to her breast or holds them in an attitude of prayer. Italian Renaissance painting showed her being crowned by God the Father, or by the *Trinity, in which case God the Father and the dove, the symbol of the *Holy Spirit, are included. The Virgin and Christ are usually central to the composition

and are often surrounded by Christian martyrs, Fathers of the church, patriarchs, and choirs of *angels, who sometimes carry musical instruments or the instruments of the *Passion. The Coronation occurs frequently in paintings made for the altars of churches dedicated to the Virgin.

Example: Fra Angelico, c. 1438–40, Museum of San Marco, Florence.

CORPUS CHRISTI. *Corpus Christi* is a Latin phrase for "body of *Christ." The Catholic church holds its Feast of Corpus Christi on the Thursday after *Trinity Sunday to honor the Real Presence of Christ in the *Eucharist. The Procession of the *Host is its most prominent feature.

CORPUS DOMINI. *Corpus Domini* is a Latin phrase for "body of God."

COSIMO I. Cosimo I de'*Medici (1519–1574) was the duke of Florence (1537–1569), the grand duke of Tuscany (1569–1574) and the son of Giovanni de' Medici. Under his ruthless, though able, rule, Florence reached its grandest material prosperity and political importance and nearly doubled its territories. Cosimo is usually depicted as a powerful individual in Roman armor.

Example: Benvenuto Cellini, bronze, 1545–1548, National Museum, Florence.

COSMAS AND DAMIAN. See BEHEADING OF SAINTS COSMAS AND DAMIAN and MIRACLE OF THE DEACON JUSTINIAN.

COSTRUZIONE LEGITTIMA. Costruzione Legittima is a system of *perspective described by Leon Battista Alberti in his treatise *On Painting* (1435). The system was taken from perspective analyses described earlier by Filippo Brunelleschi and founded on a geometrically constructed picture plane. The height of the foremost figure becomes the module on which all proportions of the whole are figured. A horizon is located in the middle of the space at the eye level of this module figure, and is hence the vanishing point.

Example: Paolo Uccello, *Battle of San Romano*, 1445, Uffizi Gallery, Florence.

COULISSE. Coulisse (from the French word *couler*, "to flow") is actually the side scene of the stage in a theatre or the space between the side scenes, so arranged as to give room for exists and entrances. Renaissance artists used the idea for a system of landscape in which the sense of recession into space is achieved by leading the eye back into depth by a series of diagonals, usually in the form of rocky masses, trees, winding rivers, pathways and similar devices.

Example: Melchior Broederlam, *Presentation and Flight into Egypt*, detail from the *Dijon Altarpiece*, 1390s, Dijon Museum, Dijon.

CREATION. The first two chapters of Genesis contain two accounts of the story of the creation of the universe and of mankind. In the first chapter the six days are in the following order: (1) The separation of light from darkness; (2)

the separation of the waters above and below the firmament; (3) the creation of dry land and plants; (4) the creation of the sun, moon, and stars; (5) the creation of living things for the water and the air; (6) the creation of domestic and wild animals and of human beings. Thus the whole universe was completed.

Examples: Michelangelo, *The Creation of Eve, The Creation of Adam, Gathering of the Waters; Creation of the Sun and Moon, Creation of the Planets,* and the *Separation of Light from Darkness,* 1508–1512, Sistine Chapel Ceiling, Vatican, Rome.

CRISTO SCORTO. *Cristo Scorto* is a phrase for the Dead Christ.

Example: Andrea Mantegna, c. 1501, Pinacoteca di Brera, Milan.

CROSSING OF THE RED SEA. Exodus tells how *Moses, the great prophet and lawgiver of the Jewish people, led the Israelites out of Egypt at the beginning of their journey to the Promised Land. They were miraculously shown the way by God in the shape of a pillar of cloud by day and a pillar of fire by night. Pharoah chased them with an army of horsemen and chariots, but when the Israelites reached the Red Sea and Moses stretched out his hand, a powerful wind parted the water, leaving a dry path through which the Israelites crossed. Pharoah's army followed and Moses allowed the water to return, engulfing the Egyptians (Exodus 14:19-31). The Israelites are usually depicted carrying bundles on their heads, their belongings wrapped up peasant style. They kneel in thanksgiving and embrace one another. The Egyptians are shown in mass confusion, horses and riders drowning in the water, their chariot wheels, having been removed by God, floating everywhere.

Example: Agnolo Bronzino, 1553–1564, Chapel of Eleonora da Toledo, Palazzo Vecchio, Florence.

CROWNING WITH THORNS. One of the last of the series of scenes known as *Christ's *Passion, the Crowning with Thorns follows the Flagellation and is the prelude to the *Ecce Homo* (Behold the Man), after which Christ was led away by Roman soldiers to be crucified. The soldiers threw a purple (or scarlet) robe around him, crowned him with thorns, put a reed in his hand as a mock symbol of power, and said, "Hail, King of the Jews" (Matt. 27:27–31; Mark 15:16–20; John 19:2–3). During the Crowning, Christ is usually shown seated, dressed in a scarlet or purple robe, and holding a reed. A convention that became popular during the Italian Renaissance depicts two soldiers each holding a pole with which they press the thorns into Christ's head. The poles symbolically form the shape of a cross. The Italians produced a gentle, physically beautiful and dignified Christ crowned with small thorns and very little blood. In contrast, Northern Renaissance painters depicted Christ in terrible anguish with blood trickling down his body from the fantastic spikes that form the crown of thorns.

Example: Titian, c. 1570, Alte Pinakothek, Munich.

CRUCIFIXION. The crucifixion of *Christ can be found in all four *Gospels (Matt. 27:33–56; Mark 15:22–41; Luke 23:33–49; John 19:17–37). In order to better understand the Renaissance artists' treatment of Christ's Crucifixion, a brief historical summary of the Crucifixion in art is presented here as a prelude to the event as depicted by artists of the Renaissance. During the first three centuries after Christ's death, the crucifixion was not shown in Christian art; the early church avoided the subject. Finally, in the fourth century, when Christianity was a proscribed religion under the Romans, the crucifixion was portrayed symbolically with the Lamb of Christ contiguous with Christ. Also, it was shown symbolically in the fourth century by a cross with no body. Christ is first shown on the cross in the early fifth century, attached by four nails in his hands and feet (Renaissance artists used three) and naked except for a loin-cloth, but he shows no trace of suffering. During the sixth century and until the eleventh century, he usually wears a long tunic, possibly to negate any portrayal of degradation. A new type appeared in the eleventh century; Christ is shown emaciated, his head fallen on one shoulder, and later artists add the crown of thorns. In the thirteenth century an even more realistic conception of Christ crucified was created in Italy, which showed Christ no longer indifferent to his ordeal, but degraded and suffering. By the time of the Italian Renaissance the scene became crowded with people. The primary participants in the Crucifixion were the Virgin and Christ's disciple Saint *John the Evangelist and Apostle. They are usually shown on either side of the cross. After the fourteenth century the Virgin's role becomes more visible, and she moves from sorrow to suffering, which becomes progressively more intense until in the fifteenth and sixteenth centuries she was often shown in a faint supported by other holy women or by Saint John. The Gospels describe many participants, and in art the subject is treated symmetrically. There is a tendency to use figures in pairs, one balanced with the other on the right and left sides of the cross. Also, a moral distinction between the right and left sides exists: good on the right of Christ, evil on his left. The good thief is always to Christ's right, the bad thief to his left. The wound in Christ's side is on the right. Also symmetrically placed are the two women who symbolize the church (New Testament) and the synagogue (Old Testament). The lance-bearer, Longinus (from the Greek word for ''lance'') and the sponge-bearer, Stephaton (who is rare in Renaissance art), are usually shown on either side of the cross. The soldiers casting lots are seen either at the foot of the cross, in the center, or in a corner of the painting. The number of soldiers varies; they may quarrel, one with a drawn knife ready to cut the seamless robe, while another tries to intervene. It was also during the Renaissance that Saint *Mary Magdalene came to be distinguished from the other holy women. She is usually a separate figure, often richly dressed with long, flowing hair, and she may support the fainting Virgin, in which case she wears a red cloak. Also, she is shown kissing Christ's feet or wiping them with her hair. Frequently she kneels to embrace the bottom of the cross. Another form of crucifixion that begins during the Renaissance is a scene that includes saints and *donors with no regard

for the age in which the saints lived. They are recognizable by their attributes and may be the patron or the founders of the order for which the work was commissioned or the city or church that paid for the work. As time went by, large numbers of other characters in exotic clothes came to crowd the scene. (The Council of Trent judged such numbers of spectators unsuitable and Counter-Reformation painters reduced the number to the essentials for a more serious scene.) Also, the skull of *Adam, who was traditionally supposed to have been buried at *Golgotha, is below the cross and is first included in the ninth century. This is an allusion to the washing away of Adam's sin. The skull is sometimes sprinkled with blood that drips from Christ's wounds. It may also be placed upside down to catch the blood as if it were a *chalice; or an *angel may receive the blood. A further allusion to the *Fall of Man is a serpent with an apple in its mouth near the skull. And, from an early period, the sun and moon are traditional features. These recall the eclipse that accompanied the Crucifixion (Matt. 27:45 and Luke 23:44). The sun and moon are depicted in early Renaissance art but are seldom included after the fifteenth century. The sun appears on Christ's right, the moon on his left. According to Saint Augustine, the sun symbolized the New Testament, the moon symbolized the Old Testament.

Example: Antonello da Messina, 1475, National Gallery, London; Andrea del Castagno, *Crucifixion with Four Saints*, c. 1445, Cenacolo of Sta. Apollonia, Florence.

CRUCIFIXION OF SAINT PETER. One of *Christ's disciples, Peter (see PETER, APOSTLE AND SAINT), was the brother of Saint *Andrew and a fisherman in Galilee. His life after the *Crucifixion and the *Ascension of Christ is told in the Acts of the *Apostles and the *Golden Legend*. He preached throughout Asia Minor and founded a church in Antioch. Subsequently, he went to Rome, where he became bishop and formed the first Christian community there. It is believed that Peter carried on his work in Rome for twenty-five years, until he was accused of having cast a spell over one of Nero's favorites. His Christian followers advised him to leave Rome, and he agreed to flee the city; on the Appian Way he saw a vision of Christ. According to tradition he took this as a sign and went back to Rome, where he was arrested and imprisoned by Nero. He was soon scourged and crucified upside down, at his own wish, to avoid irreverent comparison to Christ. This event took place either in a circus arena between two *metae* (the pair of turning-posts set in the ground at each end of the racing course), on the Vatican hill, or on the Janiculum hill. Constantine erected a huge church over his supposed burial place. Saint Peter's, as we know it today, was built on the same location. Peter is usually shown already nailed to the cross that stands upside down, or a crew of men are working to put it in place. Artists usually show him leaning up and looking out.

Example: Michelangelo, 1542–1550, Vatican, Rome.

CRUCIFIXION WITH SAINTS. See CRUCIFIXION.

CRUX COMMISSA. Also known as a "T" or "tau cross," the *Crux Commissa* is a cross of *crucifixion in which the upright shaft (the *Stipes*) does not extend higher than the transverse beam (the *Patibulum*). In Crucifixion scenes artists used this form for the two thieves who were crucified with *Christ in order to differentiate clearly between him and them. In the west, it became widespread to show the thieves tied, not nailed.

 Example: Konrad von Soest, *Crucifixion with Scenes of the Passion and the Ascension*, c. 1403, Niederwildungen Altarpiece, Church, Niederwildungen, Germany.

CRUX DECUSSATA. The *Crux Decussata* is a type of cross of *crucifixion made up of two intersecting beams in the form of an X. Other names for this cross are the Saint Andrew's Cross and the Saltine. Saint *Andrew is usually shown holding an X-shaped cross because it was the instrument of his martyrdom.

 Example: Pupil of Pietro Lorenzetti, *Saint Andrew the Apostle*, fourteenth century, Bridgeport Museum of Art, Science, and Industry, Bridgeport, Connecticut.

CRUX IMMISSA. The *Crux Immissa* is the cross of *crucifixion that is the most popular. The top of the upright shaft extends above the transverse beam forming what is known as the Latin Cross. Artists usually show *Christ crucified on this type of cross.

 Example: Masaccio, *Crucifixion*, 1426, Museo di Capodimonte, Naples.

CUER READING THE INSCRIPTION ON THE MAGIC WELL (*Livre de Cuer d'Amours Espris*). See BOOK OF THE HEART TAKEN BY LOVE.

CUMAEAN SIBYL. *Sibyl or Sibylla (the name was first used in Hellenistic Greek), was an inspired prophetess possessed with the spirit of *Apollo and thus able to foresee the future. The name "Sibyl" was localized in several areas, until its use became generic and there were many Sibyls. Traditionally the Sibyl was associated with any place inhabited by an oracle. Of the ten Sibyls listed by Varro, the most popular was the Sibyl of Cumae in Campania, who guided Aeneas into the underworld to see his father's face again.

 In Ovid's *Metamorphoses*, the Sibyl had already lived seven generations when Aeneas visited her in her temple. She explained how, being extremely beautiful, Apollo had given her as many years to live as there were grains in a handful of sand, but she failed to ask him for perpetual youth and beauty. It is said that when children saw the Sibyl hanging up in a bottle at Cumae and asked her (in Greek) what she wanted, all she would say was, "I want to die."

 By the end of the Middle Ages the western church had accepted twelve Sibyls as prophets of the coming of *Christ. Traditionally they are the writers of a collection of Jewish and Christian prophetical texts known as the *Sibylline*

Oracles or *Sibylline Books*. They are the pagan counterparts of the Old Testament prophets and often portrayed with them in art. Although their attributes vary, they often hold a book, one of the *Sibylline Books*, in which their prophecies were recorded. The Cumaean Sibyl may hold a bowl, sometimes shelllike. The Sibyl of Cumae is the Sibyl of the Roman mysteries because her *Sibylline Books* were said to be kept on the Capitoline Hill, and therefore she symbolizes the age and strength of the Roman church. She may be shown as young and extremely beautiful or horribly old, withered, and ugly.

Example: Michelangelo, 1510, Sistine Chapel Ceiling, Vatican, Rome.

CUPID. In Greek religion Cupid is Eros, the god of love. The Roman god of love was known as Amor (Latin) or Cupid. Some legends say he was the oldest of the gods born from chaos. Others say he was the son of Aphrodite (* Venus) and Ares (Mars). He was the lover of Psyche (see CUPID AND PSYCHE), and the personification of the human soul. To the Romans he was the naked winged child who is the Hellenistic Eros and also a symbol of the life after death promised by the Mysteries. Cupids were commonly used on ancient sarcophagi, where they are shown playing with *satyrs' masks. The early Christian churches used the winged *cherub as decoration. Although Cupid is one of the lesser figures in Greek and Roman mythology, he was depicted frequently in Hellenistic works and in the Renaissance. He was known to be unsympathetic and to dispense carelessly the agonies of love. Usually his presence is symbolic. He appears somewhere in the work of art, but actually may play no part in the story, which centers around love. Sometimes he is shown blindfolded, an allusion to the fact that love is blind and also a a reminder that darkness is associated with sin. The blindfold also indicates that his victims are chosen at random, and, like Venus, he could be cruel and must be feared. To the early Greeks Eros represented the most powerful forces in man's nature and the passing of earthly pleasures, but later his role became that of a cute little winged boy. Sometimes he was attended by his brother, Anteros, who was reputedly the one who opposed love or the avenger of unrequited love. Renaissance artists show Cupid as a naked child with wings, usually with a wicked grin. He may have his foot upon two books to indicate love's triumph over knowledge. He had to be punished often for the mischief he caused with his bow and arrows and so *Diana's *nymphs, the guardians of virginity, broke his bow and arrows while he slept. He was quick to carve new ones. He is shown carving the new bow from a freshly cut cherry sapling.

Example: Parmigianino, *Cupid Carving His Bow*, 1535, Kunsthisorisches Museum, Vienna.

CUPID AND PSYCHE. The story of Cupid and Psyche has all the characteristics of a fairy tale, and is first told by Apuleius (second century A.D.) in the *Metamorphoses*, and the *Golden Ass* (Books 4–6). According to these accounts, Psyche was so beautiful that she caused even *Venus to be jealous. *Cupid, sent

by Venus to cause Psyche to fall in love with some completely degraded creature, fell in love with her himself. He had her taken to an isolated castle where he saw her only at night, and she was forbidden to look at him. She disobeyed him after being urged on by her own curiosity and two jealous sisters who set out to ruin her. They suggested the lover who visited her only at night was a repulsive reptile. Therefore, one night she could not resist taking a look at him as he lay asleep. She took a lamp and a carving knife, planning to kill him, but by the lamp's light she saw he was Cupid. She felt the point of one of his arrows, which pricked her finger, and when she jumped the oil lamp spilled a drop of burning oil on his shoulder. He awoke immediately, departed, and caused his castle to vanish. Psyche was totally devastated. After trying unsuccessfully to drown herself, she searched the world in aimless misery for him, ceaselessly performing impossible and dangerous tasks for Venus in the hope of winning him back. She was able, for example, to sort an enormous heap of wheat, barley, millet, beans, lentils, poppy seeds, and vetch with the help of an army of ants. Then Venus declared Psyche a witch and told her to carry a box down to the Underworld, give it to Proserpina, and ask the queen to put some of her beauty inside the box and send it back. But as Psyche was on her return journey, out of desire to have some of the beauty for herself, she opened the box and fell down in a fatal sleep. Cupid rescued her. Zeus (see JUPITER) had taken pity on them after being moved by Cupid's pleas. Psyche was taken up to heaven by Hermes (Mercury), married to her lover, and made immortal. For the Renaissance humanists the most important aspect of the story was its symbolic interpretation. This was seen as a search of the Soul (Psyche) for union with Desire (Cupid), the result of which is Pleasure (their daughter). Psyche's story was admired in Hellenistic poetry and art, but the story is depicted sometimes as a series of scenes in the decoration of Renaissance palaces. The most popular scene is that of Psyche in the room holding an oil lamp over the sleeping Cupid.

Example: Raphael and Assistants, 1518–1519, Scenes from the story on the ceiling of the Loggia di Psiche, Villa Farnesia, Rome.

CUPID CARVING HIS BOW. See CUPID.

CURE OF FOLLY. An absurd "physician" is shown removing the "stone of folly" from the skull of a gullible patient. The moral of the story lay in the willingness of man to think that intelligence, tenacity, and wisdom could be gotten from a ridiculous operation performed by a quack.

Example: Hieronymus Bosch, 1475–1480, Prado, Madrid.

D

DALMATIC. The Dalmatic is an ecclesiastic outer vestment with side sleeves and a skirt slit at the sides worn in religious ceremonies originally by a deacon but now also by some prelates (as bishops). A similar robe of rich materials was worn by a king at his coronation.

DAMIAN. See BEHEADING OF SAINTS COSMAS AND DAMIAN and MIRACLE OF THE DEACON JUSTINIAN.

DAMNED CONSIGNED TO HELL. Renaissance painters used great imagination when presenting the concept of those who had been consigned to *hell, Satan's kingdom, the eternal abode of souls damned by the judgment of God. *Christ may be shown as the Presiding Judge, as in a *Last Judgment. At his right hand, the chosen or saved are rising or being assisted into heaven and eternal life while on the left the damned are being taken down into hell, deprived forever of the sight of God. Heaven is guarded from those who are not supposed to enter. The archangels Michael (see MICHAEL, SAINT), Uriel, and Raphael usually guard the gates of heaven or stand in the sky to keep out the unwanted. They are dressed in armor as guards. Below, the lustful are tormented in various horrible ways by demons who tear their feet apart, rip off their ears, or eat pieces of their bodies.
 Example: Luca Signorelli, 1500–1504, Saint Brixio Chapel, Cathedral, Orvieto.

DANAË. The entire story of Danaë, on the level of a fairy tale, is told by both Ovid and Apollodorus and seems to have been a favorite in antiquity and later during the Renaissance. Danaë was the only daughter of Acrisius, king of Argos. She was imprisoned by her father in a *bronze house sunk underground, but

with a part of the roof open to the sky so that air and light could come through. (Some sources cite a bronze tower.) The king put her in this place because the Oracle at Delphi foretold that a son of hers would kill him. (He was eventually killed by her son, *Perseus, as he threw a discus.) Danaë was visited in the tower by Zeus (*Jupiter) in the form of a shower of gold that fell from the sky and filled her chamber (Ovid, *Metamorphoses* 4:611). Later, she gave birth to a son, and she knew that her child was the son of Zeus. She named him Perseus and tried to keep the baby a secret from her father, but this became impossible in her small prison. Acrisius discovered the boy and, remembering what the Oracle had told him, put her and the baby in a wooden chest and had it cast into the sea, where the two were later rescued by a fisherman named Dictys, who took the pitiful cargo to his wife. Danaë and Perseus lived with the couple for many years. Later Perseus was sent by Polydectes, the ruler of the island, to kill the Gorgon. Polydectes had fallen in love with Danaë, who was even more beautiful than before, and being jealous he plotted this journey for Perseus to get rid of him. Polydectes pestered Danaë with desire until she finally had to hide after her refusal to marry him. When Perseus returned after killing the Gorgon, he turned Polydectes and his followers to stone and took Danaë back to Argos. It was there in a discus-throwing contest that Perseus accidentally killed Acrisius, his grandfather. Many Renaissance artists could see Danaë as a symbol of the transfiguring effect of divine love. Also, the theme was popular as a vehicle for portraying a beautiful female nude. Danaë is usually shown reclining on a great canopied bed with soft cushions. Her attendant is nearby. The astonished old woman may hold out her apron to catch the falling gold. During the medieval period, Danaë was both a symbol of virginity and an example of the conception of a virgin through divine intervention. In this way the idea was regarded as a prefiguration of the *Annunciation.

Example: Titian, 1554, Prado, Madrid.

DANCE OF DEATH (Ger. *Totentanz*). The Dance of Death is a topic in which all manner of men from popes to artisans are shown as being wisked away in a dance with counterpart skeleton popes and artisans. During the Renaissance, Hans Holbein the Younger produced the most celebrated of these cycles. His *Alphabet of Death* and *Dance of Death* were *woodcuts produced in 1524. The *Dance* was the most popular and ran ten editions in twelve years. See TRIUMPH OF DEATH.

DANIEL. One of the four prophets, Daniel was known as the personification of *Justice. The Book of Daniel tells how he gained an influential position in the court of Babylon because of his skill in interpreting dreams. A popular theme associated with Daniel, the ''Three Hebrews in the Fiery Furnace,'' is not found in Renaissance art. Likewise his ordeal in the lion's den is very rare after the medieval period, although it does recur in the seventeenth century. Renaissance

artists show Daniel simply as one of the greater prophets, seated, holding his book.

Example: Michelangelo, Sistine Chapel Ceiling, 1508–1512, Vatican, Rome.

DANTE ALIGHIERI. Dante (1265–1321), an Italian poet born in Florence, is an outstanding figure of Italian letters because of his *Divine Comedy*, a long poem in one hundred cantos. It recounts the story of his journey through *hell, purgatory, and heaven. Artists depict Dante as a standing figure holding a book inscribed with the opening words of the *Divine Comedy*, ''Nel mezzo del chamino di nostra vita . . . ''—''Midway in our life . . . ''

Example: Andrea del Castagno, 1440s, S. Apollonia, Florence.

DANUBE SCHOOL (Ger. *Donauschule, Donaustil*). The Danube School is the name for the pre-eminence of the Danube region in the foundations of modern landscape painting. Major painters of the Danube School are Lucas Cranach, Wolf Huber, and Albrecht Altdorfer. The latter, for example, visited the Austrian Alps and traveled the Danube, where the breath-taking scenery inspired him to become the first landscape painter in the modern sense.

Example: Albrecht Altdorfer, *Danube Landscape near Regensburg*, 1522–1525, Alte Pinakothek, Munich.

DAVID. David was a mere shepherd boy who, according to biblical accounts and legend, became king of the ancient Hebrews (c. 1012–c. 972 B.C.). He has been portrayed as a statesman, a warrior, and a leader of bandits. Traditionally he is said to be the author of the Psalms; he was a noted musician and is shown sometimes with a harp or some stringed instrument of the viol family, then popular and in general use.

Example: Andrea del Verrocchio, bronze, early 1470s, Bargello, Florence.

DAVID AND BATHSHEBA. See BATHSHEBA.

DAVID AND GOLIATH. *David was king of Israel (c. 1012–c. 972 B.C.), and successor of Saul. One of the most interesting and beautiful narratives in the Bible deals with the figure of David and Goliath of Gath, champion of the Philistines. The Philistines and Israelites were waging war against each other. The account of the fight between David and Goliath, the subject depicted most frequently by artists, concludes: ''And David put his hand into his bag and took out a stone and hit the Philistine in his forehead, that the stone sunk into his forehead; and he fell down. So David prevailed, but there was no sword in the hand of David and he ran and stood upon the Philistine and took his sword and cut off his head. And when the Philistines saw their champion was dead, they fled'' (1 Sam. 17:38–51). David had refused the armor Saul offered him before the conflict and instead had taken five stones for his sling. Thus artists usually depict him nude. The scene following the fight is David's heroic return carrying

the giant's head. The biblical account was made a prefiguration of the devil's *Temptation of Christ in the desert and came to have a wider meaning to symbolize the victory of right over wrong. The Triumph of David is told in 1 Sam. 18:6–7. Here David is carrying Goliath's head in his hand or sometimes high in the air on the point of a spear or sword. The Israelite women came out dancing, singing, and playing musical instruments when David returned. This episode was interpolated at a later date as a prefiguration of *Christ's *Entry into Jerusalem. A new conception of David was developed by Renaissance sculptors, who represented him as a handsome youth standing proudly over Goliath's severed head.

Example: Donatello, bronze, probably 1430s, Bargello, Forence.

DAVID BEFORE SAUL. Saul, the first king of the ancient Hebrews, suffered from spells of melancholia and, seeking a cure, decided that music would alleviate his condition. *David, who played the harp, was brought in and Saul liked him so much he chose him as his protégé (1 Sam. 16:14–23). (David later became his rival and then his successor.) David is shown as a youth standing before Saul in that moment when he entered the king's chamber or he plays his harp to soothe the ailing king. See also SAUL AND DAVID.

Example: Jean Pucelle, *Belleville Breviary*, illumination, 1323–1326, Bibliothéque Nationale, Paris. (Ms. lat.,10483, fol. 24v)

DAY. See NIGHT.

DEAD CHRIST. See CRISTO SCORTO.

DEAD COLOR. See LAY-IN.

DEATH. See MEMENTO MEI.

DEATH OF ACTAEON. See ACTAEON, DEATH OF.

DEATH OF CLEOPATRA. Cleopatra (69–30 B.C.), queen of Egypt, famous for her intellect and beauty, was one of the great romantic heroines of all time. A great deal of romantic legend surrounds her life, but one theme, the favorite of most artists, is her death. She is shown lying or seated on a couch, usually nude, an asp curled about her arm ready to bite her breast. Plutarch (*Lives* 44:86) describes the tragic death scene in which she took her own life.

Example: Jan van Scorel, c. 1522, Rijksmuseum, Amsterdam.

DEATH OF HAMAN (The Hanging of Haman). Haman was a favored minister of King Ahasuerus (see ESTHER AND AHASUERUS). The Jew Mordecai (see TRIUMPH OF MORDECAI) had angered him with the result that he persuaded the king to put all Jews to death. The king was unaware that

Esther, his queen, was a Jewess. Esther, learning what had happened, went to Ahasuerus to intercede on behalf of her people, and Haman was hanged on the gallows he set up for Mordecai (Esther 3-7). Haman is usually shown not dying, as in the Book of Esther, by hanging (7:10), but by *crucifixion.

Example: Michelangelo, 1508–1512, Sistine Chapel Ceiling, Vatican, Rome.

DEATH OF ORPHEUS. In Greek mythology Orpheus was a Thracian musician famous for his skill with the lyre. Supposedly he played his lyre so beautifully that trees danced, wild beasts were charmed, and rivers stood still. He married the wood *nymph Eurydice (see ORPHEUS AND EURYDICE), and when she was bitten by a snake and died, he descended into Hades in an unsuccessful attempt to bring her back to earth. He was granted the chance to allow Eurydice to follow him back to earth if he could refrain from looking at her until he reached the upper world. At the very last moment he glanced back at her and she disappeared forever into the shades. He then became a recluse and despised women. Because of this he was murdered by frenzied Maenads of Ciconia in Thrace (Ovid *Metamorphoses* 11:1–43). They tore him to pieces and threw his head into the river Hebrus and it floated, still singing, into the sea to the island of Lesbos, where the Oracle of Orpheus was established. Artists depict Orpheus being attacked by women. His lyre is on the ground.

Example: Albrecht Dürer, 1494, Kunsthalle, Hamburg.

DEATH OF SAINT FRANCIS. See FRANCIS, DEATH OF.

DEATH OF THE MISER. A dying man is shown who, even at the moment of death, reaches for the bag of money offered to him by a demon appearing from under his bed. The miser pays no heed to the *angel who points out the salvation he could have by turning to *Christ, who is depicted on a crucifix. At the foot of his bed the miser is shown adding money to his coffer and the moneybag within is held open by a demon. Another demon shows him a letter, which could be a mortgage, signed, sealed, and delivered, or a letter of indulgence. The topic is a comment on human nature and its greed even in the last seconds before death.

Example: Hieronymus Bosch, c. 1485–1490, National Gallery of Art, Washington, D.C. (Samuel H. Kress Collection).

DEATH OF THE VIRGIN (Dormition). According to the *Golden Legend*, which appeared in the thirteenth century when devotion to the Virgin was at its height, the Virgin Mary (see MARY, SAINT), after the death of Jesus, lived in a house by Mount Sion. From there she visited the holy places of her Son, namely the places of baptism, fasting, prayer, his *Passion, burial, *Resurrection, and *Ascension. She lived for twenty-four years after his Ascension. Her exact age at her death is unknown, but it is believed that when she conceived *Christ she was fourteen and fifteen when she bore him; she lived

with him for twenty-three years. Thus she was seventy-two years old when she died. (Some sources indicate she lived only twelve years after her Son and thus died at the age of sixty.) According to the *Ecclesiastical History*, the *apostles preached around Judea for that length of time. When the Virgin became lonely and longed to be with her Son again, she was visited by an *angel bearing the Palm of Paradise, which was to be carried before her bier. The angel foretold her death in three days. Mary asked that she be allowed to see her sons and brothers, the apostles, again and that she be buried by them. The apostles, who were preaching all over the world, each were caught up in a cloud and taken to the Virgin's door. Many Renaissance artists show the Virgin's body on a bed, sometimes canopied, in a regular household interior. The apostles stand round. Rarely she is shown standing, leaning to one side. Some artists show her still alive holding a lighted candle in her hands, in accordance with the old custom of putting a candle in the hands of a person who is dying (or an apostle may be preparing the candle). Peter (see PETER, APOSTLE AND SAINT), sometimes dressed in bishop's robes, conducts the service. Saint *Andrew is usually shown swinging a censer. Saint John (see JOHN THE EVANGELIST AND APOSTLE, SAINT) holds the palm, given to him by the Virgin, or he is kneeling by her bed. The figure of Christ, sometimes with angels and sometimes with a tiny effigy, which is her soul, may hover in an aureole or *mandorla* above her head. Women who are present (rarely) represent the Virgin's friends, to whom she left her robes.

Example: Hugo van der Goes, c. 1481, Groeningemuseum, Bruges.

DECEMBER. December is represented by Capricorn and a goat with a spiral tail for hindquarters. The December boar hunt in preparation for Christmas baking or feasting at the table are the usual scenes for the last month of the year. The hunt, done with dogs, is usually a scene of the kill. The hunters stand around while the dogs do their work.

Example: Limbourg Brothers, December page, *Book of Hours (Les Trés Riches Heures) of the Duke of Berry*, illumination, 1416, Musée Condé, Chantilly.

DECOLLATION. A beheading or being beheaded.

DEËSIS. In a Deësis Christ is flanked by his mother, the Virgin Mary (see MARY, SAINT), on his right and Saint *John the Baptist on his left. Sometimes it is used as the central group in *Last Judgment scenes.

Example: Jan van Eyck, Central upper section of the *Ghent Altarpiece*, completed 1432, St. Bavo, Ghent.

DEIANIRA. See RAPE OF DEIANIRA.

DELIVERY OF THE KEYS TO PETER. See GIVING OF THE KEYS TO PETER.

DELLA PITTURA. *Della Pittura* is the name of Leone Battista Alberti's Latin treatise *On Painting*, completed in 1435 and translated into Italian by Alberti in 1436. This is his first theoretical work on the arts, which was important to Renaissance artists because it contains the first description of *perspective construction.

DELUGE. In the Bible, the Deluge was the tremendous flood that covered the earth and killed every living thing except Noah's family and the animals of his ark. Actually, little evidence of the biblical flood has been revealed by archaeologists, and many flood stories exist in the folklore of many races. The earliest known flood story can be found in the Greek myth of *Deucalion and Pyrrha*. In the biblical version, the rain lasted for forty days and nights until even the mountains were covered and the flood lasted for one hundred and fifty days. The ark came to rest on Mount Ararat only when the water began to subside. Noah sent a raven off to find dry land, but the bird did not return. Then twice he sent a dove that returned the second time with an olive leaf. When sent out a third time, the dove did not return. Noah decided to lead his family and the animals out of the ark so that they might "multiply upon the earth" (Gen. 6:8; Isa. 54:9; Matt. 24:38; Luke 17:27; Heb. 11:7; 1 Pet. 3:20; 2 Pet. 2:5). Early Fathers and apologists of the church likened the flood to Christian baptism. Since the ark, which prefigures the cross as an instrument of salvation, was a popular subject in Christian art from its beginnings, a ship soon became the accepted symbol for the church itself. Renaissance artists represent the ark as a true boat. It may be beset by thunder, lightning, rain, and wind.

Example: Michelangelo, 1509, Sistine Chapel Ceiling, Vatican, Rome.

DEMETER. See CERES.

DENIS, SAINT (Dionysius). Although there is no foundation for the legend that surrounds his identity, Saint Denis is known as a third-century bishop of Paris and the patron saint of France. Some sources reveal that he was the first-century Dionysius the Areopagite, and other sources say he was the fifth-century Pseudo-Dionysius. In the *Golden Legend*, he was the highest of philosophers; his life and passion were written in Greek by Methodius of Constantinople and in Latin by Anastasius, the librarian of the Apostolic See. He was converted to the Christian faith by Saint *Paul the *apostle and named the Areopagite after the section in Athens where he lived. The areopagus was the quarter of Mars. The *Golden Legend* places his martyrdom under the reign of Domitian, in the year 96, and in his ninetieth year. He was martyred in Paris with Saints Rusticus and Eleutherius. Usually Saint Denis is known by the fact that after being beheaded, his body rose and he carried his severed head to the place known later as the Mount of Martyrs, where it was buried. However, before his beheading he was put on a grid iron and roasted over a fire. Then he was taken from the fire and thrown to savage beasts. He was then put in an oven, and,

when he emerged unharmed, his executioners crucified him. Finally, he was taken down and returned to prison where, as is sometimes shown in painting, he was given his last communion. Scenes from painting include his conversion by Paul, his receiving the blessing of Pope Clement I in Rome before his departure for missionary work in Gaul, and his martyrdom, which may show him carrying his severed head.

Example: Jean Malouel and Henri Bellechose, c. 1416, Louvre, Paris.

DEPARTURE OF AENEAS SILVIUS PICCOLOMINI FOR BASEL. Enea Sylvio del Piccolomini (1405–1464), born in Corsignano, near Siena, studied law and the humanities and became a humanist. In 1432, as secretary to Cardinal Capranica, he left from Genoa for the Council of Basel (later declared an anticouncil), where he joined a group hostile to Pope Eugenius IV. For a time Piccolomini served as secretary to the Antipope Felix V, and eventually became so disloyal to the papacy that he later had to do penance before Pope Eugenius IV. He became a priest in 1446 and in 1449 was made a bishop of Siena. In 1458 he succeeded Calixtus III as Pope Pius II. In this painting the men are shown finely dressed and astride prancing horses waiting for the departure. Genoa is shown bordering the seaport where caravels (typical small vessels of the fifteenth and sixteenth centuries) wait at anchor.

Example: Bernardino Pintoricchio (Pinturicchio), 1503–1508, Piccolomini Library, Cathedral, Siena.

DEPARTURE OF THE PRINCE FROM BRITAIN. See ARRIVAL OF THE AMBASSADORS OF BRITAIN AT THE COURT OF BRITTANY and URSULA, SAINT.

DEPOSITION. See DESCENT FROM THE CROSS.

DESCENT FROM THE CROSS. The scene Descent From the Cross is frequently called "The Deposition" and is the event that immediately follows the *Crucifixion. It is mentioned by all four of the evangelists (Matt. 27:57–58; Mark 15:42–46; Luke 23:50–54; John 19:38–40). *Joseph of Arimathea, a highly respected lawyer and secretly a disciple, obtained permission from the Roman governor, Pilate, to remove the body of *Christ from the cross. He took the body down with the help of Nicodemus, who brought myrrh and aloes to preserve it. They rubbed the body with spices and wrapped it in strips of a linen sheet provided by Joseph of Arimathea, "as the manner of the Jews is to bury." Saint *John the Evangelist alone mentions the presence of Nicodemus as the man who visited Christ by night (19:39). Early versions of the "Descent" show only the six principal participants: Joseph of Arimathea, Christ, Nicodemus, the Virgin, John the Evangelist, and Mary Magdalene. Joseph of Arimathea holds the weight of Christ's body as Nicodemus draws a nail from Christ's left hand. In early Renaissance works Nicodemus is shown withdrawing the nails from Christ's feet

with huge tongs. The Virgin holds Christ's right hand from which the nail has already been removed, and John the Evangelist, shown as youthful and often long-haired, stands sadly apart from the group. Saint *Mary Magdalene prostrates herself to kiss Christ's feet. As the Renaissance progressed, the theme became far more complex and crowded. More figures were included and two ladders were frequently used, one placed on each end of the cross-bar.

Example: Fra Angelico, 1430–1434, Museum of San Marco, Florence.

DESCENT INTO HELL (Descent Into Limbo, The Harrowing of Hell). No scriptural basis supports the early Christian's belief that *Christ descended into *hell after his death. The concept became an article of faith in the fourth century. Descriptions of Christ's descent existed as early as the second century, and that he overcame Satan and set free the souls of the Old Testament saints was also widely accepted. It was believed that those born before Christ had been relegated to a lower place and had to wait for him to redeem them. The apocryphal *Gospel of Nicodemus (possibly fifth century) tells the story first. Later the story became popular in medieval literature and drama. The *Golden Legend*, written in the thirteenth century, contains an account, and although artists continued to represent it throughout the Renaissance, it is depicted less and less after the sixteenth century. In painting Christ usually enters a doorway and the doors of hell, broken down, have fallen on top of Satan. Figures that are usually shown include: *Adam and Eve, Abel, *Moses, King *David, Saint *John the Baptist, and bearded patriarchs.

Example: Jacopo Bellini, fifteenth century, Municipal Museum, Padua.

DESCENT INTO LIMBO. See DESCENT INTO HELL.

DESCO DA PARTO (It. "birth plate"). Before the Renaissance in Italy, it was the custom to visit a woman who had just had a child and carry gifts or small sweets to her on a tiny tray. Renaissance painters used the *deschi da parto* on which to paint appropriate topics. One *desco* attributed to Masaccio, now in Berlin, shows a visit to a lady who has just had a child by ladies carrying *deschi*.

DESIO. *Desio* is an Italian word for "desire" or "yearning." The doctrine of Lorenzo de' *Medici's Platonic *Academy used *desio* to describe the soul's mystical exile from earth to its true home in God.

DESTRUCTION OF THE CHILDREN OF JOB. See JOB.

DETENTE. Detente is an elegance and attenuation of form sometimes seen in paintings of the third quarter of the fifteenth century. The style is more evident in manuscript illumination where one sees the already elongated proportions exaggerated and this "style of the long lines" emphasized with repetitive parallel verticals.

Example: Flemish, Philip the Good receiving the book, *Chroniques de Hainaut*, dedication page (Ms. 9242, fol. 1), illumination, 1446–1448, Bibliothèque Royale, Brussels.

DIANA. One of the twelve Olympians, Diana (Artemis in Greek religion) is usually associated with her role as the goddess of the hunt. In her pre-Greek origins, especially at Ephesus (see TEMPLE AT EPHESUS), she was an earth goddess associated with uncultivated places and wild animals (similar to Astarte), whose function was to protect wildlife, not destroy it. Later, however, she was primarily a virgin huntress, goddess of wildlife, and patroness of hunters. From Homer onward she was said to be the daughter of Zeus (*Jupiter) and Leto (Latona) and the twin sister of *Apollo. She was worshipped with him at Delos. When portrayed as a huntress, Diana is tall and slim. She wears a short tunic and has her hair tied back. She carries a bow and quiver or a spear and is accompanied by dogs. She was often considered a moon goddess as a complement to Apollo and as such was identified with Selene and Hecate. Sometimes she was a primitive birth goddess, and in Sparta she merged with the Dorian goddess Orthia. Her attribute, as a moon goddess, is the crescent moon worn over the brow. Of the many animals sacred to her, the bear was most important. She was known to bring natural death with her arrows. Because the Romans identified Artemis with the Italian goddess Diana, a reference in the New Testament (Acts 14) exists to the Temple of Diana of the Ephesians, when Saint *Paul's arrival caused a riot. This actually refers to the great Artemisium at Ephesus, one of the Seven Wonders of the Ancient World. The celebrated statue of Artemis was there, completely covered with breasts to mark her connection with childbirth. On the other hand, Diana took terrible measures to protect her chastity and the virginity of her *nymphs, who were expected to be as chaste as Diana herself. Zeus seduced one of them, Callisto, when he disguised himself as Diana to gain her presence. When Diana discovered Callisto's pregnancy, she changed the unfortunate nymph into a bear and set her hunting dogs upon her. They would have torn her to pieces had not Zeus pulled her up to heaven just in time. Diana may be shown carrying a shield to protect herself against Love's arrows. When confronting Callisto, she is shown in her grotto pointing an accusing finger at her. See ACTAEON, DEATH OF.

Example: Titian, *Diana Discovering the Pregnancy of Callisto*, 1559, Edinburgh, National Gallery of Scotland (on loan from the Duke of Sutherland Collection).

DIES IRAE. A Latin phrase for the day of wrath, it occurs in a thirteenth-century poem probably written by Thomas de Celano, the biographer and disciple of Saint *Francis of Assisi. It was later included in the Mass of the Dead.

DIONYSIUS. See DENIS, SAINT.

DIPTYCH. A diptych is a pair of panels that forms a devotional picture sometimes hinged together like a door. See POLYPTYCH.

DISCOVERY OF THE BODY OF SAINT MARK. Under the reign of the emperor Nero, Mark the Evangelist (see MARK, SAINT) was captured by pagans and arrested in Alexandria on Easter day while celebrating *Mass in the Christian church he had founded. The saint was dragged through the streets of Alexandria by a halter around his neck for two days until he died. The pagans said, ''We are dragging the ox to Bucculi, which means, an abattoir. Mark had constructed a church in Bucculi, a small town near Alexandria. According to the *Golden Legend*, his flesh hung from him in threads, and the pavement was red with his blood. The pagans, who were about to burn his body, fled when a hailstorm broke out and fellow Christians took his body away and buried it in his church. Later, in the fifth century, under the reign of the emperor Leo, Mark's body was taken from the Saracens and carried off by Venetian sailors, who brought it back to Venice. He became the patron saint of Venice, which adopted his symbol, the lion. Thus the saint and the lion are represented frequently in Venetian art.

Example: Tintoretto, 1562–1566, Brera Gallery, Milan.

DISCOVERY OF THE TRUE CROSS. The Legend of the True Cross was an extremely complicated medieval invention, which begins with *Adam in his final illness. An *angel tells Seth, Adam's son, that his father can be brought back to health by a twig from the Tree of the Knowledge of Good and Evil. When Seth returns from Eden with the twig, Adam is already dead and the branch is put on his grave, where it grows. Some time later King Solomon (see QUEEN OF SHEBA BRINGING GIFTS TO SOLOMON), while building his new palace, decides to use a part of the tree. The beam is too large and consequently is placed across the creek Siloam. Here the queen of Sheba finds it on her way to Solomon's court. As a prophetess she knows that this wood will serve to be the wood of the True Cross upon which the King of Kings will hang. When she reaches Solomon he has it buried. The tale then shifts to the battle between Constantine and Maxentius. Constantine saw in a dream a cross in the sky and an angel who tells him he will conquer under the sign of the cross (see DREAM OF CONSTANTINE). Protected by the Cross which he substituted for the Roman eagle on the standard of the Legions, Constantine wins at the Mulvian Bridge near Rome (see BATTLE OF CONSTANTINE AND MAXENTIUS). Constantine's mother, Saint Helena, decides then that she wants to find the real True Cross, which has been buried, along with those of the two thieves, after the *Crucifixion. Judas, a Jew, is the only person who knows the location. He is forced to tell by being put into a dry well and starved. At the same time he converts to Christianity. When the three crosses are dug up, no one can tell which one is the True Cross. A funeral procession passes by and the three crosses are held, one at a time, over the corpse. The cross that makes the corpse rise is, of course, the True Cross. When the Persian King Chosroes visits Jerusalem, he take the Holy Cross Saint Helena has left there. The

Byzantine emperor Heraclius defeats Chosroes in battle (see BATTLE OF
HERACLIUS AND CHOSROES) and carries the Holy Cross back to Jerusalem.
 Example: Piero della Francesca, probably 1453–1454, from the *Legend of the True
Cross*, San Francesco, Arezzo.

DISEGNO. *Disegno* is an Italian word with a wide range of meanings, the most
common of which is "drawing."

DISOBEDIENCE OF MAN. See TEMPTATION.

**DISPUTE (Dispute in the Temple, Dispute with the Doctors, Jesus among
the Doctors).** The "Dispute" is the first recorded instance of *Christ's teaching.
It is told by Luke (2:42–51). After the return from Egypt, when Jesus was twelve
years old, the *Holy Family lived in the village of Nazareth. At this time his
parents took him to Jerusalem for the feast of the Passover. When *Mary (see
MARY, SAINT) and Joseph set off with the group on their return journey, at
first they were unaware that Jesus had remained behind. They traveled an entire
day and looked for him among their relatives and friends. When they did not
find him, they hurried back to the city. On the third day they found him in the
Temple surrounded by the Jewish teachers (doctors), or rabbis, with whom he
was engaged in learned conversation. Usually the scene is the interior of
Solomon's Temple, where a very youthful Jesus stands or sits in the middle of
a group of older, bearded men who listen to him in honest wonder. Some artists
show the boy counting on his fingers, pointing out his arguments. He holds a
codex—a volume of the Scriptures we know today—and one of the Jewish scribes
holds a book in the form of a scroll (a rotulet), indicating, respectively, the New
Testament and the Old Testament. Mary and Joseph may be shown to the side,
or Mary may place her hand on her son's shoulder, "Son, why have you done
this to us? Your father and I have been terribly worried trying to find you." He
answered them, "Why did you look for me? Didn't you know that I had to be
in my Father's house?" (Luke 2:48-49).
 Example: Duccio, *Boy Christ Disputing with the Elders in the Temple*, 1308–1311,
panel on the reverse of the *Maestà*, Cathedral Museum, Siena.

DISTRIBUTION OF THE GOODS OF THE CHURCH. Following the
example of some of the *apostles, people of great wealth shared their possessions
with the poor. Saint Peter (see PETER, APOSTLE AND SAINT), shown as an
old but vigorous man with short, grey hair and beard and broad, rustic features,
is placed in the middle of any village in the Florentine Contado (the rural area
around a city) with four other apostles. By their example and eloquence they
had persuaded men of property to sell their goods. "No one said that any of his
belongings was his own, but they all shared with one another everything they
had" (Acts 4:32–37). The alms were then distributed to the poor. The Christian,
Ananias, who had held back a part of the price of a farm for himself was struck

down at Peter's feet after being lashed by Peter's tongue for his deceitfulness. (He is an example of the fate of a tax delinquent, for at this time the *catàsto was a part of Florentine law.) Sapphira, Ananias's wife, also castigated by Peter, suffered the same fate (Acts 5:1–10).

Example: Masaccio, 1427, Brancacci Chapel, Sta. Maria del Carmine, Florence.

DIVISION OF LIGHT FROM DARKNESS. See SEPARATION OF LIGHT AND DARKNESS.

DOMINIC, SAINT. Saint Dominic (1170–1221), a Castilian churchman named Domingo de Guzman, was the founder of the Order of Preachers, also known as the Dominican's or Black Friars. He was born in Spain, studied at Palencia, became a canon of the cathedral of Osma. He and his bishop were sent to preach among the Albigensians (a religious sect finally suppressed for heresy in the thirteenth century) of southern France. They adopted absolute poverty and were the first missionaries to be successful in preaching against heresy there. After much travel and preaching throughout Europe, Dominic died in Bologna, where he is buried. Artists depict him wearing the habit of his order, a white tunic and scapular (a sleeveless outer garment that falls almost to the feet and may include a cowl) underneath a long black cloak with a hood. He may have a star on or above his forehead in accordance with one account that his brow radiated a kind of spiritual light. Usually he holds a lily (a symbol of his purity) and a book (the *Gospels). Some artists include a dog with a flaming torch in its mouth, which alludes to a dream his mother had before his birth. He may hold a rosary because, according to an ancient tradition, he received the rosary from the Virgin Mary (see MARY, SAINT) in a vision. The special sequence of prayers to the Virgin said on rosary beads was probably instituted by Dominic. Other artists may show the Virgin or the Baby Jesus handing him a rosary. Artists who include a loaf of bread are referring to an episode that occurred one day in his life. He was told there was nothing to eat in the monastery, but went ahead and ordered the bell to ring for the meal. When the monks were seated and saying their prayers, two *angels came to the table and gave each monk a loaf of bread.

Example: Cosimo Tura, mid-fifteenth century, *Saint Dominic in Prayer*, Uffizi Gallery, Florence.

DOMINICAN ORDER. The Dominican order is an order of mendicant preaching friars founded at Toulouse in 1216 by Saint *Dominic, a Roman Catholic priest. They believed in having no possessions and survived by charity and begging. After the Franciscans they became the second great mendicant order.

DONATION, SAINT. Saint Donation was a fourth century saint and martyr, patron saint of Bruges, and bishop of Rheims. According to his legend, after his martyrdom his body was thrown into the Tiber River. His followers used a

wheel, into which were stuck five lighted candles, to locate his body. When they put it in the water it floated downstream and stopped over the spot where the saint lay on the bottom of the river bed. When his body was taken from the water, it was restored to life by prayer. Saint Donation is shown wearing bishop's robes and he holds the wheel with four lighted candles set round its rim.

Example: Jan van Eyck, *Madonna of Canon George van der Paele with Saints Donation and George*, 1434–1436 Groeningemuseum, Bruges.

DONNA VELATA. See VELATA, DONNA.

DONOR. A donor is the patron who gives or presents a work of art. The donor is often represented in the work.

DORMITION. See DEATH OF THE VIRGIN.

DOROTHY, SAINT. Dorothy or Dorothea was a Christian saint and virgin martyr of Cappadocia in Asia Minor famous for her beauty and piety. Stories of her saintly life reached the Roman governor, Fabricius (also Sapricius), and he sent two sisters to persuade her to abandon her religion. Dorothy, instead of giving up her religion, induced the two sisters to join the church. Fabricius had them burned alive and Dorothy was forced to watch. In the year 303 she, too, was condemned to death. The *Golden Legend* says that as she was being led to her execution, a young lawyer named Theophilus laughed at her and asked her to send him some flowers and fruit from the garden of her so-called heavenly bridegroom. After her death, in February, when all the trees were covered with frost, a child appeared to Theophilus and presented him with a basket of roses and apples. At the sight of this he was converted to Christianity, and he was himself subsequently executed. Saint Dorothy is usually depicted with roses in her hand or on her head, or with a basket, three roses, and three apples. She may offer the basket to the Virgin or the Christ Child. Some artists show her martyrdom and here she is tied to the stake about to be burned. *Angels flutter overhead holding garlands of roses.

Example: Albrecht Dürer, *St. Dorothy*, woodcut from the Basel series, 1515.

DOUBTING THOMAS (The Doubting of Thomas). Saint Thomas, one of *Christ's *apostles, was called "doubting" because he did not believe in the *Resurrection. When Christ first appeared to the apostles after his death and showed them his five wounds, Thomas was absent. He was told about it later, but refused to believe until he could see for himself. He said, "Except I shall see in his hands the print of the nails, and thrust my hand into his side, I will not believe" (John 20:25). Christ appeared to him and said, "Reach your finger here: see my hands; reach your hand here and put it into my side" (John 20:19–29). Thomas is most often shown putting his finger into the wound in Christ's side. He is usually young and beardless and has long hair in Renaissance art.

According to the *Golden Legend* he bore a resemblance to the Savior. He may be shown with the Virgin's girdle. Traditionally, Thomas has a similar role in doubting the *Assumption of the Virgin. Just as Christ was able to overcome Thomas' doubt by telling him to put his fingers in his side, the Virgin convinced Thomas by lowering her girdle to him from heaven. Thomas may also be shown with a set-square or builder's rule, an allusion to the building of King Gundaphorus' palace. He may hold a spear or dagger, the instrument of his martyrdom. Some artists show him transfixed with spears and embracing the cross. Thomas is the patron saint of builders and architects.

Example: Andrea del Verrocchio, life-size bronze, 1465–1483, Orsanmichele, Florence.

DREAM OF CONSTANTINE. Constantine the Great (c. 280–337) was the Roman emperor who defeated the emperor Maxentius at the battle of the Milvian Bridge (see BATTLE OF CONSTANTINE AND MAXENTIUS). The night before this battle, according to Eusebius' *Life of Constantine* (1:27–32), the emperor had a dream in which he saw a cross in the sky and at the same time he heard a voice tell him, "In hoc signo vinces,"—"By this sign thou shalt conquer." It is said that after his dream he used the cross as the emblem (instead of the Roman eagle) on the standard of the legions. Artists depict Constantine asleep in his tent guarded by three or four soldiers. The *angel that foretold his victory hovers above in a glowing light. The soldiers appear unaware of the angel's presence.

Example: Piero della Francesco, 1450s, San Francesco, Arezzo.

DREAM OF SAINT URSULA. See URSULA, SAINT.

DREAM OF THE DOCTOR. A doctor of theology is shown sleeping in a sitting position before a warm stove, his head pressed into a large, comfortable pillow. He is obviously not praying or pondering religious matters and clearly not working. He is, in fact, giving in to the vice of sloth. A female nude stands beside him (his dream?) and indicates the fact that sloth begets vice and causes the idler to give in to the worst of temptations. A demon with wings hovers at his shoulder and blows lewd thoughts into his ear with a bellows.

Example: Albrecht Dürer, engraving 1498–1499.

DRÔLERIES. Fanciful, sometimes playful marginal designs known as drôleries are characteristic features of Northern Renaissance illuminated manuscripts.

DRUNKENNESS OF NOAH. The prophet *Noah was descended from *Adam and Eve through their third son, Seth. After building the ark (Gen. 6:14–22) and riding out the flood, Noah plowed the ground and planted a vineyard. After this work he drank too much wine and lay in his tent drunk and naked. He was observed by Ham, his youngest son, who thus dishonored his parent by gazing

upon his nakedness. Ham and his two brothers laid a cloak over him, but when Noah awoke and learned what his youngest son had done to him, he laid a curse on Ham's son Canaan saying, "He will be a slave to his brothers" (Gen. 9:20–27). Noah is shown most often in his tent or under his arbor hung with vines. He is drunk, and a cup of wine is at his side. Ham may stand close by mocking him. The other sons may offer the cloak. The mocking of Noah was taken as a prefiguration of the mocking of *Christ.

Example: Michelangelo, Sistine Chapel Ceiling, Vatican, Rome.

DRUSIANA. See RAISING OF DRUSIANA.

DRYPOINT. See ENGRAVING.

DUCHESS OF URBINO. See SFORZA, BATTISTA.

DUGENTO. *Dugento* is an Italian word for "two hundred" and means the thirteenth century, the 1200s.

DUKE OF URBINO. See MONTEFELTRO, FEDERICO DA

DULLE BRIET. *Dulle Briet*, meaning "Crazy" or "Mad Meg," is a fantastic giant woman shown clad in iron armor; a helmet on her head; a long, sharp sword in her right hand; and a large cloth tied by a knot over her left arm, which is full of pots and pan and other items, the fruits of unreasoned pillaging and avarice. She strides along in a broad step, her mouth open, completely indifferent to the devastation she leaves in her path: a frightful collection of ruins, collapsing towers, incendiaries, and disturbing grottos. She seems to tackle even the Devil in his lair. It has also been suggested that *Dulle Briet* also illustrates the proverb: "If you go to hell, go sword in hand."

Example: Pieter Bruegel, 1562, Musée Mayer van den Bergh, Antwerp.

E

ECCE HOMO. *Ecce Homo* means "Behold the Man." These are the words of Pontius Pilate (see CHRIST BEFORE PILATE), the Roman governor of Judea, to the Jews waiting for his decision outside the judgment hall, after *Christ had been whipped and mocked by the soldiers (see CROWNING WITH THORNS and FLAGELLATION). According to John (19:4–6), Pilate went back out one more time and said to the crowd, "Look, I will bring him out here to you to let you see that I cannot find any reason to condemn him." So Jesus was brought out wearing the crown of thorns and the scarlet robe. Pilate said to them, "Behold the Man." When the chief priests and the temple guards saw him, they shouted, "Crucify Him!" The topic is rarely found in Christian art until the Renaissance, when it became very popular. Artists show the topic either as a crowded scene that takes place in the town square or Pilate's judgment hall (*Praetorium*); or Christ is shown only as a half figure, or only his head crowned with thorns is shown. He is depicted wearing the crown of thorns and the scarlet robe, and he may hold a reed meant to represent a king's sceptre. He is bound by the wrists, usually crossed, and he may have a rope around his neck. Some artists show his body badly scourged and his face, one of gentle compassion and understanding, is always a contrast to the malicious expressions of his tormentors. Some artists show him with tears running down his face.

Example: Albrecht Dürer, engraving from the series "The Engraved Passion," 1513.

ÉCORCHÉ. *Écorché* is the French word for "flayed," or "skinned." In art the word is used to describe a figure sculpted or painted without the skin to reveal the muscles of the body. During the sixteenth century, such models were part of the necessary equipment of an artist's workshop.

EFFECTS OF GOOD GOVERNMENT. See GOVERNMENT, GOOD.

ELIGIUS, SAINT Saint Eligius (c. 588–660) (Eloi.) was born near Limoges. A craftsman in metal, his work was so extraordinary he became master of the mint under the Frankish king, Clotaire II. He worked hard for the king and at the same time founded hospitals and monasteries. Around the year 640 he was made bishop of Noyon (Oise). Because of his work as a metal craftsman, Eligius is the patron saint of goldsmiths, silversmiths, and farriers. Artists depict him as a bishop or as a blacksmith with leather cap and apron. He is shown with the tools of his trade, an anvil, tongs, bellows, and hammer, at his feet. Some artists depict him as a goldsmith in a goldsmith's shop. When shown subduing Satan he holds him by the nose with a pair of tongs. A legend connected with Eligius is also depicted. When putting a shoe on a difficult horse, he cut off its leg in order to put the shoe on properly and when finished, the leg was miraculously restored. Saint Eligius was martyred in Flanders in Merovingian times.

Example: Petrus Christus, *Saint Eligius as a Goldsmith*, 1449, Metropolitan Museum of Art (The Lehman Collection), New York.

ELIJAH FED BY THE RAVENS. See ELIJAH IN THE DESERT.

ELIJAH IN THE DESERT. Elijah, a ninth-century Hebrew prophet, is one of the outstanding figures of the Old Testament. His forceful character helped him in his mission to destroy the worship of foreign gods. He was successful in bringing about a temporary banishment of idolatry. His story, full of incidents, is true, although it is told in strong mythical terms meant to emphasize the miracles performed by the god of the Jews. He was fed by ravens in the desert (1 Kings 17:1-6); he raised a widow's son from the dead (1 Kings 17:8-24); he had a contest of faith with the priests of Baal, which resulted in his triumph and their death (1 Kings 18:17–40); an *angel brought him food at one time when he was about to die after being driven into the desert by Jezebel (1 Kings 19:4–8); and finally, he departed from earth in a chariot of fire enveloped in a whirlwind. Elijah's usual attributes in art are a wheel of the fiery chariot and the ravens that fed him in the desert. Some artists show him dressed in hides like Saint *John the Baptist, whom he was said to prefigure, or he wears the Carmelite habit, a white mantle over a brown tunic. His legend tells that he lived as a hermit on Mount Carmel and was looked upon by the Carmelites as the founder of their order. He appeared in the *Transfiguration of *Christ, when *Christ manifested his divine nature as a symbol of the Old Testament Law and Prophets.

Example: Dirk Bouts, from the *Altarpiece of the Five Mystic Meals*, 1464–1468, S. Pierre, Louvain.

ELIZABETH, SAINT. Saint Elizabeth was the mother of Saint *John the Baptist and kinswoman of the Virgin Mary (see MARY, SAINT). She is most often depicted as an elderly woman, her head covered with a veil. In

art she has no regular attribute. Her story is in Luke 1, and her feast day is November 5.

Example: Hans Holbein the Elder, *Altarpiece of Saint Sebastian with Saints Elizabeth and Barbara*, 1515–1517, Alte Pinakothek, Munich.

ELOI. See ELIGIUS, SAINT.

EMMAUS. See SUPPER AT EMMAUS.

EMULSION. Emulsion is a watery liquid mixed with a resinous or oily liquid in such a manner that they do not separate out. Oil will mix with water if albumen, an emulsifying agent, is added. An example is *tempera, which is always an emulsion. Other emulsions include glue and wax, oil and gum, and egg-white and gum.

ENCAUSTIC. Encaustic is a method of painting on a wall or other surface with hot wax. The technique, practiced in antiquity, fell into disuse but was revived during the Renaissance by Leonardo da Vinci.

ENGRAVING. In a very broad sense, engraving is the art of cutting grooves in wood, metal, or some other material, causing a depressed design to use for decoration or for reproduction involving a printing process. In a very narrow sense, engraving is an *intaglio printing process whereby lines are incised in a metal plate with a special tool such as a *burin or graver. Engraving is also the image or print made from this metal or wood block by ink that has been provided to fill the design. The earliest known engravings printed on paper date from about the middle of the Renaissance. Andrea Mantegna and Albrecht Dürer are two major line engravers of the Renaissance. *Line engraving is a technique in which the design is engraved on a metal plate with a burin. The tool is pushed into the copper similar to the way a plough enters the earth, leaving a line that has a V-section. The earliest dated print using this method is 1446. This method of engraving is the most demanding of an artist and requires the greatest discipline and precision of hand. Drypoint, on the other hand, is the simplest technique of engraving because it consists of drawing on the metal plate with a type of "pencil" made of steel or steel-tipped with carborundum, ruby, or diamond.

ENTHRONED MADONNA AND CHILD. The Madonna enthroned with her Child depicts the Virgin, known in the mystical literature preceeding the Renaissance as the Queen of Heaven or *Regina Coeli*, pointing to her Child, embracing him, or simply holding him either sitting or standing on her lap. He may hold his right hand in the blessing position. She is usually enthroned within a small shrine where she appears very large. The architecture is that of an ecclesiastical building and is bejeweled and gilded. When represented in this way, the Virgin personifies the church. A larger throne with distinct architectural

features also represents the church. Attendant *angels may be holding or playing musical instruments at her feet, or they surround her in attitudes of adoration. The Virgin and her Child represent a concrete symbol of the reality of the central Christian doctrine of the Incarnation, and are not necessarily a symbol of motherhood. The earliest known example of the Virgin occupying the place of honor is a sixth-century apse *mosaic at Parenzo, and after that time, especially during the Renaissance, the subject was very popular.

Example: Giovanni Bellini, 1488, Sacristy, Sta. Maria Gloriosa dei Frari, Venice.

ENTHRONED MADONNA AND CHILD WITH SAINTS. During the fourteenth and fifteenth centuries the typical image of the Virgin and Child with saints on either side in separate panels developed into a new representation known as the *Sacra Conversazione*, or Holy Conversation. In this sort of depiction, any number of saints are grouped about the Virgin with her Child, and they are either kneeling or standing in attendance. Saints of different historical periods will be placed side by side, as there is never a specific time period designated. Within a work various saints may have different devotional representations and varying roles in the church. For example, a saint may be the patron of the church for which an *altarpiece was commissioned, in which case he would be included in the work; works for monastic orders always include the saint who founded the order and other important saints of that order; some saints personify intellectual and moral qualities and may be shown in pairs with the Virgin and her Child; finally, a *donor, having commissioned a work, may have the artist include both himself and his patron saint. The *Enthroned Madonna and Child with Saints* was very popular during the Renaissance and the Virgin was depicted with many different saints both male and female.

Example: Sandro Botticelli, mid-1480s, Uffizi Gallery, Florence.

ENTOMBMENT. The Entombment is an episode from the *Passion of *Christ and is told in all four *Gospels (Matt. 27:57–61; Mark 15:42–47; Luke 23:50–55; John 19:38–42). According to Luke there was a man named *Joseph of Arimathea who went to Pilate (see CHRIST BEFORE PILATE) and was granted permission to take the body of Jesus. He took the body down from the cross, wrapped it in a linen sheet, and placed it in a tomb that had been dug out of solid rock and which had never been used. According to Matthew, a large stone was put in front of the entrance to the tomb. Saint *Mary Magdalene and the other Mary were sitting, facing the tomb. Saint *John the Evangelist says that Nicodemus went with Joseph to help and carried one hundred pounds of spices to preserve the body. He also mentions that the tomb was in a garden near the place where Jesus had been put to death. Renaissance artists usually depict a sarcophagus near the foreground. The body of Christ, held in a sheet, is about to be lowered into it. Joseph of Arimathea holds Christ's head, while Nicodemus takes his feet. (Their positions are occasionally reversed.) Mary Magdalene may be shown with her jar anointing Christ's feet as an act of penitence. The Virgin

may lean to kiss her Son's face while John the Evangelist supports her in her grief. Other holy women may also be included. *Angels may hover above or beside the scene holding the Instruments of the *Passion.

 Example: Master of Flémalle, (Robert Campin), *Entombment Triptych*, center, 1415–1420, Collection of Count Antoine Seilern, London.

ENTRY INTO JERUSALEM. All four *Gospels describe, with some differences in detail, *Christ's Entry into Jerusalem, his final visit to the city riding on a donkey. In art the topic forms the first scene of the cycle of the *Passion. The entry begins when Christ, after traveling through Judea, preaching to the people, came to the Mount of Olives, just outside Jerusalem. He had already informed his disciples that he would be arrested in Jerusalem and put to death. He told two of his disciples to go into the city and bring a donkey. When the animal was brought, the disciples spread their cloaks on its back and Christ mounted and rode toward the city. A crowd met him crying "Hosanna." Artists show Christ seated on the donkey, her colt often following close behind. Jerusalem is shown in the background. It is common to find a man high in a tree, obviously there so that he can see over the crowd. The figure is supposed to be Zacchaeus, a rich tax-gatherer, who did climb a tree to see Jesus, although according to Luke (19:3-4) the event took place in Jericho when Christ was passing through. According to John (12:13) the people took branches of palm trees and went out to meet him. It is from this event that Palm Sunday (in the Christian calendar, the Sunday before Easter) takes its name.

 Example: Duccio, 1308–1311, Museo dell' Opera del Duomo, Siena.

ENVY. See SEVEN DEADLY SINS.

EPHESUS. See TEMPLE OF EPHESUS.

EPIPHANY. See ADORATION OF THE MAGI.

EPISTLE. In Christian usage, an epistle is one of the letters of the twenty-one books of the New Testament.

ERASMUS, DESIDERIUS. Desiderius Erasmus (c. 1466–1536) was a Dutch humanist born in Rotterdam. He has been called the most important Christian humanist in Europe. He was ordained a priest of the Roman Catholic church and studied at the University of Paris. He soon tired of his official church life and through visits to England became aware of humanist learning. Erasmus' influence was felt in Europe by 1500. He traveled to Italy in 1506 and thereafter led the life of the wandering scholar, gaining immense fame through his own writings and his editions of the classical authors, which were his chief occupation for years. His Latin edition of the New Testament, the *Greek New Testament* (1516), was based on original extant manuscripts of the Greek text. His most

famous book was *The Praise of Folly* (1509), a strong denunciation of evil, ignorance, corruption, and prejudice in society. The book, written in Latin, went through twenty-seven editions during his lifetime and outsold every other book except the Bible during the sixteenth century. He remained all his life within the Roman Catholic church, even though eager for reform and deploring the religious warfare of the time because of the cultural decline it produced. He is shown as a scholar in his study at his writing desk surrounded by the accoutrements of learning. In one example an inscription in Latin and Greek is on the wall beside him. (It says that the artist Dürer made this drawing of Erasmus from life, and the Greek below praises the power of the written word.)

Example: Albrecht Dürer, *Erasmus of Rotterdam*, engraving, 1526.

ERASMUS, SAINT. See MARTYRDOM OF SAINT ERASMUS.

ERATO. One of the muses or goddesses of creative inspiration in song, poetry, and patrons of all other arts, companions of Apollo, Erato was the daughter of Zeus (see JUPITER) and Mnemosyne (Memory). Erato was born at the foot of Mount Olympus. She presided over the poetry of love and according to some accounts, hymns. (The attributes of all Muses may vary.) She may also be considered the Allegory of Music. Depicted as a beautiful woman, she is shown with various musical instruments at her feet, a white swan, or several swans, and a *putto. Since the Muses were originally *nymphs who presided over streams that had the power to inspire creativity, Erato is often shown with a spring, stream, or ocean in the background.

Example: Filippino Lippi, *Erato ("Allegory of Music")*, c. 1500, Kaiser-Friedrich-Museum, Berlin.

EROS. See CUPID.

ESQUISSE. *Esquisse* is a French word for "sketch."

ESTE. An Italian noble family, the Estes were well known as patrons of the arts during the Renaissance. Possibly of Lombard origin, they acquired their name from the castle of Este, located near Padua. The family's greatness dates back to Azzo d'Este, 996–1097. Some of the family members had their portraits painted and sculpted by major artists of the Renaissance. See ESTE, FRANCESCO; ESTE, ISABELLA; ESTE, LIONELLA; ESTE, NICCOLO III.

ESTE, FRANCESCO. Francesco d'Este was the illegitimate son of Leonello d'Este. He was born c. 1440.

Example: Roger van der Weyden, c. 1455–1460, Metropolitan Museum of Art, New York.

ESTE, ISABELLA. Isabella d'Este (1474–1539) was the sister of Beatrice d'Este and married the Marquis of Mantua, Francesco Gonzaga. See GONZAGA FAMILY.

Example: Titian, 1534–1536, Kunsthistoriches Museum, Vienna.

ESTE, LIONELLO. Lionello d'Este (1407–1450) was the illegitimate son of Niccolo III d'Este. He was known as an intelligent and illustrious Renaissance patron of the arts. He was a patron of Jacopo Bellini and is shown as a *donor in his *Madonna and Child with Donor*, c. 1441, Louvre, Paris.

ESTE, NICCOLO III. Niccolo d'Este III (1384–1441) was a member of the noble Italian family of Este, rulers of Ferrara. Niccolo made Ferrara a Renaissance center of culture and increased the power of the House of Este. An equestrian statue, Niccolo III d'Este, by an unknown sculptor, was made during the Renaissance but destroyed in 1796.

ESTHER AND AHASUERUS. Esther is a book of the Old Testament. The story describes how a young and very beautiful Jewish woman named Esther (originally Hadassah) was chosen by Ahasuerus (Xerxes), the Persian king, to be queen after he had dismissed his previous wife, Vashti, because she had offended him. Ahasuerus did not know that Esther was Jewish. The story tells how Haman, an enemy of the Jews, attempted to bring about the massacre of all Jews and how Esther and her cousin Mordecai thwarted him. (See TRIUMPH OF MORDECAI.) Haman decreed that all the Jews in the Persian empire should be put to death. Esther was asked by Mordecai to plead with the king and beg him to have mercy on her people. To see the king without being summoned was forbidden on pain of death, even to the queen. Esther knew it had been a month since the king had sent for her, but she decided that she was the only one who could save her people. After fasting for three days she put on her royal robes and went to stand in the inner courtyard of the palace, looking in on the throne room. The king inside was seated on the royal throne and when he saw Queen Esther standing outside he held out to her the gold sceptre, an act to indicate he accepted her presence. She walked up to him and touched the top of the sceptre. He told her she could have anything she wanted "even if it is half my empire" (Esther 5:3). She invited the king to a banquet and in due course was able to save her people. Haman was hanged on a gallows 75 feet tall, the same gallows he had prepared for Mordecai. (See DEATH OF HAMAN.) Esther is usually shown dressed in beautiful robes kneeling before King Ahasuerus. He touches her with his sceptre.

*Example:*Konrad Witz, *Heilspiegel Altarpiece*, c. 1435, Kunstmuseum, Basel.

ETIENNE, SAINT. See STEPHEN, SAINT.

EUCHARIST. Eucharist is a word from the Greek meaning "giving of thanks." The Sacrament of the Lord's Supper is a central rite in many Christian churches in which consecrated bread and wine are used by the officiating clergyman, shared with the worshippers, and consumed as memorials of *Christ's death on the cross or as symbols of a spiritual union of Christ and the communicant, or as the blood and body of Christ. It is also called Communion and Holy Communion.

EUCLID. Euclid was a Greek mathematician who lived in the fourth century B.C. He taught at Alexandria and is famous for his *Elements*, which are thirteen books of geometry and other mathematics known at that time. In art Euclid is the personification of Geometry, one of the *Seven Liberal Arts.
 Example: Raphael, *School of Athens*, 1510–1511, Stanza della Segnatura, Vatican, Rome.

EUROPA. See RAPE OF EUROPA.

EURYDICE. See ORPHEUS AND EURYDICE and DEATH OF ORPHEUS.

EUSTACE, SAINT. Eustace was a second century saint originally known as Placidus, a captain of the guards of the emperor Trajan. According to legend Placidus was out hunting one day when he had a vision of a white stag that had a bright light in the form of a cross between its antlers. On the cross was the figure of *Christ. Placidus fell to his knees, and the figure spoke to him saying he would suffer many tribulations as a test of his new faith. He was baptized in the name of Eustace. His wife and two sons were also baptized. As Christ had foretold, Eustace experienced many tribulations. His wife was seized as payment for boat fare when the family was on a voyage to Egypt because Eustace had no money. His sons were taken by wild beasts as they tried to cross the Nile. Eustace went into the desert to pray and fifteen years later the family were all miraculously reunited. Some time later, after refusing to give thanks to the Roman gods, they were all roasted alive in a hollow, brass bull. Artists usually depict Eustace as a medieval knight or soldier on horseback in a woodland setting surrounded by hunting dogs, the vision of the stag with the crucifix between its antlers before him. He may carry both his sons in his arms and his wife may be at his side. He may also be accompanied by *Job, whose faith was also tested by suffering. The same legend is told of Hubert, whose image tended to supercede Eustace during the Renaissance.
 Example: Antonio Pisanello, *Vision of Saint Eustace*, c. 1440, National Gallery, London.

EVANGELISTS, EVANGELIST SYMBOLS. Matthew, Mark, Luke, and John, the four Evangelists, were depicted either in human form, symbolically by the four winged creatures of *Ezekiel's vision (Ezek.1:5–17; Rev. 4:6–8) or by a zoomorphic combination. The symbols of the four Evangelists are the *Angel for Matthew, the lion for Mark, the ox for Luke, and the eagle for John. From the fifteenth century onward, the four Evangelists were frequently represented, mostly as single figures with their symbols. See MATTHEW, SAINT; MARK SAINT; LUKE, SAINT; and JOHN, THE EVANGELIST AND APOSTLE, SAINT.

Example: Fra Angelico, c. 1450, Chapel of Nicholas V, Vatican, Rome.

EVA PRIMA PANDORA. See PANDORA.

EVE. See ADAM.

EXECUTION OF SAVONAROLA. See SAVONAROLA, GIROLAMO.

EXORCISM OF THE DEMON IN THE TEMPLE OF MARS. Apocryphal literature tells how Saint Philip went to the city of Hierapolis in Asia Minor and entered the Temple of Mars. From the plinth of the statue of Mars within the temple, there burst a demon in the form of a dragon, which was the object of worship in the temple. As the animal emerged it gave off such poisonous fumes that many people, including the king's son, died. Saint *Philip exorcised the demon with the aid of the cross, thus angering the priests of the temple. The enraged priests captured him and had him crucified. According to tradition, Philip was crucified upside down like Saint Peter (see PETER, APOSTLE AND SAINT). Mars, the Greek god of war, is usually shown looking more like a living person than a statue. He may stand on a tall plinth within an exedra (a semicircular architectural form) waving a shattered lance with one hand and petting a wolf with the other. (The wolf was sacred to Mars in Roman times.) A priest, directly in front of the altar below Mars, cringes at the sight of Saint Philip's mysterious power. Priests, soldiers, and courtiers, all elaborately dressed, stand on either side. *Christ is shown very small in the upper right-hand corner, carrying his cross, his hand out offering a blessing.

Example: Filippino Lippi, 1487–1502, Strozzi Chapel, Sta. Maria Novella, Florence.

EXPOSURE OF LUXURY (Venus, Cupid, Folly, and Time). The exposure of the moral dilemmas, one being the sin of luxury, of the early sixteenth century is in reality the central theme of this topic. Father Time is shown old, bald, and winged, a large hour glass on his right shoulder, drawing aside the blue veil of truth to expose a scene of incest. *Cupid is shown as a beautiful winged boy kissing his mother's lips and fondling her breast. *Venus, in turn, prepares to prick him with one of his own arrows. A *putto, delighted with the scene and its implications, prepares to pelt the couple with roses. Envy (see SEVEN

DEADLY SINS), an ugly, old hag, is behind the pair tearing out her hair, while slightly below Venus' doves bill and coo. Fraud, included to emphasize evil, is a monster with the innocent, lovely face of a young girl. However, she has the tail of a serpent and the hind legs and claws of a lion. Her left hand grows from her left arm and holds a tortoise, a symbol of the *impresa* of Cosimo de' Medici (see COSIMO I), patron of such a topic, whose motto was ''Make haste slowly.''

Example: Agnolo Bronzino, c. 1546, National Gallery, London.

EXPULSION FROM THE GARDEN OF EDEN. See ADAM.

EXPULSION OF ATTILA. Attila was king of the Huns from A.D. 445–453. After 434 he ruled with the help of his brother, whom he murdered in 445. He was a just ruler to his own people, but history holds many accounts of his savagery. He was known to admire intelligence and encouraged the presence of educated Romans at his court. Also, his conquests were far less devastating than other conquerors before and after him. His ''Expulsion,'' as depicted by Renaissance artists, was historically a withdrawal from his own plan to take Rome itself when he invaded Italy in 452. Although his withdrawal is often ascribed to the skillful diplomacy of Pope Leo I, it was actually motivated by an outbreak of pestilence, accompanied by an acute shortage of provisions, in the Hun army. Shortly after this, Attila died of a nasal hemorrhage. According to legend, Attila was defeated outside Ravenna in northern Italy through the miraculous intervention of Saint Peter (see PETER, APOSTLE AND SAINT) and Saint *Paul. Artists set the ''Expulsion'' scene outside Rome, recognizable by the familiar shape of the Colosseum and a Roman aquaduct in the background. The pope usually is seen seated on his horse holding one arm up in a gesture meant to stop the threatening advance of the ravaging barbarians. Attila's horse, terrified, turns from the pope. Many other mounted warriors seem swept back as if by a ferocious wind. Saint Peter and Saint Paul hover above the pope holding their swords. The cross of Christianity is dark against a light section in the sky.

Example: Raphael, 1513–1514, Stanza d'Eliodoro, Vatican, Rome.

EXPULSION OF HELIODORUS. Heliodorus was a Syrian statesman in the last centuries before the Christian era. At this time the Jews in Palestine were dominated by the successors of Alexander the Great, the Syrian Seleucid kings. Heliodorus, a general under one of the Seleucid monarchs, murdered the king and attempted unsuccessfully to usurp the throne. According to 2 Maccabees 3, he entered Solomon's Temple at Jerusalem with some of his guards and tried to steal the treasure kept there. He was prevented from taking it by a rider in gold armor on a white charger. The horse rushed in and attacked Heliodorus with its front hoofs. The rider's two companions were angels who came in to thrash Heliodorus and his two guards with switches as they lay helpless on the ground. Artists usually depict Heliodorus and his guards on the ground under a rearing

white horse. Gold coins lay scattered about. Two *angels holding switches sweep in to scourge him. The topic was seen as a prefiguration of *Christ driving the money-changers from the temple.

Example: Raphael, 1512, Stanza d'Eliodoro, Vatican, Rome.

EXPULSION OF THE MONEY-CHANGERS FROM THE TEMPLE (Christ Driving the Money-Changers from the Temple, Cleansing of the Temple). The expulsion of the money-changers from the temple in Jerusalem is told in all four *Gospels (Matt. 21:12–13; Mark 11:15–18; Luke 19:45–46; John 2:14–17). According to the Gospels, the sight of the sacred temple turned into a "hideout for thieves" (Matt. 21:13) caused Jesus great despair. Furious, he went into the temple and drove out everyone who was buying and selling there. He overturned the tables of the money-changers and the baskets of the sellers of pigeons. Christ is usually shown in the center of general confusion with a whip of cords (only John mentions the whip 2:15). The money-changers are clutching their purses and trying to flee; benches and tables are overturned, and women gather up their baskets of pigeons.

Example: Albrecht Dürer, 1511, woodcut.

EX-VOTO. *Ex-Voto* is Latin for "from a vow" and is an offering made for a vow or sometimes a painting given to a church in thanks for divine help.

EZEKIEL (Ezechiel). Ezekiel is a book of the Old Testament, third of the books of the Major Prophets (the others are *Daniel, *Isaiah, and *Jeremiah). His book is the account of his prophetic career as the priest who preached to the Jews of the Babylonian captivity from 592 B.C. to 570 B.C. He was among the Hebrews exiled in 579 B.C. to Babylon, where he had visions of an apocalyptic kind. In fact, his call to prophesy came to him in a vision of God seated among four creatures that had the faces of an *angel, lion, ox, and eagle, each with wings. These are the "apocalyptic beasts" that the medieval church made into the symbols of the four *Evangelists. Ezekiel is usually depicted as an old man with a beard, and sometimes he holds a scroll or a double wheel, symbolizing the Old and New Testament.

Example: Michelangelo, 1508–1512, Sistine Chapel Ceiling, Vatican, Rome.

F

FAITH. From the Latin word *fides*, Faith is one of the three theological *virtues. The others are Hope and Charity. All three are depicted as young women. Faith usually holds her hand to her breast or clutches a candle, the light of faith. Sometimes her foot rests on a stone, symbolizing her strong foundation.

Example: Michelozzi Michelozzo, marble statue, c. 1430, Tomb of Bartolommeo Aragazzi, Cathedral, Montepulciano.

FALL OF ICARUS. According to Ovid (*Metamorphoses* 8:183–235), Icarus was the son of Daedalus, architect of the legendary labyrinth that housed the Minotaur on the island of Crete. He and his father were imprisoned on the island, and Daedalus constructed for each of them a pair of wax wings with which to make their escape. The wings were attached to their shoulders with wax. Daedalus instructed Icarus to follow him closely and not fly too close to the sun because the wax would melt. However, Icarus disobeyed his father and flew too close to the sun and melted the wax. He fell into the sea and was drowned. Artists depict Icarus falling out of the sky with feathers flying all around. His father may look up at him, helpless, or he may not notice him at all. During the Renaissance the topic was used by moralists to teach the virtue of moderation or the danger of going to extremes; others used it to symbolize man's searching for the new intellectual spirit.

Example: Sebastiano del Piombo, c. 1511, lunette of Sala di Galatea, Villa Farnesina, Rome.

FALL OF MAN. In Christian theology the Fall of Man is the Original Sin, the sin of *Adam, by which all mankind fell from divine grace after Adam ate the fruit of the Tree of Knowledge of Good and Evil (Gen. 3:1–7). According to

Christian belief, man is born sinful because of Adam's original sin, but he is able to wash away this sin through baptism, which is meant to restore him to his innocent state. Artists usually depict this disobedience of man under a fig tree, which is the Tree of Knowledge. Adam either reaches for the fruit (an apple) or takes it from Eve. The tree may have a snake with a woman's head curled around its trunk, an indication of the evil about to take place.

Example: Michelangelo, 1509–1510, Sistine Chapel Ceiling, Vatican, Rome.

FALL OF SIMON MAGUS. Simon Magus was a Samaritan sorcerer first heard of in Jerusalem. He is known for having offered Peter (see PETER, APOSTLE AND SAINT) money to buy his spiritual power. From this act comes the term "simony" (Acts 8:9–24). According to the *Golden Legend*, Simon went to Rome and through his magic arts won the favor of Nero. Although able to challenge Peter and Saint *Paul in various trials, he was unable to restore the dead to life. The *apostles had this power. Simon retaliated by jumping off a tower with the intention of flying, but actually in his mind being supported by demons. The emperor was present. Peter, on his knees, prayed that the demons release him. Simon fell to his death. The story found great popularity in Renaissance Italy. Artists most often show Simon falling through the air while Peter and Paul pray. The demons run away while Nero, with his court, witnesses the entire scene. Peter may also be shown refusing Simon's offer of money or bringing a young man back to life.

Example: Jan Polack, 1492, Bayerisches Nationalmuseum, Munich.

FALL OF THE REBEL ANGELS. In Judaeo-Christian terminology, the rebel *angels are evil, supernatural beings, or other devils, as the fallen angels are called (not to be confused with the Devil or Satan). These angels were created good but chose to become evil through their own free will. They rebelled against God and were cast out of heaven (Rev. 12:7–9). Once on earth it is thought they became the tempters of men and the source of evil in the world. Early Renaissance artists depict the rebel angels falling from heaven and growing claws, tails, and other demonic features as they tumble toward earth. Heaven is shown at the top with God the Father enthroned or reaching out with long arms to encompass the entire scene. Angels with swords may help drive the rebels out of heaven.

Example: Domenico Beccafumi, c. 1524, Pinacoteca, Siena.

FATHERS OF THE CHURCH. The *Four Latin Fathers of the church are Saint Ambrose, Saint Augustine, Saint Gregory, and Saint *Jerome. They were the early teachers and defenders of Christianity and are thus depicted in Renaissance art.

FEAST IN THE HOUSE OF LEVI (Supper in the House of Levi, Christ in the House of Levi). According to Mark 2:17 and Luke 5:29–31, *Christ saw a tax collector, Levi, in the city of Capernaum and said to him, "Follow Me." Levi followed and later on Jesus had a meal in Levi's house. A great number of tax collectors and people of bad character joined Jesus and his disciples at the table. Some Pharisees asked the disciples why Jesus ate with such outcasts. Jesus heard the question and replied, "People who are well do not need a doctor, but only those who are sick: I come not to call the respectable, but sinners to repentance." Christ is shown in a central position chatting with publicans and their attendants. Drunkards and dwarfs are woven throughout the supper scene.
 Example: Paolo Veronese, 1573, Accademia, Venice.

FEAST OF HEROD (Banquet of Herod). The Feast of Herod is told by Mark 6:21–28. According to this account, Herodias, the wife of Herod, held a grudge against Saint *John the Baptist. Herod had married her even though she was the wife of his brother Philip, and John the Baptist kept telling Herod that it was not right for him to marry his brother's wife. Therefore, Herodias wanted John the Baptist dead. She got her chance for revenge when on Herod's birthday he gave a feast for all the top government officials, the military chiefs, and the leading citizens of Galilee. Herodias' daughter Salome came in and danced before them and pleased Herod and his guests very much. In fact Herod was so carried away that he swore to give her anything she desired. Salome went to her mother and wondered what she should ask for. Herodias told her to get the head of John the Baptist. Salome then demanded and got the Baptist's head on a plate. Artists often show the young girl kneeling before Herodias, hearing her fatal instructions, or she may hold the plate with John the Baptist's head on it.
 Example: Fra Filippo Lippi, 1452–1466, Cathedral, Prato.

FEAST OF THE GODS (Banquet of the Gods, Marriage of Pelus and Thetis). Thetis, a sea-nymph, and Peleus, a hero of ancient Greece, were the parents of Achilles. The Olympian gods attended their wedding feast. During the banquet Eris, the goddess of Strife, an uninvited guest, threw down a golden apple, setting off a chain of events that let to the *Trojan War. The Olympian gods are usually shown enjoying a banquet in a shady forested area. The figures are shown lounging across the foreground of the picture, drinking, eating, and sleeping. The gods appear steeped in a round of never-ending pleasure, enjoying the idyllic atmosphere and beautiful floral countryside. The bride and groom may be in the foreground. Eris may be in the clouds above throwing down the apple that was to be the prize for the fairest goddess chosen by Paris (see JUDGMENT OF PARIS). *Jupiter may hold the apple in his hand, and Juno or Minerva may reach for it. When *Venus is included, she points to herself as the winner of the beauty contest. The guests may include Mercury wearing his winged hat and holding the *caduceus, and *Neptune holding his trident. Herbe

or *Ganymede may bring bowls for drinking and dishes for eating. Music for the feast may be provided by the Muses.

Example: Giovanni Bellini, 1514, National Gallery of Art (Widener Collection), Washington, D.C.

FEAST OF THE ROSE GARLANDS. A rose garland picture is known as a "Rosenkranzbild." The subject is the *Madonna and Child. In the Feast of the Rose Garlands, they are shown with Maximilian, ruler of the Holy Roman Empire, and Pope Julius II, leader of the church of Rome. Mary (see MARY, SAINT) is shown placing a rose wreath upon the head of Maximilian, while the Christ Child rewards Pope Julius II with a similar garland. Putti (see PUTTO) with rose wreaths hover over holy men, including Saint *Dominic who, according to tradition, is credited with the invention of the rosary. To the Renaissance worshipper, the rose garland was analogous to the rosary, whose beads create a complete circle, just as Christianity encompasses all men. The idea of the universal brotherhood of Christianity is illustrated in this topic through the distribution of garlands of white roses, which symbolize the Hail Marys of the rosary and the joyful mysteries of the *Passion, and garlands of red roses, which symbolize the Our Fathers and the sorrowful mysteries of the Passion.

Example: Albrecht Dürer, 1505–1506, National Gallery, Prague.

FEAST OF VENUS. See FESTIVAL OF VENUS.

FEBRUARY. February was the second month that appeared in northern European illuminated manuscripts and Italian *fresco cycles. Artists show February as the time of year for grafting trees, chopping wood, and keeping warm. Quite often an indoor scene around a fire is shown while snow covers the ground outside. The zodiac sign, Pisces, Fishes, may be included usually across the top of the painting or calendar.

Example: Limbourg Brothers, February page, *Book of Hours (Les Très Riches Heures) of the Duke of Berry,* illumination, 1416, Musée Condé, Chantilly.

FEDERICO DA MONTEFELTRO. See MONTEFELTRO, FEDERICO DA.

FEEDING OF THE FIVE THOUSAND. See MULTIPLICATION OF THE LOAVES AND FISHES.

FEEDING THE HUNGRY. See SEVEN ACTS OF MERCY.

FERRER, SAINT VINCENT. See VINCENT, SAINT.

FESTIVAL OF VENUS. *Venus, the Roman goddess identified with the Greek Aphrodite, the goddess of love and fertility, and the mother of *Cupid, is shown at a pagan festival. This orgiastic scene of gaiety and relaxation, painted by

artists during the Renaissance, usually shows large numbers of voracious chubby cupids before an indulgent standing statue of the goddess; they romp through an open meadow kissing, playing, and devouring baskets of her golden apples; they even fly up to the trees to pick more fruit. One of Venus' conventional attributes, the mirror, is held for her by a happy Maenad or Bacchante. She holds her scallop shell, which recalls her birth from the sea. See BIRTH OF VENUS.

Example: Titian, 1518–1519, Prado, Madrid.

FIGHT BETWEEN THE LAPITHS AND CENTAURS. See LAPITHS AND CENTAURS.

FINA, SAINT. Serafina, known as Saint Fina, was a young girl who lived in the thirteenth century and died in 1253 at the age of fifteen after five years of intensive suffering. Before being completely paralyzed by her illness, she made clothes for the poor. When her paralysis rendered her helpless, she chose to suffer all the more for *Christ and decided her resting place was to be a hard wooden board in a room crawling with rats. They attacked her and she was powerless to drive them off. Because of this her most common attribute in art is a rat. Her early death was foretold by Saint Gregory the Great (see GREGORY APPEARING TO SAINT FINA). According to legend, after her death when her body was taken from the board, sweet smelling white violets covered the wood. In Renaissance art she may hold violets in her hand, her mother may be at her side, and Saint Gregory may be seen wearing papal vestments and a tiara.

Example: Domenico Ghirlandaio, *Saint Gregory Appearing to Saint Fina,* c. 1475, Chapel of Santa Fina, Collegiata, San Gimignano.

FINAL JUDGMENT. See LAST JUDGMENT.

FINDING AND PROVING OF THE TRUE CROSS. See DISCOVERY OF THE TRUE CROSS.

FINDING OF THE BODY OF SAINT FLORIAN. See FLORIAN, SAINT.

FINDING OF THE BODY OF SAINT MARK. See DISCOVERY OF THE BODY OF SAINT MARK.

FINE MANNER. Mid- and late-fifteenth-century Florentine *engravings fall into two classes—the Broad Manner and the Fine Manner. The Broad Manner uses bold lines while the Fine Manner uses fine lines, sometimes cross-hatched, so as to cause an effect similar to a wash drawing.

FLAGELLATION (Christ at the Column, The Flagellation). The four *Evangelists mention briefly that before *Christ was led away to be crucified Pilate (see CHRIST BEFORE PILATE) had him flogged (Matt. 27:26; Mark

15:15; Luke 23:16; John 19:1). Although no doubt exists that Christ was scourged, many early Christian writers speculated about the number of strokes Jesus was likely to have been given, which ranged from forty, according to Jewish law, to over five thousand according to Saint Bridget of Sweden (see REVELATIONS OF SAINT BRIDGET). Artists customarily depict Christ standing full face, bound by his wrists to a column receiving the strokes on the front of his body (the usual place would be his back, which presents the technical problem of leaving his face visible to the spectator). Generally two or three soldiers administer the flogging with thong whips or birches.

Example: Piero della Francesca, probably 1450s, Galleria Nazionale delle Marche, Palazzo Ducale, Urbino.

FLIGHT INTO EGYPT. The flight of Joseph, Mary (see MARY, SAINT), and the Infant Jesus into Egypt is told briefly in Matt. 2:13–15. When Joseph had a dream that Herod was searching for the Infant Jesus, he took him and his mother away to Egypt, where they stayed safely until Herod's death. No early Christian version of the "Flight" is known in art. Renaissance artists show three figures: Mary carrying her Child in her arms and riding an ass, and Joseph leading the animal by a rope. Sometimes Joseph carries the Child on his shoulders. *Angels may be included to stand guard over them as they travel. Some artists include the youth James, the brother of Christ, following along behind, or he may take the place of Joseph. Early Renaissance paintings sometimes show the three sons of Joseph and the midwife Salome. An ox and an ass, if included, refer to the *Nativity. Some Northern Renaissance artists show a cornfield with reapers working in the background. The *Holy Family, it was said, passed by a man sowing seed whom the Virgin told to say to those who asked that he had seen them pass by at the time of sowing. Miraculously his corn grew and ripened overnight so that when Herod's soldiers stopped the next day, they were told truthfully that the family had passed by at the time of sowing. The soldiers gave up pursuit and the Holy Family was safe.

Example: Giotto, 1305, Arena Chapel, Padua.

FLOOD. See DELUGE.

FLORA. Flora was the ancient Italian goddess of spring and flowers. Her festival, the Floralia, was celebrated in April and was, according to Ovid's *Fasti,* the scene of drunken gaiety. According to Ovid, the Greek goddess of flowers was the earth-nymph Chloris, who was pursued by Zephyr, the west wind of springtime, who begets flowers. He changed her into Flora (the Romans called her Flora) with flowers coming from her breath and spreading over the countryside. Ovid (*Fasti* 5:193–214) tells that Chloris ran from Zephyr and when he finally caught her, blossoms spilled from her lips and then she was transformed into Flora. Artists show the wind god Zephyr in pursuit of Chloris, from whose mouth issue flowers as she is transformed into Flora, goddess of spring (see

PRIMAVERA). She may be shown metamorphosed and standing beside the figure of Chloris, strewing flowers from her flower embroidered dress upon the grass.

Example: Titian, c. 1515, Uffizi Gallery, Florence.

FLORENTINE SCHOOL. During the fourteenth, fifteenth, and part of the sixteenth centuries, Florence, Italy, was the principal center of Western art. Florence produced Giotto, Brunelleschi, Donatello, Leonardo da Vinci, and Michelangelo; saw the revival of classical forms in architecture; witnessed the discovery of *perspective and was the home of the first *Academy of Art founded by Giorgio Vasari. The Florentines have always been conscious of their leadership in the arts, which began in the late thirteenth century. It was around this time that the unique Florentine style became apparent. Brunelleschi's perspective was used by Masaccio in his *frescoes for the Brancacci Chapel c. 1425. Donatello employed a new unsparing naturalism with a classical elegance. Florentine taste enjoyed the more picturesque and delicate style of Lorenzo Ghiberti and at the same time, the vigor and realism of Donatello. Finally, the master of Leonardo, Andrea del Verrocchio, reconciled the two paths of delicacy and realism. By the time of Lorenzo the Magnificent (1449–1492), the pervading atmosphere of Florence was both romantic and bourgeois and a subtle aestheticism began to appear in the works of artists such as Sandro Botticelli. A short time after 1500, even though Raphael and Michelangelo were working in Florence, Florentine leadership in culture and good taste was usurped by Rome.

FLORIAN, SAINT. Florian was a Roman soldier who, after being converted to Christianity, was martyred in 304. He was from the town of Ems in what is now Upper Austria and was martyred by being thrown into the river Ems with a rock tied round his neck. His body was recovered by Christian passers-by, and until it was taken away for burial, an eagle stood watch. Saint Florian is invoked in case of fire because, according to legend, he was said to have put out the flames of a burning building and even an entire city with one bucket of water. Artists depict him as a medieval knight or a Roman soldier carrying a banner with a cross or a rock. He may hold a pitcher or a bucket or he may be shown throwing water over a burning building.

Example: Albrecht Altdorfer, *Finding the Body of Saint Florian, from the Legend of Saint Florian,* c. 1520, German National Museum, Nuremberg.

FOGLIANO, GUIDORICCIO DA. Guidoriccio da Fogliano, a captain, was one of the many freebooting and ambitious professional soldiers (*condottieri) who led the armies of the Italian states in their many petty wars. Fogliano was painted after he was victorious in leading the recapture of the small Sienese town, Montemassi, from the Pisans in 1328. The general is shown riding along on a horse splendidly caparisoned (covered with ornamental trappings), as a real

man in a historically real situation. His army camp is shown, and banners fly over another city he has just retaken from the Sienese. He rides toward another hill-town left still to be conquered.

Example: Simone Martini, 1328, Council Chamber, Palazzo Pubblico, Siena.

FOLLY. See CURE OF FOLLY.

FONTAINEBLEAU, FIRST AND SECOND SCHOOLS OF. The royal palace at Fontainebleau was the architectural expression of *Francis I of France, whose ambition was to bring to France an emulation of the humanist princes of Italy and, with this, a total revival of the arts backed by the patronage of his court. Francis imported Florentine masters for the task, and they led the work between 1528 and 1558. During this time Italian sculptors and painters worked together on the decoration of the new royal palace at Fontainebleau. Among the most notable artists were Giovanni Battista Rosso, Francesco Primaticcio, (head of this First School of Fontainebleau), and Niccolo del Abbate. The Second School of Fontainebleau was an attempt at a similar revival by artists who carried out the work for Henri IV. The time period goes beyond the Renaissance and into the seventeenth century.

FOOL. The Fool is an illustration for Psalms 58:1, "The fool has said in his heart, there is no God." A man is shown dressed in the medieval version of ridiculous shorts, eating a stone and holding a club.

Example: Jacquemart de Hesdin, Psalter of the Duke of Berry (Ms. fr. 13091, fol. 106) illumination, c. 1380–1385, Bibliothèque Nationale, Paris.

FORGE OF VULCAN. The son of *Jupiter and Juno, Vulcan was the Roman god of fire and later identified with the Greek Hephaestus and sometimes called Mulciber, "the smelter." Because he was chiefly the god of destructive fire and was originally the god of volcanoes, the volcano is named after him. Essentially, he was a blacksmith who forged the weapons of the ancient gods and heroes. His wife was *Venus and she eventually made a cuckold of him. Artists depict him standing at the anvil in his forge, a hammer or some other blacksmith's instrument in his hands. He is usually shown crippled or deformed in some way, the result of being thrown down to earth from Olympus by Jupiter in a fit of anger. Weapons he has already forged lie about on the floor. His chariot, drawn by dogs, is seldom represented. Some artists show him with his assistants, one-eyed giants (the cyclopes), and big men who are usually depicted with two eyes.

Example: Antonio Lombardo, marble relief, 1508, The State Hermitage Museum, Leningrad.

FORMSCHNEIDER. A *Formschneider* is a professional *woodcut illustrator.

FORTITUDE. See VIRTUES.

FOUNDING OF SANTA MARIA MAGGIORE. According to legend, the ground plan for Santa Maria Maggiore at Rome was outlined by a miraculous snowfall. Liberius, pope from 352 until 366, is shown tracing the plan on the ground with a long stick in the presence of a multitude of holy men and women. The snow is still falling. Jesus and the Virgin Mary (see MARY, SAINT) are shown witnessing the miracle from above.
 Example: Masolino, from the Santa Maria Maggiore triptych, c. 1423, Museo di Capodimonte, Naples.

FOUR HORSEMEN OF THE APOCALYPSE. One of the more important themes of the *Apocalypse, the Four Horsemen of the Apocalypse is found in the Revelation of John (6:1–8), written at the end of the first century A.D. The four are usually seen as the agents of the wrath of God. The first rides a white horse and is the Conqueror. Crowned by an *angel, the Conqueror has been interpreted as *Christ and the church. The second horseman, riding a red horse, is War. Third is Famine, who, holding a large pair of scales, rides a black horse, and the fourth, Death, rides a pale horse. Galloping through the air, they sweep over the world; only Death, whom man knows well, touches the earth.
 Example: Albrecht Dürer, *The Four Horsemen,* from the *Apocalypse* series woodcut, c. 1497–1498.

FOUR LATIN FATHERS. The Four Latin Fathers or Fathers of the church is a collective name for the early Christian writers whose work is considered generally orthodox. This definition usually includes all such writers up to and including Saint Gregory I (Gregory the Great) in the West and Saint John of Damascus in the East. Several groupings of the Fathers exist. One of these is the Apostolic Fathers, which generally includes the authors of the *Didache,* of the Epistles of Clement, of the Epistles of Ignatius of Antioch, and the authors of the Shepherd of Hermas. The Four Latin Fathers of the Latin church are Saint Ambrose, Saint *Jerome, Saint Augustine, and Saint Gregory the Great. Each saint is usually placed in an architectural setting. Behind the saints, rich simulated marble panels and gold brocade hangings form the background. Each saint is placed in a separate niche and in front of each is a reference to the saint. Ambrose is shown with the cradle, in allusion to his early childhood when, as he lay in his cradle, a swarm of bees were said to have alighted on his mouth. Jerome is shown preparing to remove the thorn from the lion's foot (according to legend Jerome pulled a thorn from the paw of a lion that thereafter became his devoted friend). Augustine is shown walking along the shore pondering the mystery of the *Trinity when he met a child spooning the sea out of a hole in the sand. He told the child that what he was doing could not be done, and the child answered

that Augustine's attempt to comprehend the Trinity was equally impossible. Gregory is shown lifting the emperor Trajan from purgatory. According to the *Golden Legend* a widow in the time of Trajan demanded vengeance for the death of her son, murdered by the son of the emperor. In return Trajan gave up his own son but was condemned to purgatory. Gregory, five hundred years later, brought about the release of Trajan's soul through his prayers.

Example: Michael Pacher, *Altarpiece of the Church Fathers*, c. 1483, Alte Pinakothek, Munich.

FRANCIS, DEATH OF. Saint *Francis of Assisi died at the Porziuncolo in Assisi on October 3, 1226. When he died, he was almost totally blind. (He had contracted an eye disease in the East.) Since Francis had taken the greatest care to hide his *stigmata in his lifetime, few were aware of these wounds. After his death the stigmata was announced to the order by a circular letter. A nobleman named Jerome doubted the authenticity of the stigmata, but like Thomas (see DOUBTING THOMAS), put his fingers in the wound on the side of the saint's body and was convinced. An intimate companion of Francis left a written testimony of the event and added that in death Francis seemed like one just taken down from the cross. By the time of his death he was widely venerated. The death of Francis usually forms part of the narrative scenes of his life. The saint is shown stretched out on a simple bier before a wall; the mourners stand around him weeping, kissing his hands and feet, gazing into his eyes. Jerome may be shown putting his fingers into the wound on Francis' right side. *Angels bearing the released soul, hovering on a bed of clouds, seem to head toward heaven.

Example: Giotto, after 1317, Bardi Chapel, Sta. Croce, Florence.

FRANCIS AT GRECCIO. See CHRISTMAS AT GRECCIO.

FRANCISCAN ORDER. The Franciscan order is the first great mendicant order founded by the Italian monk and preacher, Giovanni di Bernardone or Saint *Francis of Assisi for the purpose of imitating as closely as possible the life of *Christ and filling the spiritual needs of the poor.

FRANCIS I OF FRANCE. Francis I was king of France from 1515 to 1547. While Francis was in many ways a medieval knight-king, he was at the same time a Renaissance king, open to new ideas and a patron of the arts and humanist scholarship. During his reign he transformed his country's economy and society, enlarging and uniting a kingdom made up of many different races, with different languages and customs. Under the patronage of Francis I, a national revival of the arts was carried out on a grand scale, and the Château of Fontainebleau became an outstanding monument of French Renaissance decoration and architecture. See FONTAINEBLEAU, FIRST AND SECOND SCHOOLS OF.

Example: Jean Clouet, c. 1525, Louvre, Paris.

FRANCIS GIVING HIS CLOAK TO THE BEGGAR. Saint *Francis of Assisi was the son of a wool and cloth merchant. According to a later biographer, Saint Bonaventura, Francis as a young man was "given up to pleasures" and "reared in vanity." However, he was a youth of shy temperament and gave of his possessions freely. One story of his earlier life tells how he once gave his clothes to a poor soldier whom he encountered on the road. After this Francis became a lover of poverty, of nature, a social worker, and an itinerant preacher. Francis is shown in the marketplace of Assisi. He has taken off his clothes and offers them to a beggar. He remains protected only by his bishop's mantle. His father may be shown raging helplessly in the background.

Example: Master of the Saint Francis Cycle, early fourteenth century, Upper Church of S. Francesco, Assisi.

FRANCIS IN ECSTASY. Saint *Francis of Assisi found his ecstasy (the *stigmata) when he went to the mountain retreat of La Verna (Alvernia), not far from Assisi, during the summer of 1224. His intention was to celebrate the feast of the *Assumption of the Blessed Virgin Mary (see MARY, SAINT). (August 15) and to prepare for Saint *Michael's Day (September 29) by a forty-day fast. As he prayed one morning he beheld a vision that came toward him from heaven. According to Saint Bonaventura the Italian scholastic theologian who, in the thirteenth century, wrote on the life of St. Francis:

As it stood above him, he saw that it was a man and yet a seraph with six wings; his arms were extended and his feet conjoined, and his body was fixed to a cross . . . he finally understood that by God's providence he would be made like the crucified Christ, not by a bodily martyrdom but by conformity in mind and heart. Then as the vision disappeared, it left not only a greater ardour of love in the inner man but no less marvelously marked him outwardly with the stigmata of the Crucified.

This was the ecstasy of Francis. Artists depict Francis at his mountain retreat. He stands before his cave, the entrance covered with a grape arbor (an obviously Christian symbol) that shades his writing desk. He may already have received the stigmata and stands with his arms outstretched, the wounds in full view. Other artists may show an entirely different scene with Francis, arms extended and the stigmata already in place, gliding miraculously over the water. He may stand upon Wrath, who is depicted as a crowned and bearded figure attended by a lion. Lust (see SEVEN DEADLY SINS), a beautiful young girl looking in a mirror, and Avarice, an ugly woman dressed in black accompanied by a wolf, may be shown. Also, the Franciscan Virtues may be depicted as three young blond maidens and Chastity holding her lily. Poverty, covered with rags, and Obedience, under her yoke, may be included. He may have an inscription on his halo apostrophizing him as patriarch of the poor.

Example: Giovanni Bellini, c. 1485, The Frick Collection, New York.

FRANCIS MARRIES LADY POVERTY. Saint *Francis of Assisi was known to have met in a vision three women as he traveled to Siena. They greeted him with the words, "Welcome Lady Poverty." The metaphorical bride of Francis is Poverty, sometimes shown in the form of a mystical marriage. He is shown stepping forward to place a ring on the finger of the central one of the three women he met on the road. The three women are then shown floating off to heaven, their attributes (especially the yoke of Obedience) silhouetted against the sky. Poverty, the bride of Francis, may turn and look back at her new bridegroom. Another member of the *Franciscan order may be shown in attendance.

Example: Sassetta, 1437–1444, Musée Condé, Chantilly.

FRANCIS OF ASSISI, SAINT. Known as the "seraphic saint," Saint Francis of Assisi (c. 1181–1226) was the founder of the Order of Friars Minor or *Franciscan orders of men and women. Religious movements of the early thirteenth century were attempting to reform the medieval church. Francis took over the leadership of these movements, adopted total poverty, and, because of his magnetic personality, drew thousands of followers to his side. Artists depict Francis with a grey or brown habit, its girdle tied by three knots representing the religious vows of obedience, poverty and chastity. According to some accounts, during the late summer of 1224 Francis went to the mountain retreat of La Verna not far from Assisi. Here he received the *stigmata. In art he is easily recognized by these marks on his hands, feet, and side. He is shown most often at prayer. During the Renaissance, paintings of Francis usually consisted of narrative scenes from his life. For example, in *The Apparition at Arles,* Francis appears as a vision to bless his followers. No contemporary portrait of Francis exists, though he has been variously described as of puny physique, with failing eyesight and an unkempt beard. See MIRACLE OF THE SPINI CHILD.

Example: Giotto, c. 1315–1320, Bardi Chapel, Sta. Croce, Florence.

FRANCIS' PACT WITH THE WOLF OF GUBBIO. Saint *Francis of Assisi tamed a savage wolf who had terrorized the small town of Gubbio. Artists depict Francis holding the right paw of the fearsome animal, which he had persuaded to stop devouring the people of the city and to eat instead a harmless diet that would be given to him at public expense. A notary may sit before the city gate holding the pact ready for the wolf's signature. The astonished authorities of the town stand before the gate and women and children on top of the gate may peer down at the miraculous scene.

Example: Sassetta, 1437–1444, National Gallery, London.

FRANCIS PREACHING TO THE BIRDS (Saint Francis Talking to the Birds). Saint *Francis of Assisi was well known for his relationship with beasts and birds. Animals of the forest were said to become docile upon hearing his voice and would obey his commands. He called all creatures his brothers and

sisters, and in his "Canticle of the Creatures" he referred to "Sister Moon," "Brother Sun," the water and wind, and even "Sister Death." When, on one occasion, he preached a sermon to the birds, they flew into the air in the formation of a cross. He is usually shown standing before a tree filled with birds.

Example: Attributed to Giotto, early fourteenth century, Upper Church of S. Francesco, Assisi.

FRANCIS RENOUNCES HIS EARTHLY FATHER. Saint *Francis of Assisi renounced material possessions and family ties to embrace a life of poverty. The renunciation of his father forms one of the episodes that make up Francis' conversion. According to the *Golden Legend,* the incident that caused this renunciation occurred when Francis heard a crucifix in the chapel of Saint Damiano at Assisi command him: "Go and repair my house." Francis is known to have hurried home, gathered up most of the cloth in his father's shop, taken it to a nearby town, and sold it along with the horse he rode. Then he tried to give the money to the priest at Saint Damiano. The priest refused the money, fearing the father's wrath. Francis' father, very angry, brought him before the civil authorities. Francis did not answer the summons, whereupon his father called him before the bishop. Before the bishop could speak, Francis took off his clothes and gave them to his father. He stood there wearing only a hair shirt. The bishop covered him with a cloak and Francis left the city. He is usually shown standing before the bishop naked, his clothes lay scattered on the floor while several onlookers, including his father, watch in astonishment.

Example: Sassetta, from the *Sansepolcro Altarpiece,* 1437–1444, National Gallery, London.

FRANCIS UNDERGOING THE TEST BY FIRE BEFORE THE SULTAN. The test by fire that Saint *Francis of Assisi underwent to prove his Christian faith occurred in Egypt. The saint, traveling abroad to preach during the last Crusades, went to Egypt, where the crusaders were besieging Damietta in 1219. He succeeded in gaining the presence of the sultan of Egypt and thus entered the camp of the Saracens and preached to the sultan, whom he attempted to convert. The sultan, who was impressed by him, gave him permission to visit the holy places in Palestine but would not be converted. Then Francis offered to submit to the ordeal of walking through a fire if the sultan's imams (prayer leaders of Islam) would do the same. They refused and Francis said this to the Sultan: "I will enter the fire alone if you will embrace the faith of *Christ if I come forth unscathed (Hall, *Dictionary of Subjects and Symbols in Art,* p. 132). The sultan refused. The sultan is shown seated high on his throne while Francis calmly prepares to undergo the test by fire. The fire nearly reaches Francis' shoulders, but he seems undeterred.

Example: Giotto, after 1317, Bardi Chapel, Sta. Croce, Florence.

FREEING OF SAINT PETER. Peter (see PETER, APOSTLE AND SAINT) was leader of the twelve *apostles. He is known for establishing the first Christian community in Rome and for this and other deeds he was crucified by Nero in A.D. 64. Before the crucifixion Peter was put into prison during a persecution of the apostles by Herod (Acts 12:1–11). Even though the saint was guarded day and night by two Roman soldiers in heavy armor, he managed to escape. One night as he slept, an *angel appeared before him in his prison cell. Miraculously the angel led Peter out of the cell past the guards and even through the city gates. Peter is depicted as an old man with grey hair and beard. He is almost always shown holding a key or keys. When being freed he is usually in fetters, being awakened by the angel's touch on his shoulder, and even though the angel appears in a bright light, the soldiers sleep. Early church authorities saw the freeing of Saint Peter as symbolic of the coming deliverance of the church from persecution.

Example: Konrad Witz, from the *Altarpiece of Saint Peter*, reverse of right wing, 1444, Muśee d'Art et d'Histoire, Geneva.

FRENCH AMBASSADORS (The Ambassadors). Two ambassadors shown in a double portrait are the French ambassadors to England, Jean de Dinteville and Georges de Selve, bishop of Lavour. The two men, both intellectuals and ardent humanists, stand at either side of a table covered with a patterned Oriental rug and a collection of instruments—a lute with a broken string, compasses, flutes, globes, a sundial, mathematical and astronomical models and implements, and an open hymnbook with Luther's translation of the Ten Commandments and of *Veni, Creator Spiritus*. The instruments and books could suggest a warning against pride in learning, which would agree with the new spirit of the time. The balance and serene composition is interrupted only by one unusual element, a radically elongated skull stretched diagonally across the lower center. The anamorphic image is of a skull and possibly refers to the personal device of Jean de Dinteville, whose hat medallion bears a skull. Another suggestion is that Holbein, the artist's last name, means skull. Still another undecipherable meaning may relate to the placement of de Dinteville's foot at the center of a circle in the floor design. See ANAMORPHOSIS.

Example: Hans Holbein the Younger, 1533, National Gallery, London.

FRENCH RENAISSANCE. French Renaissance is an Italian importation usually dated from the end of the fifteenth century and connected with the dynastic ambitions of the French kings from Charles VIII to *Francis I of France.

FRESCO. *Fresco* is the Italian word for "fresh." True fresco, or *buon fresco,* used in Italy from the thirteenth to the sixteenth century, is a permanent form of wall decoration in a *medium like watercolor made on wet plaster with pigments suspended in water so that the plaster absorbs the color and the painting forms a part of the wall. First the wall is rough-plastered and then a coat called

the *arricciato (or arriccio) is applied. The *cartoon is traced on this, thus transferring the composition to the wall, and an area for one day's work is smoothed with the final layer of plaster, the intonaco. Over this prepared section the cartoon is redrawn, matched with the parts still uncovered, and the wet plaster is painted with pigments mixed with water. Scaling does not occur because while the plaster is wet a chemical reaction takes place, and the colors become a part of the wall itself. Among the finest examples of this technique are Raphael's decorations in the Stanze of the Vatican in Rome executed in the early sixteenth century. During the sixteenth century it became nearly obligatory to work in *buon fresco*.

FRESCO SECCO. *Secco* is Italian for "dry." *Fresco secco* is painting on dry plaster and is not a durable technique because with time the paint tends to flake off.

FROG PERSPECTIVE. See SOTTO IN SÙ.

FRONTON. *Fronton* is a French word for "pediment," particularly the pediment form used over a window or a door. An example is the fronton over the entrance door into the Palazzo Vecchio, which is marble with the monogram of *Christ between two lions and the writing "Rex regum et dominus dominantium" ("Jesus Christ King of Kings and Lord of Lords"). This work was commissioned in 1551 by *Cosimo I de' Medici.

FUNERAL OF SAINT FRANCIS. See FRANCIS, DEATH OF.

FUNERAL OF SAINT MARTIN. See MARTIN, SAINT.

G

GABRIEL. One of the four archangels, Gabriel is known in art mainly as the angel of the *Annunciation. He is a messenger of God and is venerated not only by Christians, but also, since he is treated in the Old Testament (Dan. 8:16; 9:21) and the Koran, by Moslems and the ancient Hebrews. In Islam Gabriel revealed the Koran to Muhammad. According to Christian tradition, Gabriel will be the archangel trumpeter of the *Last Judgment (1 Thess. 4:16). He is often depicted in art with trumpet raised and facing east, where *Christ is expected to appear during the Second Coming. Gabriel foretold the birth of the Virgin Mary (see MARY, SAINT), of Saint *John the Baptist, and Samson and announced Christ's *Resurrection. He is the *angel of the *Nativity. In Annunciation scenes he wears a flowing robe and carries a lily, the symbol of the Virgin, or in early Renaissance art he holds a sceptre topped with the fleur-de-lis. A scroll may wind around the sceptre. It reads "Ave Maria," or "Ave gratia plena Dominus tecum"—"Greetings most favored one. The Lord is with you and has greatly blessed you." (Luke 1:28). Gabriel's feast day jointly with the other archangels is September 29.

Example: Jocobello del Fiore, *Justice with Sts. Michael and Gabriel,* 1421, Accademia, Florence.

GALATEA. The story of Galatea (Ovid, *Metamorphoses* 13:750–897) provided Renaissance artists with a wonderful subject for composition with the nude, *cupids, sea horses, dolphins, nereids, and tritons. Galatea was a Sicilian Nereid, or sea-nymph. She loved a handsome shepherd, Acis, and was herself loved and pursued by the Cyclops Polyphemus. The monstrous one-eyed giant sat on a hill overlooking the sea and played love songs to Galatea on his pipes. Later, while wandering along the seashore, he discovered her in the arms of Acis and crushed

the youth under a huge rock. Galatea, in response to Acis' pitiful cries, turned him into a river, and she dived into the sea off the coast of Sicily. Artists show several scenes of the story. The Cyclops may be shown playing his syrinx, the pipes of Pan, which are a symbol of lust (see SEVEN DEADLY SINS). The scene is pastoral with sheep grazing on the hillside. The lovers may be seen embracing on a rock across the water while nereids and tritons frolic about them in the water. Galatea may also be shown riding in her cockleshell car drawn by dolphins; Acis is not present in this scene. Or the two lovers run from the giant who holds a boulder over his head ready to throw it. In her triumphal scene Galatea rides in her cockleshell car and is surrounded by beautiful *nymphs and other sea-creatures. Amoretti fly overhead aiming arrows at her. Galatea may have an arch of drapery above her head, a classical attribute for a sea-goddess.

Example: Raphael, 1513, Villa Farnesina, Rome.

GANYMEDE (Ganymede and the Eagle). Ganymede was a Trojan prince (a shepherd in some accounts) mentioned in Homer as the son of Tros, a legendary king of Troy, who was carried off by Zeus (see JUPITER) after having transformed himself into an eagle in exchange for some horses, or in post-Homeric epic, a golden vine (the myth has different versions). According to Ovid (*Metamorphoses* 10:152–161) Zeus fell in love with Ganymede because of his outstanding beauty and carried him off to Olympus where he made him a cup-bearer. Aristophanes parodied the tale in his *Peace,* in which Ganymede flies up to heaven on the back of a giant dung-beetle. Ganymede is usually depicted as a beautiful, muscular youth nearly enveloped by a huge, predatory bird, ascending to heaven. To some thinkers he symbolized the ecstasy of Platonic love and showed how man is rendered helpless by an otherwordly power—love. Renaissance humanists saw the theme as an allegory of the progress of the human soul towards *Christ.

Example: Copy after drawing by Michelangelo, black chalk and pen, 1532, Windsor Castle, London.

GARDEN OF PARADISE. A garden refers to Mary's (see MARY, SAINT) virginity when thought of within a Christian context. Secular art reveals a Garden of Love that is presided over by *Cupid. Spring (see PRIMAVERA) may be shown in a flower garden. The Garden of Paradise shows lords and ladies in a lovely castle garden with flowers blooming everywhere, birds perched along the battlemented wall; the women pluck ripe fruit, play musical instruments, or draw water from a well. These subjects can often be identified as the Virgin Mary reading her book, the *Christ Child playing with Saint *Cecilia and her zither, and Saint George (see GEORGE AND THE DRAGON, SAINT) Saint *Michael, and a knight enjoying the beauty of the garden.

Example: Master of the Middle Rhine, c. 1410, Städelsches Kunstinstitut, Frankfurt.

GATHERING OF THE MANNA. Gathering of the Manna, from the story of *Moses (Exod. 16:11–36; Num. 11:7–9), was taken as a prefiguration of *Christ feeding the multitude or of the *Last Supper. The setting is the desert and occurs during the time when the Israelites began to fear starvation as they journeyed from Egypt to the Promised Land. But God provided for them as he had promised. The food appeared when the morning dew evaporated. "There was something thin and flaky on the surface of the desert. It was as delicate as frost. . . . Moses said to them 'This is the food that the Lord has given you to eat.' " The people of Israel called the food "manna." It was like a small white seed and tasted like cakes made with honey. Perhaps the word manna came from the Hebrew meaning "What is it?" Since the manna had fallen from the sky like dew, the Israelites may be shown holding up baskets in an effort to catch it from the air. Usually they gather it from the ground in ceremonial vessels or ordinary pots. Manna is now identified as the sweet secretion of certain insects.

Example: Dirk Bouts, from the *Last Supper Altarpiece*, 1464–1467, Church of St. Pierre, Louvain.

GATTAMELATA. Gattamelata (meaning "honeyed cat") was a Venetian *condottiere by the name of Erasmo da Narni. He is shown astride a large war horse.

Example: Donatello, *Equestrian Monument of Gattamelata*, bronze, 1445–1450, Piazza del Santo, Padua.

GENIUS (pl. genii). In Renaissance art genius is most often the spirit of a person, place, or thing thought to stand guard. Genii are depicted as human, often winged and seminude. They may be purely decorative.

GEORGE AND THE DRAGON, SAINT (Saint George and the Princess). Saint George was a second-century saint born of Christian parents in Cappadocia in Asia Minor before the reign of Constantine. He was martyred near the end of the third century at Diospolis in Palestine. Many legends surround his life, and he has come to represent the triumph of good over evil. According to the *Golden Legend,* a dragon, living in the marshes, was infesting the country around Selena in Lydia. In order to please the dragon, numerous human sacrifices were given to the animal, and lots were drawn to choose the victims. One day the lot fell to Cleodolinda, the beautiful daughter of the king. The girl, dressed as a virgin bride, was taken to the marsh and offered to the dragon. Saint George, then a tribune of the Roman army, happened to ride by at the moment the dragon began his attack. Making the sign of the cross, he engaged the dragon in combat and finally succeeded in pinning the beast to the earth with his lance, where he killed it with his sword. The king and the people of the town witnessed the struggle and were converted and baptized into the Christian faith. Saint George was a very popular subject during the Renaissance. He is usually depicted as a young knight clad in shining armor. Mounted on his white charger, he is seen

transfixing the dragon with his sword. Spectators are sometimes shown watching the event from the city walls. The dragon is winged and scaly with a long forked tongue and a thick tapering tail. Saint George may wear the armor of a medieval knight or a Roman soldier. The story is symbolic and represents the conversion of a heathen country to Christianity. In early paganism the dragon symbolized evil and the town itself is personified by the maiden. See MARTYRDOM OF SAINT GEORGE.

Example: Raphael, 1504–1505, National Gallery of Art, Washington D.C. (Mellon Collection).

GESSO. Gesso is a material used during the Renaissance as a *ground to prepare a canvas or panel for painting. The solution is made from plaster (dehydrated calcium sulphate prepared by roasting gypsum or alabaster) mixed with *size. When several coats are applied to a canvas, a dense and brilliantly white ground with a rather high degree of absorbency is formed. The underlayers of gesso were coarse and heavy (*Gesso Grosso*); over this was laid ten or more coats of *Gesso Sottile* (plaster of Paris slaked in water for a month or so) and the result was a fine and smooth white surface with a pleasant feel and low absorbency.

GIESZE, GEORGE. George Giesze was a sixteenth-century member of the Steelyard, that is a merchant of the Hanseatic League established in London.

Example: Hans Holbein the Younger, 1532, Gemäldegalerie, Staatliche Museen, Berlin-Dahlem.

GILDING. Gilding is a technique of coating an object with gold, gold leaf, or some gold-colored substance. During the Renaissance, techniques were created in Italy for gilding on not only architectural ornament, but painting, and sculpture.

GILES PROTECTING A HIND. An eighth-century saint about which little is known, Saint Giles is the patron of cripples and beggars, and numerous churches in Britain are dedicated to him. His cult centered around the Benedictine monastery of Saint-Giles near Arles where he was the abbot. Traditionally, Saint Giles is known for protecting and befriending animals of the forest. According to one story, Giles saved a small deer or hind who had been shot by the king out hunting one day. The saint was found holding the creature in his arms, the arrow piercing its body, but the wounds halted by a mysterious power. Giles is usually shown in a forest with a small deer in his arms. Sometimes the king's arrow passes through Giles' hand and into the deer's body. The king's men, astonished, look on. Saint Giles is generally depicted with a white beard and the white habit of the reformed Benedictines. His attributes are an arrow and a stag.

Example: Master of Saint Giles, *Saint Giles Protecting a Hind,* 1480–1490, National Gallery, London.

GISANT. *Gisant* is a word used from the Renaissance on to designate a recumbent or lying effigy on a funerary monument. Typically the *gisant* portrayed the person in death as a corpse and often formed part of a monument's lower register.

GIULIANO DE' MEDICI. See MEDICI, GIULIANO DE'.

GIVING OF THE KEYS TO SAINT PETER (The Delivery of the Keys to Peter, Christ's Charge to Peter). According to Matthew (16:19), Jesus gave *Peter (see PETER, APOSTLE AND SAINT), the leader of the twelve *Apostles, the keys to the kingdom of Heaven. He said, "I will give you the keys of the kingdom of Heaven." A gold key was meant to symbolize the gate of heaven, the upper region of the kingdom; a silver or iron key symbolized hell. At the same time Peter was given the power to give absolution and to excommunicate. This topic was very popular with Renaissance artists. Peter is shown as an old man with a beard, and he usually kneels before Christ, who hands him the keys, while the rest of the disciples watch. Sometimes artists show the Infant *Christ on his Mother's lap handing the keys to Peter. If sheep are included, they allude to one of Christ's appearances after the *Resurrection, when he told Peter to "Feed my sheep" (John 13:4–17).
 Example: Perugino, 1481, Sistine Chapel, Vatican, Rome.

GLAZE. Used for oil painting in the fifteenth century, glaze is a transparent layer of paint applied to the surface of a painting to modify the color tones. Glaze allows light to pass through its surface, and the light is reflected back by the undersurface, modified and usually very pleasing aesthetically. It is possible to lay a series of glazes one over another.

GLORY. In art a glory is the area of light placed around the head or figure of Jesus, *Mary (see MARY, SAINT), or a saint. When it is placed around the head only, it is referred to as a halo. See MANDORLA.

GLUTTONY. See SEVEN DEADLY SINS.

GOLDEN LEGEND. *The Golden Legend* is a collection of the lives of the saints written in the thirteenth century by Jacobus da Varagine. Its popularity, enormous during the Renaissance, continued until the Reformation in the sixteenth century. Although its early translation from Latin into the vernacular languages brought the scorn of some Renaissance humanists, the book continued to enjoy immense popularity. The imaginative and nearly impossible nature of some of the stories caused many who read it to feel disbelief. Even though a hagiology, it is also a devotional book and presents the ideal of saintly living.

GOLDEN SECTION. In fine arts the Golden Section is a ratio between the two dimensions of a plane figure or the two divisions of a line such that the smaller is to the larger as the larger is to the sum of the two, an approximate ratio of three to five. The Golden Section is often claimed to be aesthetically superior to all other proportions. It was defined by *Euclid (Book 6) as follows: A straight line is said to have been cut in extreme and mean ration when, as the whole line is to the greater segment, so is the greater to the less. The name "Golden Section" first occurred in the nineteenth century. It is, however, traditionally held that Plato began the study of "The Section" as a subject in itself.

GOLGOTHA. An Aramaic word for "skull" and "the place of the skull," Golgotha is the name of the place near Jerusalem where Jesus was crucified (Matt. 27–33).

GONFALONIERE. *Gonfaloniere* is an Italian word for "standard-bearer."

GONZAGA FAMILY. Gonzaga was an Italian princely house that ruled Mantua (1328–1708), Montferrat (1536–1708), and Guastalla (1539–1746) during the Renaissance. The family name is taken from the castle of Gonzaga, a small village near Mantua. The main family members were Luigi Gonzaga, 1267–1360; Gian Francesco Gonzaga, 1395–1444; Francesco Gonzaga, 1456–1519; Federigo Gonzaga, 1500–1540; Ercole Gonzaga, 1505–1563; and Ferrante Gonzaga, 1507–1557.

 Example: Andrea Mantegna, *Ludovico Gonzaga, His Family, and Court*, completed 1474, Camera delgi Sposi, Palazzo Ducale, Mantua.

GOSPEL. Glad tidings, or especially good news concerning *Christ, the Gospel, in Christian usage, is the teachings of Jesus and the story of his life as told in the first four books of the New Testament, traditionally ascribed to the Four *Evangelists, Matthew, Mark, Luke, and John. See MATTHEW, SAINT; MARK, SAINT; LUKE, SAINT; JOHN THE EVANGELIST AND APOSTLE, SAINT.

GOUACHE. Gouache is a kind of watercolor painting that is opaque; sometimes it is also known as poster paint or as body color. Gouache pigments are bound with glue, and the lighter tones are achieved by adding white pigment. The amount of white added determines the degree or opacity. The *medium lacks the brilliance of transparent watercolor painting because the admixture of white pigment prevents the reflection of the *ground through the paint. The gouache technique can be observed in Albrecht Dürer's watercolor landscapes and animal and flower studies.

GOVERNMENT, GOOD (The Effects of Good Government, The Allegory of Good Government). Good Government is a visual encyclopedia of the Sienese Republic. The topic has no real story, but instead depicts, along with many other things, the entire city of Siena as it climbs up its hillside to the cathedral. Every detail of the city is there, its towers, battlements, Romanesque and Gothic windows, the beams outside the windows for providing a means to bring things up from the streets or for hanging out the daily wash, and people talking in the street and going into their houses. Clustering palaces, churches, markets, streets, and walls are all shown in a vast panoramic view of Siena. Commerce moves through the city, the guildsmen, for example, ply their crafts and trade. Farmers arrive from the countryside with produce or driving herds of sheep. A house is shown under construction with workmen standing on scaffolding. The Commune of Siena, holding orb and sceptry, is shown as a majestic figure enthroned and guided by the theological *virtues Faith, Hope, and Charity, who hover overhead. Flanking the Commune are virtues chosen for civic significance who sit or rest on a damasked bench; *Justice, Prudence, Temperance, and Fortitude, as well as by Peace and Magnanimity. On the left side, *Wisdom, who gives rewards and punishments through the agency of even more angellike figures that represent Commutative Justice, floats above the head of Justice. Distributive Justice is shown crowning a kneeling figure with her left hand and chopping off the head of another with her right. Concordia, directly below the throne of Justice, presides over the Council of the Sienese Republic, whose members advance to do hommage to Good Government. Moving through the city gate to the country beyond its walls, a bird's eye view of the Tuscan countryside is presented; its villas, castles, plowed farmlands, and peasants working at their seasonal occupations. Grain is harvested and vines are tended. Ladies and gentlemen ride into the country to go hawking. Lady Security floats above them. Town and country both are shown and what happens in every corner of both.

Example: Ambrogio Lorenzetti, 1338–1339, Sale della Pace, Palazzo Pubblico, Siena.

GRAFFITO. See SGRAFFITO.

GRAPHIC ARTS (Ger. *Graphik*). The Graphic Arts are those arts which are limited to drawing with no color: the arts of drawing and *engraving in all their forms.

GRAVER. See BURIN and ENGRAVING.

GREGORY APPEARING TO SAINT FINA. Saint Gregory (Gregory the Great c. 540–604) is one of the four Latin or Western *Fathers of the church. As pope he established the form of the Roman liturgy and its music (Gregorian chant). He helped found Christianity in England and instituted the rule of celibacy. In art Gregory is usually beardless and tall. He is depicted wearing papal vestments with a pontifical crosier (or crozier, which is a staff with a crook

or cross). The symbol of the Holy Ghost, a dove, hovers above his head or
perches on his shoulder. Gregory may also appear with the other three Latin
Fathers, Ambrose, Augustine, and Saint *Jerome. See FINA, SAINT.

Example: Domenico Ghirlandaio, c. 1475, Chapel of Santa Fina, Collegiata, San
Gimignano.

GRISAILLE. Renaissance artists used *grisaille*, a monochrome painting in grey
or greyish color, for effects of modelling and often imitated sculpture with it.
The *grisaille* is always executed in neutral greys only. It may be used as the
first stage in beginning an oil *painting, or it may be done simply as a decoration.
In the Arena Chapel, Giotto's series of *Virtues and *Vices appears to be grey
stone. In the van Eycks' *Ghent *Altarpiece*, the two Saint Johns are painted to
seem like marble statues. Not to be confused with *en camaïeu*, which is done
in only two or three tones, the *grisaille* may use all the tones available.

GROTESQUE. Taken from the Italian *grotta*, a grotesque is a kind of ornament
that originated as a descriptive term for the mural decorations with mixed human
and animal forms and floral ornaments which were rediscovered in Roman build-
ings like the domus Aurea of Nero and in grottoes during the early part of the
fifteenth century. Thus the word *grotteschi*. The word *grottesco* was first used
in 1502, in a contract for the Piccolomini *frescoes in Siena. Raphael was also
known to use these motifs.

GROTTESCHI. *Grotteschi* is a Renaissance scheme of decoration comprised
of mostly motifs that had been inspired by what seemed to be a grotto (hence
the name). These motifs, interwoven and mixed into many various patterns,
were used to cover walls or pilasters.

GROUND. The ground is the surface on which a painting is executed. If on
panel, the ground is usually *gesso or white oil *paint; on canvas the ground
may be white oil paint with a tinted layer on top. When an artist paints on a
canvas with no ground, the results are always, eventually, fatal.

GUILLOCHE. Guilloche is an ornament consisting of interlaced bands
sometimes called "Interlacement Band." Two or more bands or strings are
interlaced or plaited over each other so as to repeat the same figure. Many
varieties of the guilloche were developed during the Renaissance based mainly
on motifs taken from classical, medieval, and Moorish models.

GULA. See SEVEN DEADLY SINS.

H

HANGING OF HAMAN. See DEATH OF HAMAN.

HARPY (pl. harpies). Harpy, the Greek word for "snatcher," is a female creature that transports souls to hell. She is usually depicted as a monster with a woman's body and head and a bird's legs, claws, wings, and tail. Rarely the harpy may be represented as a more benign spirit that carries souls to another world.

HARROWING OF HELL. See DESCENT INTO HELL.

HAWKWOOD, JOHN. John Hawkwood was an English adventurer, known as Sir John Hawkwood, and a *condottiere*, who used the name Giovanni Acuto.
 Example: Paolo Uccello, *Sir John Hawkwood Memorial*, 1436, Florence Cathedral, Florence.

HAY-WAIN. The Hay-wain is a topic of corruption and greed taken from a Flemish proverb, "The world resembles a haycart, each may seize what he can." Renaissance art depicts the selfish madhouse of life: the pope, the emperor, a king, a duke, priests and nuns, lovers and musicians seem to not hear an *angel announcing the advent of *Christ.
 Example: Hieronymus Bosch, 1485–1490, Prado, Madrid.

HEALING OF THE LAME MAN. The healing of the lame man occurred at the Beautiful Gate of the Temple, the porch of Solomon (Acts 3:1–11). Peter (see PETER, APOSTLE AND SAINT) and Saint *John the Evangelist were there together. Artists show a crippled man, usually a ragged beggar sitting on

the ground extending his hand to Peter. John stands to the side and many onlookers crowd round them.

Example: Raphael, 1515–1516, cartoon, Victoria and Albert Museum, London.

HEALING OF THE WRATHFUL SON. See MIRACLE OF THE IRASCIBLE SON.

HELEN. See ABDUCTION OF HELEN.

HELIODORUS. See EXPULSION OF HELIODORUS.

HELL. Renaissance painters used great imagination when presenting the concept of hell, Satan's kingdom and the eternal abode of souls damned by the judgment of God. Hell is sometimes indicated as a dragon's cavernous mouth into which lost, helpless souls and cruel demons are entering. The Infernal City may be filled with blazing fire and smoke. Some artists depicted hell as being entered through the doorway of a building, and the three-headed dog Ceberus of Greek myth guards the door. The influence of Dante's *Inferno* is noticeable in some representations. Minos (king of Crete) may be present as one of the three judges of Hades, the underworld of Greek religion, shown with his snakelike tail wound round his body to indicate the proper number of the sinner's circle of punishment. The lustful are tormented in various ways by demons who tear their feet apart, rip off their ears or eat pieces of their bodies.

Example: Limbourg Brothers from the *Book of Hours of the Duke of Berry* (fol. 108), 1416, illumination, Musée Condé, Chantilly.

HENRY IV OF FRANCE. Henry IV was the first of the Bourbon kings of France. He is known for bringing unity and prosperity to the country after the sixteenth-century Wars of Religion. A very popular figure in French history, he had good political insight and, though never an outstanding administrator, he was an efficient ruler. He is known as Henry the Great and Good King Henry.

Example: Frans Pourbus the Younger, 1569–1622, Louvre, Paris.

HENRY VIII OF ENGLAND. Henry VIII was king of England from 1509 to 1547. Something of an intellectual and attracted to humanist learning, he was responsible for the deaths of the outstanding English humanists of the day. He married six times, and two of his wives were executed for alleged treason. Formidable in appearance and fearsome of temper, he attracted genuine devotion and was well served by a succession of brilliant, loyal ministers; he turned upon them all, and those he elevated he invariably cast down again. Although forever making the wrong moves in politics, he emerged essentially undefeated and superficially successful in most of his attempts. Opinion has been divided over Henry since his death. Artists show him as a powerful and stern monarch. His

eyes, small and close-set, reveal the ready temper that rests behind his awesome facade.

Example: Hans Holbein the Younger, c. 1538, Collection of the Duke of Rutland.

HEPHAESTUS. See FORGE OF VULCAN.

HERACLES. See HERCULES

HERACLIUS. See BATTLE OF HERACLIUS AND CHOSROES.

HERCULES. Hercules is the Roman name for the Greek mythological hero Heracles. He is known principally as the personification of physical strength and courage, which he demonstrated in many different ways when he performed his famous twelve labors. The twelve labors were undertaken as a penance after Hercules killed his own children in a fit of madness (Apollodorus, *Bibliothēkē* 2, 5:1–12; Hyginus, *Historicus et Mithographus* 30; and Diodorus Siculus, *Bibliotheca Historica* 4). As punishment, the Oracle at Delphi ordered him to serve Eurystheus, king of Tiryns, for twelve years. During this time Hercules had to perform any task the king might require. For Hercules, a god, being sentenced to serve a mortal was a terrible punishment, even if he had offended the Olympians. Many of Hercules' tasks appear as topics during the Renaissance. The twelve labors were (1) The killing of the Nemean lion, which had an invulnerable pelt. Hercules strangled it with his bare hands. (2) The killing of the Hydra of Lerna. This monster was a seven-headed water-snake. For every head Hercules cut off, it grew two. He finally overcame it with the help of a friend by cauterizing the heads with a flaming torch. The last head, which was immortal, he buried under a large rock. (3) The capture of the golden-horned Hind of Ceryneian (the Arcadian stag). Hercules had been ordered to bring the animal back alive. After hunting it for a year he finally wounded it with an arrow and succeeded in carrying it off alive. (4) The return to Mycenae of the Erymanthian boar. This animal, a fierce beast that ravaged the country near Mt. Erymanthus, was finally driven into a snowbank and caught in a net. Hercules carried it back to the king, who was so terrified he hid it in a jar. (5) The cleaning of the stables of Augeas. These large stables belonged to Augeas, king of Elis, and held three thousand oxen. The stables had not been cleaned for thirty years. Hercules diverted riverwaters through the area and washed them out in one day. (6) The killing of the Stymphalian birds. These birds had feathers that were poisoned arrows. They were so named because they nested in the area of Lake Stymphalus in Arcadia. After frightening them into the air with a rattle, Hercules shot them with his arrows. (7) The capture (some accounts say the killing) of the fire-breathing Cretan bull belonging to King Minos. Though the bull was mad and belched flames, Hercules took it back to Greece. (8) The capture of the man-eating mares of King Diomedes. Hercules seized the mares, stunned the king with his club, and fed him to his own mares. (9) The taking of the

Girdle of Hippolyte, queen of the Amazons. Hercules obtained the girdle for the daughter of Eurystheus. (10) The capture of the oxen of Geryon. Geryon, a monster with three human bodies and one pair of legs, kept a herd of oxen guarded by a giant and a two-headed dog. Hercules captured the oxen by killing the dog, the giant, and Geryon and finally drove the herd back to his master. (11) The taking of the golden apples of the Hesperides. The apples grew on a tree guarded by a serpent. Hercules slew the serpent, took the apples, and delivered them to Eurystheus. (12) The descent to Tartarus to capture Cerberus. Hercules descended into the underworld to bring back Cerberus, the three-headed dog that guarded the entrance to Hades. He caught it by the throat and delivered it to Eurystheus. See also HERCULES AND ANTAEUS, HERCULES AND CACUS, HERCULES AND THE HYDRA, HERCULES AT THE CROSSROADS, and HERCULES KILLING THE STYMPHALIAN BIRDS.

Example: Anonymous, bronze statuette, c. 1505, Victoria and Albert Museum, London.

HERCULES AND ANTAEUS (Antaios) (Hercules Wrestles with Antaeus). This event occurred when Hercules was making his way back from the Hesperides. On this journey he wrestled with Antaeus, the giant of Libya, son of Poseidon and Earth (Ge). Antaeus was only invincible when some part of him touched the earth, from which he drew his strength. Hercules locked his arms around Antaeus' waist and held him in the air in a vicelike grip, and squeezed him to death (Apollodorus, *Bibliothēkē* 2:5–11; Diodorus Siculus, *Bibliotheca Historica* 4). During the Renaissance, the image of Hercules and Antaeus was well known and typically shows Hercules with his arms round the waist of Antaeus who, with feet dangling, levers himself with an arm against Hercules' head trying desperately to free himself. This Renaissance image does not derive from any classical model; one rarely sees the subject in antiquity.

Example: Antonio del Pollaiuolo, bronze, c. 1475, National Museum, Florence.

HERCULES AND CACUS. Hercules and Cacus are part of the legendary history of the founding of Rome, related by Livy, by Virgil in the *Aeneid* and in Ovid's *Fasti* (1:543–578). This part of the tale tells how Hercules killed a Roman god, Cacus, a fire-breathing giant, the son of Vulcan, living in a cave on the Palatine hill in Rome. Cacus stole Geryon's cattle from Hercules one evening as the latter slept and dragged them backward into his cave to put Hercules off the trail. Hercules heard them lowing, tracked them to the cave, slew the giant in a great struggle, and recovered the beasts. Later Christian humanists saw this struggle as a symbol of triumph over the forces of evil, and this is how Hercules' victory appealed to Renaissance artists. Hercules is shown standing triumphantly over Cacus.

Example: Baccio Bandinelli, marble, 1533, the Signoria, Florence.

HERCULES AND THE HYDRA. The Lernaean Hydra was a seven-headed (or nine, according to some accounts) monster living by Lake Lerna, near Argos in the Peloponnese. Hercules had to destroy the Hydra as his second labor.

(Hercules' labors [Apollodorus *Bibliothēkē* 2, 5:1–12; Diodorus Siculus, *Bibliotheca Historica* 4; Hyginus, *Historicus et Mithographus* 30] and others were undertaken as a penance for slaying his own children.) The difficulty of this labor was that as one head was cut off, two more grew in its place. Hercules eventually succeeded, with the help of a friend, by cauterizing the heads with a burning torch. He cut the last head off, which was immortal, and buried it under a rock. Then he dipped his arrows in the creature's blood (gall in some accounts) to make them poisonous. Hercules is depicted with club raised, the many-headed Hydra twisting before him. During the early Renaissance, artists often depicted the Hydra as a medieval one-headed, winged dragon breathing fire (a personification of Satan).

Example: Antonio del Pollaiuolo, c. 1460, Uffizi Gallery, Florence.

HERCULES AT THE CROSSROADS (Choice of Hercules). Hercules, the personification of physical strength and courage, reached a point in life when he had to choose between the paths of *Virtue and *Vice. He chose Virtue. Artists show two female figures when personifying Virtue and Vice. When Hercules confronts them, each invites him to follow her. The Greek sophist Prodicus created this moral fable and though not illustrated in antiquity, it became popular during the Renaissance. Virtue's path is narrow, dark, and rocky. Vice has a beautiful, bright, easily traveled path. Virtue is shown clothed, while Vice is shown nude. Virtue is usually shown with a man at her side who is crowned with laurel and holding an open book. He is the poet who will extol Hercules' heroic deeds. Virtue may also be shown as a small child. Vice may have a *satyr at her side or she may hold the reed pipe of the satyrs, masks (the symbol of fraud), playing cards (symbol of the idleness that breeds lust), and a rod and fetters (the consequences of lust and evil). Father Time may peer down from above indicating that the hero will be remembered forever. Usually Hercules is shown as a strong young man.

Example: Albrecht Dürer, engraving 1497–1498.

HERCULES KILLING THE STYMPHALIAN BIRDS. After *Hercules killed two of his own children, the Oracle at Delphi ordered him to serve Eurystheus, king of Tiryns, for twelve years. Hercules had to perform all tasks the king might ask of him. The sixth task or labor was to kill the Stymphalian birds that inhabited Lake Stymphalus in Arcadia. They had long been a plague to the people of Stymphalus because of their numbers. Their feathers were poisoned arrows and they had brazen wings, beaks, and claws. Hercules was helped by Athena to drive them out of their coverts, and as they flew up he shot them. He is usually shown with his bow drawn and an arrow aimed at two of the birds who hover in the air before him. They appear shocked and surprised that he is ready to kill them.

Example: Albrecht Dürer, 1500, Germanisches National-Museum, Nuremberg.

HERM. A herm is the upper section of a male figure emerging from a pedestal. The herm was used occasionally as a pilaster, which is a flat, engaged column.

HEROD. See FEAST OF HEROD.

HIPPOLYTUS, SAINT. See MARTYRDOM OF SAINT HIPPOLYTUS.

HISTORY PAINTING. History painting, in academic circles, is a form of art that is made up of representations of the intellect and passions as symbolized in mythology, history, or the iconography of Christian religion. Originally the term "history" referred to mythological subjects and classical history, but the histories and legends of Christianity were considered worthy enough for the artist. Some of the greatest works of history painting were by Raphael.

HOLOFERNES. See JUDITH AND HOLOFERNES.

HOLY FAMILY. The Holy Family or the *Sacra Famiglia*, which includes the Virgin and Child accompanied by Joseph and other relatives, differs from the *Sacra Conversazione* because of its domestic milieu. A simple family group including Mary (see MARY, SAINT), Jesus, Joseph, and sometimes Saint *Anne, the Virgin's mother, is not found before the fifteenth century. Renaissance painters found the homeliness of the family appealing. In some scenes the Virgin may be teaching the Child to read, while in others the Child is asleep in her lap. Some artists depict Mary feeding him at her breast.
 Example: Michelangelo, c. 1503–1504, Uffizi Gallery, Florence.

HOLY KINSHIP. Holy Kinship or Holy Company occurs most frequently as a topic in Northern Renaissance art from the fifteenth century. Usually the Virgin and Child are shown surrounded by numerous members of the family group. The members of *Christ's generation are shown as young children. Some artists depict them with the attributes they are identified with as grown men and women. For example, Little John the Evangelist may hold his chalice and *James the Greater may fill it from his toy pilgrim's canteen. Baby Simon may hold his saw, the symbol of his martyrdom. The three Maries are usually accompanied by their husbands. Anne, the Virgin's mother, and Elizabeth and her son Saint *John the Baptist may also be included in the group. See JOHN THE EVANGELIST, AND APOSTLE, SAINT; JAMES THE GREATER; SIMON, SAINT; ANNE, SAINT; ELIZABETH, SAINT; and JOHN THE BAPTIST, SAINT.
 Example: Geertgen Tot Sint Jans, c. 1480, Rijksmuseum, Amsterdam.

HOLY SPIRIT. Saint *John the Baptist described the Holy Spirit: "I saw the Spirit come down like a dove from heaven and stay on Him. I still did not know that He was the one, but God, who sent me to baptize with water, had said to

me, 'You will see the Spirit come down and stay on a man; He is the one who baptizes with the Holy Spirit.' I have seen it, and I tell you that He is the Son of God'' (John 1:32–34). *Christ is shown standing in the Jordan. As Saint John pours water over his head a white dove, the symbol of the Holy Spirit, hovers above Christ's head. See BAPTISM OF CHRIST.

Example: Piero della Francesca, *Baptism of Christ*, c. 1450, National Gallery, London.

HOLY WOMEN AT THE SEPULCHRE. See THREE MARIES AT THE SEPULCHRE.

HORTUS CONCLUSUS. See CLOSED GARDEN.

HOST. Host is a word from the Latin *hostia*, meaning a sacrificial victim. In the Catholic church it is the Eucharistic bread or wafer before or after consecration regarded as the body of *Christ.

HUMERAL VEIL. The humeral veil is an oblong scarf or veil of the same material as the vestments that are worn around the shoulders and used for covering the hands when holding sacred vessels.

HUMOROUS ART. The contribution of the Renaissance to humorous art was restricted by the demand for decorum. According to Giorgio Vasari, the Renaissance art historian, some Italian painters loved practical jokes, but their humor did not extend to their art. Near the end of the sixteenth century the circle of Italian artist Annibale Carracci created the portrait caricature. By extention some may find the grotesque heads of Leonardo da Vinci humorous.

HUNTERS IN THE SNOW. This topic, a Northern Renaissance theme, expresses the bitter, frostbitten cold of the north. The spectator perceives returning hunters with their dogs in the foreground and little figures, mostly ice-skaters, in the distance. A snowy landscape is very rare in Renaissance art, whether Northern or Italian.

Example: Pieter Bruegel, 1565, Museum of Fine Arts, Vienna.

HYPNEROTOMACHIA POLIPHILI. The *Hypnerotomachia Poliphili* is a book, *The Strife of Love in a Dream*, and is considered by many to be the most beautiful book of the fifteenth century. It was published by Aldus Manutius, the greatest publisher and printer of the age, at Venice in 1499. ''Strife of Love'' is an elaborate romance that contains pages of minute fascination with details of the Ancient World. While the book is romantic and not archaeological, it has long been seen as a reflection of late-fifteenth-century ideas on the subject of antiquity and particularly the nearly scriptural reverence paid to it.

Example: The Temple of Venus from *Hypnerotomachia Poliphili*, Venetian woodcut, Victoria and Albert Museum, London.

I

ICARUS. See FALL OF ICARUS.

ICONOGRAPHY AND ICONOLOGY. Iconography and iconology in art are the given set of symbols and the knowledge of these attached to pictorial representations. An almond, for example, in Christian iconography, is one symbol of the Virgin Mary's purity. Pagan mythological figures also have a complex iconography. A crescent moon was the ancient attribute of the virgin *Diana (Artemis), and of the moon goddess Luna, who were worshipped as one in ancient Rome. Christian and pagan mythological figures used side by side may be nearly beyond interpretation. The crescent moon, for example, also symbolizes chastity when placed under the feet of the Virgin Mary (see MARY, SAINT).

IDEAL. "Ideal" and its corresponding parallels have acquired two different definitions in the vocabulary of art, history, and criticism. Both meanings came from classical antiquity, and both were used throughout the Renaissance. First, the word is used to describe art that reproduces the beauty of nature but eliminates all imperfections. The second use of "ideal" is taken from Plato's *Theory of Ideas*, in which all perceptible objects are only inferior copies approximating to imperceptible and unchanging Ideas and Forms.

IGNUDI. *Ignudi* are nude male youths or slaves.
 Example: Michelangelo, Sistine Chapel Ceiling, 1509–1510, Vatican, Rome.

ILLUSIONISM. Illusionism is a pictorial technique used to deceive the eye into taking that which is painted for that which is real. Most of the forms of illusionism developed during the Renaissance were seen earlier in Pompeian painting, which featured fictive (sham) architectural decorations giving the illusion of spatial recession, faux vistas, and veined marbles painted to appear real and illusory wall-paintings with false frames. In 1310 Giotto practiced fictive framing, for example, in his *frescoes of the Saint *Francis of Assisi cycle in the Upper Church at Assisi. A later Renaissance example is the fictive framing used by Raphael in the Vatican Stanze (see STANZA), especially evident in his 1512, *Mass of Bolsena. Baldassare Perruzzi produced one of the most convincing examples of illusionism in paint on a wall in the Chigi Palace, Rome, where one sees the view that lies beyond the wall as if seen through an open portico. See SOTTO IN SÙ and TROMPE L'OEIL.

IMAGO PIETATIS. *Imago Pietatis* is Latin for "Image of Pity." See PIETA.

IMAGO VANITATIS. *Imago Vanitatis* is Latin for the "personification of Vanity."

IMPENITENT THIEF. See THIEVES ON THE CROSS.

IMPRIMATURA. See PRIMING.

INCREDULITY OF SAINT THOMAS. See DOUBTING THOMAS.

INDULGENCES. See TRAFFIC IN INDULGENCES.

INNOCENT VIII. See WALL-TOMB.

INNOCENTI. *Innocenti* is an Italian word for "Innocents," referring to the Bible's usage of the children under the age of two who were killed by King Herod's order so that the Child Jesus would definitely be destroyed. In art the scene is depicted with the title *Massacre of the Innocents.
 Example: Domenico del Ghirlandaio, 1485–90, Cappella Maggiore, Sta. Maria Novella, Florence.

IN SCURTO. *In scurto* is "extreme foreshortening." During the Renaissance an intense interest in *perspective grew and was demonstrated in extremes of perspective applied to a single object.
 Example: Andrea Mantegna, *Dead Christ*, 1466, Brera Gallery, Milan.

INTAGLIO. Intaglio, also *Cavo-rilievo* is a graphic technique that consists of cutting forms out of a surface so that the impression made is a form of *relief in reverse. The technique is used for seals, gems, and dies for coins.

INTARSIA. Intarsia is a *mosaic worked primarily in wood. Pieces of wood, marble, and sometimes mother-of-pearl are placed side by side to form a design. The word "marquetry" is used when the process is used on furniture.

INTERCESSION OF THE VIRGIN MARY. During the Renaissance the hieratic type of Virgin seen in medieval art was replaced by a less formal Mother of God, a Maria Mediatrix, or Mary (see MARY, SAINT) as Mediator. Artists depict her in representations of the *Last Judgment interceding for the souls of the dead. She is shown kneeling on the ground before *Christ, her arms open in a pleading gesture. She is alone; but Christ is accompanied by patriarchs whom he had brought out of purgatory before his *Resurrection: *Adam and Eve, *Noah, and *Abraham may be present.

Example: Titian, *The Perpetual Intercession of the Virgin Mary*, 1554, Collegiata at Medole near Mantua.

INTONACO. See ARRICCIO.

INVIDIA. See SEVEN DEADLY SINS.

IO. See JUPITER AND IO.

IOLE. See RAPE OF DEIANIRA.

IRE. See SEVEN DEADLY SINS.

ISAAC. See SACRIFICE OF ISAAC.

ISAIAH. Isaiah is one of the four greater prophets known primarily for his prophecy that the Virgin Mary (see MARY, SAINT) would be the mother of God. "A young woman is with Child and she will bear a Son" (7:14). This phrase may appear as an inscription on a scroll held by Isaiah. He is frequently shown in scenes of the *Annunciation. Isaiah is also known for his prophecy, "A tree shall grow from the stock of Jesse" (11:1), which is the origin of the image of the Tree of Jesse. Where represented thus, he may hold the branch of a tree. Most frequently he holds a book (open to the page of his prophecy) or a scroll. Rarely he is shown with a saw, the traditional instrument of his death. Even rarer he is shown with tongs holding a glowing ember which alludes to the *seraph that placed a hot coal on his lips (6:6–7). As a greater prophet, Isaiah, like the others (*Jeremiah, *Ezekiel and *Daniel), is depicted on Michelangelo's ceiling *frescoes in the Sistine Chapel.

Example: Michelangelo, *Prophet Isaiah*, 1509–1510, Sistine Chapel Ceiling, Vatican, Rome.

ISOCEPHALY. Isocephaly is a principle used in Renaissance painting that places all heads on the same level.

ISTORIA. *Istoria* is a name for the abundant variety of detail found in Renaissance painting after 1435, when Leone Battista Alberti published his *Della Pittura*, an analysis of what is the most desirable in painting.

ITALIAN ART. Italian art has from time to time in the history of art given new life to certain movements and in some cases decided the course of Western art. Many events occurred from the time that followed the ending of the Roman Empire to the time when the art of Italy had attained that prominence in Europe that is claimed for the Renaissance. In fifteenth century Italy, proportion and *perspective were scientifically studied. In Florence, the main center of the new art during this time, a movement away from International Gothic toward greater naturalism occurred particularly between 1420 and 1440. The antique was imitated with as much fidelity as possible, and traditional types were slowly altered under the impact of classical taste.

The new scientifically studied perspective, as created by Filippo Brunelleschi, was made evident in the Florentine painting of Masaccio (see FLORENTINE SCHOOL). This scientific approach of the Florentines was united with color by Domenico Veneziano. By c. 1460 artists such as Antonio Pollaiuolo took more liberties with naturalistic representations.

All of Italy's art centers were inspired by this new Florentine style. One example was Piero della Francesca who in Umbria (see UMBRIAN SCHOOL) combined a lovely new luminosity with a rare geometrical style. While the Umbrian style was inspired by the new achievements, Padua in northern Italy developed independently. Here Andrea Mantegna created a painting style with extreme foreshortenings (see IN SCURTO and SOTTO IN SÙ) and archaeological details. His work also includes *line engraving. The northern provinces also had a taste for marquetry (see INTARSIA), which became a specialized form of perspective. In Venice a brilliant, luminous color was adopted, although Renaissance forms were introduced late. The *Venetian School, known for its brilliant color, light, and space, prepared the way for important artists such as Giorgione and Titian.

Perspective and color were brought to perfection by the end of the fifteenth century. This period witnessed the innovative works of Leonardo, Michelangelo, and Raphael. The earlier style, still somewhat hard, was softened by Leonardo's *sfumato. Artist, philosopher, scholar, and scientist, Leonardo was, more than any other artist, the Renaissance ideal of the universal man. Michelangelo's art, dramatic, expressing the struggle of the human soul torn between action and repose, occupies a place within the time period of the Renaissance, yet, by its turbulent nature, remains apart. (See TERRIBILITÀ.) The genius of Raphael was given vast opportunity under the pontificate of Julius II. His *frescoes at the Vatican—the Stanze (see STANZA)—are the perfect expression of classical Renaissance art.

Around 1530 Italy experienced many catastrophes and the harmony, balance, and perfection reached by Raphael came to an end. Art became inharmonious,

antinatural, and even bizarre. This offshoot of Renaissance balance and order, conventionally known as *mannerism, lasts beyond the death of Titian in 1576. Examples can be found until the end of the century.

ITALIANIZERS. Northern artists, usually Flemish or Dutch, whose style was based on Italian models, poses and motives were called "Italianizers." The word is sometimes used to describe sixteenth-century Flemings like Jan Gossaert, called Mabuse, or Bernard van Orley from Brussels. Both, however, are generally called Romanists (see ANTWERP MANNERISTS).

J

JACOB AND ESAU. Jacob was the twin brother of Esau who was born second, clutching his brother's heel, a sign that he was to supplant him. He was the third of the great Hebrew Patriarchs, a prefigurative "type" of *Christ. While Esau was a hunter, Jacob lived a quiet life among the tents. The rivalry that developed between them was taken as a symbol of the conflict of synagogue and church. Jacob is known for depriving Esau, the oldest, of his father's blessing. He did this with the help of his mother, Rebecca. When the time came to give the blessing, their father, Isaac, old and partially blind, sent Esau out hunting for venison so that a feast could be prepared and the blessing given. Rebecca overheard and instructed Jacob to take his brother's place and obtain the blessing. She dressed Jacob in Esau's clothes and because "Esau was a hairy man" she covered his hands and neck with goatskins. She prepared meat, and Jacob took it to his father and received the blessing. Once given, the blessing could not be undone, and Jacob had to flee his brother's wrath (Gen. 25:19–34; 27; 28:1–5). Jacob is shown kneeling before his father, and Rebecca stands behind him with her hand on his shoulder. Esau may be shown in the background going off to hunt with his dogs, or he may be shown after the hunt entering the room with a deer over his shoulder.

 Example: Lorenzo Ghiberti, *Story of Jacob and Esau*, from the *Gates of Paradise*, bronze relief, 1425–50, Baptistery of S. Giovanni, Florence.

JACOB AND RACHEL. Jacob, the son of Isaac and Rebecca, met Rachel at the well where she was coming to water her father's sheep and goats. He removed a large stone from the mouth of the well and the sheep drank. Jacob kissed Rachel, fell in love, and told her father, Laban, he wanted to marry her. In return for his daughter Laban had Jacob serve him as a huntsman for seven

years. During the wedding feast Laban substituted his elder daughter, *Leah, and then told Jacob he would have to work seven more years for Rachel. As payment for his work Laban gave Jacob all the speckled goats and sheep that were born in his herds. Jacob tricked him by laying tree branches over the animal's drinking troughs. The newly born goats, by some magic, were born speckled. Jacob became wealthy and left secretly for Canaan with both wives and all his possessions. Rachel took her father's teraphim (tiny, sacred figurines), and when he discovered this he chased them down. Rachel hid the teraphim in her camel's saddle and remained seated on the animal while her father searched everywhere. Jacob and Laban, however, were friends before they parted (Gen. 29:9–30; 30:28–43; 31:17–55; 33:1–11). Jacob is sometimes shown kissing Rachel, and numerous goats and sheep drink water in the background. Leah may also be present. Rachel may also be shown sitting upon her camel hiding the teraphim.

Example: Copy after Hugo van der Goes (?), drawing, 1475–1490, Christ Church, Oxford.

JAMES BEFORE HEROD AGRIPPA. Saint James, also known as *James the Greater, the Great, the Elder, and the More, was the brother of Saint *John the Evangelist and Apostle. He was one of the twelve *Apostles. At Jerusalem in the year 44 he was brought before Herod Agrippa who, after putting him on trial, had him beheaded. James is shown standing before Herod Agrippa, who is seated on a high throne. He is shown as a mature man with a beard, his dark hair is usually long, falling to his shoulders and in some depictions he looks like *Christ. Roman soldiers surround him as he listens to his sentence.

Example: Andrea Mantegna, *St. James Before Herod Agrippa*, 1454–1457, Ovetari Chapel, Eremitani Church (destroyed 1944), Padua.

JAMES LED TO HIS EXECUTION. See BEHEADING OF SAINT JAMES.

JAMES THE GREATER. Saint James the Greater was one of the twelve *Apostles. The brother of Saint *John the Evangelist and Apostle, he is said to have been closely related to *Christ. Along with Peter (see PETER, APOSTLE AND SAINT) and John, he was among those who were closest to Christ. The *Gospels frequently mention Christ calling the three aside, thereby suggesting a closer relationship with these three Apostles. They witnessed the *Transfiguration of Christ and were with him during the agony at Gethsemane (see AGONY IN THE GARDEN). Saint James is credited with one of the *Epistles in the New Testament. No word of him is mentioned after the *Ascension of Christ. James met his martyrdom in the year 44 after he was put on trial in Jerusalem by Herod Agrippa (see JAMES BEFORE HEROD AGRIPPA). After the execution, James' body was carried to Spain by his disciples who were guided by an *angel. According to legend his body was buried in Spain at Compostella. After the discovery of James' tomb in the ninth

century, his burial site became a major place of pilgrimage and by the eleventh century it was well recognized. The great church there, Santiago (Spanish for "Saint James") de Compostella, became in the Middle Ages a great center of Christian pilgrimage. Legends surrounding James' life were possibly made popular to encourage the long and dangerous trek to Compostella, located far to the northwest in Spain. Artists show Saint James as a man of mature years with long, dark hair. He may hold a sword, the instrument of his martyrdom (some accounts say Herod Agrippa himself killed the saint), or he holds a pilgrim's staff that may have a gourd hanging from it. A scallop shell, the badge of the pilgrim who journeyed to Compostella, may appear on his hat, cloak, or wallet. See LIBERATION OF THE COMPANIONS OF SAINT JAMES.

Example: Simone Martini and Assistants, *Saint James the Great*, early fourteenth century, National Gallery of Art, Washington, D.C.

JAMES THE LESS. Saint James the Less may also be called James the Brother of the Lord, or James the Just. One of the *Apostles, James became the first bishop of Jerusalem. He is mentioned by Saint *Paul (Gal. 1:19) as being the brother of *Christ. "I went to Jerusalem to obtain information from Peter, and I stayed with him for two weeks. I did not see any other apostle except James, the Lord's brother" (see PETER, APOSTLE AND SAINT). James and Christ may be shown somewhat alike in appearance. According to the *Golden Legend*, his features were so like Christ's that more than once he was mistaken for Jesus. (This is one reason why Judas [see PACT TO JUDAS] was used to point out Christ to the authorities with a kiss.) According to tradition, James met his martyrdom by being thrown from the roof of a temple. Having survived the fall to the ground, he was beaten to death by an enraged mob of pagans with clubs or fulling stocks (wooden beaters used for compacting cloth; also, mallets used to beat oil into hides). James the Less was buried beside the temple. Josephus later said it was in punishment for the murder of James that the destruction of Jerusalem was carried out. Artists, when depicting James as the bishop of Jerusalem, show him in episcopal robes with *mitre and crozier. Otherwise he holds a club or fulling stock.

Example: Master of Wittingau, *Saints James the Less, Bartholomew, and Philip*, reverse of the Resurrection panel, 1380–1390, National Gallery, Prague.

JANUARY. In chronology January is the first month in the cycle of months depicted by artists from the early Christian era. It is found in Renaissance Italy and in Books of Hours in Northern Renaissance Europe. As in other months of the cycle, an illustration of January is usually accompanied by its corresponding sign of the zodiac, Aquarius, the water-bearer. Artists usually show feasting at a heavily laden table. The word "January" is from the Roman god, Janus, who was the god of beginnings in Roman religion. Janus was shown with two heads placed back to back so that he could, while looking in two directions, represent

the past and the future. Janus may also be shown closing the door on an old man and opening another door on a young man.

Example: Limbourg Brothers, January page, *Book of Hours (Les Très Riches Heures) of the Duke of Berry (fol. IV)*, illumination, 1416, Musée Condé, Chantilly.

JEREMIAH (Jeremias). Jeremiah is a book of the Old Testament, twenty-fourth in order of the Authorized Version and second in the books of the Major Prophets. He was one of the four Major Prophets (the others being *Daniel, *Isaiah, and *Ezekiel) who preached in Jerusalem under King Josiah and his successors c. 628–586 B.C. He advocated moral reform, both personal and social, and preached that the Hebrews would find their salvation only through suffering and oppression. His views led to his eventual imprisonment and death by stoning. His book is a commentary on the destruction of Jerusalem at the hands of the Chaldeans in 586 B.C. Jeremiah is most often shown as an old man holding his book, or his work may be in the form of a scroll.

Example: Donatello, marble, 1427–1435, (formally on the Campanile, Florence), Museo dell 'Opera del Duomo, Florence.

JEROME, SAINT. Saint Jerome, c. 347–420 whose Roman name was Sophronius Eusebius Hieronymus, was a Christian scholar, one of the four Latin (Western) *Fathers of the church, and a doctor of the church. He was born of Christian parents (although he was not baptized until the age of nineteen) on the border of Dalmatia and Pannonia at Stridon. He was a classical scholar until he experienced a vision of *Christ who reproved him for his study of pagan literature (see VISION OF SAINT JEROME). He retired to the Syrian desert and lived there as a hermit for four years doing penance, studying Hebrew, and devoting himself entirely to scriptural studies. During this time he experienced dramatic sexual hallucinations (according to the **Golden Legend*, ''until the fires of concupiscence were lighted''), and he tells in one of his works how he beat his breast with a stone until the feverish delirium passed. Some artists show Jerome, his breast torn and bleeding, with his rock nearby or in his hand. It was also in the desert that he thought he heard trumpets signaling the *Last Judgment. In this case he may be shown listening to *angels who sound trumpets above his head. After his desert experience Jerome was spiritual advisor to a number of ladies, one was Saint Paula, whom he had converted to Christianity. Eventually she built convents and a monastery in Bethlehem. It was in this monastery that Jerome worked for fifty-five years and six months translating the Old and New Testaments into Latin. This work is known as the Vulgate. One day while in his study a wounded lion walked up to him. The lion's pads were full of thorns and Jerome cared for the beast who, forever grateful, lived at the monastery and, according to legend, helped with much of the work. (The lion has a long story of its own.) Renaissance artists usually include the lion somewhere in their compositions.

Besides the lion many artists show Jerome with a cardinal's hat and in cardinal's robes, but he was never made a cardinal—the office did not then exist. In 382 he was papal secretary to Pope Damasus I, and perhaps it was in connection with this appointment that he came to be shown in cardinal's robes.

Jerome died at age ninety-eight. When depicting his Last Sacrament, artists show Jerome held by other priests with one holding the cup ready to administer the Sacrament. Artists may also include Saint Paula and the lion.

Example: Vittore Carpaccio, 1507, Scuola di San Giorgio degli Schiavoni, Venice.

JEROME AND THE LION. See JEROME, SAINT.

JEROME IN HIS STUDY. See JEROME, SAINT.

JESUS AMONG THE DOCTORS. See DISPUTE.

JETHRO. See MOSES AND JETHRO'S DAUGHTERS.

JOACHIM IN THE WILDERNESS. See MEETING AT THE GOLDEN GATE.

JOB. In the Bible, in the Book of Job, Job epitomizes the paradox of the righteous man's suffering. He is the just man of Uz who, in the face of destruction, steadfastly refused to give up his God. Job's miseries were the result of a controversy between God and Satan, who argued whether his belief was powerful enough to overcome adversity. His test, administered by Satan, was long and terrible. His children were killed in a hurricane that razed his house; his servants were killed and all his livestock stolen; finally, Job himself was covered with boils and he had nothing left but a pile of dung. Renaissance artists show Job as an old man with a beard, naked except for a rag provided by his comforters that covers the lower half of his body. He may recline uncomfortably on his dung pile while his wife reproaches him in disgust, or she may pour a bucket of water on him. Some Northern Renaissance artists show him being scourged by Satan while his children try to escape their toppling home. In the Old Testament, Job is in eighteenth place in the Authorized Version. Based on folktale, the story is of unknown authorship and date (600 to 400 B.C. are probable dates assigned by many scholars).

Example: Jean Fouquet, *Job and His Comforters, Book of Hours of Étienne Chevalier*, 1452–1460, illumination, Musée Condé, Chantilly.

JOHN ON PATMOS. See JOHN THE EVANGELIST AND APOSTLE, SAINT.

JOHN THE BAPTIST, SAINT. Saint John the Baptist (It. Giovanni Battista) was a Jewish prophet who forms a link between the Old and New Testaments. As the forerunner of *Christ, he is the last in the line of the Old Testament

prophets and the first of the saints in the New. His father was Zacharias, a priest in the Temple of Jerusalem; his mother was Saint *Elizabeth, who was a kinswoman of the Virgin Mary (see MARY, SAINT). His birth was miraculously foretold to Zacharias by the *angel *Gabriel, whom he disbelieved because Elizabeth was barren. Because he did not believe this news, he was struck dumb (Luke 1:5–22). Some artists show him holding his finger to his mouth to indicate this. When Elizabeth gave birth it was proposed to name the child after his father. Elizabeth refused and insisted he be named John. Zacharias, since he could no longer talk, wrote "His name is John" on a tablet, and immediately his ability to talk returned (Luke 1:57–64). Elizabeth is usually shown as a very old woman in bed attended by midwives. The child may be in his mother's arms, or according to an account in the *Golden Legend* held by the Virgin Mary (see BIRTH OF SAINT JOHN THE BAPTIST). John, when a young man, after spending some time as a preacher living an ascetic life in the desert, received a divine call to preach repentance as preparation for the Messiah. In the waters of the Jordan he baptized all who came there, including Jesus, whom he recognized as the Son of God when the *Holy Spirit, in the form of a dove, was seen to descend from above (Matt. 3:5–6). Finally, John's vigorous preaching offended the aristocracy. He enraged Herodias, the wife of Herod Antipas, son of Herod the Great, when he rebuked Herod for having married Herodias, the wife of his brother Philip (Mark 6:17–20). It was her will and the direct request made by her daughter Salome that caused John's execution by beheading (see FEAST OF HEROD and BURNING OF THE BONES OF JOHN THE BAPTIST). Renaissance artists have shown him as a child with the Infant Jesus and as a youth beginning his life in the desert. Also, he is shown as an adult, wearing clothes made of camel's hair. He may carry a lamb and hold a honeycomb (his food, along with locusts in the desert). His attribute is the reed cross.

Example: Albrecht Dürer, *S. John the Baptist and Onuphrius*, woodcut, c. 1502.

JOHN THE BAPTIST IN THE DESERT (WILDERNESS). See JOHN THE BAPTIST, SAINT.

JOHN THE EVANGELIST AND APOSTLE, SAINT. Also called John the Divine, John was the youngest of the twelve *Apostles of *Christ and the traditional author of the fourth Gospel, three *Epistles, and the Revelation. He was the son of Zebedee and the brother of *James the Greater. One of the first to be called to follow Christ, he is called "the disciple whom Jesus loved." The Gospel of John refers to him as "leaning on Jesus' breast" at the *Last Supper, and many artists depict him thus. John, *James the Greater, and Peter (see PETER, APOSTLE AND SAINT) witnessed the *Transfiguration and were with Jesus at Gethsemane (Matt. 17:1–13; 26:36–46; Mark 9:2–13; 14:33–45). Jesus, in his dying moments, asked John to care for the Virgin Mary (see MARY, SAINT) (John 13:23; 19:26; 21:20–23), and in fulfillment of these words John

lived with Mary until her death. Then he journeyed to Asia Minor where he founded seven churches. Eventually he went to live at Ephesus (see TEMPLE OF EPHESUS) where he was persecuted by the Roman emperor Domitian. The emperor ordered him on one occasion to drink a cup of poisoned wine; when John attempted to drink, the poison turned into a snake. According to the *Golden Legend*, the emperor had him thrown into a vat of boiling oil, but he emerged unhurt, even rejuvenated. He was then exiled to the island of Patmos, an island in the Aegean (Revelation 1:9). On the island, living alone, he experienced the series of visions recorded in the Book of Revelation, also known as the *Apocalypse. Domitian died that same year, and the senate revoked all his decrees. Thus, Saint John, who had been exiled as a criminal, returned to Ephesus in glory, where he performed miracles. He died when he was ninety-nine years old. (See ASCENSION OF SAINT JOHN and RAISING OF DRUSIANA.)

Example: Donatello, marble, c. 1410, Museo dell 'Opera del Duomo, Florence.

JOHN THE GOOD, KING. John II, (1319–1369), known as John the Good, was king of France from 1350 until 1364. He was the son and successor of King Philip VI. John was an inept ruler who appointed unpopular and dishonest advisors and after having the constable of France executed, gave the office to a favorite, Charles de La Cerda. In 1356 he was taken prisoner by the English at the Battle of Poitiers. He was later released in exchange for a ransom and hostages. When one of the hostages escaped in 1364, John went voluntarily to England and into captivity to honor his chivalric obligations and save his honor. He died in England.

Example: Girard d'Orleans, *King John the Good*, c. 1356–1359, Louvre, Paris.

JOSEPH, THE STORY OF. Joseph was the favorite son of the Hebrew patriach Jacob and of Rachel (see JACOB AND RACHEL). Although he had ten older brothers, they were only half-brothers, being the sons of handmaidens, or of Leah, Rachel's sister. Joseph was the son of Jacob's old age, and Jacob loved him more than all his children. He gave him a coat of many colors, which was meant to show that Joseph, unlike his brothers, was allowed to enjoy special privileges and remain in his father's house. Joseph had the gift of oneiromancy, the art of interpreting dreams. Being jealous of this and of the coat of many colors, Joseph's half-brothers took his coat and threw him into a pit. When they lifted him from the pit they sold him to some Ismaelite merchants for twenty pieces of silver. The merchants took Joseph to Egypt and when in Egypt he was sold to Potiphar, the captain of Pharoah's guard (Gen. 39:7–20). Potiphar's wife gave him a position of authority in her household and then one day made advances to him, which he refused. She later told her husband that Joseph had tried to violate her. He was shut away in prison but later freed after interpreting Pharoah's dream of the lean and fat kine. Pharoah renamed him Zaphnath-paaneah and appointed him chief administrator. Later Joseph recognized his half-brothers when they were in Egypt to buy corn. He did not disclose his identity, but instead

took one of them hostage and demanded that Benjamin, his real brother who had been left at home, be brought to him. Benjamin was brought to Joseph. Before he left, though, Joseph secretly hid his silver cup in his true brother's sack. After all the brothers had departed Joseph sent servants to find them and search their belongings. The cup was discovered and the brothers were brought back to Joseph. They all promised to be slaves for Joseph, but he claimed he wanted only the thief who had taken his silver cup. The brothers explained that their father Jacob, already near death, would die if Benjamin did not return because he had already lost his favorite son. Joseph then made himself known and forgave them.

Joseph's own children Ephraim and Manasseh, the oldest, were both taken to Jacob's bedside so that Manasseh could receive his rightful blessing. Joseph sat between the two during the blessing with Manasseh on his left and Ephraim on his right so that as they faced Jacob, the old man would automatically extend his hand and bless Manasseh. Jacob, however, crossed his hands over and did not let Joseph uncross them. In this way Jacob blessed the younger child Ephraim saying "His descendants shall be a whole nation in themselves." The story of Joseph is told in Gen. 37–39:7–20; 40; 41:1–45; 42–47 and 48. Artists tell the story in a series of scenes. He is put by his brothers in the well; he is sold to the Ismaelite merchants; he is sold by the merchants to Potiphar whose dreams he interprets and warns of the coming famine and counsels provisions; he recognizes his brothers and forgives them; finally, he meets his father, Jacob.

Example: Lorenzo Ghiberti, *Gates of Paradise* (East Doors), *The Story of Joseph* Panel, 1425–1452, Baptistery, Florence.

JOSEPH OF ARIMATHEA. Joseph of Arimathea was the disciple, a wealthy lawyer, who gave the body of *Christ a decent burial in his own tomb (Matt. 27:57 60). All four of the Evangelists described how the body of Christ was taken down from the cross and how Joseph of Arimathea went to Pilate (see CHRIST BEFORE PILATE) and asked for the body, and the request was granted. Only Saint *John the Evangelist and Apostle tells how Joseph was joined by Nicodemus in wrapping Christ's body in linen, together with spices of aloes and myrrh, "as the manner of the Jews is to bury" (John 19:40). According to legend, Joseph caught the blood from the wound in Christ's side in the Holy Grail, the cup of the *Last Supper, and that he founded the first church at Glastonbury in England. Joseph is shown either on the ground receiving the body of Christ or on a ladder lowering the body. His attributes are the nails and crown of thorns and the shroud.

Example: Michelangelo, *Pietà,* marble, 1555, Cathedral, Florence

JOSEPH'S DOUBT. Saint Joseph was the husband of the Virgin Mary (see MARY, SAINT) and the foster-father of *Christ. He was a descendant of the

house of David and by trade, a carpenter. His last appearance in the *Gospels is Luke 2:42–50 at the finding of the twelve-year-old Jesus in the temple. At one time after his marriage Joseph was momentarily doubtful about Mary's miraculous Immaculate Conception. His fears were relieved when the *angel *Gabriel appeared to him and gave him the explanation. Joseph is shown peering in at Mary, who sits at her table winding wool. An angel hovers above his head giving him the message. In Northern Renaissance painting the message may be written on a scroll and held before Joseph's eyes to read. Joseph's attributes are a lily (for purity), different carpenter's tools, and a flowering rod (the sign from heaven that he was chosen to be Mary's husband). See MARRIAGE OF THE VIRGIN and WATCHING OF THE RODS.

Example: Upper Rhenish, c. 1420, Musée de l'Oeuvre Notre-Dame, Strasbourg.

JOSHUA. Joshua was the successor of *Moses in the Exodus. He was the warrior-leader of the Israelites who captured Jericho, an ancient city of Jordan, in the thirteenth century B.C. (Jos. 2:6) and subsequently conquered the Promised Land, Canaan. The name ''Joshua'' is a variant of the name ''Jesus.'' Just as Joshua was seen as one of the Old Testament prefigurations of *Christ, the fall of Jericho was seen as a foreshadowing of the *Last Judgment. In Renaissance art the following scenes from Joshua's life are the most popular: the crossing of the Jordan; the twelve stones taken from the river; the fall of the walls of Jericho; the Israelites taking the city.

Example: Lorenze Ghiberti, *Gates of Paradise* (East Doors), *The Story of Joshua* Panel, 1425–1452, Baptistery, Florence.

JOVE. See JUPITER.

JUDAS. See PACT OF JUDAS.

JUDE, SAINT. Jude was one of the twelve *Apostles whose name was also Judas, ''the other Judas, not Iscariot'' (John 14:22), and is known as Saint Jude, an English form, to distinguish him from Judas Iscariot, also one of the twelve Apostles and the betrayer of Jesus. Alternately called Thaddeus and Lebbaeus, he was said to have preached after the *Crucifixion of *Christ in countries bordering Palestine. The *Epistle of Jude, a book of the New Testament, is sometimes attributed to Saint Jude. His death, martyrdom by being either clubbed to death or run through with a lance, according to various accounts, occurred in Persia. He is usually shown holding a lance, club, or halberd (an iron spear mounted on the end of a long shaft).

Example: Andrea Bregno, marble, fifteenth century, William Rockhill Nelson Gallery of Art, Kansas City, Missouri.

JUDGMENT DAY. See LAST JUDGMENT.

JUDGMENT OF CAMBYSES. See JUSTICE OF CAMBYSES.

JUDGMENT OF PARIS. Paris, one of the sons of Priam, king of Troy, was a Trojan prince who was also a shepherd, known as Alexandros in Homer. He is the legendary figure held responsible for the *Trojan War because of his *Abduction of Helen from Menelaus. It was prophesied at his birth that he would bring devastation at Troy. This is why he was left as an infant to die at the foot of Mt. Ida. Fortune dictated his rescue by shepherds and they brought him up. In later legend, Oenone, a *nymph of streams and fountains, loved him, but he abandoned her for Helen, the Spartan queen. Also, later legend introduced the Judgment of Paris, the account of a beauty contest between *Venus, Minerva, and Juno. Paris awarded the prize, a golden apple, to Venus. He is usually shown with three beautiful contenders wearing filmy, revealing veils and richly adorned from the neck up with jewelry. Sometimes he is shown with another judge, and they discuss the three nearly naked beauties.

Example: Lucas Cranach the Elder, 1530, Staatliche Kunsthalle, Karlsruhe.

JUDGMENT OF SOLOMON. Solomon (c. 972–931 B.C.) was the third king of united Israel, son of *David and Bathsheba, who probably succeeded David c. 970 B.C. The account of the Judgment of Solomon is found in 1 Kings 3:16–28. Solomon was called upon to judge two women in an argument over a child. Both lived in the same house, and both had given birth to a child. One child had died and each woman then argued that the other belonged to her. To settle the argument, Solomon ordered a sword and said, ''divide the living child in two, and give half to one, and half to the other.'' Upon hearing these words the true mother of the child revealed herself by giving up her child because she loved the infant so much and did not want to see it die. She said, ''O my lord, don't kill the child. Give it to her.'' But the other woman said, ''Don't give it to either of us; go on and cut it in two.'' Solomon was able to identify the real mother from these words and restored the child to her. Renaissance artists usually show Solomon on his throne surrounded by courtiers. The two women, usually one on each side of him, argue, their hands in dramatic gestures. The executioner stands off to one side with the child in one hand and a sword in the other.

Example: Titian, *The Judgment of Solomon,* c. 1512, Loggia of the Palazzo della Ragione, Vicenza (destroyed).

JUDITH AND HOLOFERNES. Judith is the biblical book included in the Old Testament of the Western Canon and Septuagint, and in the Apocrypha in the Authorized Version. Judith, the heroine, is symbolically the patriotic heroine of the Jews' struggle against their oppressors in the Near East. According to Apocrypha literature (10:5), Judith saved the people of her city, Bethulia. When Nebuchadnezzar's General Holofernes commanded his army to attack Bethulia,

Judith devised a plan to save her people just as they were at the point of surrer
Being a Jewish widow of great beauty and devotion, she dressed herself "ʼ
to catch the eye of any man who might see her," and with her maid left her
city and entered the Assyrian lines. As she was extremely beautiful and claimed
to have a plan to take the city, the soldiers took her and her maid to their general.
He was impressed with her beauty and intelligence, and when she told him of
her plan he believed her. She remained in the camp for three days, leaving only
at night to pray. On the fourth day Holofernes held a banquet for his army officers
and invited Judith. During the festivities Holofernes became very drunk so that
when the party was over and the two were alone, instead of seducing Judith, as
he had planned, he fell asleep. Judith took his sword, cut off his head, and put
it in a sack held by her maid. The two took the head back to Bethulia, and the
Jews routed the armies. Judith was seen as a woman of great sacrifice and
nobility. Artists nearly always show her either holding the head of Holofernes
after she has cut it off, or she is in the act of beheading him. Her maid, usually
an older woman, holds the sack open to receive the general's head.

Example: Donatello, bronze, 1486, Piazza della Signoria, Florence.

JULIAN, SAINT. Julian the Hospitator is a ninth-century legendary figure about
whom little is known. In medieval romance the story is that Julian was a nobleman
who spent a great deal of time hunting. It was foretold that one day he would
accidently kill his mother and father. A stag that he was chasing one day turned
to him and said, "Thou that pursuest me to death shall cause the death of thy
father and mother." Julian left his home and began to travel. During his travels
he met and married a beautiful woman named Basilissa. Julian's mother and
father, sick with grief over the loss of their son, went to look for him. Finally
they found his new home, but he was away when they arrived. Basilissa received
them happily and gave them her own bed so that they might rest. Julian, returning
home unexpectedly in the early morning, was furious to find two people in his
wife's bed and he killed them both. When he discovered his crime he promised
never to rest until *Christ had forgiven him. To atone for his crime he and
Basilissa set out upon a pilgrimage. They came to a river and set up a hospital
for the poor where travelers could be cared for. Julian also built a penitential
cell for himself. In the middle of a storm one night Julian saw a leper dying of
cold on the other side of the river. Risking his life, Julian ferried across the
river, brought the dying man back, and gave him his own bed to recover. When
Julian came to him the next morning the leper had been transformed into an
*angel. He announced that Julian by his penitence had been forgiven for his
crime. Julian may be shown slaying his mother and father or carrying the leper
across the river on his shoulders. He may be shown as a huntsman with a stag
by his side, and the river and a boat may be in the background, a reference to
his work as a ferryman. Julian is the patron saint of travelers, ferrymen, and
traveling minstrels. Inns, hospitals, and churches are named after him.

Example: Andrea del Castagno, *St. Julian*, c. 1454, Church of the Santissima Annunziata, Florence.

JULY. One of the twelve months in the cycle of months, July was represented from the early Christian era. July's corresponding sign of the zodiac is Leo the Lion. Peasants are usually shown cutting corn, carrying sheaves, or threshing. Some may be sharpening sickles in preparation for the harvest.

Example: Limbourg Brothers, July page, *Book of Hours (Les Très Riches Heures) of the Duke of Berry* (fol. 6v), illumination, 1416, Musée Condé, Chantilly.

JUNE. One of the twelve months in the cycle of months, June was represented from the early Christian era. June's corresponding sign of the zodiac is Cancer the Crab. Artists usually show men at their summer work in the fields, carrying scythes and carrying or cutting hay. Sometimes Phaeton (in Greek mythology the son of Helios, the sun-god) is seen racing his chariot across the sky.

Example: Limbourg Brothers, June page, *Book of Hours (Les Très Riches Heures) of the Duke of Berry* (fol. 6v), illumination, 1416, Musée Condé, Chantilly.

JUPITER. Originally the Italian sky-god of rain and agriculture, Jupiter, also called Jove, was identified as Zeus, the Olympian father and supreme ruler of all gods and mortals. He was chief of the twelve Olympians. As god of the sky, he used thunderbolts to destroy his enemies. Jupiter was the son of Saturn (Cronus), the god who devoured all his children because it had been prophesied that one would overthrow him. Jupiter survived because his mother, who had fled to Crete for his birth, gave Saturn a stone wrapped in swaddling clothes, which he ate. He was brought up by *nymphs. The traditional image of Jupiter may have come from the statue of him, one of the seven wonders of the ancient world in gold and ivory (now lost) carved by Phidias. It was located at the seat of his worship, the Temple of Zeus at Olympia. Jupiter became famous because of his numerous metamorphoses and seductions. One, popular to Renaissance humanists, was the seduction of the shepherd Ganymede by the god in the form of an eagle. See GANYMEDE.

Example: Antonio Correggio, *Jupiter and Ganymede*, early 1530s, Kunsthistorisches Museum, Vienna.

JUPITER AND IO. In Greek mythology Io was the daughter of Inachus, the first king of Argos. Ovid (*Metamorphoses* 1:588–600) tells how *Jupiter (Zeus) changed himself into a cloud and seduced her. He thought the cloud would conceal his infidelity from Juno (Hera) his wife. Juno was not fooled, and, when Jupiter turned Io into a white heifer to protect her *(Metamorphoses* 1:639–663), Juno asked for the animal as a present. Once the heifer was in her possession she sent Argus, the hundred-eyed giant, to guard it. Jupiter then sent Hermes to recover Io. Hermes killed Argus by cutting off his head. After this Juno sent a gadfly to pester Io. The gadfly chased her across Europe and then Asia, and

finally she came to rest in Egypt. In Egypt Jupiter returned her to human form and she bore his child Epaphus. The most popular scene shown by artists is Jupiter in the form of a cloud seducing Io who appears to be in ecstasy.

Example: Antonio Correggio, early 1530s, Kunsthistorisches Museum, Vienna.

JUSTICE. Along with Temperance, Fortitude, and Prudence, Justice is one of the four cardinal *virtues and, according to Renaissance humanists, Justice was the leader of the other three virtues. During the Renaissance the topic of Justice was very popular. Her emblems shown most frequently by artists are the sword, an allusion to her power, and a scale, which indicates her impartiality. She usually holds these, one in each hand. She may also be accompanied by a lion, which personifies justice for everyone.

Example: Jacobello del Fiore, *Justice with Saints Michael and Gabriel*, 1421, Accademia, Venice.

JUSTICE, INJUSTICE, AND INCONSTANCY. Justice is the leader of the four cardinal *virtues. According to Plato, Justice regulates the actions of the ideal city. Justice is shown as a regal figure, crowned and enthroned within a royal architectural setting. Commerce, agriculture, and travel, essential human activities of the city, proceed before her undisturbed. Her counterpart, Injustice, is shown as a man seated to her left, also in regal dress, within a gate or entrance to his castle. He presides over murder, rape, and plunder. To the left of Injustice is Inconstancy, a woman dressed in a plain gown. She is shown standing on a wheel trying desperately to maintain her balance (a balance that is essential to the existence of mankind).

Example: Giotto, 1305, Arena Chapel, Padua.

JUSTICE OF CAMBYSES (Judgment of Cambyses). During the sixth century Cambyses was king of the Medes and Persians. According to Herodotus (*History* 5:25), Cambyses, upon discovering an unjust judge named Sisamnes, had him punished by death. The judge's body was flayed and the skin hung over the seat of judgment. Then Cambyses appointed the judge's son to his father's position and ''bade him never forget the way in which his seat was covered.'' Some artists show the judge's arrest by Cambyses and others show the flaying. Sisamnes is shown gritting his teeth as the executioner removes the skin very carefully so as to preserve the pieces intact. Cambyses and a group of Flemish judges act as witnesses.

Example: Gerard David, *Judgment of Cambyses*, depicting the seizure and flaying of Sisamnes, 1498, Groeningemuseum, Bruges.

JUSTICE OF EMPEROR OTTO III. The ''justice'' derives from a tale found in the *Pantheon* of the twelfth century historian Godfrey of Viterbo. Otto III (or Otho) was born near Viterbo, Italy, in 980. He died in 1002. He was a German king and Holy Roman emperor who hoped to recreate the glory and power of

the ancient Roman Empire in one universal Christian state governed from Rome. He planned to have the pope subordinate to the emperor in religious as well as secular affairs. At one time he assumed the titles "the servant of Jesus *Christ," "the servant of the *Apostles," and "emperor of the world." He saw himself as the leader of world Christianity. The "Justice of Otto," sometimes known as the "Judgment of Otto," involved a situation with his wife who, according to the story, caused the execution of a German count. In revenge for the rejection of her repeated advances, she told her husband that the count had insulted her with his advances. Otto had the count beheaded. The count's widow accompanied him to his execution and at this time he swore to her his innocence. She believed him. In order to prove her husband's innocence, she voluntarily underwent the ordeal by red-hot iron (which was held in the hand for a prescribed length of time), at that time a normal and accepted way to establish innocence or guilt. During the ordeal she stood before Otto, her husband's head in her right hand and the red-hot iron bar in her left hand. Otto, amazed and satisfied, atoned for his earlier wrong decision by having his wife burned at the stake. The count is shown on his way to execution, his wife at his side listening to his words of innocence. She is shown receiving his head and then holding the red-hot iron bar while Otto, on his throne, lifts his hand in amazement. Otto's wife is shown in the background burning at the stake.

Example: Dirk Bouts, 1470–1475, Musées Royaux des Beaux-Arts, Brussels.

JUSTINA, SAINT. Justina was a Christian virgin who lived during the third century under the reign of Diocletian. According to the *Golden Legend,* a magician of Antioch named Cyprian fell in love with her and tried with all his magical powers to have her love him in return. A magic ointment was spread on the outside of her house and a demon went in to her, but when she became aware of his intentions of arousing illicit desire in her heart, she covered her whole body with signs of the cross. So strong was her belief in God that she finally converted Cyprian to the faith. When brought before the authorities they both refused to sacrifice to pagan gods and were thrown into a cauldron filled with wax, pitch, and sulphur. They were taken out of the cauldron and beheaded together. Their bodies were left exposed to dogs for seven days, but remained untouched. Artists sometimes show the two together. She is young and beautiful and usually has a unicorn at her side and a martyr's palm in her hand. If Cyprian is included, he may hold a sword and trample his books of sorcery under his feet.

Example: Giambattista Moretto, *Saint Justina with a Donor*, early 16th century, Kunsthistorisches Museum, Vienna.

K

KISS OF JUDAS. See BETRAYAL.

KORAH, DATHAN, AND ABIRAM. See PUNISHMENT OF KORAH, DATHAN, AND ABIRAM.

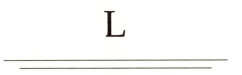

L

LABORS OF ADAM AND EVE. After the Expulsion from the Garden of Eden (Gen. 3:8–24), *Adam was condemned to toil in the fields until the day he died. Eve was condemned to painful childbearing and to be dominated by Adam. Artists show Adam as being young and muscular and digging in the ground with a primitive shovel. Eve, sometimes shown with her two children, Cain and Abel, watches sorrowfully. Sometimes she holds a card of wool.

Example: Jacopo della Quercia, 1425–1438, relief panel, main Portal of San Petronio, Bologna.

LABORS OF HERCULES. See HERCULES.

LADY IN HER BATH. See TOUCHET, MARIE.

LAMENTATION. See PIETÀ.

LANDSCAPE PAINTING. As an independent type of topic, landscape painting did not emerge in Italy until the Renaissance. In Renaissance Italy Leonardo da Vinci saw painting as more than mere illustration. To him the landscape was a world by itself. His notes contain numerous observations relating to landscape painting. However, credit for the first ''pure'' landscape painting must go to Albrecht Altdorfer, a Bavarian painter who traveled the Danube area and visited the Austrian Alps, where he was moved by the scenery. Producing numerous drawings and etchings of pure landscape, he became head of the *Danube School, which pioneered in modern landscape painting.

Example: Wolf Huber, *Mondsee*, 1510, National Museum, Nuremberg.

LAPITHS AND CENTAURS (The Battle of Lapiths and Centaurs, The Rape of Hippodamia, Fight Between the Lapiths and Centaurs). The Lapiths were a primitive, peace-loving mountain tribe who lived in Thessaly. The Centaurs were, in Greek myth, a race of wild creatures, half-human, half-horse, who lived in the mountains of Thessaly. Described as ''wild beasts'' by Homer, they represented primitive, unbridled desire and were known for fighting, getting drunk, and chasing women. The story of their famous battle with the Lapiths at the marriage of Hippodamia with Lapith king Pirithous is well known from the detailed account in Ovid (*Metamorphoses* 12:210–535). According to Ovid, King Pirithous invited the Centaurs to his wedding, but it was not long until the Centaur Eurytus, drunk, tried to rape the bride. A bloody battle raged until Theseus, a friend of King Pirithous, drove the Centaurs away. During the Renaissance the theme symbolized the victory of civilization over barbarism. Hippodamia is usually shown struggling in the arms of Eurytus. A ferocious fighting scene surrounds them. Theseus may be shown in armor swinging a sword or huge club.

Example: Piero di Cosimo, c. 1500, National Gallery, London.

LAST JUDGMENT (Judgment Day, Final Judgment). The Last Judgment is a central issue of Christian eschatology. In the New Testament the doctrine of Last Judgment states that this world will come to an end. At that time the dead will be raised up in a general *Resurrection, and *Christ will come to judge not only the living, but the dead. The condemned (sinners) will be consigned to *hell and the chosen (those free from sin) will live in paradise forever. Although scriptural reference is plentiful, the principal authority is Matt. 25:31– 46. Christ said,

When the Son of Man comes as King and all the angels with Him, He will sit on His royal throne, and the people of all the nations will be gathered before Him. Then He will divide them into two groups, just as a shepherd separates the sheep from the goats. He will put the righteous people at His right and the others at His left . . . These, then, will be sent off to eternal punishment, but the righteous will go to eternal life.

The reign of Christ upon earth was fully expected to begin in the year 1000. According to Christian millenarianism, Christ was supposed to return to rule the earth for a period of a thousand years. Satan was supposed to return for a short time and be destroyed. When Christ's reign upon earth failed to materialize, the Church's teaching began to stress the doctrine of the ''Four Last Things,'' death, judgment, heaven, and hell. From this time artists begin depicting the Last Judgment. Many Renaissance artists used the same scenes depicted on Romanesque churches and Gothic cathedrals. Christ is shown seated on a throne, his hands raised with palms outward so as to display his wounds. Some Italian artists of the fifteenth century show Christ hurling arrows at the damned. Early Renaissance painters show the saints and *apostles lined up in formal rows on either side of Christ, but later Renaissance depictions show them freely grouped around

him. The Old Testament patriarchs and prophets (the twenty-four elders of the *Apocalypse), may be included and even such medieval saints as *Dominic and *Francis of Assisi. If the Virgin is included, she is usually shown kneeling to the right of Christ and acts as interceder for those about to be judged (see INTERCESSION of the VIRGIN MARY). (Rarely she is shown in the role of judge herself, sitting beside Christ with equal status.) Saint *John the Baptist may be kneeling beside Christ. Near the bottom of the work, the dead may emerge from their tombs or out of jagged cracks in the earth, even occasionally from the sea. Some artists show them as skeletons when they leave the earth and gradually acquiring flesh as they emerge. Saint *Michael, a weigher of souls, may be shown in armor holding a balance. The soul may be be shown as a tiny naked figure kneeling in prayer. Or Michael may stand guard, sword drawn and barring the way of those consigned to hell as they try to avoid punishment. Angels usually blow on trumpets to raise the dead and accompany the saved to heaven. They too may help Michael drive the damned back into hell. Some artists show them holding the instruments of the *Passion. Heaven was depicted as a Gothic church or an archway with Peter (see PETER, APOSTLE AND SAINT) at the gate. Hell is shown in a variety of ways. Some Renaissance artists retained the medieval image of gaping jaws; others show a cavern. Both are located in the lower right of the work (to the left of Christ). In this area the damned are being driven by ugly demons with long forks or dragged by the hair toward the fire. Some are carried or pulled down to the spot by monsterlike demons. During the Renaissance Michelangelo introduced a new motif that was used frequently thereafter. From the *Inferno* (3:82ff), he showed Charon taking the condemned to hell in his boat; he whips them with his paddle. They receive their sentence from Minos, who is shown with his snakelike tail around his body to denote the appropriate number of the sinner's circle.

Example: Michelangelo, *The Last Judgment*, 1534–1541, Sistine Chapel, Vatican, Rome.

LAST SUPPER. The last meal that *Christ had with his disciples in Jerusalem before his *Betrayal by Judas (see PACT OF JUDAS) and his subsequent arrest is known as the "Last Supper." This scene, one of the events collectively called the *Passion, is described in the *Gospels (Matt. 26:17–29; Mark 14:12–25; Luke 22:7–23; John 13:21–30). It was at this meal that Christ announced to his disciples that one of them would betray him. He took the cup, gave thanks, and gave it to them and told them to drink all of it because it was his own blood shed for the remission of man's sins. The meal, a celebration of the Jewish feast of the Passover, is the basis for the Christian rite of Communion. The disciples are usually seated at a rectangular table with Christ in the center performing the actions of the priest. He may be in the process of handing a communion wafer to one of the disciples, consecrating a loaf, or sitting at the center of the table with his hands outspread as he seems to tell the disciples that one of them is going to betray him. Judas may be shown apart from the others or on the opposite

side of the table. He may be shown in shadow, have a black halo, or he may be without one. He has two reasons for holding a purse. He was the steward in charge of the purse, or the purse may hold the thirty pieces of silver, the money received for the betrayal.

Example: Leonardo da Vinci, 1495–1497/98, Refectory, Sta. Maria delle Grazie, Milan.

LAWRENCE DISTRIBUTING THE TREASURES OF THE CHURCH.

Lawrence, also Laurence (It. *Lorenzo*), was a third-century saint born at Huesca in Spain who died in Rome in the year 258. He studied at Saragossa where he met Pope Sixtus II, who took him back to Rome and had him ordained deacon. In this office, Lawrence was in charge of all the treasures of the church. Tradition has it that when Sixtus was arrested by the prefect of Rome and condemned to execution because of his religion, Lawrence wanted to die with him. Sixtus, however, instructed Lawrence to follow him to martyrdom in three days. During the three-day interval Lawrence gave all the treasures of the church to the poor. He was ordered by the Roman prefect to give them up, but by that time Lawrence had completely carried out the instructions of Sixtus and had gathered around him a crowd of the sick and poor. He told the prefect, ''Here are the treasures of the church.'' The prefect was enraged and ordered that Lawrence be roasted to death slowly, a torture he underwent with equanimity. Lawrence is usually depicted as a young man wearing the deacon's *dalmatic, bearing the palm of martyrdom, and carrying the gridiron upon which he was roasted. It usually appears as a rectangular metal lattice. When distributing the treasures of the church, he holds a bag of money and is surrounded by cripples, beggars, women, and small children. They extend their hands to receive the alms. See MARTYRDOM OF SAINT LAWRENCE.

Example: Fra Angelico, 1447–1450, Chapel of Nicholas V, Vatican, Rome.

LAY-FIGURE.

A lay-figure is a detailed, sometimes life-size, model of the human figure with arms and legs attached in such a way that it can be posed and copied by an artist. The first description of a lay-figure is found in the third book of Antonio Filarete's *Treatise on Architecture* (1451–1464). Although the art historian Giorgio Vasari mentions a life-size model of wood made by Fra Bartholommeo, most of the Renaissance lay-figures were small and called manikins.

LAY-IN.

Lay-in is the traditional method of oil painting. The artist began by making an exact drawing of his subject on the canvas. Then he filled in or ''laid in'' the contours in monochrome, usually a brown, grey, green, or dull red. In this manner the whole design and tonal effect, without the actual color, was completely worked out.

LAZARUS. See RAISING OF LAZARUS.

LEAH. Leah was Laban's elder, uglier daughter and Jacob's first wife (Gen. 29–30). See JACOB AND RACHEL.

Example: Michelangelo, *Tomb of Julius II,* marble, finished 1547, San Pietro in Vincoli, Rome.

LEDA AND THE SWAN. Leda was the mother of Clytemnestra, Helen, and the twin brothers Castor and Pollux (Polydeuces). She was an Aetolian princess, the daughter of Thesios, king of Aetolia, and wife of Tyndareus, king of Sparta. A Greek myth relates how Leda was loved by *Jupiter (Zeus) in the form of a swan when he came to her by the river and seduced her. Sometime after this union Leda produced one or perhaps two eggs—versions differ—from which were hatched Castor and Pollux, Helen of Troy and Clytemnestra. Although this is the most popular legend, variants can be found. The swan is usually shown enfolding Leda's body, craning its long neck toward her face, as she reclines on her back.

Example: Rosso Fiorentino, after Michelangelo, early 1530s, National Gallery, London.

LEO, SAINT. See MIRACLES OF THE VIRGIN.

LEO X. A Florentine named Giovanni de' *Medici, Leo X was pope from 1513 to 1521. He succeeded Julius II. The son of Lorenzo de' *Medici (the Magnificant), he was made a cardinal early in life and before his thirtieth birthday he was head of his family. Although a noteworthy patron of art, he was not a competent ruler. He was a dilettante of letters but not concerned with the advancement of the church. His pontificate was noteworthy because it was during this time that the Protestant Reformation began in Germany (1517), and he was a patron to the painter Raphael. He also continued the rebuilding of Saint Peter's in Rome. Leo sold indulgences (the activity that prompted Martin Luther to post his famous theses) to provide income for his massive building program. (see TRAFFIC IN INDULGENCES). There is no evidence that he realized the gravity of the situation, and he failed to deal effectively with it. In fact, the only solution he offered was to ban Martin Luther in 1521. Leo is usually shown not occupied with affairs of state but with the delight of possession and antiquarian erudition. He is shown by Raphael sitting at a table, at which he is enjoying a magnificent *Trecento illuminated manuscript (so accurately painted that the original has been identified).

Example: Raphael, *Pope Leo X with Cardinals Giulio de' Medici and Luigi de' Rossi,* c. 1517, Uffizi Gallery, Florence.

LIBERAL ARTS, SEVEN. See SEVEN LIBERAL ARTS.

LIBERATION OF SAINT PETER FROM PRISON. The story of Saint Peter's (see PETER, APOSTLE AND SAINT) miraculous release from prison is told in Acts 12:1–11. It happened during the time of King Herod Agrippa's persecution. Herod had Peter arrested and put into prison during the Festival of Unleavened Bread. He was guarded by four groups of four soldiers each. Herod planned to put him on trial after Passover. The night before the trial Peter was sleeping between two guards and tied with two chains. Guards were on duty at the prison gate. Suddenly an *angel appeared in Peter's cell, woke him up, and told him to stand. The chains fell off Peter's hands. He thought he was seeing a vision, but he followed the angel and passed the first guards unnoticed and then the second guard station unnoticed. When Peter and the angel came to the iron gate that opened into the city, they saw it open by itself. As they walked down the street, the angel disappeared. The story was seen as symbolic of the coming deliverance of the church from persecution. Peter is usually shown in his cell chained. A guard stands on either side of him, and the angel, appearing in a shining light, stands before him and points to freedom.
 Example: Raphael, 1513, Stanza d'Eliodoro, Vatican, Rome.

LIBERATION OF THE COMPANIONS OF SAINT JAMES. The companions or disciples of Saint *James the Greater were liberated miraculously after the saint had been beheaded. According to the *Golden Legend* James' companions took his body and searched for a suitable burial place. *Angels appeared and guided them to Padron in Galicia, Spain, where they placed James' body on a great stone, which immediately softened and changed shape to form a sarcophagus fitted to his height and shape. His companions then went to the pagan queen Lupa (later converted to Christianity by a series of miracles), told her the story of their miraculous arrival, and requested her to appoint a burial site. She deceitfully sent them to the king of Spain, who had them arrested and thrown into prison. During the night, however, an angel set them free. When the king learned of this he sent soldiers in pursuit; just as the soldiers were crossing a bridge, the structure collapsed and the soldiers were drowned. Artists usually show this final scene. The bridge has collapsed; horses and soldiers flounder in the water. James' companions stand on the bank watching. James may stand with them recognizable by a halo and a pilgrim's staff.
 Example: Jacopo Avanzo, c. 1374, Chapel of St. Felix, S. Antonio, Padua.

LIBYAN SIBYL. Although many Sibyls existed in antiquity, the Libyan Sibyl is one of the twelve pagan women endowed with the gift of prophecy recognized as foretelling the life and *Passion of *Christ. The Libyan Sibyl, from Libya, and the last of her line, is shown as a young woman holding a book, one of the Sibylline Books in which the Sibyl's prophecies were recorded. Her special

attribute is a torch or candle. She usually wears a kind of turban and sits on a throne.

Example: Michelangelo, 1511, Sistine Chapel Ceiling, Vatican, Rome.

LINE ENGRAVING. Line engraving is a method of *engraving with a *burin in which this tool is pushed into a copper plate, cutting a clean V-shaped furrow, while the shavings are thrown up in a spiral from the moving point. These shavings and the slight *burr raised at the sides of the V are cut off by a scraper, which is also used for making corrections. Tone and shading may be suggested by cross-hatching, parallel strokes, or textures made up of different dots and flicks. The process of line engraving probably originated in the workshops of goldsmiths in the middle of the fifteenth century first in Germany, then in Italy.

LITANY. The word "litany" is from the Greek *litaneia*, meaning "supplication." It is a form of group prayer made up of a series of invocations and supplications either read or sung by the clergy with responses from the congregation.

LITTLE BOAT. See CHRIST WALKING ON THE WATER.

LITTLE MASTERS. Little Masters, an English term, is a misleading translation of the German *Kleinmeister* which means "Masters in Little." The artists being described were a group of sixteenth-century engravers who worked small plates of illustrating mythological genre or biblical scenes. Outstanding engravers of this kind of work were the Nuremberg masters Hans Sebald Beham, his brother Bartel Beham, and Georg Pencz. They were all influenced by Albrecht Dürer. Artists who may be included because of some of their work are Hans Brosamer, Heinrich Aldegrever, and Albrecht Aldorfer.

LITURGY. The liturgy is a collection of rites or series of rites observances or procedures for public worship; specifically, in the Roman Catholic, Orthodox, and Anglican churches, the collection in accordance with the authorized or standard form used in the celebration of the *Mass.

LOST WAX PROCESS. See BRONZE.

LOT AND HIS DAUGHTERS. The story of Lot and his daughters is told in Gen. 19:30–38. According to this account, the Lord had decided to destroy the sinful cities of Sodom and Gomorrah. Lot, his wife, and two daughters were chosen to be saved because Lot was a good man. An *angel told him to leave the city with his family, but it was necessary that not one of them look back. Lot's wife looked back and was turned into a pillar of salt. After this, Lot, very much afraid, took his two daughters and moved up into the hills and lived in a mountain cave. After a time they decided they wanted children and there were

no men for them to marry. They believed that they were the only humans on earth left to perpetuate the human race. They conspired together to seduce their father. By making him very drunk he received them each in turn in his bed without realizing what he was doing. Both daughters became pregnant by their own father. The older daughter had a son, whom she named Moab. The younger daughter had a son also whom she named Benammi. The name Moab sounds like the Hebrew for "from my father." The name Benammi in Hebrew means "son of my relative" and sounds like the Hebrew for "Ammonite." Lot and one of his daughters are usually shown in some kind of embrace. They are both nude. The other daughter may be in the background waiting. The wine is nearby.

Example: Albrecht Altdorfer, 1537, Kunsthistorisches Museum, Vienna.

LOUIS OF TOULOUSE CROWNING ROBERT OF ANJOU KING OF NAPLES. Louis of Toulouse, the second son of Charles II, king of Naples, and the great-nephew of Louis IX of France, was born in 1274 and died at the early age of 23 in 1297. He renounced the throne of Naples in favor of his brother Robert and entered the *Franciscan order. He was consecrated as bishop of Toulouse at a very early age and was canonized the year of his death. (Some accounts say he was canonized in 1317.) Artists show him as an extremely young bishop. The golden fleurs-de-lis are embroidered on his cope (a large, capelike vestment worn by priests at certain ceremonies), signifying his kinship with the French throne. A crown and sceptre may be at his feet in reference to the throne he renounced, or he may still wear the crown and hold the sceptre. His brother Robert kneels before him.

Example: Simone Martini, *Saint Louis of Toulouse Crowning Robert of Anjou, King of Naples*, 1317, Museo di Capodimonte, Naples.

LUCRETIA (The Rape of Lucretia). The story of Lucretia is told by Livy (*History of Rome* 1:57–59) and also by Ovid in his *Fasti* (2:725–852). Lucretia and her story are probably legendary. In early Rome, Lucretia, the wife of a nobleman, Tarquinius Collatinus, was a very beautiful and virtuous woman. One night when she was alone in her chamber, Sextus, the son of the tyrant Tarquinius Superbus (Tarquin the Proud), came to her. He threatened that unless she gave herself to him he would murder her, cut a slave's throat, and place his dead body beside hers. Everyone would believe she had been caught in her bed with a slave. Lucretia gave in to him, but later found her shame to be too great. After she told her father and husband the truth in a letter she killed herself. This resulted in the rebellion led by Junius Brutus, the nephew of Tarquin, and the expulsion of the Tarquins. Lucretia, usually nude, is shown on her couch with Sextus, who struggles for her attention and threatens her with a knife. A servant may stand in the room holding a light. She may also be shown taking her own life either by falling on a sword or, dagger in hand, ready to stab herself.

Example: Urs Graf, pen drawing, 1523, Kupferstichkabinett, Basel.

LUCY, SAINT. Lucia or Lucy was a third- or fourth-century saint who, according to legend, was from Syracuse in Italy. Some accounts say she met her martyrdom in 304 during the emperor Diocletian's persecution of Christians. She was the daughter of a noble lady, Eutychia, who suffered from an incurable eye disease. Lucy took her mother, after much persuasion, on a pilgrimage to the shrine of Saint Agatha in Catania. There Lucy saw Agatha in a vision. The saint told her that her mother would be cured, but that she herself would suffer martyrdom. The miraculous healing of her mother moved Lucy to distribute her wealth among the poor. This upset the young man to whom she was betrothed, and he denounced her to the magistrate Paschasius as a Christian. When she refused to recant, soldiers were ordered to drag her away to a brothel, but she stood fast even though she was tied to a team of oxen. The governor ordered her to be tortured, but she survived all they inflicted upon her. She was boiled in urine, oil, and pitch, her teeth were drawn one by one, her breasts sheared, molten lead was poured in her ears, and the governor ordered her to be burned alive. The flames did not touch her. Finally, one of the soldiers stabbed her in the neck with a poniard and killed her. One legend says she impatiently plucked out her eyes one day and sent them to a man who loved her because he would not stop telling her how beautiful they were. This may explain why one of her special attributes is her eyes. They lie on a plate or sprout from a stem in her hand. Her other attributes are a poniard, a wound in her neck, and a lamp, to suggest divine light and wisdom. The name Lucy also suggests light. During the Renaissance Lucy was shown in narrative cycles that showed her praying before Agatha's tomb, distributing her riches to the poor, her betrothed denouncing her to the magistrate, the team of oxen attempting to drag her, and her execution.

Example: Domenico Veneziano, *Saint Lucy Altarpiece: Madonna and Child with Saints*, c. 1445, Uffizi Gallery, Florence.

LUKE, SAINT. Luke was a Syrian, a native of Antioch. By profession he was a physician and was described by Saint *Paul (Col. 4:14) as "the beloved physician." Luke is well known because of his authorship of the third *Gospel and its sequel, the book of The Acts of the *Apostles. He became Paul's constant companion and faithfully recorded his life. He accompanied Paul on his second missionary journey and went with him to Rome. After Paul's death he continued preaching alone in Egypt and Greece and died a martyr's death by crucifixion in Greece, although Greek tradition says he died a natural death. He was supposed to have been a painter and is the patron saint of painters. Luke's most frequent attributes are the winged ox, possibly because in his Gospel he emphasizes the priesthood of *Christ, and the ox symbolizes sacrifice; his Gospel; and a portrait of the Virgin. He is usually shown writing the Gospel with the ox always in close proximity. Sometimes he is shown drawing or painting the Virgin. See LUKE PAINTING THE VIRGIN.

Example: Giovanni di Paolo, *Saint Luke the Evangelist,* mid-fifteenth century, Seattle Art Museum, Seattle.

LUKE PAINTING THE VIRGIN (Luke Drawing the Virgin). One of the four *Evangelists, Luke, according to tradition, loved to draw and paint. He is supposed to have painted several portraits of the Virgin, although those ascribed to him have been done so without foundation. Because of this he became the patron saint of painters. Northern Renaissance painters of the fifteenth and sixteenth centuries painted the topic frequently, and were often commissioned by the painters' Guild of Saint Luke. The Virgin is usually shown with the *Christ Child, although she may be alone. She may nurse the Child as Luke draws with his pencil or paints with a brush and palette. Sometimes he is shown kneeling before her in an extremely awkward position, still holding his pencil and pad, and studying her face. She may also appear to him in a vision wrapped in clouds.

Example: Rogier van der Weyden, *Saint Luke Drawing the Virgin,* c. 1435–1437, Museum of Fine Arts, Boston (Gift of Mrs. Henry Lee Higginson).

LUST. See SEVEN DEADLY SINS.

LUTHER, MARTIN. Martin Luther, (1483–1546), was the German leader of the Protestant Reformation. He was born in Eisleben, Saxony, and became a lawyer, but several months later had an intense religious experience. Shortly after this he entered the monastery of the Augustinian friars at Erfurt. He was ordained a priest in 1507. In 1508 he was sent to the University of Wittenberg to lecture on Aristotle and to continue his studies. When sent to Rome on business, he was appalled at the laxity he saw in high ecclesiastical places. When he returned to the university, he completed the work for a theological doctorate and became a professor at Wittenberg. These years became a period of profound physical and spiritual anguish. He was increasingly obsessed with his own salvation and devoted himself to the work of the church. He had a friend in John von Staupitz about whom he later wrote, ''I have received everything from Staupitz.'' Because of his strong religious convictions, Luther felt compelled to protest the dispensation of indulgences (forgiveness for sins obtained, among other things, with the payment of money) (see TRAFFIC IN INDULGENCES). In 1517, when Johann Tetzel proclaimed the indulgence granted by *Leo X, Luther posted a parchment containing his historic ninety-five theses on the door of the collegiate church of Wittenberg. Many Catholic theologians had already condemned the abuse of indulgences but financial success had been great and ecclesiastical authorities had not halted it. The propositions were brought to the attention of the pope, who merely ordered the head of the Augustinians to exert better control over his order. However, while Luther considered his activities as reforms within the church, his opponents found his ideas heretical. A compromise was never reached, and in 1518, at the meeting with the papal legate

at Augsburg, Luther refused to recant. He was finally forced to declare his stand as one at variance with many of the doctrines of the church. Further, he broadened the base of his reforms as the break with Rome became inevitable. On June 15, 1520, Pope Leo X condemned his teaching as heretical and on January 3, 1521, his formal excommunication from the Catholic church was announced. The Protestant Reformation had begun. In 1525 Luther married a former nun, Katharina von Bora, and they raised six children. He died in Eisleben and was buried at Wittenberg. He left an evangelical doctrine behind him that spread throughout Europe. His work marked the first break in the unity of the Catholic church.

Example: Lucas Cranach the Elder, *Portrait of Martin Luther*, c. 1526, Uffizi Gallery, Florence.

LUXURIA. See SEVEN DEADLY SINS.

M

MADONNA ADORING HER CHILD. See ADORATION OF THE CHILD.

MADONNA AND CHILD. The "Madonna" is the Virgin Mary (see MARY, SAINT), the mother of Jesus Christ. The concept of "Madonna and Child" can be traced back as far as the fourth century. Even though the Council of *Ephesus, which met in 431, was the first to foster a new and purposely tender image of the Mother and Child as official doctrine, wide dissemination of this image did not occur until the seventh century, when artists used models from Byzantine art. Medieval artists put inscriptions on works of the Virgin and Child: *Sancta Dei Genitrix*, and *Mater Maria Dei*. Also, the discovery of supposed portraits of Mary painted by Saint *Luke, one of the four *Evangelists, proved to be an inspiration (see LUKE PAINTING THE VIRGIN). The thirteenth century witnessed an extensive development of interest in the Virgin. At this time many cathedrals in France were dedicated to "Notre Dame," or "Our Lady." This Gothic period saw a formal "Queen of Heaven" type of Mary, enthroned and crowned. During the Renaissance, however, this formal, hieratic Virgin Queen was replaced by a more human and delicate "Madonna," and the maternal aspect of the mother-child relationship was emphasized. During the fifteenth and sixteenth centuries, the Madonna and Child gradually became more and more human until in some instances the religious aspect of the topic was lost altogether. The Virgin is usually shown wearing her traditional colors, a red robe under a blue cloak. She holds the Child in her arms in many different poses. Some artists include various attributes of the Virgin such as the lily for purity, an olive branch (the emblem of peace) and a star which derives from her title, *"Star of the Sea" (Lat. *Stella Maris),* and is the meaning of the Jewish form of her name,

Miriam. She may hold her Infant's foot in a tender pose, and he may reach up to touch her neck.

Example: Masolino, 1423, Kunsthalle, Bremen.

MADONNA AND CHILD WITH SAINTS (Madonna and Child with Saints and Donors). During the Renaissance the Madonna (Virgin Mary [see MARY, SAINT], Mother of Jesus Christ) is shown framed on either side by saints. This depiction becomes frequent and evolves from formal to informal. A typical early Renaissance *altarpiece represented the Virgin in a central panel flanked on either side by saints in separate panels or compartments (sometimes more than one in each panel). By the fourteenth and fifteenth centuries the Virgin is shown in the same room or area with saints. They are usually standing on either side of her or kneeling before her. This unified and more personal representation is known as a *Sacra Conversazione*, or "holy conversation." An interesting fact to note is that saints of different periods may be shown side by side.

Example: Masaccio, 1422, S. Giovenale, Cascia di Reggello.

MADONNA AND SAINT ANNE. Saint *Anne was the mother of the Virgin Mary (see MARY, SAINT) and the wife of Joachim. The Madonna (Virgin Mary) is sometimes accompanied by her. Anne has no distinctive attribute. She does, however, usually wear a red dress with a green cloak. Usually no age difference is shown between the two. Both may have their attention focused upon the *Christ Child.

Example: Leonardo da Vinci, c. 1508–1513, Louvre, Paris.

MADONNA DELLA MISERICORDIA. See MADONNA OF MERCY.

MADONNA OF HUMILITY. During the Renaissance the Madonna (Virgin Mary [see MARY, SAINT]) was sometimes depicted sitting on the ground holding the *Christ Child in her lap. She is usually shown seated low upon a cushion. By the fifteenth century, this representation was very widespread, not only in Florence but in North Italy. See MADONNA AND CHILD.

Example: Domenico di Bartolo, 1433, Pinacoteca, Siena.

MADONNA OF MERCY (*Madonna della Misericordia*). The Madonna (Virgin Mary [see MARY, SAINT]) is depicted as a large standing figure, her arms outspread, shielding a group of dimunitive kneeling supplicants with her ample cloak. The cloak symbolized protection in antiquity and may be found in Byzantine and medieval art, perhaps worn by *Christ or by saints. Occasionally Renaissance artists show the cloak held up on each side by *angels so that the Virgin's arms are free for expressive gesture. The theme had run its course by the end of the sixteenth century and is rarely found in the art of the seventeenth century.

Example: Piero della Francesca, *Misericordia Altarpiece,* commissioned 1445, Pinacoteca, San Sepolcro.

MAESTÀ. *Maestà* is the Italian word for "majesty." It is an abbreviation for the Virgin and Child enthroned in majesty and accompanied by saints and/or *angels. The subject, during the Renaissance, was most common in those periods of the 1300s known as the "Proto-Renaissance."

Example: Duccio, 1308–1311, Front Panel of the High Altar of Siena Cathedral.

MAGDALENE. See MARY MAGDALENE, SAINT.

MAGI. See ADORATION OF THE MAGI.

MAGUS. A magus (pl. magi) was a member of the hereditary priestly cast among the ancient Medes and Persians traditionally reputed to have believed in astrology. In Renaissance art the word is used to denote one of the three wise men who, according to the *Gospel of Matthew (see MATTHEW, SAINT), came from the east to do homage to the Infant Jesus. See ADORATION OF THE MAGI.

MAIOLICA. *Maiolica* was the name applied to the painted, tin-glazed faience of the Renaissance, especially in Italy, that was decorated with, among other things, scaled-down designs of the great contemporary masters, painted by artisans using small brushes made of mouse whiskers. The name also refers to Majorcan traders who shipped a similar pottery from Spain.

MANDORLA. The Italian word for "almond," a *mandorla* is a glory of light shaped like an almond that is used to enclose the whole figure of the Resurrected *Christ or of the Virgin at her *Assumption.

Example: Nanni di Banco, *Assumption of the Virgin,* 1414–1421, Marble Gable on the Porta della Mandorla, Cathedral, Florence.

MANIKIN. See LAY-FIGURE.

MANNERISM. A period of style in Italian art, mannerism was seen principally in Rome between c. 1530 and 1590. Some historians regard this period as a degeneration of High Renaissance classicism or even as an interlude between High Renaissance and baroque, in which case the dates are usually from c. 1520 to 1600, and it is considered a positive style complete in itself. Some works were produced during this time that cannot be called Renaissance or baroque. *Maniera,* the word from which mannerism is derived, was used by Giorgio Vasari, Renaissance artist and art historian, to describe the schematic quality of artistic works, based on sets of intellectual "rules" deduced from classical art put forth during the Renaissance rather than direct visual perceptions. However, if the spectator is unaware of the rules, there is no point in breaking them.

The style, with or without rules, was particularly unsettling, with the human figure set in strained poses, willfully attenuated and in vivid, often ugly color. In some ways mannerism was the result of the upheaval of the Protestant

Reformation (1517) and the Catholic Counter-Reformation. The disturbed social, political, and religious conditions led many artists to abandon the serenity and calm classicism of the Renaissance. Also, by 1520 (date of Raphael's death) a perfection of composition and perspective had been reached and with no change, only pointless emulation was possible.

MAN OF SORROWS. Most often a Northern Renaissance topic, the Man of Sorrows is usually a nonnarrative representation of *Christ displaying his five wounds and either holding or otherwise accompanied by the instruments of the *Passion. He is often wearing the crown of thorns and shows profound suffering. He may sit on the edge of an open sepulchre or stand on it. He may be pointing to the wound in his side, thus making the "Man" the center of an emotional drama. Sometimes he carries the cross and is bent down with the weight of it. His body, sometimes nearly covered with blood, is emaciated and gaunt. *Angels may be weeping in the background.

Example: Geertgen Tot Sint Jans, c. 1495, Aartsbisschoppelijk Museum, Utrecht.

MAQUETTE. *Maquette,* French for "small model," is a term used when referring to sketches in wax, clay, and so on, for sculpture. See BOZZETTO.

MARCH. March is the third month in the cycle of the months and has been represented from the early Christian era. The month takes its name from the Italian war-god Mars, who in early Greek myth was also concerned with agriculture. Mars may be shown accompanied by a shepherd playing a lyre. He may wave a torch and carry a spear or a sword.

Example: Limbourg Brothers, March Page, *Book of Hours (Les Très Riches Heures) of the Duke of Berry,* illumination, 1416, Musée Condé, Chantilly.

MARGARET, SAINT. Formerly one of the most popular Christian saints, Margaret was removed from the Church Calendar in 1969 when it was decided that no evidence existed that her story was true. According to the *Golden Legend,* Margaret was born in Antioch, where her father was chief priest of a pagan cult. A Christian nurse cared for and instructed her in the ways of the church. By the time she was fifteen her beauty was so radiant that she attracted the attention of the prefect of Antioch who wanted to marry her. When she refused, he had her taken to prison, put on the rack, and cruelly tortured. Still she would not change her mind and was locked in a cell. Here a dragon appeared to her and after devouring her burst open when she made the sign of the cross. (The *Golden Legend* says this legend is apocryphal and most people consider it a groundless fable.) The next day, when again Margaret refused to worship idols, she was stripped, burned, and put into water. When this happened the earth shook, the tub broke, and she stepped out unharmed. The five thousand persons who saw this were converted to Christianity on the spot. They were beheaded and so was Margaret. Before her execution she prayed that women in labor, by

invoking her, might be safely delivered of their children. Margaret is usually shown either standing on a dragon, trampling it under her feet, or stepping forth from its belly. She usually holds a cross and sometimes a martyr's palm. In pictures and *altarpieces of the Virgin Mary, Margaret is often accompanied by Saint *Catherine of Alexandria.

Example: Titian, *Saint Margaret,* c. 1565, Prado, Madrid.

MARIA MEDIATRIX. See INTERCESSION OF THE VIRGIN MARY.

MARK, SAINT. One of the four *Evangelists, Saint Mark is traditionally the author of the second *Gospel. His full name was John Mark and during his early life he accompanied Saint *Paul and Barnabas on their early missions and was in Rome with Paul. His mother was named Mary and her house in Jerusalem was used by the early Christians for a meeting place. He was baptized by Peter (see PETER, APOSTLE AND SAINT) and became his associate. In fact, he has been called the "interpreter of Peter" by Eusebius (*The History of the Church* 3.39:15). Because of this it is thought that Mark wrote down the words of his Gospel from facts furnished him by Peter. The *Golden Legend* says that Mark faithfully wrote down the account (*Christ's life) as he heard it from Peter's lips. It is traditionally believed that Peter sent Mark to Alexandria to preach the Gospel. He became the first bishop of that city. While in Alexandria he miraculously healed a cobbler named Anianus who had seriously wounded himself in the left hand while repairing one of Mark's boots. The cobbler and his entire family were converted to Christianity. Mark made Anianus bishop of Alexandria when he had to flee the city. Two years later he returned, and on Easter day, while he was celebrating *Mass, the pagan men of the city dragged him out of the church and through the streets until he was dead. He was about fifty years old. Mark may be shown writing the Gospel, his symbol, the Lion, by his side, or he may simply hold a book. See DISCOVERY OF THE BODY OF SAINT MARK, MARK FREEING A CHRISTIAN SLAVE, and TRANSPORT OF THE BODY OF SAINT MARK.

Example: Donato Donatello, *Saint Mark,* marble, 1411–1412, Orsanmichele, Florence.

MARK FREEING A CHRISTIAN SLAVE. Saint Mark, one of the four *Evangelists, once rescued a Christian slave who had made a pilgrimage to Venice to visit his tomb. According to the *Golden Legend,* the slave was a faithful Christian who was in the service of a noble of Provence. His master would not give him leave to visit Venice and pray at the tomb of Saint Mark. The slave, however, went without permission. When he returned his master ordered him to have his eyes gouged out. In the public square before a crowd, some of the master's faithful slaves began their task, but the points of their stakes broke when they touched the slave's eyes. Then the master ordered the slave's limbs to be broken with hatchets; the iron of the axes softened and would not work. The master then ordered the slave's teeth to be smashed with iron hammers, but again the iron softened. Saint Mark miraculously swept down

from above and released the slave. Overcome with astonishment, the master begged forgiveness of the slave and went with him to pray at the tomb of Saint Mark. The master, executioners, and onlookers are shown drawing back in awe as the figure of the saint descends over the scene.

Example: Tintoretto, *Saint Mark Freeing a Christian Slave,* 1548, Accademia, Venice.

MARRIAGE AT CANA. See WEDDING AT CANA.

MARRIAGE OF ALEXANDER AND ROXANA. Alexander the Great or Alexander III (356–332 B.C.) was the king of Macedonia, conqueror of much of Asia, and founder of an empire. Alexander married Roxana, a Bactrian princess, the daughter of a chieftain of Sogdiana, one of the conquered territories of Asia. She became one of his several wives. Alexander died at the age of thirty-two and is therefore shown as young and vigorous. He usually wears a cloak and helmet, although the latter may be placed on the ground when he is shown in the bridal chamber. Roxana, young and beautiful, sits on a couch or the edge of a bed while *putti disrobe her. Alexander may place a crown on her head. Putti may tug him in her direction. Hymen (Hymenaeus), the god of marriage, may preside over the occasion.

Example: Giovanni Antonio Bazzi (called Il Sodoma), c. 1512, Bedroom, Villa Farnesina, Rome.

MARRIAGE OF SAINT FRANCIS TO LADY POVERTY. See FRANCIS MARRIES LADY POVERTY.

MARRIAGE OF THE VIRGIN (Betrothal of the Virgin, Wedding of the Virgin). The Virgin, or Mary (see MARY, SAINT), the mother of *Christ, was married to Joseph. Although there is no mention of the story in the *Gospels, the topic was very popular during the Renaissance. It may also be found as part of a cycle of scenes of the life of Mary. According to the *Golden Legend,* Joseph was chosen to be the husband of the future mother of Christ by a sign, the miraculous flowering of the rod he carried (see WATCHING OF THE RODS). Seven virgins who had been Mary's companions during her upbringing in the temple saw Joseph's rod burst into bloom and knew he was the chosen one. Joseph is usually shown as a mature man. His rod, which he holds in one hand, has blooms on the end. With his other hand he places a ring on Mary's finger. The ring, supposedly the real one, was said to be kept in the Cathedral of Perugia. During the Renaissance Perugia was the center of Umbrian art, and the topic is popular in the work of that school. Some artists show the wedding in the French manner, Mary and Joseph giving their hands to each other. This version is seen in French painting.

Example: Raphael, 1504, Brera Gallery, Milan.

MARS. See EXORCISM OF THE DEMON IN THE TEMPLE OF MARS.

MARS AND VENUS. In Roman religion Mars was the god of war and one of the twelve Olympians. He was the father of Romulus and Remus, who were reared by a she-wolf and a woodpecker (the wolf and woodpecker were sacred to him). After *Jupiter, he had the highest position in Roman religion. He was despised by nearly everyone because of his brutal and aggressive nature. In fact, Homer refers to him as murderous, bloodstained, and even a coward who bellowed with pain and ran away when he was wounded. (The Romans liked Mars better than the Greeks liked Ares.) The exception to those who disliked the god was *Venus, who fell in love with him. He is usually shown as an armed warrior with breastplate, helmet, shield, and spear or sword. These, however, are put aside when he is conquered by love. Mars, the Greek Ares, plays a small role in mythology, although in one story he is the lover of Venus. During the Renaissance, artists used the topic to show Mars and Venus together in an idyllic forest setting. Venus' *cupids play with Mars' weapons of war and the shining armor that he has discarded for the moment. He may be sleeping while Venus, smiling and reclining, simply contemplates her lover. The story is also found in Ovid and Homer. According to Ovid's *Metamorphoses* (4:171–189), and Homer's *Odyssey* (8:266–365), Venus was married to Vulcan (Hephaestus) (see FORGE OF VULCAN), the blacksmith of the gods, and in Roman religion the fire god. Among the perfect and beautiful immortals, he alone had been born ugly and lame. His wife fell in love with Mars and visited him in his palace. Soon, however, her actions were noticed by the sun god, Helios, who told her husband. Vulcan, after deciding to trap the lovers, devised an invisible net that he hung over Mars' bed. It was not long before the two were caught, tangled in the net, as they made love. Mars was then held up to the contempt of the Olympians, and Mercury said, "Oh, for the same opportunity." During the Renaissance the topic was sometimes painted in honor of a marriage with Mars and Venus portrayed as a representation of the engaged couple.

Example: Sandro Botticelli, late fifteenth century, National Gallery, London.

MARSYAS. See APOLLO AND MARSYAS.

MARTIN, SAINT (Martin of Tours). Saint Martin, c. 315–397, bishop of Tours, was a Christian saint born a heathen in Pannonia (present-day Hungary) during the reign of Constantine the Great (see CONSTANTINE AND SAINT HELENA). The son of a soldier, he became a convert and refused to fight Christians. His father, a military tribune, insisted that the young man pursue the life of a soldier. Martin joined the cavalry and for a time was stationed in France. After seeing *Christ in a vision one night, Martin determined to devote his life to him and asked to be released from the military. He was then accused of being a coward; however, Martin said he would go to the front lines with only a cross.

The enemy surrendered before Martin could be tested and many believed that his faith in God brought about this surrender. Martin left the military and went to live a life of seclusion near Poitiers, France, where he founded a monastery, possibly the first in France. In 371 Martin became bishop against his will. He even hid from the emissaries who arrived to take him back to Tours. One story says that his hiding place was disclosed by a quacking goose. He remained bishop of Tours for thirty years. Numerous churches are dedicated to him in England and France. Artists usually show Martin as a bishop, although he may be seen also as a Roman soldier on horseback wearing his cloak, a symbol of heroic charity (see MARTIN DIVIDING HIS CLOAK). A lame beggar and a goose may be in close proximity. His feast day is November 11, which coincides with the migration of geese. It is known in England as Martinmas. His major shrine was at Tours.

Example: Masolino, *Saint Martin of Tours,* c. 1423, John G. Johnson Collection, Philadelphia.

MARTIN DIVIDING HIS CLOAK. Saint Martin, the fourth century bishop of Tours, was stationed in France during his tour of duty as a soldier. According to the *Golden Legend, one bitter winter day Martin was passing through the city of Amiens, where he chanced to pass a poor and almost naked beggar suffering from the cold weather. The poor man said he had received no alms all day. Martin took off his military cloak and cut it in two parts, gave one part to the beggar and wrapped himself in the other. That night, in a vision, *Christ appeared to him wearing the piece of his cloak that he had given away. He heard Christ saying to the *angels who surrounded him, ''Martin, while yet a catechumen (unbaptized Christian), has clothed me with this garment.'' Martin then decided to devote his life to Christ. Nevertheless, he continued his life in the military for two years at the insistence of his tribune. Martin is shown as a Roman soldier astride his horse cutting the cloak with his sword. The beggar kneels on the ground before him. Roman soldiers and some townspeople may be shown.

Example: Lucas Cranach the Elder, *Saint Martin Dividing His Cloak,* 1504, Staatliche Graphische Sammlung, Munich.

MARTYRDOM OF SAINT BARTHOLOMEW. Saint Bartholomew was one of *Christ's twelve *Apostles. According to the *Golden Legend,* he made a missionary journey to India, considered then to be ''the end of the earth.'' After preaching in Armenia during his return journey, he was captured by heathens and put to death. Opinions as to his martyrdom are diverse. Saint Dorotheus says Bartholomew met his martyrdom by being crucified with his head down. Saint Theodore says that he was flayed alive. Other sources say that he was beheaded. The *Golden Legend* says ''these contradictions can be made to agree, by saying that he was first crucified, then flayed while still alive to increase his sufferings, and finally beheaded.'' Most artists choose the flaying scene when

depicting Bartholomew's martyrdom, which is the most popular scene. His attribute is a knife and not uncommonly the flayed skin hangs over his arm. Other scenes from Renaissance art show him baptizing, preaching, exorcizing demons, and being brought before the authorities for refusing to worship idols.

 Example: Stephan Lochner, *Martyrdom of Saint Bartholomew, Last Judgment Altarpiece,* 1435–1440, Städelsches Kunstinstitut, Frankfurt.

MARTYRDOM OF SAINT CATHERINE. Saint Catherine, a third-century saint, was born at Alexandria in Egypt. According to the **Golden Legend,* Catherine, born into a noble and illustrious family, not only showed erudition from an early age, but was extremely beautiful. The emperor Maxentius II, who shared the imperial crown with Constantine the Great (see CONSTANTINE AND SAINT HELENA) and Licinius, selected Alexandria as the capital of his section of the empire. To begin, he ordered the death of all Christians and anyone who would not sacrifice to the Roman gods. Catherine gave a speech hoping to see the emperor and open his eyes to his cruelty. The emperor decided to refute her teaching and gathered together the most astute philosophers of his empire. Catherine converted all of them to Christianity. Maxentius had the philosophers beheaded, Catherine beaten with scorpions, and then put in a dungeon. She was left there twelve days with no food. It is said that *angels brought food to her during this time. While in prison Catherine even converted Maxentius' wife. He then decided to have all Christians in his realm killed except Catherine. He offered to make her empress, but she refused so he ordered her to be tied between four wheels rimmed with iron saws and sharp nails. The instruments, all moving in different directions, were supposed to tear her apart, but instead a fire came from heaven and destroyed them. Maxentius then had her beheaded and according to legend, milk, not blood, issued from her wound. Angels carried Catherine's body to Mount Sinai, which still houses her relics. Catherine is nearly always shown with a wheel. It may be broken and it may be studded with iron spikes. She may also have the sword of her execution and a martyr's palm. A crown indicates her noble birth. She is the patron saint of education. See CATHERINE, SAINT.

 Example: Albrecht Dürer, *The Martyrdom of Saint Catherine of Alexandria,* woodcut, c. 1498.

MARTYRDOM OF SAINT DENIS. See DENIS, SAINT.

MARTYRDOM OF SAINT ERASMUS. Erasmus was the legendary bishop of Antioch or, according to other sources, of Formiae in Campania. He died a Christian martyr c. 303. Legend says he was disemboweled. His executioners wound his entrails round a windlass. Erasmus was the patron saint of Mediterranean sailors and, according to some, the origin of the story of his martyrdom was the capstan, an apparatus used mainly on ships for hauling in cables and hawsers. As a devotional figure Saint Erasmus is dressed as a bishop

and has a ship or a capstan as his attribute. Artists depict him on a rock or table, during his martyrdom, having his entrails wound up on a rod. He may have carpenters' nails pushed under his fingernails, a torture he underwent before his disembowelment.

Example: Dirk Bouts, c. 1460, Church of St. Pierre, Louvain.

MARTYRDOM OF SAINT GEORGE. George was a legendary saint and Christian martyr. According to the *Golden Legend,* the *Calendar* of the Venerable Bede says he was martyred in Persia in the city of Diospolis; other sources say he suffered under the emperors Diocletian and Maximian or under the Persian emperor Dacianus in the presence of seventy of his kings. Legend says that during the reign of Diocletian and Maximian, George, then a Roman soldier, saw the persecution of seventeen thousand Christians in one month. He put down his armor and was converted. He then rushed into the public square shouting, "All your gods are demons, and our God alone is the Creator." The prefect Dacian had George stretched upon a rack and ordered his body to be torn with iron hooks, burned with torches and the wounds "out of which his vitals started were rubbed with salt." Dacian ordered his magician to conquer George's spell and the magician said, "If I fail to conquer George's spells, I agree that thou mayest put me to death." The magician gave George a cup of poisoned wine and when nothing happened he gave him an even stronger cup. Then he fell down and asked to become a Christian. Dacian then had George dragged through the city and beheaded. This was in the year 287. It is said that as Dacian left the place of George's martyrdom a fire from heaven consumed him and his ministers. George is usually shown killing the dragon (see GEORGE AND THE DRAGON, SAINT), and scenes of his martyrdom are rare. He may be shown stretched out on the rack while two *angels intervene and smash the wheel with their swords. Crowds of onlookers move back, terrified at the scene.

Example: Altichiero, 1380–1384, Oratory of S. Giorgio, Padua.

MARTYRDOM OF SAINT HIPPOLYTUS. According to the *Golden Legend,* Hippolytus was a Roman soldier who became a Christian after seeing the *martyrdom of Saint Lawrence. He performed Lawrence's funeral rites and buried his body. For doing this he was taken to Caesar and accused of being a sorcerer and of stealing Lawrence's body. He said he was not a sorcerer, but a Christian. Decius Caesar had him stripped of his Christian vesture and ordered that his face be beaten flat with stones. Then he was lacerated with iron rakes and when he continued to say he was a soldier of *Christ, Decius handed him over to the prefect Valerianus and ordered that he be put to death in the worst possible way. The prefect had Hippolytus tied by the feet and hands to the necks of four untamed horses and pulled apart. This was in the year 256. Hippolytus may be shown wearing armor, and sometimes he holds keys as an allusion to being Lawrence's jailer. In the scene of his martyrdom, his hands and feet are

tied to four horses who walk in opposite directions in order to pull him apart. He may also be shown with each foot bound to the tail of a rearing horse.

Example: Master of the Munich Taking of Christ. *Martyrdom of Saint Hippolytus, Saint Hippolytus Altarpiece,* center, c. 1474–1479, Cathedral of Saint-Sauveur, Bruges.

MARTYRDOM OF SAINT JAMES. One of the twelve *Apostles, Saint James is known also as *James the Greater. It is said that on one of his pilgrimages he arrived at Compostella, Spain, where he was the first to convert heathens to the Christian religion. It was on his return to Judea that he was arrested and tried in Jerusalem by Herod Agrippa. According to the *Golden Legend,* on March 25 in the year 44 he was beheaded. James is shown as a man of mature years with gentle features and dark hair, parted and falling on either side. He is usually on the ground waiting for the executioner to strike.

Example: Andrea Mantegna, 1454–1457, Ovetari Chapel, Eremitani Church (destroyed 1944), Padua.

MARTYRDOM OF SAINT LAWRENCE (Laurence). A third-century Roman deacon and martyr, Lawrence is one of the most venerated martyrs of the Roman Catholic church. He was of Spanish birth and died in Rome in 258. He is highly praised in the writings of the Latin Fathers for his role in the conversion of Rome. He was condemned to be slowly roasted to death on a gridiron. Defiant in the midst of his torture, he shouted to Decius, the prefect of Rome, ''Behold, wretch, thou hast well cooked one side! Turn the other and eat!'' (*Golden Legend*). The most common scene shows Lawrence on the gridiron. The prefect and a crowd of Roman soldiers watch as his executioners bring fuel, stoke the fire, and poke the saint with long forks. He may be in the act of turning on his other side. See LAWRENCE DISTRIBUTING THE TREASURES OF THE CHURCH.

Example: Titian, c. 1567, Escorial, Madrid.

MARTYRDOM OF SAINT SEBASTIAN. Saint *Sebastian was a young nobleman of Narbonne in Gaul and an officer of the Praetorian guard, the special bodyguard of the Roman emperors, during the reign of Diocletian in the third century. Diocletian liked him and made him commander of his soldiers in Milan. Although his occupation was in the military, Sebastian was secretly a Christian, and it is thought by some that he entered the Roman army to assist and protect Christians. His identity as a convert was revealed when two of his fellow officers, Marcus and Marcellinus, were being tortured for their belief and he encouraged them to die rather than give up their faith. When Diocletian heard this, he asked Sebastian to abandon his God and worship the Roman gods. When he refused his execution was ordered immediately. He was tied to a tree and shot with arrows. The executioners, however, hit no vital organs and Sebastian was nursed back to health by the mother of one of his martyred friends, a Christian widow named Irene. Contrary to her advice, when well Sebastian returned to confront

Diocletian. This time he was taken to the amphitheater and beaten to death with clubs. His body was thrown into the main sewer of Rome, the Cloaca Maxima, so that his friends might not find it. It was discovered and buried in the catacombs at the feet of Saint Peter (see PETER, APOSTLE AND SAINT) and Saint *Paul. He died in 288. Sebastian is usually shown as a young man whose body is bound to a tree or stake and transfixed with arrows.

Example: Antonio and Piero del Pollaiuolo, c. 1475, National Gallery, London.

MARTYRDOM OF SAINT URSULA. See URSULA, SAINT.

MARTYRDOM OF THE TEN THOUSAND. The brutal execution of ten thousand knights by King Shapur of Persia is known as the "Martyrdom of the Ten Thousand." The knights, having been converted to Christianity, preferred death to renouncing their faith. Symbolic of *Christ's martyrdom, some knights were crucified, flayed, and crowned with thorns; others were pushed over cliffs, impaled with spears, stoned to death, or beheaded. Thousands of Knights are shown undergoing these torments.

Example: Albrecht Dürer, 1508, Kunsthistorisches Museum, Vienna.

MARY, SAINT. Mary was the mother of Jesus. Her name in Hebrew is Miriam. The New Testament contains sparse details about her life and her rich iconography (see ICONOGRAPHY AND ICONOLOGY) owes only a small part to the *Gospels. Luke (1:48) ascribed this prediction (which was fulfilled) to her: "Henceforth all generations will call me blessed." No strict biography is possible for Mary. Apart from the Gospels and Acts 1:14, Mary is not explicitly named in the New Testament. According to tradition, she was born to Joachim and Saint *Anne at Jerusalem or Nazareth. Roman Catholic doctrine says she was conceived without original sin, that Anne produced her without concupiscence. As a young girl she entered the temple at Jerusalem and lived there until she was twelve or thirteen. According to Luke 1:5–23, the *angel *Gabriel visited Mary and announced that she would have a son by the *Holy Spirit. According to Luke 1:39, she went to Judah to visit Saint *Elizabeth, her cousin, kinswoman, and the mother of Saint *John the Baptist, the precursor of Jesus. Elizabeth was made aware of the honor intended for Mary, and Mary stayed with her until just before the birth of John, when she returned to Nazareth. The Gospels say Mary married Joseph, a Nazarene carpenter, to be protected by him. He was declared to have been a descendant of *David. Many believe that Mary, too, was of Davidic lineage, because she was told that her child should receive the throne of his father David. The cause of her pregnancy was revealed to Joseph in a dream (Matt. 1:18–21). He was directed to marry her and name the child "Jesus." She went with him to Bethlehem to have their names put down as members of the House of David after Caesar Augustus ordered a census of his realm. There she gave birth to Jesus in a stable. Saint *Matthew tells the story of the family's *Flight into Egypt to escape Herod's massacre of all infants (see

MASSACRE OF THE INNOCENTS). Another reference to Mary in the Gospels is during Jesus' childhood when, at the age of twelve, he disappeared on a Passover trip to Jerusalem (Luke 2:41) (see DISPUTE). According to John (2:1–10), she appeared also at the *Wedding at Cana. The sufferings of Jesus brought great sorrow into Mary's life. According to John she stood at the foot of the cross at the *Crucifixion, when Jesus asked John to care for her (as no mention is made of Joseph, it is supposed that she must have been a widow at this time). Very little is known of her later life. The last mention of her (Acts 1:14) includes her with those who devoted themselves to prayer after the *Ascension. Although there is no record of her death or the manner of her death, it is believed she died in Jerusalem c. 63. Her tomb is shown in the Valley of Kidron, but there is no reason to believe in its genuineness. Mary is shown as the Mother of God, as the Madonna, and the Virgin. Portraits of her were supposedly painted by Saint *Luke (see LUKE PAINTING THE VIRGIN). During the Renaissance she is not a formal type of virgin as seen in the medieval period, but rather a mother of humility holding her child on her lap. When shown as the Virgin of Mercy, the Misericordia, she is without the child. Renaissance artists also depict her standing at the Crucifixion. Mary traditionally wears a blue cloak and veil, the symbolic color of heaven and a reminder of her role as Queen of Heaven. Her dress is usually red. In scenes of the *Passion, artists show her in violet or gray.

Example: Giotto, *Narrative Cycle on the Life of Mary,* 1305, Arena Chapel, Padua.

MARY IN THE BURNING BUSH. The burning bush symbolized the Virgin Mary who (see MARY, SAINT), after her Immaculate Conception, miraculously bore the *Christ Child and still kept her virginity intact. Mary is shown seated in the center of the burning bush holding the Christ Child. See BURNING BUSH.

Example: Nicolas Froment, 1476, Cathedral, Aix-en-Provence.

MARY MAGDALENE, SAINT (Magdalen). Saint Mary Magdalene is the image of the penitent Christian. A faithful follower of Jesus, she had become a disciple during the early Galilean ministry. She was called Magdalene because she was born in the village of Magdala in Galilee (modern Migdal). Saint *Luke puts her name at the head of a list of women of Galilee (Luke 8:2). She has long been connected with the sinful woman of Luke 7:36–50, and she was known as the one from whom Jesus "had cast out seven devils." There is, however, no basis for this belief. The woman who annointed *Christ's feet (Luke 7:36–38), from whom this image is derived, was unnamed. John (11:2) and the *Golden Legend identify her as the sister of Lazarus (see RAISING OF LAZARUS) and Martha. She stood at the cross and saw Christ die (Matt. 27:55–56; Mark 15:40; Luke 23:49; John 19:25), and she was the first person to see him after he arose from the tomb (Mark 16:9–10; John 20:11–18). According to John, Christ appeared to her as she stood by the empty tomb (see NOLI ME TANGERE). She recognized him, but he told her not to touch him but to find

the disciples and give them the message that he was now risen. She reported his *Resurrection to the other disciples (John 20:18). Nothing further is known of her history. Some sources say she passed the last thirty years of her life in a secluded mountain retreat near Sainte-Baume fasting and doing penance. According to the *Golden Legend:* "Everyday the angels bore her aloft at the seven canonical hours, and with her bodily ears she heard the glorious chants of the heavenly hosts. Then, being filled with this delightful repast, she came down to her grotto, and needed no bodily repast." Artists show Mary Magdalene with long flowing hair that sometimes covers her entire body. Her attribute is a jar, or vase of ointment, which is held in her hand or placed near her feet. Before her conversion she is shown in gorgeous attire, jeweled and gloved; as a penitent she may be naked or wear a simple cloak. She may have a crucifix, a skull, a whip, and a crown of thorns. The setting may be the entrance to her cave at Sainte-Baume in France.

Example: Donatello, *Mary Magdalen,* wood statue with polychromy and gold, 1454–1455, Baptistery, Florence.

MASS. The Mass is a sequence of prayers and ceremonies used in the celebration of the *Eucharist constituting a commemorative sacrifice of *Christ upon the cross. It is also the particular *liturgy used in this celebration.

MASSACRE OF THE INNOCENTS. According to Matthew 2:16, the Massacre of the Innocents, meaning the infants, occurred at the time of Christ's *Nativity under the reign of Herod the Great. Herod, hearing of the birth of a child who was destined to become "King of the Jews," feared that his own power would be usurped. His solution was to slaughter all the infants of Bethlehem and the entire surrounding area. Joseph and Mary (see MARY, SAINT), however, had already been forewarned by an *angel and had fled to Egypt (see FLIGHT INTO EGYPT). The scene artists usually show is the courtyard of Herod's palace. His soldiers with drawn swords are taking babies from the arms of their horrified mothers. Dead infants are scattered about on the ground. Herod is usually shown witnessing the scene from a balcony or from a throne. Saint *Elizabeth, the mother of Saint *John the Baptist, may be shown running, her child hidden under her cloak. The apocryphal Book of James tells the story of her escape into the hills. A woman seated to one side and crying over a child's body alludes to Jeremiah's prophecy: "Rachel weeping for her children; they are gone and she refuses to be comforted . . . " (Jer. 31:15). This scene was taken, by the medieval church, as a prefiguration of Herod's massacre and is included by some artists. During the Italian Renaissance some artists included children, the Holy Innocents, holding martyrs' palms, in paintings of the *Madonna and Child with saints.

Example: Domenico del Ghirlandaio, 1485–1490, Capella Maggiore, Sta. Maria Novella, Florence.

MASS OF BOLSENA. This *mass was to commemorate a thirteenth-century miracle connected with the feast of Corpus Domini. According to legend, a Bohemian priest, worried with doubts about transubstantiation, was given proof of the *Eucharist when the altar cloth he used for a mass became stained with blood from the *Host. The cloth, then a relic, was taken to Orvieto Cathedral, where it was venerated by Sixtus IV. The relic is still preserved in a special altar of the cathedral.

Example: Raphael, 1512, Stanza d'Eliodoro, Vatican, Rome.

MATER AMABILIS. During the Renaissance the Virgin Mary (see MARY, SAINT), as *Mater Amabilis*, replaced the hieratic type of virgin and child known to the Middle Ages. Artists began to show the real maternal aspects of the loving mother with her child. Some artists added a touch of naturalism by not placing a halo on either Mary or her child. She may be shown embracing him and in turn he may seem to squirm forward to kiss her face, which in some cases may be quite lovely.

Example: Fra Filippo Lippi, *Madonna and Child* (Tarquinia Madonna), 1437, National Gallery, Rome.

MATER DOLOROSA. *Mater Dolorosa* is a Latin term meaning "the Virgin mourning." In this context concern is with the Virgin alone. She may be the mourning mother as she stands beside the cross or sits lamenting over the dead body of her son lying in her lap (see PIETÀ). She may be shown weeping, her hands raised in despair.

MATIERA. French for "material," the *matiera* of a painting is simply the paint.

MATTHEW, SAINT. One of the twelve disciples, Matthew was a publican or tax gatherer, in the service either of the Roman or Herodian government, stationed at Capernaum. Tradition says that as he sat in the tax office, he was called by Jesus to become his follower and, leaving his business, he immediately obeyed. According to Matt (9:9), "Jesus saw a man named Matthew sitting in his office in the custom-house; and He said to him, 'Follow me.' Matthew got up and followed Him." He was afterward appointed one of the twelve *Apostles. Saint *Mark and Saint *Luke say that his father's name was Alphaeus and his name was Levi. Either he had two names, which was not uncommon among the Jews, or he received the name Matthew when he became a Christian. He is, however, known as Matthew in the lists of Apostles and as the author of the first *Gospel. The *Golden Legend* says his Gospel was discovered with the bones of Saint Barnabas in the year 500. The saint carried the Gospel everywhere, and when he placed it upon the heads of the sick, all were cured. According to the *Golden Legend,* he was martyred as he stood at the altar with his hands raised to heaven in prayer and a swordsman drove a sword into his back. Other sources say he

was beheaded. His symbol as one of the four *Evangelists is a winged young man or an *angel, one of the apocalyptic beasts. Some artists show it dictating as Matthew records the human ancestry of *Christ. He may have other attributes of a writer: a book, pen, and inkhorn. Sometimes an angel holds his inkhorn. Also, he may hold a purse or a bag of money, a reminder of his early occupation as a tax gatherer.

Example: Lorenzo Ghiberti, *Saint Matthew,* bronze, 1419–22, Orsanmichele, Florence.

MAURICE, SAINT. In third-century Rome Maurice, a legendary warrior saint, was the captain of the holy legion called the Theban Legion because its soldiers were Romans from Thebes in Egypt. According to the *Golden Legend,* when Diocletian and Maximian began to reign c. 287, having decided to exterminate the Christian faith, they summoned all soldiers to Rome. In Thebes a legion of over six thousand was formed not to bear arms against the Christians, but to defend them. The leader of the holy legion was Maurice. Once on the march, after crossing the Alps, the emperor ordered all who were with him to sacrifice to the idols and swear to wage war against all who rebelled against the emperor, especially the Christians. The soldiers of Maurice's Theban Legion refused and were punished first by decimation and finally a massacre of the entire legion. Saint Maurice is usually shown dressed either in medieval armor or as a Roman soldier. He may have a red cross, the emblem of the Sardinian Order of Saint Maurice on his breastplate. Also, he may hold a red banner, which may carry the eagle of Austria, of which country he is a patron saint. Maurice is usually shown as a saint, but occasionally the massacre of the legion is represented.

Example: Master of Moulins, *Saint Maurice and Donor,* c. 1500, Cathedral, Moulins.

MAXENTIUS. See BATTLE OF CONSTANTINE AND MAXENTIUS.

MAXIMILIAN I, HOLY ROMAN EMPEROR AND GERMAN KING. See TRIUMPHAL ARCH FOR MAXIMILIAN.

MAY. May was the fifth month of the calendar that appeared in northern European illuminated manuscripts and Italian *fresco cycles. Each month was usually accompanied by its corresponding sign of the zodiac. In the case of May, the Gemini twins were usually placed above the month's illustration. The subject for May was noblemen and ladies on foot or on horseback, dressed in the latest fashion on their way to the hunt. Some of the men have falcons on their wrists. Their castle may be shown in the background, and peasants may rest in the shade or cut the grass with scythes. Above the scene *Venus and *Cupid may be shown, their chariot drawn by Castor and Pollus, the twins. Venus' veil is carried by the Zephyrs.

Example: Limbourg Brothers, May page, *Book of Hours (Les Très Riches Heures) of the Duke of Berry*, illumination, 1416, Musée Condé, Chantilly.

MAZZOCCHIO. A *mazzocchio* is a wicker or wire frame around which a hood was wrapped to create a headdress worn by fifteenth-century Florentine men.

MEDICI. The Medici were a Florentine family of merchants and bankers that became the ruling house of Tuscany in the sixteenth century and were known for their patronage of the arts throughout the Renaissance.

MEDICI, COSIMO DE'. See COSIMO I.

MEDICI, GIULIANO DE'. Giuliano de' Medici, duke of Nemours, younger son of Lorenzo de Medici (Lorenzo the Magnificent) and brother of Pope *Leo X, was born in 1479 and died in 1516. He went to Florence in 1512 when the Holy League restored the Medici to rule the city. He became duke of Nemours when he married a princess of the Nemours branch of the House of Savoy. *Francis I of France invested him with the duchy when he intended to place him on the throne of Naples. Considered a mediocre member of the increasingly degenerate Medici family, Giuliano, a patron of the arts, was carved by Michelangelo as one of two *Capitani* in antique armor with a general's baton, holding coins in his left hand, perhaps referring to the liberality *Castiglione praised.
 Example: Michelangelo, marble, 1519–1533, Medici Chapel, San Lorenzo, Florence.

MEDICI, LORENZO DE'. Lorenzo de' Medici, duke of Urbino and son of Piero de' Medici, was born in 1492 and died in 1519. During his life Florence was controlled through him by his uncle Pope *Leo X, who had made him duke of Urbino. After his early death in 1519, however, Urbino reverted to the Della Rovere family. Lorenzo, a patron of the arts, was immortalized by Michelangelo, who designed and made his tomb. The statue Michelangelo carved of him is known as the *Pensieroso* because it depicts Lorenzo in a pensive attitude. He is one of the two *capitani* (the other being Giuliano de' Medici) in antique armor, his face shadowed by a fantastic zoomorphic headdress. The whole pose could have been influenced by the fact that he died insane.
 Example: Michelangelo, marble, 1519–1533, Medici Chapel, San Lorenzo, Florence.

MEDITATION ON THE PASSION. Carpaccio's *Meditation on the *Passion* shows two old, bearded hermit-saints sitting on either side of the dead *Christ who, seeming only to be asleep and dreaming, is seated upon a crumbling throne. His wounds are obvious and the crown of thorns has fallen from his head to his feet. Saint *Jerome is seated to Christ's right, his lion nearby. On Christ's left, facing Jerome, yet in deep meditation, is *Job. Reminders of death are everywhere: a skull and some bones are on the ground under Job's legs; Saint Jerome's staff is made up of a hand grasping a bone; his rosary, hanging to his left, is a set of human vertebrae threaded to form a string of beads. The background is divided to form two very different landscapes. On the left side a

withered tree stands against the sky and the mountainside is wild and rocky. A leopard is killing a stag, while a doe grazes quietly below. A fox watches the incident from the opening of its den. The right side has a landscape of farms, castles, orchards, and a town, although close at hand another leopard chases a stag. A green tree grows on this side. A bird flies up and away from the crumbling throne of the Old Law. Symbolically, the stag, representing the human soul, is caught by the leopard on the left side and escapes on the right side, just as Job, tested to the limit, was, in the end, blessed by Christ.

Example: Vittore Carpaccio, late 1490s, Metropolitan Museum of Art, New York.

MEDIUM. A medium is a liquid substance necessary for the preparation of paint. Pigment is ground into a medium (most commonly linseed oil and turpentine) so that the pigment will be rendered capable of application. Some Renaissance painters used more than one medium in the same painting. In the north, for example, Flemish artist Jan van Eyck ground color into an oil medium and used this mixture over a solid *tempera underpainting. Italian artists such as those of the *Venetian School of painting (the Bellini family and Titian) inherited this unique Flemish practice because of its unusual brilliance of color. In this process the tempera underpainting dries quickly and the luminosity, so sought after by the Venetians, is secured. Formally it was thought the Venetian masters used a mixed medium of egg tempera and oil (referred to as the *a putrido* method used by Titian and Paolo Veronese).

MEETING AT THE GOLDEN GATE. The story of the Meeting at the Golden Gate is the most popular single episode in the cycle of scenes of the life of the Virgin Mary (see MARY, SAINT). It is from the story of Mary's parents, Joachim and Saint *Anne, found in the *Golden Legend,* which took it from the apocryphal New Testament literature. According to this account, Joachim, a rich man from Galilee, and Anne of Bethlehem had no children after twenty years of marriage. They made a vow to the Lord that if he granted them offspring, they would dedicate the child completely to the service of God. Toward this end they went to Jerusalem to celebrate the three principal feasts each year. On the feast day of the Dedication one year Joachim was turned away at the temple. A priest, angry because he dared to come close to the altar of God, told him to leave and called it unseemly that one who was under the curse of the Law would want to offer sacrifice to the Lord of the Law, or that a man without offspring, who gave no increase to the people of God, would be able to stand with men who bore sons. Confused and ashamed to return home, Joachim went out into the wilderness and lived for some time with the shepherds. One day when he was alone an *angel appeared in a vision and told him that his wife would conceive and that the child would be the mother of Jesus. As a sign he was to go to the Golden Gate at Jerusalem where his wife would be waiting. Meanwhile Anne cried, not knowing where Joachim had gone. The angel appeared to her and told her the same things that he had announced to Joachim. Following the

angel's command, they came face to face at the Golden Gate. According to the doctrine of the Immaculate Conception, Anne conceived *sine macula*. Artists before the thirteenth century used the embrace of Joachim and Anne to symbolize her conception. The Franciscans taught that it was the kiss when the two met at the Golden Gate that brought about Anne's conception, and this was the first redemptive act of God. Joachim and Anne are shown outside a city gate at the moment of their embrace. Anne's women servants may stand behind her and shepherds may stand behind Joachim. The *Annunciation angel *Gabriel may float overhead.

Example: Giotto, 1305, Arena Chapel, Padua.

MEETING OF ABRAHAM AND MELCHIZEDEK. See ABRAHAM AND MELCHIZEDEK.

MEETING OF PILGRIM AND ENVY. In art the pilgrim usually wears a dark broad-rimmed hat that may be pointed at the front and turned up at the back. The pilgrim is a male who carries a tall staff and has a wallet or script (a small pouch) hanging from his shoulder or his staff. His special attribute is the scallop shell and it will be placed on his wallet, shirt, hat, or elsewhere. Envy, one of the *Seven Deadly Sins, is usually, although not always, female. She has been described as having a sickly face, squinting eyes, a wasted body, and a tongue dripping poison within a mouth of decayed teeth. She is usually a hideous old woman, an ugly low type sometimes accompanied by a vicious barking dog. The pilgrim is shown innocently walking along, probably to some shrine (the principal places were Rome, Santiago de Compostella in Spain, and the Holy Land), when he encounters Envy, who blocks his path.

Example: Netherlandish, from Guillaume de Deguileville, *Pèlerinage de la Vie Humaine*, (Ms. 10176, fol. 68) illumination, c. 1390–1400, Bibliothèque Royal, Brussels.

MEETING OF SOLOMON AND THE QUEEN OF SHEBA. See QUEEN OF SHEBA BRINGING GIFTS TO SOLOMON.

MELANCHOLY (*Melencolia*). Melancholy, symbolic of one of the four humors or temperaments, was the daughter of Saturn. Even though late-medieval thought found her surly, absent-minded, mournful, greedy, and cowardly, Renaissance humanists, under the influence of the Florentine Neoplatonists, elevated her to a higher position and identified her with the introspective, intellectual qualities of their ideal contemplative man. Melancholy is usually shown sitting in perplexed reflection, her head in her hands. She seems to be sorrowing over her despair of acquiring the ultimate knowledge or her loss of creativity. Since Saturn presided over the *Seven Liberal Arts, she may be

surrounded with the attributes of Geometry: a compass, set-square, and ruler. She may also be surrounded by a saw and plane, since carpenters were also the children of Saturn.

Example: Albrecht Dürer, *Melencolia I,* engraving, 1514.

MELANCHTHON, PHILIP. A German scholar and humanist born in 1497. He died in 1560. One of the leading Protestant intellectuals, he was second only to Martin *Luther as a figure in the Lutheran Reformation. His name, Melanchthon, is the Greek rendering of "black earth." His original name was the German Schwarzerd, also meaning "black earth." Melanchthon made the first systematic presentation of the principles of the Reformation and in this way clarified the new *Gospel to those outside the movement.

Example: Albrecht Dürer, engraving, 1526.

MELISSA. Melissa was a good natured, but distinctive character in the Italian Renaissance romantic epic poem *Orlando Furioso,* written by Ludovico Ariosto (1474–1533) and published in its final form in 1532. The *Orlando* is actually an epic treatment of the Roland story intended to glorify the *Este family. Melissa is the benign personage who frees humans whom the wicked sorceress Alcina has turned into animals and plants. She is usually shown burning Alcina's seals, erasing her spells, and freeing men who are emerging from the trunks of trees. Other men, probably just liberated, sit in the background. A large dog (who is probably a person) stares at a suit of armor he hopes to wear soon.

Example: Dosso Dossi, 1520s, Borghese Gallery, Rome.

MEMENTO MEI. *Memento Mei* is a Latin phrase for "Remember Me." It is a commentary on death with the crowned figure of death shown astride a skeleton horse. Death's left hand clutches a scythe and the right hand grips the horse's mane. A large bell hanging from the animal's neck symbolizes the death knell.

Example: Albrecht Dürer, charcoal sketch, 1505, British Museum, London.

METAL CUT. Metal cut is a type of *engraving made on a metal plate in the manner of a *woodcut so that a *relief printing is obtained.

METAL POINT. A drawing instrument, the metal point is a small metal (copper, lead, silver, or gold) rod pointed at one end. It was used as a drawing tool during the Renaissance. Lead point probably began in the sixth century and gave place to the graphite pencil, the only metal point that doesn't need an abrasive surface in order to leave a mark. Of all the metal points, *silver point is considered by many to be the most beautiful. It is also the commonest type of metal point.

MICHAEL, SAINT. The name of the Archangel Michael means "Who is like God" in Hebrew. Michael is prominent in Jewish, Christian, and Muslim traditions. He is mentioned in the Bible as a prince or a warrior and as the

guardian *angel of Israel (Dan. 10:13, 21; Jude 1:9; Rev. 12:7–9). Traditionally he is the angel with the sword, the defender of heaven and conqueror of Satan. He is also shown weighing the souls of the dead at *Last Judgment scenes. According to tradition it is Michael who will sound the last trumpet at the general *Resurrection. He is usually depicted as young and beautiful most often is wearing a coat of mail and is armed with a shield and sword or spear, and he may hold a marshal's baton. Sometimes he wears a jeweled crown. He has wings like nearly all angels. The representations of Saint Michael the archangel during the Renaissance were many. He is shown doing battle with Satan (see MICHAEL SLAYING THE DRAGON); he appears in Old Testament paintings, such as Mary and the *Burning Bush and the *Sacrifice of Isaac, and he plays an important role in the legends of the Virgin.

Example: Perugino, *Virgin Adoring the Child, Saint Michael, and Tobias with the Archangel Raphael,* c. 1499, National Gallery, London.

MICHAEL SLAYING THE DRAGON. According to Christian tradition, Saint *Michael the Archangel is the captain-general of the hosts of heaven, the protector of the Jewish nation who became, after the Christian revelation, the protector of the Church Militant. Michael is shown most frequently during the Renaissance waging war against Satan, who is depicted as a serpent, dragon, or demon. This is in reference to the description in Rev. 12:7–9:

And there was war in heaven: Michael and his angels fought against the dragon, who fought back with his angels; but the dragon was defeated, and he and his angels were not allowed to stay in heaven any longer. The huge dragon was thrown out, that ancient serpent named the Devil, or Satan, that deceived the whole world. He was cast out into the earth, and his angels were cast out with him.

Michael's origins were probably the ancient religion of Persia whose pantheon was divided into two, light and dark, symbolic of good and evil. Michael is associated with the gods of light, who were in eternal conflict with the gods of darkness. Satan, either as a dragon or in semihuman form, is prostrate under his feet. He has wings that prevent any confusion with Saint George (see GEORGE AND THE DRAGON, SAINT).

Example: Raphael, *Saint Michael Slaying the Dragon,* c. 1502, Louvre, Paris.

MINIATURE. The word "miniature" is taken from *minium,* a red lead used to emphasize initial letters, drawn by a *miniator.* The Renaissance portrait medal (a portrait miniature) was a revival of the classical form. Detached miniatures appeared in France near the end of the fifteenth century, but they were prevalent in the Netherlands, and the art was also established in England. Hans Holbein the Younger, during the last years of his life, painted miniature portraits in meticulous detail (less than a dozen survive).

Example: Hans Holbein the Younger, *Mrs. Pemberton,* c. 1540, Victoria and Albert Museum, London.

MIRACLE OF SAINT ZENOBIUS. A fourth-century saint, Zenobius was born in Florence of noble birth. He was converted to Christianity by one of his tutors when still a young man. Eventually he became a priest and a friend of Saint Ambrose of Milan, who recommended him to Pope Damasus I. After the death of Damasus, Zenobius returned to Florence, where he was chosen bishop. Many legends are told of the exceptional powers Zenobius had of restoring the dead to life. He is often shown thus in Florentine Renaissance painting. One of the most popular themes of his miraculous abilities is that of restoring life to a child who had been run over and killed by an ox-cart. The saint is shown as an elderly bishop on his knees praying over the dead body. The child's mother, grief stricken and backed by her kinswomen, seems to plead with the child to rise, but to no avail. Church officials stand behind Zenobius and seem astonished over the miracle about to happen.

Example: Domenico Veneziano, c. 1428, predella panel of the *Saint Lucy Altarpiece,* National Gallery, Washington.

MIRACLE OF THE BELIEVING DONKEY. See ANTHONY OF PADUA.

MIRACLE OF THE DEACON JUSTINIAN. The Miracle of the Deacon Justinian is told in the *Golden Legend.* According to this account, in the late third century a deacon named Justinian was dying because his leg was consumed by cancer. It so happened that Pope Felix, who was an ancestor of Saint Gregory (see GREGORY APPEARING TO SAINT FINA), had constructed a church in Rome in honor of the two martyred saints Cosmas and Damian (see BEHEADING OF SAINTS COSMAS AND DAMIAN). In this church the deacon, dying with his gangrenous leg, devoted himself to the service of the two holy martyrs. The saints appeared to him one night as he slept, and one said to the other, "Where shall we find new flesh to replace the rotted flesh we are to cut away?" The other said, "This day an Ethiop was buried in the cemetery of Saint Peter in Chains; fetch his leg and we shall put it in place of the sick one." (*Golden Legend,* p. 577, 578). They exchanged the leg of the sick man for the healthy leg of the Moor. When the deacon awoke he felt no pain. When he discovered the new leg (one was brown and one was white) he told everyone what he had seen in his dream. The people went to the Moor's tomb, found his leg cut off and the sick man's leg laid in the tomb beside him. The twin brothers Cosmas and Damian, skilled in the art of medicine, were featured especially in fifteenth-century Florentine painting because they were patrons of the *Medici family in Renaissance Florence. Their role was to protect against the plague and sickness in general. They were often in paintings of thanksgiving, standing before the Virgin Mary (see MARY, SAINT). They usually wear the long, dark red gown of the Renaissance physician. Their round hats are usually red also. They may hold a pestle and mortar, a surgical instrument, or a box of ointment. Often they are seen healing the sick. In the Miracle of the Deacon Justinian the saints are

shown exchanging the deacon's gangrenous leg for a healthy one. They hover over the deacon as he sleeps.

Example: Fra Angelico, c. 1438–1440, on the predella of the Saint Marco Altarpiece, Museum of San Marco, Florence.

MIRACLE OF THE HOST. The Miracle of the Host is an anti-Semitic legend that concerns a poor woman who was forced by a Jewish pawnbroker to reclaim her cloak at the price of a consecrated *Host (in Roman Catholic practice, the consecrated wafer of the *Eucharist, which is unleavened white bread baked in small disks). After the pawnbroker took the Host from the woman, he began to roast it on the fire. Soon streams of blood poured from the Host. This aroused the attention of the bailiffs, who beat the door down with sticks. They took the Jewish pawnbroker and his entire family away to be burned at the stake, and after the Host had been returned to its altar by the pope himself they hanged the repentant woman. The poverty-stricken woman is seen standing before the Jewish pawnbroker trying to redeem her cloak in one episode. In a second episode the bailiffs are shown beating down the door.

Example: Paolo Uccello, 1468, Galleria Nazionale delle Marche, Palazzo Ducale, Urbino.

MIRACLE OF THE IRASCIBLE SON (The Healing of the Wrathful Son). The Miracle of the Irascible Son is one of the stories from the legend of *Anthony of Padua, a thirteenth-century Christian saint and Doctor of the church. Several legends are written concerning Anthony's miracles. Among them is the story of the young man who had cut off his own leg in a fit of remorse for kicking his mother. Miraculously, Anthony restored the leg. He is usually shown kneeling down holding the boy's leg in front of a crowd of spectators who watch in disbelief as the miracle is being performed.

Example: Donatello, bronze relief on the high altar, 1446–1450, San Antonio, Padua.

MIRACLE OF THE SNOW. According to the legendary foundation of Sta. Maria Maggiore in Rome, one *August in the year 352, a miraculous fall of snow occurred after Pope Liberius and the patrician John both dreamed that a snowfall in August would mark the site of a new church. The next morning after their dream they awoke to find snow covering the ground. The pope is shown with cardinals holding his long, red cloak marking the outlines of the future church while John and his wife kneel nearby. The pope may also be shown dreaming in his curtained bed, and a vision of the Virgin Mary (see MARY, SAINT) appears in the sky.

Example: Matthias Grünewald, 1519, Augustinermuseum, Freiburg in Breisgau.

MIRACLE OF THE SPINI CHILD. The Miracle of the Spini Child is one of the episodes from the numerous legends surrounding Saint *Francis of Assisi and his miraculous powers to heal even after death. According to the *Golden

Legend, a small child had fallen from the window of the Palazzo Spini in Rome and had died of his wounds. The child's parents invoked Saint Francis and at once the boy, already on his bier, was returned to life. The little boy can usually be seen falling from the window of the Palazzo Spini in the background, but in the center of the picture, Saint Francis appears to the child, who is sitting up on his bier.

Example: Domenico del Ghirlandaio, 1483–1486, Sassetti Chapel, Sta. Trinita, Florence.

MIRACLES OF THE VIRGIN. The miracles of the Virgin Mary (see MARY, SAINT) were numerous. An idea of her powers can be grasped from the story of Saint Leo. According to the *Golden Legend,* while Leo was celebrating *mass in the Saint Mary Major Church and was giving communion, as he usually did, a woman kissed his hand and aroused in him a violent temptation of the flesh. But Leo, a true man of God, punished himself severely. He cut off the hand which had scandalized him. Before long the people grew unhappy because Leo no longer celebrated the divine office. He prayed instead to the Blessed Virgin and entrusted himself wholly to her care. When she appeared to him, she, with her holy hands, restored his hand to him and told him to proceed with offering the Holy Sacrifice. Saint Leo told everyone what had happened, showing them the hand that the Virgin had miraculously restored. Leo is usually shown kneeling before the Virgin.

Example: Jean Pucelle(?), Scene from Gautier de Coincy (Ms. nouv. acq. fr. 24541, fol. 119), illumination, c. 1330, Bibliothèque Nationale, Paris.

MIRACULOUS DRAUGHT OF FISHES. See CHRIST WALKING ON THE WATER.

MIRIAM. See MARY, SAINT.

MISANTHROPE. A person who hates or distrusts all people is known as a "misanthrope." In Breugel's painting the Misanthrope decides to wear a suit of mourning because the world is treacherous. He has apparently decided to renounce the world and sacrifice himself; the road in front of him is paved with thorns and he is carrying his money. Is he tempting the thief who follows behind, imprisoned in a glass ball; the ball is, perhaps, a symbol of the world. The Misanthrope might be a disguised criticism directed against the greedy nature of certain ecclesiastics. The painting itself has a round format and could possibly form a prison for the old man. As the pickpocket robs him, then he too is locked in a world dedicated hopelessly to perversity and vice. One ray of light, however, has been provided. A faithful shepherd is seen in the background, placed directly above the sphere of evil doings. He quietly watches his sheep in a typical Flemish countryside.

Example: Pieter Bruegel the Elder, 1568, Capodimonte National Gallery, Naples.

MISERICORDIA. See MADONNA OF MERCY.

MISSAL. A missal is the book used for the celebration of the *mass. It contains the Canon of the Mass and the prayers of the masses for the primary church festivals throughout the year. Those missals that were illuminated traditionally included a miniature of *Christ in Majesty and of the *crucifixion.

MITRE (Miter). A mitre is the headdress of bishops and abbots of the Western church, including the pope, which is in the form of a tall cap terminating in two peaks.

MOCKING OF CHRIST. One of the scenes comprising the Trial of Christ, the Mocking of Christ follows the *Flagellation. After *Christ had been scourged, he was taken by Roman soldiers into the Common Hall, where his clothes were taken and he was tormented by being subjected to degrading indignities. They spat in his face and beat him with their fists. They blindfolded him and hit him saying, ''Guess who hit you.'' After this Christ went before Pilate (Matt. 26:67; Mark 14:65; Luke 22:63) (see CHRIST BEFORE PILATE). In some respects the *Crowning with Thorns is a similar incident, but the two scenes should not be confused. During the mocking Christ may be shown standing before Caiaphas, who sits on his throne (see CHRIST BEFORE CAIAPHAS), or Christ is seated, surrounded by Jews who strike him with fists and sticks. They may be shown pulling his hair and spitting on him. Some scenes include musicians who try to deafen him with cymbals, pipes, and drums. In the mocking scene Christ wears no crown and is surrounded by Jews, not Roman soldiers.
 Example: Matthias Grünewald, 1503, Alte Pinakothek, Munich.

MODELLO, MODELLETTO. *Modello* and *modelletto* are Italian words used to describe a small version of a large painting that was made for presentation to the group or person commissioning the larger work so that approval could be given or denied. *Modelli,* usually in oil *paint, but also done in a combination of chalk, ink, and paint, were not merely preliminary sketches, and many still exist that are what some historians consider finished. See BOZZETTO.
 Example: Federico Barocci, *Madonna of the Rosary,* c. 1589–1593, Ashmolean, Oxford.

MOHAMMED AND THE MONK SERGIUS. Mohammed, also Muhammed, Mahomet, and, according to the *Golden Legend*, the sorcerer and false prophet Magumeth, was born in 570(?) and died in 632. Historically he was the Prophet of Islam. At the age of forty he felt himself selected by God to be the Arab prophet of true religion (the Arabs had no prophet at this time). In a cave at Mount Hira, north of Mecca, he had a vision that told him to preach. Throughout his life he continued to have visions, and many of them have been collected and recorded in the *Koran*. According to one account in the *Golden Legend* (there

are several), Mohammed was instructed by a certain monk named Sergius. Sergius, having fallen into the error of Nestorius and being expelled by the monks, joined up with Mohammed. They remained together for some time and Sergius taught him the Old and New Testaments. Mohammed was an orphan who spent his childhood with an uncle. Before meeting Sergius he had decided that he would usurp the kingship of the Arabs, but when he saw that he could not do this by force, he decided to pretend that he was a prophet. For this purpose he followed the counsels of Sergius and caused him to remain in hiding. He brought all questions to him and, when giving them to the people, he called the monk the Archangel *Gabriel. It was in this way that Mohammed won the mastery of all the Arabs. Sergius is shown in his monk's habit seated with Mohammed, who is dressed as an Arab. Several men lurk about curious as to Sergius' identity.

Example: Lucas van Leyden, engraving, 1508.

MOHAMMED II. See SULTAN MOHAMMED II.

MONA LISA. The *Mona Lisa* is considered by many an ideal beauty, but she was not Leonardo's ideal of beauty. However, something so fascinated him, perhaps another sort of ideal, that he worked on her portrait for three years. The painting is the portrait of a specific human being, her real name being Madonna Lisa. She was the third wife of a Florentine official named Francesco di Bartolommeo del Giocondo (the painting's real title is *La Gioconda* for this reason). When she first posed for Leonardo she was about twenty-four, or, at the time of the Renaissance, approaching middle age. Leonardo went beyond portraiture to make his subject not only a woman, but Woman. She appears at once cold, beautiful, and even voluptuous, and yet faintly repulsive. A sense of charm and chill radiates from her eyes, and for centuries she has been looked at with delight and puzzlement. Her face holds the eye, and the Mona Lisa has been more often copied than any other painting. Walter Pater said her face had

the animalism of Greece, the lust of Rome, the mysticism of the middle age, the return of the Pagan world, the sins of the Borgias. . . . Like the vampire, she has been dead many times and learned the secrets of the grave, and has been a diver in deep seas. . . . and trafficked for strange webs with Eastern merchants, and, as Leda, was the mother of Helen of Troy, and, as Saint Anne, the mother of Saint Mary; all this has been to her but as the sound of lyres and flutes. (*The Renaissance*)

Example: Leonardo da Vinci, 1503, Louvre, Paris.

MONOCHROME. Monochrome is a drawing or painting executed in any one color. An architectural theorist of the Renaissance, Leon Battista Alberti, advocated the use of monochrome in his essay on painting, *Della Pittura*, which was dedicated in 1436.

MONSTRANCE. A monstrance is an open or transparent vessel of gold or silver in which the consecrated *Host is exposed to receive the adoration of the faithful.

MONTEFELTRO, FEDERICO DA. Montefeltro was an Italian noble family whose members were noted patrons of art. One member, Federico da Montefeltro (1422–1482), the successor of the first Montelfeltro duke of Urbino, was prominent in Italian politics and accumulated an outstanding art collection. Piero della Francesca painted portraits of the count and his countess, Battista *Sforza, designed to be seen together as a kind of *diptych, and also to stand freely. They are both shown in profile. Federico's profile is shown because his face had been disfigured by a sword blow in a tournament. He lost his right eye and the bridge of his nose which made any portrait other than profile unthinkable.
 Example: Piero Della Francesca, 1465, Uffizi Gallery, Florence.

MORBIDEZZA. The word *morbidezza* is Italian for "softness" or "delicacy." It refers to flesh tints rendered in painting with an attention to extreme delicacy and softness.

MORDECAI. See TRIUMPH OF MORDECAI.

MORE, SIR THOMAS (Saint Thomas More). An English statesman and the author of *Utopia*, Sir Thomas More was born in 1478 and died in 1535. He is celebrated as a martyr in the Roman Catholic church. After receiving a Latin education in the household of Cardinal Morton and at Oxford, More became an English humanist. He attracted the attention of *Henry VIII of England when he became a successful London lawyer and entered the king's service in 1518. By 1521 he had been knighted. He held important offices in King Henry's government and was made lord chancellor after the fall of Wolsey in 1529. Ill health caused him to resign in 1532, and he also found himself in disagreement with many of the king's policies. Finally he was beheaded at the Tower of London because he would not swear an oath accepting King Henry VIII as Supreme Head of the Roman Catholic church. He felt that it was every person's duty to live cheerfully and as far as possible delightfully. The name of his book, *Utopia*, is an example. The word "utopia" comes from the Greek words *Ou* and *topos* meaning "not" and "place"—that is, "nowhere." Among other things, the book is a social satire with a comic spirit. Often it gives way to indignation or pathos. More was a man of noble character and great personal charm. He had a good humor and wit along with fearlessness that enabled him to jest even at his own execution. It is reported that he "bade the executioner stay until he had removed aside his beard, saying that *that* had never committed any treason" (Introduction to *Utopia*, p. vii). This same personality pervades his works. Artists show him as a man of determination and intelligence. His jaw

is set and his eyes are piercing. He wears a golden chain with its Tudor rose pendant, which indicates his high position.

Example: Hans Holbein the Younger, 1527, The Frick Collection, New York.

MOSAIC. A mosaic is a picture or pattern made by placing tesserae (colored pieces of glass, marble, and other suitable materials) in a bed of cement. The Romans used it extensively in pavements, but it is suitable for walls and vaults. During the Renaissance the Florentine painter Domenico Ghirlandaio created several pictures in mosaic, and some improvements were made in technique, including the invention of a lighter and stronger cement (powdered travertine mixed with linseed oil). Some artists painted over the finished surface in an effort to bring the art closer to painting.

Example: Domenico Ghirlandaio, *Annunciation*, c. 1490, located over the north door of the cathedral in Florence.

MOSES. Probably born in Egypt, Moses, a prototype of the prophets, was a Hebrew leader and legislator who led his people in the thirteenth century B.C. out of captivity in Egypt to the edge of Canaan. He was a Levite from the family of Kohath, the house of Amram (Exod. 6:18–20). Jochebed is called the mother of Moses, but historically this fact is doubted. His brother was Aaron. The Bible is the source for information on Moses' life. As an infant he was divinely protected. Hebrew male children were cast into the Nile according to an edict existing at the time of his birth. His mother, however, hid him in her house for three months. The time came when she could no longer hide him, and she placed him in a small ark of bulrushes and set it on the river's bank. He was found by a Pharoah's daughter named Thermuthis, who later adopted him and called him Moses. According to Acts 7:22, Moses received an excellent Egyptian education. It was God's intention to prepare him for leadership of the Hebrews. He learned of justice and court life along with the arts of a civilized life. After killing an Egyptian who had abused one of his countrymen, however, he had to flee Egypt when he was forty years old. He arrived at Midian and aided the daughters of Jethro (see MOSES AND JETHRO'S DAUGHTERS). At the close of this period in his life, when he learned of the wilderness, its resources, and climate, he saw a bush burning and yet remaining unconsumed (see BURNING BUSH). Here God made known his name (Exod. 3:13–15), the name YHWH (Yahweh), which had not been revealed before this time. Moses returned to Egypt. Exodus tells how at Sinai, during a sojourn of forty days, he received two tablets of stone on which the Ten Commandments from God were written. While he was gone, the Israelites had taken to worshipping a golden calf. When he returned and saw this, he threw the tablets to the ground and punished his people. Again he was called to the mountain and he received two other tablets inscribed like the first. His name is forever associated with the laws given at Sinai. Through Moses God passed down not only the Ten Commandments and the criminal code, but the whole liturgical law as well. Later, in old age, when the Hebrews arrived

at the Jordan River and prepared to cross, God gave Moses a view of the Promised Land from Mount Pisgag; but Moses never entered it. He died and was buried at Moab. The books of Exodus, Leviticus, Numbers, and Deuteronomy tell his story. The authorship of these and Genesis (together called the Pentateuch) is ascribed to Moses (although this is questioned by some critics). His law is called the Mosaic law. After death, Moses reappeared with *Elijah and Christ at the Transfiguration (Matt. 17:3–4) (see TRANSFIGURATION OF CHRIST). Moses is usually shown with a white beard and flowing hair in the patriarchal style, seldom as a younger man and beardless. Rays of light or horns sprout from each side of his head. Both are seen during the Renaissance. The idea of horns came from the use of the word *cornutam* (horned) in the *Vulgate, to describe Moses' face when he returned from Mount Sinai with the Commandments. He may also be shown with the tablets, sometimes inscribed with extracts from the Commandments or with the numbers one through ten. He may also hold a rod or wand.

Example: Michelangelo, marble, c. 1515, San Pietro in Vincoli, Rome.

MOSES AND JETHRO'S DAUGHTERS. Moses, the leader of the Hebrews and the lawgiver and founder of their religion, after fleeing Egypt and arriving in Midian, aided the seven daughters of Jethro, the priest of Midian, to water their sheep. They had been kept from watering their father's animals by some shepherds who tried to drive them away. Moses took the women's side and watered the flocks himself. Pleased, Jethro gave him hospitality and employment and gave him his daughter Zipporah for a wife. She bore him two sons, Gershom and Eliezer (Exod. 2:22; 18:3–4). He stayed in Midian for forty years (Acts 7:30). He may be shown as a young man, and if so, he is beardless. He does battle singlehandedly with a number of young men while Jethro's daughters usually stand around the well with looks of amazement on their faces. Sheep may be included in the background and between the fighting figures.

Example: Rosso Fiorentino, c. 1523, Uffizi Gallery, Florence.

MOSES AND THE ROCK OF HOREB. See MOSES STRIKING WATER FROM THE ROCK.

MOSES AND THE SERPENT OF BRASS. See BRAZEN SERPENT.

MOSES STRIKING WATER FROM THE ROCK (Moses and the Rock of Horeb). The story of Moses drawing water from the rock is taken from Exod. 17:1–7 and Num. 20:1–13. After the whole Israelite community had come out of the wilderness, they put up their tents and camped at a place called Rephidim. They soon complained of thirst because they could not find water in the desert. When Moses called upon God for help, the Lord said, ''Take some of the leaders of Israel with you, and go on ahead of the people. Take along the stick with which you struck the Nile. I will stand before you on a rock at Mount Sinai.

Strike the rock, and water will come out of it for the people to drink.'' Moses did this in the presence of the leaders of Israel, and the people and their flocks were watered. The place was named Massah and Meribah (these names in Hebrew mean "testing" and "complaining") because the Israelites complained and put the Lord to the test. Water is shown sprouting from the rock while people hold their pots high to catch it. The elders who accompanied Moses to the rock are sometimes shown throwing up their hands in thanksgiving. The topic was seen through the Christian period as a symbol of the spiritual refreshment drawn by man from the church.

Example: Tintoretto, 1577–1581. Ceiling of Sala Grande, Scuola di San Rocco, Venice.

MOTHER OF MERCY. See MARY, SAINT.

MUHAMMED II. See SULTAN MOHAMMED II.

MULTIPLICATION OF THE LOAVES AND FISHES (Feeding of the Five Thousand). All four Gospels describe the miracle of feeding the five thousand men. The story relates how Jesus went up into a mountain near the shore of the Sea of Galilee with his disciples and a great crowd of people, some five thousand, followed him because they had seen his miracles of healing the sick. Among them were many lame, blind, and maimed people who sat at his feet and were cured. *Christ asked Saint *Philip how this multitude might be fed (He said this to test Philip because he already knew what he was going to do). Philip answered, "For everyone to have even a little, it would take more than two hundred silver coins (one coin was the daily wage of a rural worker) to buy enough bread." Saint *Andrew said, "There is a boy here who has five loaves of barley bread and two fish. But they will certainly not be enough for all these people." Jesus told them to make the people sit down. He took the bread, gave thanks to God, and distributed it to the people who were sitting there. He did the same with the fish, and they all had as much as they wanted. After the crowd was fed, twelve baskets of leftovers were collected (John 6:1-13). During the Renaissance artists depicted a landscape crowded with people seated in groups. Christ stands or sits blessing the food. Andrew or Philip may be shown handing him the bread or taking it from the basket held by a small boy. Andrew is shown as an old man with white hair and a beard. Philip is younger, also bearded and with dark hair. Like the *Last Supper, the topic was used to decorate the refectories (dining halls) of convents. It was intended as a kind of *Eucharist but also served as an example of one work of mercy, that is, feeding the hungry. During the late fifteenth century, especially in the north, artists showed the crowds in aristocratic dress and included among them portraits of contemporary society persons.

Example: Limbourg Brothers, page from the *Book of Hours (Les Tres Riches Heures) of the Duke of Berry*, illumination, 1416, Musée Condé, Chantilly. (fol. 168v).

MYSTICAL MARRIAGE OF SAINT CATHERINE. Catherine of Siena, a Christian mystic and member of the *Dominican order, was married mystically to *Christ. During her mystic marriage she is usually shown kneeling to receive a ring from the infant Christ, who is seated in his mother's lap. The infant Christ holds her hand and prepares to put a ring on her finger. Artists who show Catherine marrying the adult Christ depict him standing beside his mother. *Angels may peer down from heaven and other saints and musicians may be present. See also CATHERINE OF SIENA, SAINT; COMMUNION OF SAINT CATHERINE; and STIGMATIZATION OF SAINT CATHERINE.
 Example: Paolo Veronese, 1570s, Accademia, Venice.

MYSTICAL NATIVITY. The *Mystical Nativity* seems in many ways upon first glance to be a typical *nativity. The painting, however, is extremely difficult to interpret. At the top of the picture is a Greek inscription. It reads:

This picture, I, Alessandro, painted at the end of the year 1500 during the trouble in Italy in the half-time after the time which was prophesied in the eleventh of John and the second woe of the Apocalypse when the Devil was loosed upon the earth for three years and a half. Afterward he shall be put in chains according to the twelfth woe, and we shall see him trodden underfoot as in this picture.

In spite of this inscription, written by the artist, Botticelli, only a few elements from the imagery in Revelation, chapters 11 and 12, are illustrated. Some of the figures and groups are not in those chapters, and one is reminded of certain sermons by Girolamo *Savonarola. The martyrdom of Savonarola and his principal follower, Fra Domenico da Pescia, could be the second woe, describing the fiery prophecies of the two witnesses and their death at the hands of the *Antichrist. The "half-time after the time" could refer to the half-millennium after the millennium after the Nativity of *Christ, the painting's subject, indicating the year 1500. "Trouble in Italy" probably meant the armies of Cesare Borgia in Tuscany. Ideally, after all this has happened, we will all be brought to where the mystical woman of Revelation 12 has found refuge with her Child in the wilderness. Devils will be chained (shown thus under rocks) and *angels will embrace us. They carry olive branches, the symbol of peace. We will all, finally, live in peace. Close to the stable are angels holding olive branches and bringing shepherds from the fields to adore the Christ Child, already being adored by his mother. Above, twelve angels carrying olive branches with crowns hanging from them dance in a circle, the symbol of eternity.
 Example: Sandro Botticelli, 1500, National Gallery, London.

MYTHOLOGICAL PAINTING. One of the features of the Renaissance was a growing interest in the authentic texts of the classics. Ovid's stories are often shown on fifteenth-century *cassoni*, even representing the figures in fifteenth-century contemporary costume, with classical or Byzantine attire used for an air of authenticity. Mythological paintings at this time were confined to the sphere

of illustration and decoration and would have remained so if the continued tradition had not seen more in the ancient images than the excuse to portray a naughty fable or as a mere pretext for painting a sensuous nude. Examples such as Raphael's famous *frescoes (*Galatea) in the Villa Farnesina taken from Ovid evoke explicitly the revelry and carefree level of the pagan world. However, it is never that simple to separate allegory from illustration. Mars can represent a personification of war and Minerva may be an allegory of *Wisdom or a goddess.

N

NAILING OF CHRIST TO THE CROSS, THE. See CHRIST NAILED TO THE CROSS.

NARRENSCHIFF. See SHIP OF FOOLS.

NATIVITY. The Nativity is the name given to the birth of *Christ. Matthew (2:1–2) tells how Jesus was born in the town of Bethlehem in Judea, during the time when Herod was king. Soon afterward, some men who studied the stars came from the east to Jerusalem and asked, ''Where is the baby born to be the king of the Jews? We saw His star when it came up in the east, and we have come to worship Him.'' Luke (2:7) tells how Mary (see MARY, SAINT) gave birth to her first son, wrapped him in cloth, and laid him in a manger. By the time of the Renaissance, legend had changed the wise men from men who studied the stars into kings. An ox and an ass had appeared in the stable (although the ox and ass were represented on a fourth-century Roman sarcophagus with no written source for them at that time). (The Apocryphal *Gospel of *Pseudo-Matthew* is the first to mention an ox and an ass.) The shepherds were bringing gifts of their own, and Mary herself knelt in adoration. The tradition that Christ was born in a cave rather than a stable is first mentioned in the apocryphal *Protevangelium of James* or the *Pseudo-Matthew*. In the cave scene (which tended to prevail in the east), the Virgin is usually lying down, Joseph is seated, and two midwives bathe the Christ Child in the foreground. The apocryphal Book of James tells that one of the midwives, Mary Salome, said that Mary could not have had a child and remained a virgin. When she touched the Virgin in an attempt to prove herself correct, her hand withered, but was righted when she picked up the Child. This theme was condemned during the Renaissance at

the Council of Trent in the mid-sixteenth century. The most popular presentation of the Nativity during the Renaissance depicted the Virgin on her knees adoring the Child. This is from an account given by Saint Bridget of Sweden, who was in Bethlehem in 1370. In her Revelations (see REVELATIONS OF SAINT BRIDGET) she described her vision of the Virgin as follows:

When her time came she took off her shoes and her white cloak and undid her veil, letting her golden hair fall on her shoulders. Then she made ready the swaddling clothes which she put down beside her. When all was ready she bent her knees and began to pray. While she was thus praying with hands raised the Child was suddenly born, surrounded by a light so bright that it completely eclipsed Joseph's feeble candle.

Renaissance artists usually depict the *Holy Family in the stable at Bethlehem. The Virgin kneels in adoration before the Christ Child. Joseph, in his amazement stands off to the side. An ox and an ass stand inside the stable usually looking at the Child. *Angels may be present and may play musical instruments.
 Example: Master of Flémalle (Robert Campin), c. 1420, Musée des Beaux-Arts, Dijon.

NATIVITY OF SAINT JOHN THE BAPTIST. See BIRTH OF SAINT JOHN THE BAPTIST.

NAVICELLA. See CHRIST WALKING ON THE WATER.

NEMESIS.
In Greek religion Nemesis was one of the daughters of *Night. She was the personification of the gods' retribution for violation of sacred law. She was the avenger upon those whose natures had been governed by pride, or *hubris*, and was capable of bringing about a man's undoing. Sometimes she was said to be the goddess of good and bad fortune. Renaissance artists depicted her nude and winged standing on a terrestrial globe. In her left hand she holds a rope or more often a bridle with which she binds man's pride. In her right hand, held high, is a vase containing honor and rewards for the just. She may stand above a landscape and her victims may fawn at her feet.
 Example: Albrecht Dürer, engraving, 1501–1502.

NEOPLATONISM.
Neoplatonism was a third-century school of Greek philosophy that grew up primarily in Alexandria and was revived during the Renaissance by Italian humanists. These men translated the works of Plotinus and Plato and attempted to reconstruct a system that would reconcile Neoplatonic mystical thinking about Christian beliefs. See PLATONIC ACADEMY.

NEPTUNE.
In Roman religion Neptune (Poseidon) was the god of the sea and its inhabitants. Sailors invoked him in order to have a safe voyage because they knew his anger could cause dreadful storms and shipwrecks. Neptune is recognized by his trident, a three-pronged, sometimes barbed spear. He may ride in a shell-shaped chariot drawn by sea-horses (Hippocampi), which have

the heads and forequarters of horses and the tails of dolphins or fish. He may be shown riding a dolphin, sacred to him in classical times. He may be accompanied by his wife, Amphitrite, and their son Triton (see NEPTUNE AND AMPHITRITE). Neptune was a natural subject for the Renaissance fountains of Italy.

Example: Giovanni da Bologna (Giambologna, Jean de Boulogne), *The Neptune Fountain,* 1563–1567, Bologna.

NEPTUNE AND AMPHITRITE. *Neptune, God of the Sea, was married to Amphitrite. The daughter of Nereus, she was a beautiful Nereid, or sea-nymph. She was the mother of Triton, a merman. When Neptune decided that he wanted Amphitrite for his bride she fled from him, but he sent dolphins after her. They persuaded her to return and marry him. She may be shown riding beside his shell-shaped chariot on a dolphin's back or in a cockleshell cart pulled by dolphins. The circle of drapery blowing in the wind over her head was a common feature of sea-goddesses from antiquity. They may be shown standing alone or be surrounded by a cortege of Nereids and Tritons.

Example: Jan Gossart, 1516, Staatliche Museen zu Berlin, East Berlin.

NIGHT. During the Renaissance, Night was considered a destructive power by Italian humanists. Along with Day, they marked the inevitable and ceaseless passage of time that led eventually, for everything, to darkness and death. Some artists depicted Night and Day as rats, one white (day) and one black (night). Night personified may be shown as a female figure hovering in the sky sometimes studded with stars. A white child in one of her arms alludes to sleep, a black one, death. She may be shown with an owl (a nocturnal bird), poppies (which have great sleep-inducing properties), and masks (a symbol of deceit that provides Night with her cover for vice), sometimes worn by putti (see PUTTO) or somewhere close by. Also, she may be accompanied by the sleeping Morpheus, one of the gods of sleep who may be wearing a crown of poppies.

Example: Michelangelo, marble figure, 1519–1523, on the tomb of Giuliano de' Medici, Medici Chapel, Florence.

NOAH. A direct descendant of *Adam and Eve through their third son, Seth, Noah alone was deemed by God to be worth saving when God saw the wickedness of man. Noah had three sons, Shem, Ham, and Japheth. He is one of the main patriarchal types of *Christ. The Flood (see DELUGE) was likened to Christian baptism by the early Fathers and apologists. Genesis tells how God determined to destroy man, whom he had created. He told Noah, "I have decided to put an end to all mankind. I will destroy them completely, because the world is full of their violent deeds. Build a boat for yourself out of good timber; make rooms in it and cover it with tar inside and out." He gave Noah the exact specifications, telling him to take his wife, his sons and their wives, and a male and female of every kind of animal and bird in order to keep them alive because he was going

to send a flood to earth to destroy every living being. Noah did all of these things. He was six hundred years old when the flood came. It continued for forty days. Everything on earth that breathed died in the water. The only living things left were Noah and those who were with him in the boat. The water did not start going down for a hundred and fifty days. Finally the rain stopped and the water gradually went down. On the seventeenth day of the seventh month the boat came to rest on a mountain in the Ararat range of Turkey. To determine whether the earth was habitable, Noah opened a window and sent out a raven. It did not come back. Meanwhile, Noah sent out a dove to see if the water had gone down, but it had not and the dove had no place to light. It flew back to the boat. Noah sent out another dove and it returned to him in the evening with a fresh olive leaf in its beak. When Noah was six hundred one years old, on the first day of the first month, the water was gone. Noah then went out of the boat with his wife, his sons, and their wives. He took all of the animals and birds out also so that they could multiply and spread over the earth. He built an altar and made a sacrifice as thanksgiving to the Lord. God then said, "I promise that never again will all living beings be destroyed by a flood; never again will a flood destroy the earth. As a sign of this everlasting covenant which I am making with you and with all living beings, I am putting my bow in the clouds. Whenever I cover the sky with clouds and the rainbow appears, I will remember My promise." Noah was a farmer and he then planted the first vine. But after he drank some of the wine he became drunk and took off his clothes and lay naked in his tent. His son Ham discovered him and told his brothers, Shem and Japheth, who took a robe and covered their father. Noah died at the age of nine hundred fifty years (Gen. 6:9-21; 7, 8 and 9). Artists usually depicted Noah as an aged white-bearded man. During the Renaissance the ark became a true boat (before this it had been a kind of floating house), and sometimes Noah's sons are shown sawing the wood. If the ship is seen as finished, animals may stand on deck or look out through portholes. A rainbow may be seen in the sky. Occasionally Noah is shown planting his vines, but more often he is shown in his tent with a wine cup beside him and Ham may be nearby deriding him. The Mocking of Noah by his son was seen as a prefiguration of the *Mocking of Christ. Rabbinic commentary indicates that Ham did not merely look at his father's nakedness, but that he castrated him, an element that could have been deliberately left out of Genesis.

Example: Lorenzo Ghiberti, *The Story of Noah*, from the Gates of Paradise (East Doors), 1425–1452, Baptistery, Florence.

NOLI ME TANGERE (Touch Me Not). According to John 20:14–18, *Christ appeared several times after his *Resurrection. The first person who saw him was Saint *Mary Magdalene as she stood by the empty tomb. She did not recognize him at first, thinking he was the gardener, and she asked him where he had put the body. When he spoke her name "Mary," she knew who he was and said in Hebrew, "*Rabboni!*" (This means "teacher.") He told her not to

touch him (*noli me tangere*) because "I am not yet ascended to my Father." He told her to tell the disciples that he was now risen. Mary Magdalene is usually shown kneeling, reaching out for Christ, who signals with his right arm stretched out in her direction that he does not want her to touch him. He may seem to be backing away from her. Some artists show him holding a spade or hoe in reference to John's remark that she thought at first Christ was a gardener, or he may hold the banner of Resurrection.

Example: Giotto, *The Angel at the Tomb and the Noli Me Tangere*, 1305, Arena Chapel, Padua.

NONFINITO. The Italian word for "unfinished," *nonfinito* usually applied to sculpture. Michelangelo left some pieces of sculpture *nonfinito* or unfinished, always, however, leaving the form implicit in the stone.

NOVEMBER. One of the twelve months of the cycle of months, November was represented from the early Christian era. November's corresponding sign of the zodiac is Sagittarius, the archer, who may be shown as a centaur with a bow. Peasants are shown gathering wood for the coming winter, sowing winter seed, tending animals to be fattened for the Christmas festivities, and, in some locations, picking olives.

Example: Limbourg Brothers, November page, *Book of Hours (Les Très Riches Heures) of the Duke of Berry*, illumination, 1416, Musée Condé, Chantilly.

NYMPH. In Greek mythology nymphs were young and beautiful female spirits who often worshipped in caves, woods, or springs. Those who frequented caves and woods were called "dryads" or "hamadryads." Nymphs of fresh water springs were called "Naiads." The daughters of Nereus, commonly known as the old man of the sea, were called "Nereids." Homer is the earliest to mention them. Sometimes they are called daughters of Zeus (*Jupiter) and have the ability to inspire men with prophetic power, or they are attendants of Pan or Hermes and join the followers of Dionysus. *Diana (Artemis) is usually accompanied by nymphs who hunt and bathe with her in secluded forest pools. Frequently they are harassed by or they tease lecherous *satyrs. They can also be harmful to mortals; they drown Hylas, destroy Hermaphroditus, and blind Daphnis. Common as secondary figures during the Renaissance, they are shown as beautiful, slender, young women in a variety of provocative poses.

Example: Benvenuto Cellini, *Diana of Fontainebleau*, bronze, 1543–1544, Louvre, Paris.

O

OBED. See RUTH, OBED, AND BOAZ.

OCCUPATIONS OF THE MONTHS. Calendar pictures to illustrate the months can be traced through history and go back as far as ancient Egypt and Mesopotamia. The Renaissance, no longer an age of the encyclopedic cathedrals, sometimes connected the months with astrological cycles. The subject usually shown for the occupations of the months is man's labors in the fields, each appropriate to the time of year and the geographical location. A brief list of each month's occupations is as follows: *January, the cutting of trees; *February, the grafting of fruit trees; *March, the pruning of vines; *April, the training of vines; *May, the cutting of grass; *June, making hay; *July, cutting corn and threshing; *August, harvesting and ploughing; *September, threshing, gathering and treading grapes; *October, sowing seed, casking the wine; *November, gathering wood, picking olives, fattening hogs for winter, sowing seed; and *December, killing hogs, preparing food for Christmas. The occupations of the months gradually disappeared from post-Renaissance art.

Example: Luca della Robbia, plaques from the Palazzo Medici, Florence, c. 1450, Victoria and Albert Museum, London.

OCTOBER. October was the tenth month of the calendars that appeared in northern European illuminated manuscripts and Italian *fresco cycles during the Renaissance. October is the month of sowing the winter grain, casking the wine, knocking down acorns, and feeding hogs. Above the illustration the signs of the zodiac may appear both for the previous month and for the month being illustrated. In this case, *September, a pair of scales or a balance is shown to indicate Libra. For October a scorpion is shown to indicate Scorpio. Artists

usually show men at work in the fields, preparing the soil and throwing out the seeds. Some artists show bacchanalia with *satyrs and Silenus drunk and crowned with vine leaves.

Example: Limbourg Brothers, October page, *Book of Hours (Les Très Riches Heures) of the Duke of Berry*, illumination, 1416, Musée Condé, Chantilly.

ODYSSEUS. See ULYSSES AND PENELOPE.

OIL PAINTING. The exact origin of oil *painting is obscure. Giorgio Vasari, Italian painter, architect, and biographer, attributes its invention at the beginning of the fourteenth century to Jan van Eyck, and this is a popular belief. However, the linseed and nut oil used by van Eyck had been used as a *medium in the Middle Ages long before van Eyck. Certainly no doubt exists that van Eyck was responsible for a revolution of the techniques of oil painting in Europe with richer color and a wider range from light to dark.

ORATORY OF DIVINE LOVE. The Oratory of Divine Love was a confraternity, founded in Rome in 1517 under Pope *Leo X, whose goal was the reform of the Catholic church from within. Its members were pledged to the cultivation of a spiritual life with a strong emphasis on frequent Communion and prayer. It was dissolved in 1524, but its members carried on their original work in the newly founded *Theatine order.

ORIGINAL SIN. See FALL OF MAN.

ORPHEUS AND EURYDICE. In Greek mythology Orpheus was a celebrated legendary Threcian poet and musician, famous for his skill with the lyre. He was the son of the muse Calliope by either Oeagrus, a king of Thrace, or *Apollo. Apollo gave him a lute and supposedly the music of his lyre was so beautiful that when he played trees danced, rivers calmed, and savage beasts were charmed (Ovid, *Metamorphoses* 10:86–105). He married the wood *nymph Eurydice but she died after being bitten by a snake as she fled the attentions of Aristaeus who tried to violate her (*Metamorphoses* 10:1–10). Orpheus descended to Hades and with his music succeeded in charming Pluto to allow Eurydice to follow him back to earth, on the one condition that he would refrain from looking at her until they reached the sunlight of the upper world. At the last moment he could not resist, and when he looked back she vanished forever into the shades. Grieving inconsolably, he wandered about Thrace singing of his love until he was attacked by frenzied Maenads of Ciconia and torn to pieces (*Metamorphoses* 11:1–43) (see DEATH OF ORPHEUS). In later legends the Muses buried the fragments of his body, but his head, still singing, and his lyre, floated out to sea to the island of Lesbos. In Italian Renaissance painting Orpheus sits under a tree plucking the lyre or playing a *lira da braccio* (an instrument of the viol family). He is young and may wear a laurel crown, an award for victory in

Greek contests of song and poetry. Wild and domestic animals may be gathered about him. Other versions may show Eurydice lying dead on the ground while Orpheus weeps over her. Demons may be shown in the background dragging her soul into the entrance of Hades. Scenes of the underworld show Pluto seated on his throne, his wife Proserpine seated beside him. Orpheus may stand before them playing or pleading for the release of Eurydice. The three-headed dog Ceberus may sit beside the throne with teeth bared. Orpheus is occasionally shown leading Eurydice away, his arm over her shoulder and his head turned back to glance at her. Orpheus being torn to pieces by the Maenads of Ciconia may also be depicted.

Example: Niccolo dell Abbate, c. 1557, National Gallery, London.

P

PACT OF JUDAS. Judas Iscariot, son of Simon Iscariot, was one of the twelve disciples; in fact, he is said to have been their treasurer. He is the disciple who betrayed *Christ to the Jewish chief priests and elders for thirty pieces of silver (see BETRAYAL). By being surnamed Iscariot, Judas is distinguished from the other disciple also named Judas (Luke 6:16; John 14:22). His surname is usually interpreted as meaning that he came originally from Kerioth and may indicate that he was not a Galilean. He possibly followed Jesus because he hoped to derive material advantage from the establishment of Christ's kingdom. Without naming anyone, however, Jesus early referred to the treason that one of his twelve followers would commit (John 6:70). Later Christ again foretold his betrayal at the *Last Supper. As treasurer Judas kept the money box, but he was dishonest and appropriated some of the money for himself. When Saint *Mary Magdalene broke the box of precious ointment and anointed Jesus, Judas was the one who called her act extravagant, not that he considered the poor, but that he thought the price of the precious ointment should be put into the money box so that he could help himself (John 12:5–6). Jesus reproved him, but this only aroused his resentment and it was after this that he went to the chief priests, and made a pact with them to betray Jesus for a price. The price they agreed to, thirty pieces of silver, was just the ordinary price of a slave. It was after this pact that Judas looked for the opportunity to betray Jesus (Matt. 14–16; Mark 14:10–11). Judas is usually depicted as an older man with dark hair and a beard. Sometimes he is dark complexioned. Since he was the *apostles' treasurer, he may hold a purse. In early Renaissance art a demon may sit on his shoulder whispering the words of Satan in his ear. In scenes of the Pact, Judas, the High Priest, and the other priests are shown together in a huddle. One of the priests may be counting out the pieces of silver into Judas' hand.

Example: Barna da Siena, 1350s, Collegiate Church, San Gimignano.

PACT WITH THE WOLF OF GUBBIO. See FRANCIS' PACT WITH THE WOLF OF GUBBIO.

PAINT. Paint is made by mixing dust-fine solid particles of pigment with a *medium. Actually paint requires nothing more than an ability to be of such consistency that it can be applied to the *ground (canvas, board, wall, etc.) and then remain preserved for an indefinite period both in substance and color while in place.

PAINTING. In principle, a painting consists of five layers: (1) the support (board, wall, canvas, etc.); (2) the *ground (a preparation designed to keep the paint from direct contact with the support); (3) the *priming (a thin coat applied over the ground); (4) the *paint; and (5) a protective layer of varnish over the completed painting. Not all of the above elements are necessary and may be omitted or even combined according to the artist's purpose.

PALA. *Pala* is an Italian word for a large *altarpiece. It differs from an *ancona* in that it may consist of only one picture. All the figures in a *pala* are shown as inhabiting one single space, which is treated as a consistent uninterrupted pictorial sequence. Each scene in most *polyptychs, and even each saint, has its own panel of space.

PALLAS AND THE CENTAUR. Pallas is the name given to the Greek goddess Athena or Athene (Minerva) after she killed either the youthful Pallas, her playmate, or in some legends, the goatish giant Pallas, who tried to rape her. The title "Pallas" is of unknown derivation and was often used in post-classical times as a synonym for Athena. During the Renaissance she was the goddess of reason. The Italian philosopher and exponent of Platonism, Marsilio Ficino (1422–1499), under the patronage of *Cosimo I, taught that Pallas appealed to the head (she herself had sprung fully armed from the head of Zeus (*Jupiter), that is, to the intellect, the highest of human facilities. The centaur, one of a race of creatures, described as "wild beasts" by Homer, symbolizes man's lower, partly animal, nature. They were usually brutal, drunken, and lecherous, and Renaissance humanists contrasted them with the higher wisdom symbolized by Pallas Athena. Athena is usually shown grasping a centaur by the hair on his head as he cringes and pulls away.

Example: Sandro Botticelli, after 1482, Uffizi Gallery, Florence.

PAN. In Greek religion Pan was the pastoral god of the woods and fields, flocks and herds. The Greek word *pan* means "all." Pan pervaded all things. He was worshipped primarily in his home of Arcadia, that region of the Peloponnese known as a romantic paradise. Arcadia was inhabited by *nymphs, *satyrs, maenads, silenus, centaurs, and Priapus, who, along with Pan, formed the fun-loving retinue of *Bacchus. One legend says that he was the son of Hermes,

another Arcadian god. Pan was supposed to make flocks fertile; when he was unsuccessful, his image was whipped to stimulate him. On occasion he was known to be ill-tempered, even dangerous. He loved to frighten unwary travelers, stampede flocks, and induce irrational "panic" terror in men (hence the word panic). His many myths deal with love affairs. According to one legend he chased the nymph Syrinx, but before she was caught her sister nymphs changed her into a reed. Thus Pan usually plays the reed, or syrinx, in her memory. Later, when he was worshipped in other parts of Greece and Rome, he became associated with the Greek Dionysus and identified with the Roman Faunus, both gods of fertility. In Renaissance allegory Pan is identified with Lust (see SEVEN DEADLY SINS). He charmed the nymphs with music and was reputed to have lain with all the Maenads. As a fertility god, however, he was amorous with both sexes. During the Renaissance Pan appeared frequently with *Venus and *Cupid and it has been suggested that the well-known "love conquers all" is strained to mean "love conquers Pan." He is usually depicted as having goat's legs and sometimes a goatlike face with pointed ears. He is sometimes shown teaching the blind shepherd Daphnis to play the syrinx. He may also carry a shepherd's crook.

Example: Luca Signorelli, *School of Pan*, c. 1490, Kaiser Friedrich Museum (destroyed 1945), Berlin.

PANDORA. According to Hesiod, the eight-century Greek poet, in his *Works and Days* (57–101) Pandora was, in Greek mythology, the first woman on earth. Zeus (*Jupiter) ordered Hephaestus (Vulcan) to create her as vengeance upon man after Prometheus had created and helped man by giving him fire. Hephaestus had fashioned her from clay. The gods endowed her with every charm, together with deceit and curiosity. She was given a box in which all the diseases and evils of the earth were stored and warned not to open it. Zeus sent her to marry Epimetheus, Prometheus' guileless brother. Despite Prometheus' warnings, Epimetheus allowed her to open the box, and after all the evils and diseases had escaped, only hope was left at the bottom to be some alleviation of the troubles let loose upon the world. The Golden Age had come to an end. Pandora became the pagan counterpart of Eve when the early church drew the parallel between Pandora's story and the *Fall of Man. She is shown thus during the Renaissance.

Example: Jean Cousin the Elder, before 1538, Louvre, Paris.

PANEL. Panel is a word used in painting for a *support of some rigid material such as metal or wood, as differentiated from canvas. During the Renaissance most artists preferred wood. The Italian masters liked white poplar, the Germans pine, the Flemings oak, but most artists used panels from many other trees such as walnut, olive, linden, mahogany, larch, beech, cedar, chestnut, and fir. For large works several planks had to be jointed together and glued with cheese glue (casein). Transportable paintings of Europe were done on wood until artists began using canvas in the fifteenth century. A few artists (the *Little Masters)

of the Netherlands worked on copper (both Leonardo and the Renaissance architect and theorist Alberti mentioned its use). Other metals used were tin and silver.

PARABLE OF THE BLIND. See BLIND LEADING THE BLIND.

PARADISE GARDEN. The first earthly paradise or paradise garden was probably the Garden of Eden. Here man lived in harmony with God and with animals. All his needs were supplied by nature because he had no tools or means, or even knowledge of cultivating the earth. He ate acorns, fruits, and berries and maybe he found honey. Eden is often called Paradise. According to Genesis, when God made the universe there were no plants on the earth. He planted a garden in Eden, in the east, and there he put the man he had made. He created all kinds of beautiful trees. A stream flowed in Eden and watered the garden. Beyond Eden were four rivers. The first river was the Pishon, which flowed around the country of Havilah. It was said that pure gold, rare perfumes, and precious stones could be found there. The second river was the Gihon, which flowed around the country of Cush. The third river was the Tigris, which flowed east of Assyria, and the fourth the Euphrates. God placed man in the Garden of Eden, in this Paradise, to keep it and guard it (Gen. 2:8–15). Artists usually show a lovely landscape of rivers, trees, and mountains. Men and women are seen playing together, eating fruit, and sleeping on the grass. Tame animals and birds surround them. Sometimes they sit in a landscape of thousands of flowers. They eat and drink, pluck fruit, and play musical instruments. The Paradise Garden may be surrounded by a wall. Sometimes the Virgin and Child are shown seated in a landscape of flowers, birds, fruit trees, angels and even saints. See GARDEN OF PARADISE.

Example: Unknown German Master, c. 1415, Städelsches Kunstinstitut, Frankfurt.

PARIS. See JUDGMENT OF PARIS.

PARNASSUS (Parnassos). An outlying spur of the Pindus range in central Greece and rising to 8,200 feet, Parnassus is a mountain northeast of Delphi, which was traditionally sacred to *Apollo and the muses. The temple of Delphi was on its slopes and close at hand the stream of Castalia flowed. The mountain was traditionally the abode of music and poetry. Usually it is shown as a small hill rather than a mountain with a stand of trees, possibly laurels. Apollo, surrounded by dancing muses, is sometimes seen playing his lyre or some other instrument. The clear stream is at their feet. Pegasus, the winged horse, symbol of poetic genius, may be included as well as *Mars and Venus who symbolize Strife conquered by Love.

Example: Andrea Mantegna, 1497, Louvre, Paris.

PARTING OF LOT AND ABRAHAM (Abraham and Lot Separate). When *Abraham went north out of Egypt to the southern part of Canaan, his wife, Lot, and everything he owned went with him. Abraham was a wealthy man with not only silver and gold, but sheep, cattle, and goats. Lot also had sheep, cattle, and goats as well as his own family and servants. Because of their large animal herds, there was not enough pasture land for the two of them to stay together. Arguments broke out between the men who took care of Abraham's animals and those who cared for Lot's animals. Abraham said to Lot, "We are relatives. Our men should not be quarreling. It is best if we separate. Choose any part of the land you desire, then you go one way and I'll go the other." Lot saw the Jordan valley with plenty of water and chose the whole valley for himself. Abraham stayed in the land of Canaan. Thus the two men parted not as enemies but as friends. They are both shown as old men with white flowing beards. Each has a herd of animals on his side and they both point in opposite directions to indicate where they intend to settle.

Example: Jean Bondol, from the *Bible of Jean dy Sy*, (Ms fr. 15397, fol. 14), illumination, c. 1380, Bibliothèque Nationale, Paris.

PASSAGE TO THE INFERNAL REGIONS. The infernal regions were also known as the infernal city, *hell, Hades, or the underworld, which was ruled by Pluto and Persephone. In Greek mythology passage there was by boat. The boatman who ferried the dead across the river Styx (hateful) was the avaricious Charon. It was necessary that the funeral rites had been performed properly and the fare (an obol, a small coin) had been put in the mouth of the corpse. Charon is usually shown standing in his boat pushing a paddle. A dead soul may be seated beside him. He is old and bearded. *Angels may be seen escorting souls to the bank in preparation for their trip across. The fearful dog Ceberus may be seen guarding the entrance to hell. Mercury, the one who guided the dead to hell, may stand beside a soul who is ready to depart (see CHARON CROSSING THE STYX).

Example: Joachim Patinir, c. 1520–1524, Prado, Madrid.

PASSION. The last events of *Christ's life on earth, his suffering and death on the cross including the events leading up to and following the *Crucifixion, are collectively called "The Passion." The word is used by the church to indicate Christ's suffering during his last week of earthly life or to describe the events leading up to and following his Crucifixion in narrative or pictorial form, not only as single subjects but as cycles of consecutive scenes. The complete series of a portrayal of the Passion cycle begins with the *Entry into Jerusalem and ends with the Descent of the Holy Ghost at *Pentecost. The number of episodes varies considerably and often concludes earlier, with the *Entombment or *Ascension. The Passion scenes most frequently represented usually include *Entry into Jerusalem; Christ Washing the Feet of the Disciples; *Last Supper; *Agony in the Garden; *Betrayal; *Christ before Pilate; Denial of Peter; *Christ

before Caiaphas; *Flagellation; *Mocking of Christ; *Ecce Homo; *Road to Calvary; *Crucifixion; *Descent from the Cross; *Pieta (Bearing of the Body of Christ); *Entombment; *Descent into Hell; *Resurrection; Holy Women at the Sepulchre (see THREE MARIES AT THE SEPULCHRE); *Christ Appearing to His Mother; Mary Magdalene (see MARY MAGDALENE, SAINT), *Noli me tangere; Journey to Emmaus; *Supper at Emmaus; *Doubting Thomas; Miraculous Draught of Fishes (see CHRIST WALKING ON THE WATER); *Ascension; and Descent of the Holy Ghost.

PASTEL PAINTING. A painting technique using dry colors is known as pastel painting. Sticks, similar to crayons or chalk, are made from pure powdered pigments and bound together with gum or resin. Pastel painting developed from the end of the fifteenth century, but art theorist Giovanni Lomazzo (1538–1600) records that Leonardo used colored chalks for some of his preliminary drawings for the *Last Supper.

PASTORAL. A pastoral scene is a type of idyllic landscape often painted with a studied elegance and including animals grazing quietly and travelers at rest or moving slowly under leafy trees. The pastoral world artists created is imaginary, deliberately artificial, and infused with poetic glamor.
 Example: Giorgione, *The Tempest*, c. 1505, Academy, Venice.

PATEN. The plate of precious metal on which the *Host is laid at the celebration of the *Eucharist is known as a paten.

PAUL, SAINT. The sources of Paul's life are the Acts of the *Apostles and the Pauline *Epistles. Paul was an apostle, although he was not one of the original twelve. Although Jewish by race (his Jewish name was Saul), his mission in life was with the Gentile world. He was a tentmaker by trade, educated in Jerusalem. He was born c. A.D. 10 in Tarsus, the chief city of Cilicia, in Asia Minor and was of the tribe of Benjamin. He inherited Roman citizenship from his father. He first appears in Christian history at the stoning (which he approved) of Stephen, c. A.D. 33, first deacon of the church. He was then a young man. At that time Paul regarded the new sect as politically and religiously dangerous. His conversion to Christianity, c. A.D. 34–35, was sudden (Acts 9:1–9). He and his companions, probably on horseback, were on their way to Damascus. It was high noon and they had nearly reached the ancient city when suddenly a light from heaven overcame them with its blinding brilliance, and Paul and his companions fell to the ground. His companions, however, got up, while he remained prostrate. The voice of God said, "Saul, why do you persecute me? Rise, and go to Damascus, and there you will be told all that is appointed for you to do." His companions heard the voice also and they discovered that Paul had been blinded by the light. They took him to a house in Damascus where he remained blind and fasting, praying, and meditating on the revelation that had

been made to him. On the third day a Jewish Christian named Ananias went to Paul and gave him his sight back. Paul received his sight and accepted baptism. Soon after his conversion Paul began evangelistic work. He retired to the desert for a time and then joined *Christ's other disciples to become the greatest missionary of the Christian faith. He made three missionary journeys throughout Greece and Asia Minor. His carrying the word of Christianity to the non-Jewish world earned him the title, "Missionary to the Gentiles." Before long he was arrested in Palestine and, as a citizen of Rome, appealed for a hearing. In A.D. 60 or 61 he was sent to Rome and imprisoned. He was released c. A.D. 63, and his subsequent activity lasted about four years. His death took place, according to Eusebius, in A.D. 67; according to Saint *Jerome, in A.D. 68. No one knows how he came to be rearrested. Tradition says that he suffered martyrdom by the sword and that Saint *Peter (see PETER, APOSTLE AND SAINT) was martyred with him in Rome on the same day. One legend tells that on the way to his execution a Christian woman named Plautilla gave him her veil to blindfold his eyes. After his death he appeared to her in a vision and handed her the veil stained with blood. Renaissance artists show him as short and bald and he may have a dark beard. He usually holds a sword, the instrument of his martyrdom, and a book or scroll to indicate his authorship of the Epistles. Sometimes he is seen with the apostle Peter, Peter symbolizing the original Jewish element, Paul the Gentile.

Example: Raphael, *Saint Paul Preaching at Athens,* 1515–1516, Victoria and Albert Museum, London.

PAUL III. Paul III, a Roman named Alessandro Farnese, was pope from 1534 to 1549. He succeeded Clement VII. After being created cardinal by Alexander VI, his influence increased steadily. He was an astute church diplomat and his major efforts were directed chiefly toward reform. With his election the Catholic Reformation began. Paul was a great patron of the arts. He founded the Farnese Palace, spent a great deal of money repaving and rebuilding the streets of Rome, and employed Michelangelo to continue the decoration of the Sistine Chapel in Saint Peter's. Paul is shown as an old man with a flowing white beard. He may be studying the plans for Saint Peter's, pointing toward the construction, and being followed by Renaissance architects. Drawing and stonecutting tools lie on the steps.

Example: Giorgio Vasari, *Paul III Directing the Continuance of Saint Peter's,* 1544, Great Hall, Palazzo della Cancelleria, Rome.

PENDANT. A pendant is a balancing figure in a composition. A good example is a small lapdog asleep on the end of a bed to balance a reclining nude.

Example: Titian, *Venus of Urbino,* 1538, Uffizi Gallery, Florence.

PENTAPTYCH. See POLYPTYCH.

PENTECOST. The word "Pentecost" is Greek for "fiftieth." The Jewish feast of Pentecost is the Palestinian celebration of the closing of the spring grain harvest, which formally began in Passover. On the Pentecost after the *Resurrection, which was fifty days from the Passover, in which *Christ was crucified, the *Holy Spirit descended on the *apostles and gave them the power to speak in such a way that people of different languages could understand them. According to Acts 2:1–4, the apostles returned to Jerusalem after the *Ascension. They and a number of Christ's followers were gathered together in one place when suddenly there was a noise from the sky that sounded like a strong wind blowing, and it filled the entire house where they were sitting. They saw what looked like tongues of fire that spread out and touched each person there. They were all filled with the Holy Spirit and began to talk in other languages. Artists show the apostles and followers gathered together, which, according to an earlier reference in Acts (1:14), included the Virgin Mary (see MARY, SAINT) and sometimes other holy women. Mary is usually the center of the picture, when she is included, and the apostles are seated around her. Above them is the dove of the Holy Spirit, which extends a ray of light to each apostle's brow, at the end of which burns a tongue of flame. Sometimes twelve figures are seen below the twelve apostles. (According to Acts 1:26, Judas' place had been taken by Matthias.) They represent twelve nations of the world.
 Example: Giotto, 1305, Arena Chapel, Padua.

PERPETUAL INTERCESSION OF THE VIRGIN MARY. See INTERCESSION OF THE VIRGIN MARY.

PERSEUS. In Greek mythology Perseus was the son of Danaë, who became pregnant after being visited by Zeus (*Jupiter), who had turned himself into a shower of golden rain. Acrisius, Perseus' grandfather, had been previously warned by an oracle that his grandson would kill him. Because of this, he put the baby Perseus and his mother in a box and cast it into the sea. The box was recovered by King Polydectes of Seriphus after it had washed up on shore. The king befriended the two and it wasn't too long before he fell in love with the beautiful Danaë. He was, however, embarassed by the presence of her son, by now full grown. He sent Perseus to bring him the head of the Gorgon Medusa, fully believing he would die in the attempt (see PERSEUS AND MEDUSA). Eventually Perseus killed Polydectes and his followers and went with his mother and his wife Andromeda to Argos. Later, while competing in a discus contest, he accidentally killed his grandfather. The prophecy was thus fulfilled. Perseus was the father of Electryon, the grandfather of *Hercules. Perseus is depicted as a beautiful young man; he is beardless and usually dressed as a warrior in armor. He wears winged sandals and a winged helmet like Mercury's and he may hold his gift from Mercury, a curved sword. He may also hold the polished

shield given him by his protectress, Minerva (see PALLAS AND THE CENTAUR).

Example: Benvenuto Cellini, 1545–1554, Loggia dei Lanzi, Florence.

PERSEUS AND ANDROMEDA. Andromeda was the daughter of Cepheus, the king of Ethiopia and Cassiopeia. Perseus was the son of *Danaë and Zeus (*Jupiter). According to most legends (some depart from Ovid), Cassiopeia angered Poseidon by saying that Andromeda was more beautiful than the nereids (*nymphs, daughters of Nereus, who lived in the depths of the Mediterranean Sea). Poseidon (*Neptune), the god who ruled the sea and its inhabitants, sent a sea monster to prey upon the country; he could be satisfied only by the sacrifice of the king's daughter Andromeda. As a sacrifice she was chained to a rock by the seashore; but she was rescued by Perseus who, when flying overhead, fell in love with her at first sight. He swooped down just in time, killed the monster, and later married her (Ovid, *Metamorphoses* 4:665–739). Perseus, wearing the winged shoes and helmet of Mercury, is usually shown freeing Andromeda. She is shown as a voluptuous nude chained to a rock at the seashore. He removes the chains from her arms as the sea-monster moves toward them from the sea. Beautiful mermaids may sport about the green sea and playfully retrieve branches of red coral. A band of anguished onlookers can be seen on the opposite shore.

Example: Piero di Cosimo, late fifteenth or early sixteenth century, Uffizi Gallery, Florence.

PERSEUS AND MEDUSA. Perseus was the son of *Danaë and Zeus (*Jupiter). In Greek mythology Medusa was one of three monstrous sisters collectively called the Gorgons. Medusa, with snakes for hair, had the special power of turning anyone who looked at her into stone. She was beheaded by Perseus, who had been sent by Polydectes, a king who had fallen in love with Danaë, his mother. Perseus offered the head of Medusa to Polydectes, who had wanted it for a long time. Also the king was sure Perseus would be killed in the attempt and he wanted him out of the way. The gods, however, helped Perseus. Athena gave him a mirrorlike shield, Hermes' winged sandals and a special curved sword; Hades contributed a cap that made him invisible. Hermes then showed him where the Gorgon sisters lived. By good fortune they were asleep when Perseus found them. He viewed them only in the mirror of his shield. Athena and Hermes were both beside him. They told him which one was Medusa because she alone was mortal and could be killed. Then, as Athena guided his hand, he cut off her head. Her two sisters chased him and he asked *Atlas for help. When Atlas refused, Perseus, using Medusa's head, turned him into a mountain of stone. On his way home he found Andromeda (see PERSEUS AND ANDROMEDA), rescued her from the sea monster, and married her. He killed Polydectes, gave the head of Medusa to Athena, and took his wife and his mother to Argos (Ovid, *Metamorphoses* 4:765–786). Perseus is usually shown grasping Medusa's snake-hair, his sword high in the air as he prepares to behead her.

Sometimes her head is turned toward Athena, who holds the shield. Medusa's sisters may be sleeping in the background. Perseus may also be shown standing, holding the decapitated head.

Example: Baldassare Peruzzi, c. 1511, ceiling of the Sala di Galatea, Villa Farnesina, Rome.

PERSPECTIVE. In the context of pictorial and scenic art, perspective is any method used to represent a three-dimensional space on a flat surface or in *relief sculpture. Perspective, in the modern sense, was probably first formulated around 1420 by the Renaissance architects Filippo Brunelleschi and Leone Battista Alberti. A mathematically proportioned system of perspective was designed by Brunelleschi c. 1420 in which he depicted two architectural views of Florence. Alberti, in his *De Pittura,* 1435, joined the science of perspective to the theory that painting is actually an imitation of reality. He saw the picture plane of a painting as a window through which one looks at the visible world. He taught that objects in a picture had to be foreshortened or they would not appear to recede into the distance. Also, orthogonal lines had to converge at a single vanishing point, which had to correspond to the fixed viewpoint of the spectator. This technique of linear perspective had an enormous influence on Renaissance art. Another influence was Leonardo da Vinci, who was primarily responsible for the development of *aerial or atmospheric perspective. Basically, this type of perspective teaches that the perception that contrasts of color and of light and dark appear greater, and the outlines or contours of objects are more defined in near objects than in far. The Italian word *sfumato, meaning "evaporated" and "cleared" (like mist), can be used to describe the transitions of color or tone from light to dark. This occurs in such small steps as to be, in the farthest distance, imperceptible. Leonardo said that light and dark should blend "without lines or borders, in the manner of smoke."

Example: Paolo Uccello, *Perspective Study of a Chalice,* 1430–1440, Gabinetto dei Disegni e Stampe, Uffizi Gallery, Florence.

PETER, APOSTLE AND SAINT. Saint Peter was the leader of the twelve *apostles. He was the brother of Saint *Andrew, son of a certain John, and his original name was Simon. By trade he was a fisherman on the Sea of Galilee. He was probably a disciple of Saint *John the Baptist and could have been brought to Jesus by his brother (see CALLING OF PETER AND ANDREW). Jesus gave him the surname of Cephas, or Peter, that is, rock. Peter's position among the other apostles (he is always named first in the lists of the apostles) was probably that of spokesman. He was the first to call Jesus the *Christ of God: "Thou art the Christ, the Son of the living God," and tried to dissuade him from his chosen path of suffering. Jesus told him, "Thou art Peter, and upon this rock I will build my church; and the gates of *hell shall not prevail against it. And I will give you the keys of the Kingdom of Heaven" (Matt. 16:15–19). Peter was chosen with *James the Greater and Saint *John the

Evangelist and Apostle to see the *Transfiguration of Christ (Matt. 16:13–20; 17:1–13). After the *Last Supper, again Peter with Saint James and John the Evangelist witnessed Jesus' *Agony in the Garden at Gethsemane. Peter drew his sword when Jesus was betrayed, but denied him later in the same night as Jesus had predicted he would (John 13; Matt. 26:26–46, 57–35). Jesus appeared by the Sea of Galilee after the *Resurrection and told Peter to "feed my sheep" (John 20:1–10; 21). Much attention is given to Peter's miracles (see PETER HEALING WITH HIS SHADOW, PETER: THE HEALING OF THE CRIPPLE, PETER: THE RAISING OF TABITHA, and PETER: THE RAISING OF THE SON OF THEOPHILUS). Overall, his life can be divided into three major parts: his years of personal association with Christ as he accompanied him during his ministry; his period of leadership in the church when after the *Crucifixion he led the Apostles in their teaching of the *Gospel, exhibited in the earlier chapters of The Acts; the time in his life when he went to Rome and established the first Christian community and was, in A.D. 64, crucified by Nero. Artists usually depict Peter as an old but vigorous man. He is almost immediately recognized by his appearance, which has remained constant in art. His hair is grey, curly, and short, and he is always balding or tonsured with a short curly beard. His features are broad and rustic. Generally he wears a yellow cloak over a green or blue tunic. He usually holds the keys, a gold key to heaven and a silver or iron key to hell. Less often he is shown with an upturned cross (he was crucified upside down; see CRUCIFIXION OF SAINT PETER), a cock, symbol of his denial, and a book, the Gospel. See also DISTRIBUTION OF THE GOODS OF THE CHURCH.

Example: Masaccio, *Saint Peter Baptizing the Neophytes,* 1425, Brancacci Chapel, Sta. Maria del Carmine, Florence.

PETER: THE HEALING OF THE CRIPPLE. Peter, leader of the twelve *apostles, often performed miracles and acts of healing. During these missions he was sometimes accompanied by other apostles. The story of the lame man who was healed is one example of his healing powers. According to Acts, one day Peter and Saint *John the Evangelist and Apostle went to the temple at three o'clock in the afternoon, the hour for prayer. There at the Beautiful Gate, as it was called, was a man who had been crippled all his life. Someone always carried him to the gate to beg for money from the people who were going into the temple. When he saw Peter and John going in, he begged them to give him some money. They looked at him and Peter said, "Look at us." And the man looked at them expecting to receive some money. But Peter said to him, "I have no money at all, but I give you what I have: in the name of Jesus *Christ of Nazareth I order you to get up and walk." Then Peter "took the cripple by his right hand and helped him up. At once the man's feet and ankles became strong; he jumped up, stood on his feet and started walking around. Then he went into the Temple with them, walking and jumping and praising God" (Acts 3:1–9). Artists usually show the cripple, a ragged beggar, sitting on the ground holding

out his hand for money. Peter and John stand before him, and Peter may reach out to the man at the same time asking him to rise and walk.

Example: Masolino, *Healing of the Cripple and the Raising of Tabitha,* c. 1424–1425, Brancacci Chapel, Sta. Maria del Carmine, Florence.

PETER: THE RAISING OF TABITHA. Peter, leader of the twelve *apostles, often performed miracles and acts of healing. One such miracle was the raising of Tabitha. As told in Acts there was a woman in Joppa named Tabitha (her name in Greek was *Dorcas,* meaning "a deer"). She performed many acts of charity, helping the poor and making clothes for poverty-stricken widows. One day she fell sick and died.

Her body was washed and laid in a room upstairs. Joppa was not very far from Lydda, and when the believers in Joppa heard that Peter was in Lydda, they sent two men to him with the message, "Please hurry and come to us." So Peter got ready and went with them. When he arrived, he was taken to the room upstairs, where all the widows crowded around him, crying and showing him all the coats and shirts that Dorcas had made while she was alive. Peter put them all out of the room, and knelt down and prayed; then he turned to the body and said, "Tabitha, get up." She opened her eyes and when she saw Peter, she sat up. Peter reached over and helped her get up. Then he called all the believers in and presented her alive to them. (Acts 9:36–41)

Peter is shown standing at the foot of the bed with his hand raised. Sometimes other apostles are with him. Tabitha is sitting up in her bed while the widows and other people of the town raise their hands in wonder. Garments made by Tabitha may be spread about.

Example: Masolino, *Healing of the Cripple and the Raising of Tabitha,* c. 1424–1425, Brancacci Chapel, Sta. Maria del Carmine, Florence.

PETER: THE RAISING OF THE SON OF THEOPHILUS. Leader of the twelve *apostles, Peter performed many miracles including bringing the dead back to life. According to the **Golden Legend,* Peter raised a young boy who had been dead for fourteen years. This is the story of the son of Theophilus, the prefect of Antioch. When Peter was preaching in Antioch he was accused by Theophilus of corrupting the people there. Since Peter did not stop preaching, he was bound in chains and cast into prison without food or water. While in prison Peter prayed, "Jesus *Christ, help of the unfortunate, come to my aid in these trials." And Christ sent Saint *Paul to him. Paul presented himself to Theophilus as a skilled artist and thus gained his confidence. A few days later he went to Peter's cell. Peter was nearly dead and Paul gave him some food. Paul then went to Theophilus and told him of Peter's miraculous healings and how he could raise the dead. Theophilus merely replied that if all this were true, then the man would surely free himself from prison. And Paul answered, "Christ, Who later rose from the dead, did not come down from the cross, so also this Peter, following the example of his Master, refuses to make his escape, choosing rather to suffer for Christ." Theophilus then said, "Go and tell him that I shall

set him free if he restores my son to life that has been dead these fourteen years.'' Paul went to Peter with the message and Peter said he could perform the miracle with the help of God. He was then led to the tomb of Theophilus' son, ordered the door opened, and called the dead boy to life. The *Golden Legend* adds that this miracle seems unlikely. Peter is shown standing over the boy who kneels before him. A crowd has gathered to watch the miracle.

Example: Masaccio and Filippino Lippi, *Raising the Son of Theophilus,* 1427, Brancacci Chapel, Sta. Maria del Carmine, Florence.

PETER HEALING WITH HIS SHADOW. Peter, leader of the twelve *apostles, performed many miracles and wonders among the people. It was believed by many of the people of Jerusalem that the apostle was able to heal with his shadow. As a result, sick people were carried out into the streets and placed on beds and mats so that Peter's shadow might fall on them as he passed by. Crowds of people came in from the towns around Jerusalem, bringing with them those who were sick in hopes that they too might be cured. Artists show them lying on beds and pallets or propped against walls of buildings. Peter is shown quietly walking past, the rest of the apostles walking behind him.

Example: Masaccio, *Saint Peter Healing with His Shadow,* 1427, Brancacci Chapel, Sta. Maria del Carmine, Florence.

PHILIP, SAINT. One of the twelve *apostles, Philip was from Bethsaida on the Sea of Galilee. A fellow townsman of Saint *Andrew and Peter (see PETER, APOSTLE AND SAINT), he was one of the first to be called to follow *Christ. Jesus met him at Bethany beyond the Jordan, where John (see JOHN THE BAPTIST, SAINT) was baptizing. It was Philip whom Christ turned to when about to perform the miracle of feeding the five thousand. He asked, ''How are we to buy bread, so that these people may eat?'' (John 6:5–6). Also, on the day of Christ's *Entry into Jerusalem, those Greeks who wanted to see Jesus applied to Philip who saw to it that they spoke to him (John 12:20–23). Philip is named after the *Resurrection as one of the apostles who met in the upper chamber (Acts 1:13). Scenes from Philip's life are fairly rare, as his place in art is not prominent. He is usually depicted as a middle-aged man, usually with a short beard. His attribute is a cross. He is said to have been martyred at Hierapolis of Phrygia by being crucified upside down like Peter. See also EXORCISM OF THE DEMON IN THE TEMPLE OF MARS.

Example: Filippino Lippi, *Saint Philip Casting Out the Devil,* 1487–1502, Strozzi Chapel, Sta. Maria Novella, Florence.

PHILIP OF BURGUNDY. Philip II, known as Duke Philip the Bold, was the fourth son of John II of France. He became duke of Burgundy in 1363 and acquired Flanders and Artois (1384) through marriage to Margaret, heiress of Count Louis II. He ruled until 1404. Along with his brother, John, duke of Berry, Philip was one of the greatest sponsors of the arts of the time in northern

Europe. His interests centered in Arras tapestries, illuminated manuscripts, and rich furnishings for the numerous castles and town houses the family had scattered throughout the duchies. Philip's largest single artistic undertaking was the foundation of the famous Charterhouse of Champmol near Dijon. It was built to receive the tombs of the family. To the left of the main portal Philip is shown kneeling before the Virgin. He is shown as middle-aged with shoulder-length hair.

Example: Claus Sluter, marble, 1385–1393, Portal of the Chartreuse de Champmol, Dijon.

PICCOLOMINI. See DEPARTURE OF AENEAS SILVIUS PICCOLOMINI FOR BASEL.

PIETÀ. *Pietà* is the Italian word for "pity." A devotional theme, it usually shows the Virgin alone with her dead son's body on her lap. No mention is made of this theme in the *Gospels, but the subject is found in the Byzantine painter's guide, in the *Revelations of Saint Bridget* of Sweden (fourteenth century), and the *Meditations* of Giovanni de Caulibus (thirteenth century). During the early Renaissance, artists depicted the dead *Christ lying across the knees of the seated Virgin. Later, Christ is shown lying on the ground with his head in her lap. The idea was first expressed in fourteenth century Germany and is an expression of northern piety, which drew upon the human relationship between Christ and his mother, and which here drew a parallel with Saint *Mary holding the Child on her lap. The earliest example (c. 1320) is at Veste Coburg.

Example: Michelangelo, *Saint Peter's Pietà*, 1498, marble, Saint Peter's, Rome.

PIETRE DURE. *Pietre dure* is Italian for "hard stone." It is used to describe a type of *mosaic work in which colored tesserae (small pieces of stone), such as lapis lazuli, *porphyry, and agate, are used to try to achieve the effect of painting. During the Renaissance the main center of art was Florence and in 1588 the Grand Duke Ferdinand opened a factory in the Uffizi for the production of panels for cabinets and tabletops, decorated with flowers and birds or landscapes. It was successful until the nineteenth century.

PILATE, PONTIUS. See CHRIST BEFORE PILATE.

PLACE OF THE SKULL. See GOLGOTHA.

PLACIDUS. See EUSTACE, SAINT.

PLAQUETTES. Plaquettes were small decorative *reliefs in metal, usually lead or bronze, almost always cast by the lost wax or cire-perdue (see BRONZE) process, and new editions could be made from the wax image of an existing plaquette. After casting, some of the plaquettes were chiselled, chased, and

finished with a *gilding. Sometimes they were made as less expensive replicas of goldsmiths' work, especially in Germany. Circular reliefs on the inside of shallow dishes were often cast as lead plaquettes. These replicas were used in the workshop and helped make designs common property among German artists. Some plaquettes were mounted as ink-wells, caskets, and sword-hilts and applied as decoration to a number of objects; tiny plaquettes served as buttons, and a religious subject could be mounted as a pyx (container for the *Host) for use at *mass. Many plaquettes were collected during the Renaissance, especially those made in precious metal or from contemporary gems. Plaquettes flourished from the end of the fourteenth century until the middle of the sixteenth century. Being easily transported, they were copied, and, like *engravings, they helped to disseminate the taste of the Renaissance. The greatest name connected with plaquettes is Donatello, though his were probably made in his studio and not by his own hand. Also known for making the most beautiful plaquettes was Andrea Riccio, an assistant of Donatello trained as a goldsmith. His most famous work is the great bronze Easter candlestick.

Example: Andrea Riccio, Paschal candlestick, 1507–1515, Santo, Padua.

PLASTER CAST. The practice of making plaster casts from famous Greek statues was very popular during certain periods of the Roman Empire. The art went out of use, however, with the fall of Rome and was not revived again until the Renaissance. Plaster casts were made as replicas of existing sculptures or from clay models or natural objects as a guide to the sculptor. A clay object crumbles unless it is kept wet or fired. Because of this, it is usual to make a plaster cast of it for the sake of preservation. This cast is then ready to be used as a model for casting in *bronze or some other metal, or it may be used by a sculptor, who by *pointing can copy the model in stone. Andrea del Verrocchio, the Florentine painter, goldsmith, and sculptor, is attributed with reviving the practice of making plaster casts. He made plaster casts of parts of the human body (the earliest examples of such casts are those found at Tel-el-Armarna, c. 1400 B.C.) so that the artist could have them continually before his eyes. Also, the practice of making death masks began in the fifteenth century.

PLASTICITY. In painting or drawing, plasticity is a three-dimensional appearance produced by the use of light and dark gradations. This creates the effect of modelling. A painting with plasticity is one that gives the impression that the figures are fully formed and capable of moving within the space provided by the artist.

PLATONIC ACADEMY. The Platonic Academy was begun in Florence by Cosimo de' Medici (1389–1464) in the middle of the fifteenth century for the purpose of the study of Plato's rediscovered Greek writings. The head of the *academy was a young humanist, Marsilio Ficino, who translated not only Plato but Plotinus into Latin.

POINTING. Pointing is a method used by stone-carvers for mechanically transferring the proportions of a three-dimensioned model, most often a *plaster cast, to a piece of stone. The main idea is that if three points are fixed in space, it is possible to find any other point in relation to them. First, three points on the model must be fixed. They must be easily accessible. In a standing model one point may be at the top of the head and two points at the feet. The distances between these points are measured with three pairs of callipers. Then the measurements are transferred to stone and marked. The points must be fixed in such positions that the entire figure will be contained within the block of stone. The remaining process is mechanical. The artist chooses a fourth point on the model, possibly the navel. The spaces on the model between this fourth point and the first three are measured with the callipers. Then all callipers are put to the block in such a way that one end of each pair touches one of the three points. The point where the free ends of the callipers meet is the point sought. It is possible that they cannot meet because the point needed is not on the surface of the block but somewhere inside it. The stone in that area is drilled away until they meet. Here another mark is made. When the process is repeated, each successive point is found by reference to the three others already established. It is possible to transfer all measurements to a larger scale so that a larger figure may be made. The practice grew up during the Renaissance of employing masons to cut the stone statue using a model of plaster or terracotta.

POITIERS, DIANE DE. See TOUCHET, MARIE.

POLYPTYCH. Usually an *altarpiece, a polyptych is a picture or *relief that is made up of three or more panels. Two panels make a *diptych, three a triptych, five a pentaptych. Any number over three is usually referred to as a polyptych. A typical Italian Renaissance polyptych was usually made up of a large central panel of the Madonna, with possibly a saint on either side and an *Annunciation on top. The *predella had narrative scenes from the lives of the saints shown above and possibly a scene from the life of *Christ. A polyptych was hinged so that it could close. Figures were painted on the wings so that when closed the panels formed a scene or two, one above the other. These panels might include the *donors.

Example: Hubert and Jan van Eyck, The Ghent Altarpiece, 1432, St. Bavo, Ghent.

POMONA. See VERTUMNUS AND POMONA.

PONDERATION. The principle of weight-shift necessary in order to depict motion in the human figure is known as ponderation. During the Renaissance the first fundamental step in this direction was made by the sculptor Donatello. See also CONTRAPPOSTO.

Example: Donatello, *Saint Mark,* marble, 1411–1413, Or San Michele, Florence.

POPE PAUL III. See PAUL III.

PORPHRY. Porphry is a hard volcanic stone varying in color from green to red. Purple porphry was the favorite color of royalty through the ages. During the Italian Renaissance this very costly stone of antiquity came again into favor, particularly with the *Medici and some sculptors.

PORTA CLAUSA. *Porta clausa* is the Latin term for "closed door" and refers to the closed door of Mary's (see MARY, SAINT) virginity.

POUNCING. Pouncing is the method by which a *cartoon is transferred to a plaster surface. The outlines of the drawing are pricked with small holes and dusted with powdered charcoal so that the primary lines of the drawing appear on the plaster beneath.

POVERELLO. *Poverello* is an Italian word meaning "poor little man." The term refers to Saint *Francis of Assisi, whose followers were often called *poverelli*.

PREACHING OF THE ANTICHRIST. The coming of the antichrist is told in Saint Matthew. Using the words of Jesus, he describes exactly what will happen when he appears.

Many men, claiming to speak for me, will come and say, "I am the Messiah" and they will fool many people. You are going to hear the noise of battles close by and the news of battles far away; but do not be troubled. Such things must happen, but they do not mean that the end has come. Countries will fight each other; kingdoms will attack one another. There will be famines and earthquakes everywhere. All these things are like the first pains of childbirth. Then you will be arrested and handed over to be punished and be put to death. All mankind will hate you because of me. Many will give up their faith at that time; they will betray one another and hate one another. Then many false prophets will appear and fool many people. Such will be the spread of evil that many people's love will grow cold. But whoever holds out to the end will be saved (24:5–13).

The Antichrist usually is shown standing on a podium preaching. He is Christlike in his clothes, hair, and beard, but his expression is terrible. A demon stands beside him whispering into his ear. The Antichrist repeats everything the demon tells him. Around him stand people of all ages and in all manner of dress. Some of them begin to fight, and in the background many have already been killed. Soldiers have stripped the temple of its vessels and piled them high before the Antichrist. Many innocent people are being beheaded in the total disorder the Antichrist has caused.

Example: Luca Signorelli, 1499–1504, S. Brixio Chapel, Cathedral, Orvieto.

PREDELLA. *Predella* is the Italian word for "kneeling stool." The word is used for all paintings that form the lower part or socle of an *altarpiece or *pala. These paintings are usually narrative scenes from the lives of the saints who are depicted in the paintings above. The word is also used to indicate a raised shelf at the back of an altar or for a painting on the front of this shelf.

Example: Gentile da Fabriano, *The Adoration of the Magi, Strozzi Altarpiece*, 1423, Uffizi Gallery, Florence.

PRESENTATION IN THE TEMPLE. The bringing of the baby Jesus by *Mary (see MARY, SAINT) and Joseph to the temple in Jerusalem to be "consecrated to the Lord" according to all the requirements of the law of *Moses is known as the Presentation in the Temple. The Presentation is not to be confused with his *Circumcision. According to Mosaic law, the firstborn of all things had to be sacrificed to the Lord. Children were redeemed by the payment of five shekels (Num. 18:15–17). This ritual commemorated the killing of the firstborn in Egypt when the Jews had been spared (Exod. 13:11–15). The early church adopted it as a Christian feast. Saint *Luke says, "They also went to offer a sacrifice of a pair of doves or two young pigeons, as required by the law of the Lord" (2:24). This Jewish rite of purification of the mother was celebrated simultaneously, and it too became a Christian festival. (It is called the Churching of Women in the Anglican prayer book.) According to Luke, there was a man of Jerusalem named Simeon in the temple when Jesus was brought there by his parents. He had revealed that he would not die until he had seen the Lord's *Christ. When he saw Jesus, Simeon took the Child in his arms and said, "Now Lord, you have kept your promise, and you may let your servant go in peace. With my own eyes I have seen your salvation which you have prepared in the presence of all peoples" (2:29–31). Mary and Joseph were amazed and Simeon told Mary, "This child is chosen by God for the destruction and the salvation of many in Israel. He will be a sign from God which many people will speak against and so reveal their secret thoughts. And sorrow, like a sharp sword, will break your own heart." Also in the temple was "one widow named Anna, a prophetess . . . and she coming in that instant spoke about the child to all who were waiting for God to set Jerusalem free "(Luke 2:36–38). The scene in which Mary and Joseph bring the baby Jesus to the temple is depicted often in Renaissance art. Saint Simeon is usually identified with the high priest of the temple and wears priest's vestments. Mary and the high priest are shown standing side by side. She may hold the Child, or he may hold the Child and is in the act of handing it back to her. Joseph and a female attendant usually stand behind Mary, and one of them holds a pair of doves, an allusion to the theme of the *Purification in the Temple. In early Renaissance paintings Mary herself holds the doves. Some artists show Joseph reaching into his purse for the five shekels. Anna, the widow prophetess, may also be present holding a long scroll indicating her prophecy and at the same time pointing a finger at Mary. Anna is more often featured in Italian than in Northern Renaissance painting. The feast of the

Purification involved a procession of candles and because of this, the main figures in the paintings, or acolytes, may carry candles, in reference to the Candlemas, as the procession came to be called. Because of the prophecy of Simeon that through her Child Mary would be pierced to the heart, the theme may form one of the series of the Seven Sorrows of the Virgin, Simeon's prophecy being the first. The other six are: *Flight Into Egypt, Christ lost by his mother or Dispute with the Doctors (see DISPUTE), *Bearing of the Cross, *crucifixion, *Descent from the Cross, and the *Ascension.

Example: Ambrogio Lorenzetti, 1342, Uffizi Gallery, Florence.

PRESENTATION OF THE RODS. See WATCHING OF THE RODS.

PRESENTATION OF THE VIRGIN IN THE TEMPLE. According to the *Golden Legend*, which tells the story of the childhood of the Virgin Mary (see MARY, SAINT) after the accounts in the early New Testament apocryphal literature, the Virgin was brought to the temple with gifts when she was three years old. Her parents, Joachim and Saint *Anne, brought her there after she was ''weaned from the breast.''

Around the Temple there were fifteen steps, one for each of the fifteen gradual Psalms; for since the Temple was built upon a hill, one could not go up to the altar of holocaust from without except by the steps. The Virgin, placed upon the lowest of these steps, mounted all of them without the help of anyone, as if she had already reached the fulness of her age. (*Golden Legend*, p. 523)

After making their offering, Joachim and Anne left Mary with the other virgins in the temple and returned to their home. ''And the Virgin Mary profited in every virtue, and was visited daily by the *angels, and enjoyed the vision of God.'' The theme of the Presentation is rare in Western art before the Renaissance. During the Renaissance it may be shown as a separate scene or as part of the cycle of the life of the Virgin. Artists show the child Mary climbing the steps of the temple (not always fifteen in number), toward Zacharias, the high priest, who waits for her at the top with outstretched arms. Mary may reach out toward him. She is usually shown at a little more than three years of age. Joachim and Anne stand with numerous onlookers at the foot of the steps, follow behind her; or, contrary to the text, help her up the stairs.

Example: Titian, 1534–1538, Accademia, Venice.

PRIDE. See SEVEN DEADLY SINS.

PRIE-DIEU. A French phrase, *prie-dieu* literally means ''pray God.'' Actually it is a small kneeling bench or a prayer desk having a footpiece on which to kneel and a raised shelf to hood a book.

PRIMAVERA. The Italian word for spring is *primavera*. From antiquity and beyond the Renaissance, spring is usually depicted as a beautiful young woman holding bunches of flowers or with flowers scattered throughout her hair. She may also hold a hoe or a spade, and a garden or grove of succulent fruit may form the background or be somewhere in the landscape. During the Renaissance the antique tradition of representing spring as *Flora was revived. Flora was the ancient Roman goddess of flowers, spring, and fertility. The Floralia, her ancient festival, was celebrated with much licentiousness. The Greek goddess of flowers was Chloris who was married to Zephyr, the mild west wind that heralded the spring and caused the flowers to bloom. Ovid tells in *Fasti* (5:193–214) that Chloris was chased by Zephyr and changed into Flora with flowers coming from her breath and spreading slowly over the countryside. This is the moment some artists depict. Chloris is usually shown fading from Zephyr's grasp as flowers spill from her lips and she is transformed into the beautiful Flora. Flora is shown standing beside her fully metamorphosed, strewing flowers from her flower-embroidered dress upon the already flowering grass.

Example: Sandro Botticelli, c. 1478, Uffizi Gallery, Florence.

PRIMING. Priming is a thin layer applied on top of the *ground to make it more suitable to receive *paint. Sometimes the term is mistaken for ground. If the ground is too absorbent, for example, the priming will cause it to be less so, or the priming is able to supply a tint. During the Renaissance the Italian word *imprimatura* was commonly used in this sense. It involved laying over the *gesso ground a pigmented mixture that assisted the drying of the paint. Flemish and Italian painters of the early Renaissance toned their white grounds with a thinly applied *glaze of transparent color that could also be used as a middle tone in the painting. Sometimes the *imprimatura* was brown, yellowish, or reddish, but usually grey or greenish, according to the intended result. Different media could be used such as glue *size, oil *tempera, or resin oil. Some artists applied the *imprimatura* on top of the preliminary drawing, which had been done in India ink or color on a canvas or panel. The Flemish artist Jan van Eyck was known to use this method. *Imprimatura* was also used over *grisaille underpaintings.

PRIORI. An Italian word for "priors," the *priori* was the principal governing body of a town.

PROCESSION OF THE MAGI. The magi, following a star, came from the east. According to Saint *Matthew, soon after the birth of Jesus in the town of Bethlehem in Judea, some men who studied the stars came from the east to Jerusalem and asked, "Where is the baby born to be the king of the Jews? We saw his star when it came up in the east, and we have come to worship him" (2:1–2). They were directed by Herod's officials to go to Bethlehem. During the Renaissance the magi are sometimes shown leading a long procession that

winds far into the landscape. Their retinue form an array of ceremonial costumes and fantastic horse-trappings studded with gold and blazing with color. The red Florentine costume worn during the Renaissance by all foreigners is seen sprinkled throughout the long procession. Some of the followers may be seen engaging in a deer hunt. See also ADORATION OF THE MAGI.

Example: Benozzo Gozzoli, 1459, Chapel, Palazzo Medici-Riccardi, Florence.

PROCRIS. See CEPHALUS AND PROCRIS.

PRODIGAL SON (The Lost Son). Of all the parables, the Prodigal Son, teaching the virtues of forgiveness and repentance, is the one represented most often in art. In this parable, which Jesus tells in Saint *Luke (15:11–32), there was a man who had two sons. The youngest one said to him, ''Father, give me my share of your property now.'' So the man divided his property between his two sons. After a few days the youngest son sold his part of the property and left home with the money. He went to a far away country where he wasted his money in reckless living. He spent everything he had. Then a famine spread over that country and he was left with nothing. So he went to work for one of the citizens of that country who sent him out to his farm to take care of his pigs. No one gave him anything to eat and he wished he could eat the bean pods the pigs ate. Finally he said, ''All my father's hired workers have more than they can eat, and here I am starving. I will go home and say, Father I have sinned against God and against you. I am no longer fit to be called your son; treat me as one of your workers.'' So he got up and started home. He was still a long way from home when his father saw him; his heart was filled with pity, and he ran, threw his arms around his son, and kissed him. ''Father,'' the son said, ''I have sinned against God and against you. I am no longer fit to be your son.'' But the father called his servants. ''Hurry, bring the best robe and put it on him. Put a ring on his finger and shoes on his feet. Go and get the prize calf and kill it and let us celebrate with a feast. My son was dead, but now he is alive.'' And so the feasting began. In the meantime, the older son upon returning home heard music. A servant told him what had happened. The older brother was so angry he would not go into the house. His father came out and begged him to come in. But he spoke back to his father, ''Look, all these years I have worked for you like a slave, and I have never disobeyed your orders. What have you given me? Not even a goat for me to have a feast with my friends. But this son of yours wasted all your property on prostitutes, and when he comes back home, you kill the prize calf for him.'' The father said, ''My son, you are always here with me, and everything I have is yours. But we had to celebrate and be happy because your brother was dead, but now he is alive; he was lost, but now he has been found.'' The lost son is usually shown kneeling in the pig pen with the pigs who swarm about him. He is praying. Pigs are feeding in a trough nearby. The son may also be shown after he has returned to his father. He is kneeling before his father dressed in rags and his father is shown blessing him

or making a gesture of pardon. Servants may be in the background bringing new clothes. The scene of the calf being slaughtered may be shown in the background.
 Example: Albrecht Dürer, engraving, 1497.

PROPORTION. The idea of proportion comes from that of ratio, which is the relation of one part to a whole or to other parts. In the arts proportion is the search for harmonious mathematical relationships between various parts of the human body. The search, probably started during classical times as evidenced in Greek sculpture, led to significant theorizing during the Renaissance. The two artists who devoted much time to proportion were Leonardo da Vinci and Albrecht Dürer. Renaissance architects particularly interested in proportion were Filippo Brunelleschi, and Leone Battista Alberti. Both took measurements from classical buildings and statues in the hope of locating that rational basis for beautiful forms, which they thought the ancients to have possessed. The buildings of both are planned with classical systems of proportion in mind. Brunelleschi also led a movement in Florence to devise canons for the figure. These early theorists made an honest attempt to understand the principles underlying the classical ideal. With this in mind they made measurements of ancient statues in Rome, and furthered their search by applying the same scientific method to live models. Alberti divided the whole length of a figure into six hundred *minuta*. This provided him with an accurate scale for making and recording measurements. During this same time proportion was studied in relation to *perspective. Many artists, such as Dürer, became obsessed by the search for ideal proportion.

PROTO-RENAISSANCE. The term ''proto-Renaissance'' was first used by Jakob Burckhardt to characterize those elements in Italian architecture that demonstrate the closest connections with classical antiquity. It was a desire to use revived antique forms before the Renaissance proper. Some historians describe it as a movement that began in the latter part of the eleventh century, reached its climax in the twelfth, and continued into the thirteenth century. Some say it was a Mediterranean phenomenon, beginning in southern France, Italy, and Spain. The artist Nicola Pisano is usually regarded as the highest point in this early revival of classicism, and artists well into the Renaissance proper felt the influence of his work.

PRUDENCE. See VIRTUES.

PSYCHE. See CUPID AND PSYCHE.

PSYCHE RECEIVED ON OLYMPUS. During the Renaissance the story of Psyche was treated as a philosophical allegory of the search for the soul (Psyche) for union with Desire (*Cupid). According to Homer, a soul, symbolized by Psyche, appeared in the underworld looking as it did in life, and it was under the influence of Orphism that souls were conceived by philosophers and poets

as being apart and different from the body. Sometimes the soul was shown, especially in funeral art, as a bird and even as a butterfly. The personification of soul or Psyche as a girl was a favorite story during the Renaissance. The girl Psyche was visited at night by her lover, Cupid. She was forbidden to view him, but, of course, could not resist, and when holding a lamp over him to do so, she dropped hot oil on him and he disappeared. Psyche then searched the world for him until Zeus (*Jupiter) felt sorry for her and arranged for her reunion with Cupid on Olympus. She was escorted to Olympus by Mercury. A full assembly of the gods was called and Cupid and Psyche were formally married (see CUPID AND PSYCHE). Psyche is shown as a beautiful young woman (she was so beautiful she had aroused even *Venus' envy) standing before Zeus. Mercury, seen in the assembly of the gods, is easily recognized by his winged hat and caduceus, or magic wand with two snakes entwining it. Zeus is usually shown as an old man seated on a throne, his head in one hand as he contemplates the situation. The entire group may be standing on fluffy clouds, which are supposed to represent heaven.

Example: Raphael and Assistants, 1518–1519, eastern half of ceiling, Loggia di Psiche, Villa Farnesina, Rome.

PSYCHOMACHIA. During the Renaissance a conflict such as that between the soul and the body or the conflict of good and evil was known as psychomachia. Psychomachia was also a long allegorical poem by the fourth-century Spanish poet Prudentius, in which the *Virtues and *Vices confront each other. In a series of single combats Faith goes against Idolatry, Chastity against Lust, Patience against Wrath, Pride against Humility, and so forth (see SEVEN DEADLY SINS). In the end all the virtues triumph. During the Renaissance they are usually found as separate figures with Charity and *Justice being the commonest virtues and lust and avarice the most frequently depicted vices.

PTOLEMY (Claudius Ptolemaeus). Ptolemy was a second-century Greco-Egyptian astronomer, geographer, and mathematician. The last great astronomer of ancient times, he discovered the irregularity in the moon's motion called "evection," and made original observations concerning the motions of the planets. Ptolemy's works on geography and astronomy became the standard in textbooks until the work of Copernicus came to be accepted. Ptolemy is usually shown contemplating a celestial globe. He is dressed as an ancient astronomer.

Example: Raphael, *School of Athens,* 1510–1511, Stanze della Segnatura, Vatican, Rome.

PUNISHMENT OF KORAH, DATHAN, AND ABIRAM. The story of the punishment of Korah, Dathan, and Abiram is from the book of Numbers (16:1–35), which tells the story of the Israelites during the nearly forty years from the time they left Mount Sinai until they reached the eastern border of the land that God had promised to give them. The book is also an account of people who

rebelled against God and against *Moses. According to this account, Korah had the audacity to rebel against Moses. He was joined by two others—Dathan and Abiram—and by two hundred fifty Israelites. They gathered before Moses and Aaron and said to them, "You have gone too far. All the members of the community belong to God. Why, then, Moses do you set yourself above God's community?" Moses prayed when he heard this. Then he told Korah and his followers:

"Tomorrow morning God will show us who belongs to Him; He will let the one who belongs to Him approach Him at the altar. Tomorrow morning you and your followers take fire pans, put live coals and incense on them, and take them to the altar. Then we will see which of us God has chosen."

Moses then said to God, "Do not accept any offerings these men bring. I have not wronged any of them; I have not even taken one of their donkeys." When Korah and his followers put live coals and incense on their pans they stood at the entrance of the tent with Moses and Aaron. Then Korah gathered the whole community, and they stood facing Moses and Aaron at the entrance of the tent. Suddenly the blinding light of God's presence appeared to the entire community, and God said to Moses and Aaron, "Move back from these people and I will destroy them immediately." But Moses and Aaron said, "You are the source of all life. When one man sins do not become angry with the entire community." God said to Moses, "Tell the people to move away from the tents of Korah, Dathan, and Abiram." Moses did this. He told them, "Get away from the tents of these wicked men and don't touch them or anything that belongs to them. Otherwise you will be wiped out with them for all their sins." So they moved away. Dathan and Abiram had come out and were standing at the entrance to their tents with their wives and children. Then Moses said:

"This is how you will know that God has sent me to do all these things. If these men die a natural death without some punishment from God, then the Lord did not send me. But if the earth opens up and swallows them with all they own, you will know that these men have rejected the Lord."

As soon as he had finished speaking, the ground under Dathan and Abiram opened and swallowed them and their families, together with all of Korah's followers and their possessions. The earth then closed over them and they vanished. Korah, Dathan, and Abiram are usually shown falling into a great split in the earth. Sometimes only two figures arc shown indicating that one has already vanished into hell. Flames may arise to consume them. Other figures offer the false fire to God from censers at an altar. The two hundred fifty followers are shown backing away from the entire scene.

Example: Sandro Botticelli, 1481–1482, Sistine Chapel, Vatican, Rome.

PURIFICATION IN THE TEMPLE (The Purification of the Blessed Virgin Mary). According to the *Golden Legend* the Purification of Mary (see MARY, SAINT) is celebrated on the fortieth day after the *Nativity. The feast is known by three names: Purification, Hypopani, and Candelaria, or Candlemas. The

Purification is so called because on the fortieth day after the birth of *Christ, Mary came to the temple at Jerusalem to purify herself in accordance with the custom of the law, even though she was not subject to the law. The law, as set forth in the book of Leviticus (12:2–8), says that a woman who has borne a male child shall be unclean for seven days. During that period she shall have nothing to do with anyone and shall not enter the temple; but after seven days, then she shall be clean. But she shall not enter the temple for another thirty-three days. After the forty days have passed, she shall go into the temple on the fortieth day, and bring her child with her, and offer gifts. Mary did not have to obey the law of purification, since her childbearing was not due to human contact, but to the overshadowing of the *Holy Spirit. Nevertheless she submitted to the law for four reasons: to serve as an example of humility; to do homage to the law, which her son had come to fulfill and not to destroy; to put a term to the Jewish purification, and to mark the beginning of the Christian purification, which purifies the heart; and to teach us to purify ourselves throughout our entire life. According to Saint *Luke, "When the days of her purification according to the Law of Moses were accomplished, they brought the Child to Jerusalem to present him to the Lord; and to offer sacrifice according to that which is said in the Law of the Lord, a pair of turtle doves, or two young pigeons" (2:22, 24). This scene is called "Purification of the Virgin." If, however, the emphasis in this scene is placed upon Jesus, rather than upon his mother, the scene is then entitled *Presentation in the Temple. Mary is usually shown as a young woman ascending the steps of the temple. She holds a small basket that contains two turtle doves or two pigeons. Her father, Joachim, and her mother, Saint *Anne, stand at the foot of the steps or follow along behind her. Onlookers crowd into the scene behind them. The high priest of the Temple, Zacharias, waits for Mary at the top.

Example: Limbourg Brothers, from the *Book of Hours (Les Très Riches Heures) of the Duke of Berry (fol. 54v),* illumination, 1416, Musée Condé, Chantilly.

PURSUIT AND BETRAYAL OF SAINT BARBARA. See BARBARA, SAINT.

PUTTO (pl. Putti). Italian for "little boy," *putto* is used when referring to a naked little boy seen frequently in art as a motif of decorative art. The chubby child developed from the Greek god of love, Eros, or the corresponding Latin personifications, Cupido and Amor. The innocent charm and appeal of this delightful boy-child has allowed his entry into seduction scenes and the church. See also AMORINO.

Example: Donatello, *Putti,* on a portion of his marble and mosaic *Cantoria,* 1433–1439, Museo dell 'Opera del Duomo, Florence.

PYTHAGORAS. A pre-Socratic Greek philosopher and founder of the Pythagorean school, Pythagoras was born c. 582 B.C. and died c. 507 B.C. He left his native Samos, moved to Crotona and founded a secret religious society

or order similar to the earlier Orphic cult. Little is known of his life and nothing of his writings. It is impossible to distinguish his teachings from those of his disciples, since they came to worship him as a demigod and to attribute all the doctrine of their order to him. Pythagoras' followers came to be known as Pythagoreans. They are best known for two teachings; the theory that numbers make up the true nature of things and the transmigration of souls. His followers performed purification rites and followed dietary, ascetic, and moral rules to ensure a higher rank for their souls in their subsequent lives. They also treated slaves in a human manner, respected animals, and regarded the sexes as equal. Pythagoras is credited with the first use of the term "philosophy." In art Pythagoras is the personification of Music and Arithmetic, two of the *Seven Liberal Arts. He is usually shown as an old man dressed in Greek garments demonstrating his proportion system on a slate.

Example: Raphael, *School of Athens*, 1510–1511, Stanza della Segnatura, Vatican, Rome.

Q

QUATTROCENTO. The word *quattrocento,* which means "four hundred" in Italian, is used to designate the 1400s or the fifteenth century in Italian art.

QUEEN OF SHEBA BRINGING GIFTS TO SOLOMON. Sheba is the biblical name of a region in Arabia also called Saba, which included present-day Yemen and the Hadhramaut. In the tenth century the biblical queen of Sheba (called in Muslim tradition Balkis) made her visit to Solomon. The story of Solomon and the queen of Sheba is told in 1 Kings 10:1–13. Since the queen's country was known for its enormous wealth, she brought to Solomon great amounts of gold, spices, and jewels. The queen of Sheba decided to visit Solomon after she had heard so much of his fame. She traveled to Jerusalem to test him with difficult questions and brought with her a large group of attendants as well as many camels loaded with gifts. When she met Solomon she asked him all the questions she could think of. He answered everything she wanted to know about. Now she knew of his wisdom and saw for herself the palace he had built. She saw the food that was served at his table, the living quarters for his officials, the uniforms of his palace staff and the servant who waited on him at feasts, and the sacrifices he offered at the temple. She was amazed and told King Solomon so. She told him she would never have believed it until she had seen everything for herself. Then she added that what she had heard wasn't even half of it, that his wisdom and wealth were much greater than she had been told. "How fortunate are your wives. How fortunate your servants, who are always in your presence and are privileged to hear your wise sayings," she told him. "Even God has shown how pleased He is with you by making you king of Israel." Then she presented Solomon the gifts she had brought: nearly five tons of gold and a large amount of spices and jewels. The amount of spices she gave

him was by far the largest that he had ever received at any time. The queen of Sheba is shown either before Solomon's throne, her attendants carrying urns and pots containing gifts; or she is seated at his side. The topic was seen as a prefiguration of the *Adoration of the Magi.

Example: Piero della Francesca, *Meeting of Solomon and the Queen of Sheba,* from the *Legend of the True Cross,* 1453–1454, S. Francesco, Arezzo.

QUINCE. A yellow lemon- or pear-shaped fruit sacred to *Venus is known as a quince. As a symbol of fertility and marriage, it may be seen in portraits commemorating a wedding. If the quince is held by the Infant *Christ it has the same meaning as the apple. In Latin, the word for apple and the word for evil, *malum,* are the same. Thus the legend has grown up that the Tree of Knowledge in the Garden of Eden, the fruit of which *Adam and Eve were forbidden to eat, was an apple tree. However, the quince held by Christ symbolizes the fruit of salvation. Also, the quince placed in the hands of the Virgin Mary (see MARY, SAINT) is considered an allusion to salvation.

Example: Fra Filippo Lippi, *Madonna and Child with Saints and Angels,* 1437, Louvre, Paris.

QUI TOLLIS PECCÁTA MUNDI. This is an inscription seen on early Italian paintings of Saint *Jude. It means "Thou who takest away the sins of the world."

R

RACHEL. As told in Genesis 29:9–30; 30:28–43; 31:17–55; 33:1–11, Rachel was the daughter of Laban. Jacob, who met Rachel at the well while watering her father's sheep, fell in love with her after he kissed her and "was moved to tears." Rachel and her sister *Leah both became wives of Jacob. (see JACOB AND RACHEL). Rachel may be shown in prayer, her hands raised to heaven, her garment the type worn by nuns in a convent. In art she may be the companion piece to Leah. Together the two figures symbolize the virtue that Saint *Paul called the greatest: love of God and love of mankind.

Example: Michelangelo, *Tomb of Julius II,* marble, finished 1547, San Pietro in Vinceli, Rome.

RAISING OF DRUSIANA. The story of Drusiana is found in the account of Saint *John the Evangelist and Apostle in the *Golden Legend*. In Ephesus John met a procession that accompanied the mortal remains of one of his most devoted friends, a woman named Drusiana. She, more than anyone else, had longed to see John when he returned to Ephesus (see TEMPLE OF EPHESUS). Her kinswomen told John that they were about to bury her and how she had told them only moments before her death that she wanted to see the *apostle of God once more before dying. John ordered them to set down the coffin and open it. He told Drusiana: "My Master Jesus *Christ raises thee to life. Arise and go into thy house and prepare my meal." She got up and went into her house thinking that she had awakened from sleep. John is usually shown with outstretched hand ordering Drusiana to arise. Drusiana, restored to life, is shown sitting up in her coffin. The townspeople stand around the scene in attitudes of awe as they witness the miracle.

Example: Giotto, mid-1320s, Peruzzi Chapel, Santa Croce, Florence.

RAISING OF LAZARUS. The story of the death and the miracle of his raising is told in John (11:1–44). Lazarus, the brother of Martha and Saint *Mary Magdalene, lived in Bethany and became gravely ill. As he lay dying, word was sent to Jesus. When he received the news he stayed where he was for two more days because he knew the sickness would not be the death of Lazarus. By the time Jesus arrived in Bethany Lazarus had been buried for four days. Jesus was met on the road by Martha and Mary, and they went to the grave, a cave with a stone placed at the entrance. Jesus ordered the stone to be taken away and Martha, fearing that by now the corpse would stink, reminded Jesus that Lazarus had been buried for four days. Jesus told her that if she had faith she would see a miracle. Jesus then called out in a loud voice, "Lazarus, come out!" He came out, his hands and feet wrapped in grave cloths, and with a cloth around his face. Jesus told them, "Untie him and let him go." This topic features in religious art from earliest times as a type of *Resurrection. Lazarus is usually depicted standing (in ancient Jewish funeral rites bodies were put into tombs in an upright position), and he is still wrapped in grave cloths. Martha and Mary may be shown kneeling at *Christ's feet. They may also be shown holding their noses against the smell they expect from a decomposed body. This adds force to the performance of Jesus' miracle.

Example: Giotto, 1305, Arena Chapel, Padua.

RAISING OF TABITHA. See PETER: THE RAISING OF TABITHA.

RAISING OF THE SON OF THEOPHILUS. See PETER RAISING THE SON OF THEOPHILUS.

RAPE OF DEIANIRA. The daughter of the river-god Oeneus of Calydon, sister of Meleager, and wife of *Hercules, Deianira asked the centaur Nessus to carry her over a flooded river. Instead he violated her and, upon being discovered, was shot full of arrows by Hercules. He gave his blood-soaked shirt to Deianira as he lay dying and told her it was a lovecharm. A few years later Hercules fell in love with Iole, and Deianira gave him the shirt as a gift. It was a lovecharm, whose poisons were released when he put it on and they began to corrode his flesh. In an effort to end his agony, Hercules flung himself on a burning pyre. Deianira, learning of this, killed herself. Deianira is usually shown in the arms of the centaur. They seem to fly over the swollen river, and Hercules is on the opposite bank taking aim at Nessus with his bow and arrow.

Example: Antonio del Pollaiuolo, c. 1475, Yale University Art Gallery, New Haven.

RAPE OF EUROPA. In Greek mythology Europa was the daughter of a legendary king of Tyre and sister of Cadmus. Her story is taken from a poem of the third-century Alexandrian poet Moschus and is also told by Ovid (*Metamorphoses* 2:836–875). According to the myth, Europa was exceedingly beautiful and attracted the attention of *Jupiter (Zeus) one day as she and her

companions gathered flowers in meadows near the seashore. *Venus, the Goddess of Love, along with her son, *Cupid, shot one of her shafts into Jupiter's heart and he fell madly in love with Europa. Even though Hera (Juno) was away, he thought it best to be cautious, and, before appearing to Europa, he changed himself into a white bull. Of course, he was not an ordinary bull as one might see standing in a stall, but rather one beautiful beyond all bulls that ever were. (Hamilton, *Mythology*, p. 79). He appeared so gentle as well as beautiful that the girls were not frightened as he walked up to them. They all gathered around, but it was Europa he drew toward him. He lay down before her feet and she sat down upon his back and even though Europa's companions wanted to join her, they could not, for the bull leaped up at full speed, rushed to the seashore, and then over the wide water. As he went, Europa still upon his back, a whole procession rose up from the water and accompanied him: strange sea-gods, Nereids astride dolphins, and Tritons blowing their horns. Europa knew this was no ordinary bull and begged him not to leave her in some strange place all alone. He told her he was Jupiter and he was taking her to Crete, his own island. They landed at Crete and the Seasons, the gatekeepers of Olympus, arrayed her for her "wedding." Jupiter, assuming his normal shape, ravished her. She bore him Minos, Rhadamanthus, and Sarpedon on the island of Crete. Later, she married the king of Crete, who adopted her sons. After her death Europa was worshipped as a goddess in the Festival of the Hellotia. Europa may be shown on the bull's back. She holds onto one horn as he plunges through the waves. Her companions stand helplessly on the distant shore. Amoretti fly overhead while one rides a dolphin close by her side. The *Moralized Ovid,* which interpreted the classical myths in terms of Christian allegory during the medieval period, saw *Christ as Jupiter, incarnate in the bull, taking a human soul to heaven.

Example: Titian, 1559–1562, Isabella Stewart Gardner Museum, Boston.

RAPE OF HELEN. See ABDUCTION OF HELEN.

RAPE OF HIPPODAMIA. See LAPITHS AND CENTAURS.

RAPE OF LUCRETIA. See LUCRETIA.

RAPE OF PROSERPINE (Gr. Persephone). In Greek and Roman religion, Proserpine was the goddess of fertility and queen of the underworld. She was the daughter of Zeus (*Jupiter) and *Ceres (Demeter). Her story is from Ovid (*Metamorphoses* 5:385–424; *Fasti* 4:417–450). As she was picking flowers one day with some of her friends she was observed by Pluto, the king of the underworld. He immediately fell in love with her. One day he seized her and carried her off by force to his kingdom below. The intensity of his love was explained by the fact that he had just been hit by one of *Cupid's arrows. Even though Ceres persuaded the gods to let her daughter return to her, Proserpine was required to stay in Pluto's underworld for four months because he had

tricked her into eating a pomegranate (food of the dead). When she left the earth, the plants withered and the grain died, but when she returned the flowers and trees blossomed anew. Her story symbolizes the annual vegetation cycle and was celebrated in the *Eleusinian Mysteries* performed at Eleusis, a Greek religious sanctuary. Originally the celebration was intended to promote fertility of the crops. Artists show Pluto carrying Proserpine away. She fights and flings her arms in desperation while her friends either flee or watch helplessly. Pluto's chariot may be nearby, ready to descend into a black cavern. He usually has black hair and a black beard, and he may wear a crown. The flames of hell may be seen, although the Greeks' Hades had no fires.

Example: Niccolo dell Abbate, mid-sixteenth century, Louvre, Paris.

RAPE OF THE SABINE WOMEN. A well-known legend, the Rape of the Sabine Women is a dramatic episode described in the first book of Livy (1:9) and Plutarch (2:14). The Sabines were ancient people of central Italy, centered mainly in the Sabine Hills northeast of Rome. Not much is known about them that can be considered dependable. According to the legend, however, Romulus, the founder of Rome, needing women to ensure the future growth of the population of his city, decided to abduct the women of the Sabines. He arranged a large gathering and invited all the inhabitants of neighboring settlements including the Sabines, with their wives and children. While the party was at its height, at a given signal from Romulus, the men of Rome broke into the crowd, picked out the unmarried Sabine women, and carried them away. According to Plutarch they took only one married woman and did not commit rape wantonly, but in order to form an alliance with their neighbors. The affair led to war with the Sabines and eventual reconciliation and intermarriage after the girls' mothers intervened. Little doubt exists that the account was designed to explain the slow infiltration of early settlers into the indigenous peoples of Italy. Many Roman practices are said to have originated with the Sabines, and Rome was actually involved in numerous wars with the inland Sabines. In 268 the Sabines became Roman citizens. Italian Renaissance artists usually combine a scene of men and women in Renaissance attire enjoying the entertainment of acrobats and musicians with the rape scene in which the unmarried Sabine women are carried away by Romulus' armed men. Some artists depict the men and women nude and only the rape scene is shown.

Example: Giovanni Bologna, marble, 1583, Loggia dei Lanzi, Florence.

REALM OF PAN. See PAN.

REDENTORE. The Italian word for "redeemer" is *redentore*. During the Renaissance this word was used frequently in reference to *Christ.

REGINA COELI. The Virgin Mary (see MARY, SAINT), when represented as the Queen of Heaven, is known as the *Regina Coeli*. During the Renaissance the portraits and half-length figures of the Virgin alone, crowned or veiled and sometimes shown gazing devoutly upward, represented Mary as the Queen of Heaven. See CORONATION OF THE VIRGIN.

RELIEF. *Relievo* or relief is sculpture that is not free-standing, but rather three-dimensional and projecting from a flat background. Varying depths of projection are indicated by several names. In high relief, or *alto relievo,* the protrusion is great and is nearly detached from the background. The term *mezzo rilievo* is used when the dimension of depth is about half the scale of the other dimensions. *Basso rilievo,* low or better known as *bas relief,* is used when the scale of projection is slight and there is no undercutting at all. The reverse of relief, when the design is incised and sunk beneath the surface of the block and molded in reverse, is known as *intaglio. During the Renaissance a type of very low relief called *rilievo stiacciato* or **rilievo schiacciato,* was invented by the Italian sculptor Donato Donatello that is barely more than a scratching on the surface.
 Example: Lorenzo Ghiberti, gilded bronze, 1403–1424, north doors, Baptistery, Florence.

REMEMBER ME. See MEMENTO MEI.

REPOUSSÉ. The process or the product of ornamenting metallic surfaces with designs in *relief hammered out from the back by hand is known as *repoussé.* Copper, tin, bronze, silver, and gold are suitable for the process. The process is of ancient origin and can be traced back to most early civilizations. During the Renaissance much of the gold and bronze work of Benvenuto Cellini included the process of *repoussé.*

REPOUSSOIR. A French word meaning "to push back," *repoussoir* is, in painting, the use of a strongly defined figure or other object placed in the foreground of a picture, most often at the right or left edge, in order to push back, give depth to, and deflect the spectator's eye into the principal scene or episode.

REPRODUCTION. The process of reproducing an image exactly is known as reproduction. The Egyptians and Babylonians used the *woodcut for impressing *intaglio designs into bricks, but as far as Europe is concerned, two-dimensional reproduction begins with the first examples in intaglio *engraving on metal and woodcutting during the Renaissance. The purpose behind the invention of all the techniques of engraving and their modern descendants was the multiplication of exact copies of a single desirable design. Yet until the Renaissance the reproduction of images was hampered by the lack of treatises and textbooks with diagrams and illustrations the artist could depend on. Fifteenth-century woodcuts

were a great advance in this respect because they insured that once the block had been cut, identical copies could be printed, including diagrams and illustrations. During the Renaissance, illustrations became so popular that the simple woodcut was unable to meet the new and complicated demands put upon it. By the sixteenth century a new reproductive technique was needed and this is where the history of reproductive engraving and the intaglio techniques on metal begin.

Example: Albrecht Dürer, *Flight into Egypt*, woodcut, c. 1504.

REST (REPOSE) ON THE FLIGHT INTO EGYPT. According to Matthew 2:13-15, an *angel appeared to Joseph, the Virgin Mary's husband, and told him that Herod was looking for the Infant Jesus in order to kill him. The angel told him to take the mother and child and escape to Egypt (see FLIGHT INTO EGYPT). During their journey they stopped to rest. They are usually shown in a landscape or near several buildings. Joseph may be at work preparing for the evening while Mary watches over her child. If an old woman is included, she is Salome, the midwife. Angels may stand beside them or hover overhead, sometimes offering food. God the Father and the *Holy Spirit may sometimes be seen hovering above. The belongings of the family may be tied in a bundle, which is on the ground. If a town is included in the background it may be Sotinen in Egypt. This alludes to a story from the apocryphal Gospel of Pseudo-Matthew, which tells of the Infant Jesus entering a temple there and causing the statues of pagan gods to crash to the ground and break. The same source also tells the story of the palm tree. As the family rested in its shade, the child ordered it to bend its branches. When it did the family plucked its fruit. The palm frond is the emblem of the Christian martyr. It may be somewhere in the scene.

Example: Albrecht Dürer, woodcut, 1504-1505.

RESURRECTION. The rising again of *Christ on the third day after his death and burial is known as the Resurrection and is one of the fundamental tenets of Christian faith. The scene is mentioned in the *Gospels but not described since there were no witnesses at the moment of Christ's return. Confirmation is found in his subsequent appearances to the disciples. Resurrection scenes before the Renaissance depicted Christ floating in the air framed by a *mandorla*. During the early Renaissance Christ was shown firmly on the ground either stepping out of a sarcophagus (coffin) or standing upright in it holding the banner of Resurrection with its red cross. From the second half of the sixteenth century, it is more usual to see Christ standing in front of a closed tomb. (The Council of Trent, which disapproved both of the floating figure and the open tomb, had demanded a return to scriptural accuracy.) Soldiers are usually recumbent around the tomb. The only Gospel to mention a guard of soldiers is Saint *Matthew and may have been included to refute charges made by Jews at that time that Christ's disciples had purposely and secretly removed the body. Occasionally in Italian painting, the soldiers may be replaced by the four *Evangelists or

saints. The word "Resurrection" is used also to describe the *Resurrection of the Dead, the rising again of all men at the *Last Judgment. The word is usually used only for these two events, the word "Raising" being preferred for the miracles of the son of Theophilus, Tabitha, and Lazarus. See RAISING OF THE SON OF THEOPHILUS, RAISING OF TABITHA, and RAISING OF LAZARUS.

Example: Piero della Francesca, c. 1463, Palazzo Comunale, Borgo San Sepolcro.

RESURRECTION OF LAZARUS. See RAISING OF LAZARUS.

RESURRECTION OF THE DEAD. The rising again of all men at the *Last Judgment is known as the Resurrection of the Dead. The dead are shown nude emerging from cracks and holes in the earth. Some are shown already walking about, while others are still struggling and may have only their head and shoulders exposed. Those who have climbed out of their tombs may help others who appear to have difficulty. Occasionally some figures are shown rising from the sea. They may be undergoing a change, having the form of skeletons as they leave the ground, and gradually, as they emerge, recovering their flesh. The entire skeleton may remain as it climbs from the earth and even as it stands off to the side awaiting judgment. According to Saint Augustine, all men would be the same age as *Christ at his resurrection, which was then taken to be thirty years. Their age at death had no bearing on this. Most artists portray them accordingly.

Example: Luca Signorelli, 1499–1504, S. Brixio Chapel, Cathedral, Orvieto.

RESURRECTION OF THE TWO WITNESSES AND EARTHQUAKE. The story of the Two Witnesses is found in Revelation 11 and forms part of the central theme that God will finally and totally defeat all of his enemies, including Satan, and will reward his faithful people with the blessings of a new heaven and a new earth when this victory is complete. Wide differences of opinion exist regarding the interpretation of details of the Revelation. The writer's main concern was to give Christian's hope and encouragement during times of persecution. Revelation is a message from God consisting primarily of visions that show the overcoming of persecution and evil and the triumph of God. The Resurrection of the Two Witnesses and the Earthquake forms a part of seven visions which include the two witnesses. The text says:

I will send my two witnesses dressed in sack-cloth, and they will proclaim God's message. . . . The two witnesses are the two olive trees and the two lamps that stand before the Lord of the earth. . . . When they finish proclaiming their message, the beast that comes up out of the abyss will fight against them. He will defeat them and kill them, and their bodies will lie in the street of the great city, where their Lord was crucified. The people of the earth will be happy because of the death of these two.

The author of Revelation then switches from the future to the past tense, which adds to the impact of the divine hand in the foretold events.

After three and a half days a life-giving breath came from God and entered them, and they stood up; and all who saw them were terrified. . . . As their enemies watched, they went up into heaven in a cloud. At that very moment there was a violent earthquake; a tenth of the city was destroyed, and seven thousand people were killed. The rest of the people were terrified.

Artists show the future. The two witnesses are usually depicted as two men on the ground who appear to be dead, and the past as God stands beside them and appears to begin their *Resurrection. A city is shown crumbling and falling to the ground. People of the city stand to the side watching God resurrect the Two Witnesses. *Angels wait in heaven above.

Example: Jean Bondol, scene from the *Apocalypse Tapestries*, after 1375, Musée des Tapisseries, Angers.

RETABLE. The word "retable" may be used for a painted or carved *altarpiece that is made up of one or more fixed panels and not hinged like a triptych. The word is also used to describe a shelf, ledge, or frame enclosing decorated panels located above the back of an altar. In some cases ornaments are placed on it.

REVELATIONS OF SAINT BRIDGET. A fourteenth-century saint, Bridget (also called Brigitta) was a Swedish nun and one of the great saints of Scandinavia. A devout noblewoman, she was attached to the Swedish court. After she bore a large family of eight children, her husband died. She then devoted herself to religion and founded the Order of the Most Holy Savior (the Bridgettines). In 1349 she went to Rome and worked to reform the religious life of most Italians. One of her major labors was to work for the return of the pope from Avignon to Rome. She kept an account of her numerous visions, her *Revelations,* which was widely read during the Middle Ages. Her book includes details about the birth and death of *Christ and had some influence on Christian *iconography and iconology. Most artists show her wearing a nun's black habit with a white wimple and veil, occasionally with a red band across her forehead. She is usually shown holding a candle, which alludes to the story that she would let drops of hot wax fall on her hand in order to simulate the wounds of Christ. As head of the Order of Bridgettines, she may hold a crozier. Her trips to Rome and the Holy Land are alluded to with a pilgrim's staff, a wallet, and a hat. A crown at her feet alludes to the giving up of her life at court and a book and inkhorn her *Revelations.* In 1391 she was canonized.

Example: Albrecht Dürer, *Revelationes Sancte Birgitte,* 1500, book of 58 woodcuts.

RILIEVO SCHIACCIATO. An Italian term for "flattened *relief," *rilievo schiacciato* refers to a new kind of sculpture initiated by Donatello in which the previous notion of relief is abandoned in favor of optical suggestion. In this way distance and *perspective are achieved by optical suggestion rather than by sculptural projection. The new kind of relief is physically shallow yet creates an illusion of infinite pictorial depth. Some Greek and Roman reliefs had achieved

schiacciato to some degree, but in all previous cases, the actual depth of the space represented the forms in the front plane in high relief, and those in the background became progressively lower, seemingly immersed in the background. Donatello changed this relationship; behind his figures, the new landscape consisted of delicate surface modulations that caused the marble to catch light from many angles. In this way every small ripple became endowed with a descriptive power far greater than its real depth. The technique was not borrowed from painting, as one might suppose, for no painter in the early fifteenth century had achieved such an atmospheric view of nature.

Example: Donatello, *Saint George and the Dragon,* portion of relief below Saint George, c. 1415–1417, Or San Michele, Florence.

RISEN CHRIST. The *Gospels vary as to who it was that first discovered that *Christ had risen. Saint *Matthew states that it was Saint *Mary Magdalene and Mary, the mother of James, who came to the sepulchre early in the morning and were told by an *angel that Christ had risen. According to Saint *Mark, these two, together with Salome, came to the tomb and found the stone rolled away. Inside the sepulchre, they saw an angel who told them that Christ had risen. Saint *John the Evangelist and Apostle specifically states that it was Mary Magdalene who came to the tomb at an early hour and found that the stone had been removed. She went to Peter (see PETER, APOSTLE AND SAINT) and John to tell them that Christ's body had been taken away. They both rushed to the tomb and found that the sepulchre was empty. All of them departed, with the exception of Mary Magdalene. Crying, she remained at the tomb, and when she looked in she saw two angels; one, where Christ's head had been; the other, at the place of his feet. Then she saw the risen Christ standing beside her. Christ is shown standing. He usually holds the instruments of his *Passion, including a cross. See *Noli me tangere.*

Example: Michelangelo, marble, c. 1518–1521, Santa Maria Sopra Minerva, Rome.

ROAD TO CALVARY. See CALVARY.

ROMANISTS. See ANTWERP MANNERISTS.

ROOD-SCREEN. During the fourteenth and fifteenth centuries, the rood, a crucifix mounted above the entrance to the chancel and flanked by figures of the Virgin Mary (see MARY, SAINT) and Saint *John the Evangelist and Apostle, was an almost invariable feature in the European church. The Virgin and Saint John were most often carved in wood and painted and gilded (see GILDING). The screen of stone or wood closing the chancel from the nave was richly ornamented and became the support for the figures and cross and was called a rood screen. Rood screens survived into the sixteenth century. Subsequently they went out of style and, because most of them were destroyed in the eighteenth century, they are known, if at all, only as dismembered fragments.

ROSARY. The rosary is featured in a number of Renaissance paintings, both in the north and in Italy. The rosary is a string of beads ending in a crucifix which is used in counting prayers and series of prayers. It was created by the Dominicans as an aid to memory in the recitation of prayers of devotion to the Virgin Mary (see MARY, SAINT). Hail Marys, for example, are recited in groups of ten, preceded always by an Our Father and ending with a Glory Be to the Father. In northern painting a rosary is found on the back wall in Jan van Eyck's *Arnolfini Wedding* while in Italy, Michelangelo showed a negroid couple being raised into heaven by a rosary in his *Last Judgment* on the back wall of the Sistine Chapel, indicating the power of prayer and faith, which he once called "la catena della fede."

ROSENKRANZBILD. See FEAST OF THE ROSE GARLANDS.

RUTH, OBED, AND BOAZ. The story of Ruth is found in the Old Testament, the eighth chapter in order in the Authorized Version. It is a peaceful story set in the violent times of the judges. Ruth, a Moabite woman, was married to an Israelite. When he died, she insisted upon remaining with her mother-in-law, Naomi, telling her, "Don't ask me to leave you. Let me go with you. Wherever you go, I will go; wherever you live, I will live. Your people will be my people, and your God will be my God" (Ruth 1:16–17). Because of this Ruth accompanied Naomi to Bethlehem, the town of her birth. Ruth went into a field to glean some grain which remained after the reapers had passed because the two women were hungry. The field belonged to Boaz, a wealthy man. He was of the same family as Naomi. Boaz fell in love with Ruth when he saw her standing in the field. He allowed her to gather grain with his workers in the field. Naomi decided that Ruth must have a husband and they thought of Boaz. Ruth dressed herself in her best clothes, put on some perfume, and went to Boaz. She lay at his feet as he slept. By this act Boaz saw her good intentions and decided to assume the responsibilities toward her of a kinsman. He married her and of their marriage was born a son, Obed, who was the father of Jesse, who in turn became the father of *David the king (Ruth 2:3:4). The story of Ruth, written between 450 B.C. and 250 B.C., is one of the most popular of the scriptural stories. The figure of Ruth is well known in Renaissance art. She may be shown as a beautiful young woman holding Obed in her arms. Boaz may be shown as a bent old man leaning on his staff.

Example: Michelangelo, 1511, Sistine Chapel Ceiling, Vatican, Rome.

S

SABINE WOMEN. See RAPE OF THE SABINE WOMEN.

SACRA CONVERSAZIONE. In art the *Sacra Conversazione* is a "holy conversation" usually including the Virgin and Child with saints. In early Renaissance art these figures were most often found on an *altarpiece and were located on separate panels. The fifteenth and sixteenth centuries saw this idea developed into a unified group in "Holy Conversation," *Sacra Conversazione,* or *Conversatio Mystica*.
 Example: Lorenzo Lotto, c. 1520s, Kunsthistorisches Museum, Vienna.

SACRED AND PROFANE LOVE. In art, love has several aspects, and during the Renaissance love was sometimes depicted in secular works as *Cupid and *Venus. The Christian ideal of love as seen in religious art was personified by the figure of Charity. Sensuous passion was personified by Lust (see SEVEN DEADLY SINS). Sacred and profane love present a contrast between two forms of love, one more exalted than the other ("sacred" and "profane" implying a dichotomy rather than a scale of values within what is actually the same experience). The two kinds of love are depicted as two Venuses, each with her own attributes, sitting at either end of a fountain. One is dressed, girdled with a locked belt, and gloved, and holds a closed jar. She is wreathed with myrtle which, less perishable than the rose, symbolizes the legitimate and lasting joys of marriage. Behind this terrestrial Venus is a wooded hill dominated by a fortified castle. The hill offers safe shelter to a couple of hares, symbols of love, who converse in peace. The other Venus is nude and has no attribute except her mantle thrown over her left arm, which is lifted to hold a small urn from which a flame rises. Behind this celestrial Venus there is a luminous landscape

dominated by the steeple of a peaceful village, offering grass to a flock of sheep and serving as a hunting ground for two huntsmen who with their greyhound, catch up with a rabbit (instead of leaving it alone with its mate). The fountain upon which the Venuses sit has the shape of a sarcophagus, and its lid is pushed aside so that Cupid may stir its waters. Cupid in this role may symbolize the principle of harmonization by virtue of which the two forms of love depicted by the two Venuses, though different, are one in essence. On the sarcophagus-fountain is an emulation rather than an imitation of ancient sculpture. On the left an unbridled horse is led by its mane by an indistinct figure. During the Renaissance the unbridled horse was the most popular symbol of unbridled passion. On the right a man is beaten and a woman is led by her hair. Near the right-hand margin two figures appear carrying a stake possibly in order to tie the victim to it and to torture him further. The nude Venus is exhorting her "sister," but the nature of that exhortation is not known. Sacred and Profane become a document of Neoplatonic humanism, the two kinds of love hold sway over the two spheres of a world within which love is an innate and uniting force that causes the higher things to care for the lower ones, the equal things to a new communion with each other, and finally causes all lower things to turn toward the higher ones; thus a world to which new love is truly sacred from mere lust.

Example: Titian, c. 1515, Borghese Gallery, Rome.

SACRIFICE OF ISAAC. The story of *Abraham's offering of his son, Isaac, to God is told in Genesis 22:1–19. God tested Abraham's faith by commanding him to offer his only son, Isaac, as a sacrifice to him. The next morning they set out for the place of sacrifice, Abraham, Isaac, and two servants. On the third day they arrived. Abraham told the servants to remain with the donkey while he and Isaac went to worship. Isaac carried the wood for the sacrifice, and Abraham carried a knife and live coals for starting the fire. Isaac asked his father, "Where is the lamb for the sacrifice?" Abraham told him that God would provide one. When they arrived at the spot God had described, Abraham built an altar and put the wood on it. He tied up his son and placed him on the altar, on top of the wood. He picked up the knife to kill him but an *angel told him not to hurt the boy. He looked around and saw a ram caught in a bush by its horns. He got it and offered it as a burnt offering instead of his son. Abraham's intended sacrifice of his son was seen as a type of *Crucifixion—God's sacrifice of *Christ. By carrying the wood Isaac prefigured Christ carrying his cross. The thorns of the thicket became the crown of thorns, and the ram became Christ crucified. Traditionally Abraham's sacrifice occurred on the site of the Mosque of Omar (The "Dome of the Rock") at Jerusalem. Abraham is usually shown with his knife ready to kill Isaac. Isaac, sometimes naked, lies or kneels on a kind of low altar on which wood has been piled. The angel is shown above Abraham and is in the act of staying his hand while at the same time indicating the ram caught in the thicket.

Example: Titian, 1542, Sacristy, Sta. Maria della Salute, Venice.

SACRIFICE OF NOAH. The story of Noah's sacrifice is told in Genesis 8:20–22, 9:1–17. After the great flood (see DELUGE) Noah, as a thanksgiving, built an altar to God. He took one of each kind of ritually clean animal and bird and burned them whole as a sacrifice. God was pleased and said to himself, ''Never again will I put the earth under a curse because of what man does. Never again will I destroy all living beings as I have done this time.'' Then God said to Noah and his sons, ''I am making my covenant with you and with your descendants, and with all living beings. As a sign of this everlasting covenant I am putting my bow [rainbow] in the clouds. It will be the sign of my covenant with the world.'' Noah is shown with his family before the altar usually gazing up to heaven in wonder.

Example: Michelangelo, 1508–1512, Sistine Chapel Ceiling, Vatican, Rome.

SACRIFICE OF THE PASCHAL LAMB. The story of the Sacrifice of the Paschal Lamb is told in Exodus 12:3–14. God spoke to *Moses and Aaron in Egypt and told them that on the tenth day of the month each man had to choose either a lamb or a young goat for his household. It had to be a one-year-old male without any defects. On the evening of the fourteenth day of the month, the whole community of Israel would kill the animals. The people were to take some of the blood and put it on the doorposts and above the doors of the houses in which the animals were to be eaten. That night the meat was to be roasted whole, including the head, the legs, and the internal organs. It was not to be eaten raw. If any of the meat was left over it had to be burned. God told them that on that night he would go through the land of Egypt killing every first-born male, both human and animal, and punishing all the gods of Egypt. That night the destroying *angel came and passed over the Jews whose houses had the identifying blood mark on the doorposts. This disaster overcame Pharoah's stubbornness and he finally sent the Jews away. The Passover, as this was called, remains one of the chief religious festivals of Judaism. The Christian view of it is as a foreshadowing of the *Last Supper. Men and women are shown standing about a table ready to partake of the paschal meal. The lamb is shown on a plate

Example: Dirk Bouts, from the *Last Supper Altarpiece,* 1464–67, Church of St. Pierre, Louvain.

SAGRA. The word *sagra* is Italian for ''consecration'' and is used when referring to the consecration of a new church. Masaccio's *Sagra* represented a procession of contemporary Florentines, all recognizable.

Example: Masaccio, *Sagra,* c. 1424, cloister alongside the Church of Santa Maria del Carmine, Florence (destroyed).

SAINT SYLVESTER REVIVING TWO SLAIN MEN. See SYLVESTER RESUSCITATING TWO DECEASED ROMANS.

SALA. *Sala* is an Italian word for "hall" or "room."

SALOME BEFORE HERODIAS. See FEAST OF HEROD.

SALVATOR MUNDI. *Salvator Mundi* is a Latin phrase for Savior of the World. The Savior, or *Christ, is shown holding the cross and the orb in one hand and blessing with the other.

SAMSON KILLING THE LION. The story of Samson slaying the lion is from Judges 14:5–9. Samson went to the town of Timnah to look for a certain Philistine girl he had seen there earlier. She had caught his eye. As he went through the vineyards of the town with his mother and father, he heard a lion roaring. "Suddenly the power of the Lord made Samson strong, and he tore the lion apart with his bare hands, as if it were a young goat." Like *Hercules, Samson, by slaying a lion with his bare hands, demonstrated his superhuman strength. He is usually shown with his foot or knee in the lion's back or astride it, grasping its jaws in an attempt to pry them apart. The medieval church interpreted Samson's combat with the lion as the struggle of *Christ against the devil.
 Example: Albrecht Dürer, woodcut, c. 1498.

SAND-CASTING. See BRONZE.

SANGUINE. A crayon or chalk drawing done in flesh or reddish coloring. Usually a pigment, chalk, or clay containing some form of iron oxide is used. Leonardo da Vinci used this type of drawing to execute his sketches for the *Last Supper. When used in conjunction with black and white, sanguine forms the technique known as *à trois crayons.*
 Example: Michelangelo, *Profile with Oriental headdress,* c. 1522, Ashmolean Museum, Oxford.

SAPPHIRA. See DISTRIBUTION OF THE GOODS OF THE CHURCH.

SATYR. In ancient Greece, the satyr was a part bestial, part human, creature of the woods and mountains, identified with the god Faunus of Roman mythology. An important part of *Bacchus' (Dionysus') entourage, they were lustful, lazy, amorous creatures always merrily drinking, dancing, and chasing *nymphs. Satyrs were usually depicted as being very hairy with goatlike features such as cloven hoofs and horns. During the Renaissance satyrs personified evil, more particularly Lust (see SEVEN DEADLY SINS). The cloven hoof and horns of the devil or Satan derive from the satyrs. They participate with the Maenads, the female followers of Bacchus, in his orgiastic rites, the Bacchanalia. The Roman god Faunus, according to one ancient tale, wanted to ravish his daughter and succeeded in getting her drunk but only had his way with her after he had turned himself into a snake. The satyr's attributes, possibly because of this story,

are the wine pitcher and snake. Also, satyrs may hold a thyrus, a fertility symbol of Bacchus, and play pipes. Sometimes they carry a cornucopia or baskets of fruit. In this case they are fertility spirits themselves. Artists depicted satyrs creeping up on bathing nymphs, drawing their robes aside as they sleep (see ANTIOPE), pouncing upon maidens, or simply chasing them. Satyrs can be small and childish, as they are shown in Botticelli's *Mars and Venus, and also in the *Bacchus* figure by Michelangelo. By the end of the Renaissance they were conventionally grouped with arcadian shepherds and nymphs, and their evil, lusty aspects are sometimes forgotten.

Example: Albrecht Altdorfer, *Satyr Family,* 1507, Gamäldegalerie, Staatliche Museen, Berlin-Dahlem.

SAUL AND DAVID. The story of Saul is told in the first book of Samuel 10–31. Saul was the first king of the ancient Hebrews who reigned in the eleventh century. He was a Benjamite (member of the Hebrew tribe of Benjamin), and Samuel anointed him king of the people of Israel. Unfortunately his close proximity with the Philistines brought him into constant conflict with them. The story of Saul is told dramatically in the Bible, for it is actually the story of *David, first the protégé, then the rival, and ultimately the successor, of the king. Jonathan, Saul's son, was David's close friend, a fact that adds pathos to Saul's attempts to destroy David. In turn, David would never harm Saul. The king suffered from spells of despondency, which David succeeded in easing with the music from his harp. However, Saul met a melancholy end after he visited the witch of Endor and heard the prophecy of his defeat and death. In the end, defeated and wounded in battle with the Philistines on Mount Gilboa, he ordered the young man carrying his weapons to kill him. But the young man was too terrified to do it. So Saul took his own sword and threw himself on it. The young man did the same and died with Saul. Though Saul was unsuccessful in defeating the Philistines, he unquestionably paved the way for national unity under David. See DAVID AND GOLIATH and DAVID BEFORE SAUL.

Example: Lorenzo Ghiberti, gilded bronze panel on the *Gates of Paradise,* 1425–1452, Baptistery, Florence.

SAVONAROLA, GIROLAMO. A Dominican monk born in Ferrara in 1452, Savonarola went to Florence in 1489, where he was appointed prior of San Marco. In a short time he became the virtual dictator of the republic, having easily made known his political expertise and intense fervor for reform in Florence. After his rise, religious and political intrigues against him led to his fall. He was hanged and then burned with two of his companions in front of the Palazzo Vecchio in 1498. He is shown thus as a huge crowd looks on.

Example: Anonymous painter, *The Execution of Savonarola, 1498,* c. 1505, Museo di San Marco, Florence.

SCHIACCIATO. See RILIEVO SCHIACCIATO.

SCHÖNE MADONNEN. *Schöne Madonnen* is a type-name for Beautiful Madonnas. Each madonna has small, tight features and curly, golden hair that frames a perfectly round face with a very high forehead. She smiles a sweet, tender smile with languid eyes and her delicate seemingly boneless fingers seem barely able to hold the weight of her chubby, sprightly child. This genre survived down to the mid-fifteenth century, becoming weaker as the original inspiration became more worked out.
 Example: Wilton Diptych, 1400–1410(?), National Gallery, London.

SCHOOL OF ATHENS. A great assembly of philosophers is shown in the *School of Athens.* Included are Platonists, Aristotelians, pagans, and Christians. Plato and Aristotle stand side by side, the two most important members of the School. Together they represent the reconciled leaders of the two great opposing camps of Renaissance philosophy. Plato, the Greek philosopher and founder of a school, the *academy, holds the *Timaeus* in his left hand and points with his right to heaven, the region from which his ideas radiate to their embodiment in earthly forms. Aristotle, who studied under Plato and opened a school of his own in 335 in Lyceum, stands to Plato's left and holds the *Nichomachean Ethics* in his left hand. At the same time he points downward to earth with his right hand. The earth represents his source for the observation of reality. Sophocles, the fifth-century Greek tragic poet, is included engaging some of the intelligent youths of Athens in argument, pointing out particularly important facts on his fingers. Diogenes, the Greek Cynic philosopher who taught that the virtuous life is the simple life, is shown. He is depicted as an old man with his cup, his last utensil, which he finally threw away when he noticed a peasant drink from his hands. Included also are *Pythagoras, who demonstrates his proportion system on a slate; *Ptolemy, who contemplates a celestial globe held before him; *Euclid, the fourth-century Greek mathematician who appears to be considering Ptolemy's concern with geometry; and the sixteenth-century Sienese painter Giovanni Antonio Bazzi, called Il Sodoma. Other figures are shown standing or sitting about engaged in conversation. The atmosphere is relaxed; a quiet place of learning is represented.
 Example: Raphael, 1510–1511, Stanza della Segnatura, Vatican, Rome.

SCHOOL OF PAN. See PAN.

SCUOLA. *Scuola* is the Italian word for "school"; *scuole* is "schools."

SEBASTIAN, SAINT. Saint Sebastian was a third-century Christian nobleman of Narbonne in Gaul and commander of a company of the Praetorian Guard, the special bodyguard of the Roman emperors. Although little is known about his life and martyrdom, his legend is believed by many, even though it is without

historical foundation. He lived during the reign of Diocletian and even though a special member of the military, Sebastian was secretly a Christian. This fact was revealed when he encouraged two of his companions named Marcus and Marcellinus, who were being tortured for their belief, to die rather than renounce their faith. Diocletian, being told this, urged Sebastian to abandon his belief in *Christ and return to the worship of the Roman gods. Diocletian ordered that he be bound to a stake and shot to death with arrows when he refused. The order was carried out and Sebastian was left for dead by his executioners. None of his vital organs was pierced and Irene, the mother of one of his martyred friends, discovered that he was still alive. After she nursed him back to health, she advised him to leave Rome. Contrary to her advice, he returned to confront Diocletian with a renewed avowal of his belief. He appeared on the steps of the emperor's palace and reproached the emperor for his intolerance toward Christianity. Diocletian, even though amazed, ordered that he should be taken to the arena and beaten to death with clubs. In order that his friends might not find it, his body was thrown into the Cloaco Maxima, the main sewer of Rome. It was discovered, however, and was buried in the catacombs at the feet of Saint Peter (see PETER APOSTLE AND SAINT) and Saint *Paul. Sebastian was extremely popular with Italian Renaissance painters, and he was shown in a variety of poses and situations. The most familiar image is Sebastian bound to a tree or pillar, sometimes with his armor at his feet. He is pierced by one or several arrows. Rome, as seen from the Palatine Hill, may be shown in the background. According to legend this was the supposed place of his martyrdom, which occurred about 287. See SEBASTIAN, SAINT, DESTROYING IDOLS and MARTYRDOM OF SAINT SEBASTIAN.

Example: Antonello da Messina, *Saint Sebastian,* c. 1475, Gemäldegalerie, Dresden.

SEBASTIAN, SAINT, DESTROYING IDOLS. Saint Sebastian was responsible for converting many young men who were in his First Cohort, a company of the Praetorian Guard that followed and protected the Roman emperors. Marcellinus and Marcus, twins who were a part of this company, met their martyrdoms after Sebastian urged them to die rather than renounce their faith in *Christ. The father of the twins, Tranquillinus, was baptized by the priest Polycarp after the death of his sons. He had suffered from a grievous malady for a long period of time, but found himself cured as soon as he was baptized. The prefect of Rome, who was himself very ill, heard of this and asked Tranquillinus to bring to him the man who had cured him. Sebastian and the priest Polycarp were brought, but told him that he would not be healed unless he allowed them to destroy the idols of the gods in his presence. More than two hundred idols were destroyed. When Sebastian saw that the prefect was not restored to health, he accused him of keeping another idol intact somewhere. The prefect confessed that he had a secret room in his house where the whole firmament was represented, enabling him to foresee the future. He said that his father had spent more than two hundred pounds of gold in creating this room.

Sebastian told him that his health would not be restored until the room was destroyed. But the prefect's son, Tiburtius, who did not believe in miracles, told them that he would not permit the tearing down of so splendid a work to go unpunished. On the other hand, he did not want it said that he did not want to see his father cured. He proposed that fire be set in two furnaces. If his father was not healed after the room was demolished, Sebastian and Polycarp would both be burned alive. After the room was destroyed, the prefect was cured and he and his son Tiburtius and four thousand persons of his household received baptism. Sebastian is usually shown knocking idols down from their stands. Pieces of broken idols lay at his feet. The prefect is shown in bed being visited by an *angel who pronounced him well. Two furnaces blaze in the background.

Example: Master of Saint Sebastian (Josse Leiferinxe?), *Saint Sebastian Destroying Idols,* c. 1499, John G. Johnson Collection, Philadelphia.

SECCO. See FRESCO SECCO.

SELLA GESTATORIA. A *sella gestatoria* is the portable throne on which the pope rides during certain ceremonial occasions.

SEPARATION OF LIGHT AND DARKNESS (Division of Light from Darkness). The Separation of Light and Darkness is from the Story of the Creation, Genesis 1:3–5: "Then God commanded 'Let there be light'—and light appeared. God was pleased with what he saw. Then he separated the light from the darkness, and he named the light 'Day' and the darkness 'Night.' Evening passed and morning came—that was the first day." Artists usually show God standing beside a heaven made from cloud forms, in which sometimes the head of God appears again. He may also fill the entire composition, in which case his arms are high over his head. On one side of his body is the darkness while on the other side the light appears.

Example: Master Bertram, from the *Grabow Altarpiece,* 1379, Kunsthalle, Hamburg.

SEPTEMBER. September was the ninth month of the calendars that appeared in northern European illuminated manuscripts and Italian *fresco cycles. Each page usually depicted the activities of that month and the signs of the zodiac associated with the month. September depicts Libra, the Balance. The illustration is usually of threshing, gathering, or treading grapes and wine casks. *Ceres (Demeter), the ancient Italian corn-goddess may be shown as a personification of the earth's abundance. She may be crowned with fruit and holding a cornucopia full of grapes and a pair of scales. Since the Roman names are the ones known in the Renaissance and traditionally used since, the use of Demeter will be more prevalent.

Example: Limbourg Brothers, September page, *Book of Hours (Les Très Riches Heures) of the Duke of Berry* (fol. 2v), illumination, 1416, Musée Condé, Chantilly.

SERAPH (pl. seraphim). The seraph is an *angel depicted with the head only and one, two, or three pairs of wings. Traditionally seraphim are red and may have a candle. During the Renaissance various kinds of angels provided artists with a convenient framework for the representation of heaven. These angels are seen surrounding the image of God the Father in heaven. Saint *Francis of Assisi is shown receiving the *stigmata from the composite figure of a man and a seraph. See CHERUB.

Example: Jean Bourdichon, *Stigmatization of Saint Francis, Book of Hours of Frederick II of Aragon* (Ms. lat. 10532, fol. 370), illumination, 1501–1504, Bibliothèque Nationale, Paris.

SERGIUS. See MOHAMMED AND THE MONK SERGIUS.

SERMON ON THE MOUNT. The Sermon on the Mount is from *Matthew 5:1–12 and forms what is known as the eight *Beatitudes, which are the eight blessings uttered by Jesus in the opening of his Sermon. According to Saint Matthew, Jesus saw the crowds and went up a hill, where he sat down. His disciples gathered round him and he began to teach them. This is the first time in the *Gospels that *Christ's teaching is told in detail. He began by speaking of the eight conditions of true happiness or blessedness: Blessed are the poor, the sorrowful, the humble, those whose greatest desire is to do what God requires, those who are merciful, the pure in heart, those who work for peace, and those who are persecuted. Christ is usually shown standing on a low hill surrounded by men and women standing or kneeling in prayer before him. The Sea of Galilee may be in the background.

Example: Cosimo Rosselli, 1481–1482, Sistine Chapel, Vatican, Rome.

SEVEN ACTS OF MERCY. The Acts of Mercy are told in Matthew 25:35–37. The early church taught that charity was both love of God, *amor dei*, and at the same time love of one's neighbor, *amor proximi*, and that the second was no good without the first. Acts of charity, or mercy were easy for artists to interpret visually and thus became topics that were represented in Renaissance art. Actually, there are six works of mercy which *Christ spoke of when he gave his sermon on the Final Judgment of man. He said, ''I was hungry and you fed Me, thirsty and you gave Me a drink; I was a stranger and you received Me in your homes; naked and you clothed Me; I was sick and you took care of Me; in prison and you visited Me.'' The theme of the Seven Acts is developed by the appearance of Christ in painting as both witness and ordinary member of the people receiving the benefits of the works of charity and mercy. He is usually shown standing among townspeople performing one of the acts. In *Feeding the Poor* he distributes bread to a cripple and a beggar. They seem to be unaware of the fact that Christ himself is feeding them.

Example: Master of Alkmaar, *Feeding the Hungry, Seven Acts of Mercy*, 1504, Rijksmuseum, Amsterdam.

SEVEN DEADLY SINS. The seven deadly, or capital, sins are Anger *(Ire)*, Envy *(Invidia)*, Sloth *(Acedia)*, Pride *(Superbia)*, Lust or Luxury *(Luxuria)*, Avarice *(Avaricia)*, and Gluttony *(Gula)*. Anger or Wrath, though one of the Seven Deadly Sins, is an infrequent figure in Renaissance painting. The angry person attacking a defenseless person is a common type found in all periods. The figure of Wrath may have a lion as an attribute. Envy, when depicted in art, is usually, but not always, female. Renaissance artists usually depicted her gnawing her entrails or her heart, which she holds in her hands. Her attribute is a snake (because of her poisoned tongue), and it may hang from her mouth. Some artists depicted her with snakes for hair, like Medusa. A viciously barking dog may be at her side. Also rare in Renaissance art is Sloth. During the Renaissance Sloth became a type of melancholy, called *acedia,* which indicated a loss of creative inspiration, not ordinary laziness. Even so, Sloth, a very obese figure, usually rides an ass or leans against a pig and an ox. Sloth may also be seen with Lust or Poverty because indirectly idleness could lead to Poverty and even to Lust. Pride is considered the root of evil and is, during the Renaissance, a female figure with a lion, an eagle, a peacock, and a mirror in which artists show an image of Satan. Lust, supreme among the Seven Deadly Sins in the medieval church, became, during the Renaissance, an aspect of Luxury, sensual gratification, and came to be regarded as a virtuous pursuit. Lust gradually turns into Love during the Renaissance and is shown as Venus, who is accompanied by, or rides, a he-goat. Other attributes include the rabbit and dove. Lust may hold a mirror, symbolizing her vanity. An ape holding the mirror looking at its own reflection is a common symbol of Lust. During the Renaissance Avarice appears as a woman or sometimes as a man who may be blindfold. Avarice may have a purse that she holds in her hand or has it dangling from her neck. She may also be shown with a harpy, a woman with normal head and breasts, but with wings and the claws of a giant bird. The harpy, known to torment misers, may also be blindfolded and may have the miser's wealth in the form of golden apples or balls. Gluttony, one of the sins of the flesh, is found, during the Renaissance, on tapestry, where a good moral example might be viewed by all. Gluttony was shown as both male and female, but always fat and in the process of eating or occasionally vomiting. The figure may hold a dish of fruit. Those who viewed scenes of the Seven Deadly Sins might be warned with the words, "Beware, beware, God is watching," and God himself might be included in the center of these scenes.

Example: Hieronymus Bosch, painted table top, c. 1475, Prado, Madrid.

SEVEN LIBERAL ARTS. Frequently represented during the Renaissance, the Seven Liberal Arts consisted of Arithmetic, Astronomy, Geometry, Grammar, Logic, Music, and Rhetoric. Their origins can be found in the standard medieval prephilosophical education; they were born of the aristocratic spirit of the Greek city state expressed in social and educational theories that separated activities suitable for "liberal" or free-born citizens and menial tasks undertaken only by

foreigners or serfs. Italian Renaissance artists used figures of the Liberal Arts as subjects for the sculpture of tombs and pulpits and also in *frescoes and other *painting. Northern artists depicted the arts in tapestry and *engraving. Grammar may have two young pupils at her feet. Logic may hold scales for determining the true and false. Rhetoric may have a sword and shield, a book and a scroll. Geometry usually holds a compass and may also have a set-square and ruler. Arithmetic holds a tablet, and she may be in the process of writing. Occasionally she holds an abacus. Astronomy holds a globe, which she may measure with compasses or a sextant. Occasionally she may hold an armillary sphere, an ancient astronomical instrument in which the main circles of the heavens were represented by means of metal rings. Music is generally depicted as a woman playing an instrument such as an organ, lute, violin, or viol. A swan alludes to the legend of its song.

Example: Pintoricchio, c. 1495, Appartamento Gorgia, Rome.

SEVEN SORROWS OF THE VIRGIN. See PRESENTATION IN THE TEMPLE.

SFORZA, BATTISTA. Duchess of Urbino and wife of Federico da *Montefeltro, Battista Sforza helped make Milan a great artistic center during the Renaissance. Urbino was particularly noted for its school of *painting in the fifteenth, sixteenth, and seventeenth centuries. The original ruling house was the Visconti (see VISCONTI, BERNABO), but by the middle of the fifteenth century Francesco Sforza, a *condottiere* (mercenary) had established his own dynasty. Battista is usually shown as a beautiful young woman.

Example: Piero della Francesca, 1465, Uffizi Gallery, Florence.

SFORZA DYNASTY. The Sforza family ruled Milan from 1450, when Francesco seized power, until the end of the century, when his son Lodovico (Il Moro) called the French into Italy, and Milanese independence came to an end. The Sforzas were lavish patrons of the arts, who built the Milan Cathedral and the Certose of Pavia and founded the Sforza Castle and many other palaces and churches. Lodovico employed the great Renaissance architect Donato Bramante and the true Renaissance man himself, Leonardo da Vinci. Leonardo painted his famous *Last Supper for Lodovico and also worked for him on commissions that involved military engineering and costumes for court masques. During the Renaissance the leading patrons of the arts in Milan were the Sforzas.

SFUMATO. *Sfumato* is from the Italian word *fumo*, meaning "smoke." In *painting it is the achievement of smooth and imperceptible transitions of color or especially tone from light to dark "like smoke dissolving in air." Leonardo da Vinci, in his notes on painting, said that light and shade should blend "without lines or borders, in the manner of smoke." Sfumato was, according to Giorgio

Vasari, a distinguishing mark of the perfect art of painting exemplified by Leonardo da Vinci.

SGRAFFITO. *Sgraffito* is the Italian word for "scratched." It is a technique of producing a design by which white plaster is covered with a thin layer of tinted plaster (or vice-versa), the top layer being scratched through to reveal the layer of a different color beneath. The technique was used for arabesques and similar decorations on many facades of Renaissance palaces.

SHIP OF FOOLS. As a Renaissance topic, the Ship of Fools is taken from a long verse allegory, *Das Narrenschiff*, written in 1494 by the German humanist and moralist Sebastian Brant. The theme was popular in Flanders, where it was known as *Blaue Schuut*. The poem tells of 112 fools, each representing a small weakness found in man's character, who set sail for the "fool's paradise," Narragonia, and all die because of their folly. *Das Narrenschiff* went through six editions in Brant's lifetime alone and became a vehicle for satirical comment and castigation on vice of all kinds: drunkeness, lust, corruption, quack doctors, and all manner of loose-living. The "fools," dressed in bells and fool's hats, are depicted in numerous situations, not always on board ship. One foible of man, procrastination, is typified by crows perched on one fool croaking "Cras, cras!" ("Tomorrow"). The original edition was illustrated during the Renaissance with numerous *woodcuts, many of which have been ascribed, without certainty, to Albrecht Dürer.
Example: Hieronymus Bosch, c. 1495, Louvre, Paris.

SIBYL. In antiquity a sibyl was a Greek or Roman prophetess. The Western church accepted the sayings of twelve sibyls and interpreted them as the foretelling of the coming of *Christ. When the emperor Augustus (Octavian) consulted the Tiburtine sibyl as to whether he should accept apotheosis as decreed by the Roman Senate, she foretold the coming of a child who would overshadow all the Roman gods. The emperor even saw a vision of the Virgin Mary (see MARY, SAINT) standing on an altar with the baby Jesus in her arms. In art the sibyls are usually depicted as young women and are sometimes juxtaposed with the prophets.
Example: Michelangelo, *The Sibyls on the Sistine Ceiling*, 1508–1512, Vatican, Rome.

SILVER POINT (Silverpoint). During the Renaissance silverpoint was a highly favored drawing technique. The paper on which the drawing is made is prepared with a coating of Chinese white or Chinese white with a slight tint of water-color pigment. The drawing is done with a piece of silver wire held in wood similar to a modern pencil. The wire makes a fine, indelible, silver-grey line on the prepared surface that will not smudge. This line cannot be removed except by disturbing the *ground. Silverpoint was popular with fifteenth-century Flemish

artists; pictures by Jan Gossaert (known as Mabuse) and Rogier van der Weyden depicted artists drawing with silverpoint.

Example: Albrecht Dürer, *Self-Portrait,* 1484, Albertina, Vienna.

SIMON, SAINT. Simon has two names, Simon Zelotes and also Simon the Cananean, after Cana of Galilee, where *Christ changed water into wine. The two surnames, Zelotes and Cananean, synonyms for Cana, mean "zeal." He was one of the twelve *apostles in the *Gospels and died a martyr's death in Persia. Very little is known of his life, except that after the *Crucifixion tradition says he and Saint *Jude preached the Gospel throughout Mesopotamia and Syria. According to the **Golden Legend*, he returned to Jerusalem after he had preached in Egypt and upon the death of *James the Less was elected bishop of Jerusalem, with all the apostles concurring. Also, before his death he raised thirty dead men to life. One legend says he met his martyrdom by being nailed to the gibbet of the cross. Another tells that he was sawn in half. His attribute is a cross or a saw. He is usually shown as a young man with a beard.

Example: Simoni Martini and Assistants, early fourteenth century, National Gallery, Washington.

SIMON MAGUS. See FALL OF SIMON MAGUS.

SINE MACULA. The Latin phrase *sine macula* means "without con-cupiscence" and was taught by the church in the doctrine of the Immaculate Conception. The mother of the Virgin Mary (see MARY, SAINT), Saint *Anne, conceived *sine macula,* like the Virgin Mary herself did.

SINOPIA (Sinopie). A reddish-brown ochre, *sinopia* is sometimes used for the underdrawing of a *fresco. The red earth is mixed with water, then painted on the *arricciato of the wall. The term is Italian, taken from Sinope, a city in Asia Minor noted for its red earth. Frequently the term is used to mean the drawing itself. For a while in the fifteenth century *sinopia* drawings seem to have been used in the same fresco; by the sixteenth century the *sinopia* stage was usually skipped.

Example: Andrea del Castagno, *Crucifixion*, sinopia drawing, 1445–47, Cenacolo of Sta. Apollonia, Florence.

SINS. See SEVEN DEADLY SINS.

SIXTUS IV APPOINTING PLATINA. Sixtus was an Italian named Francesco della Rovere born near Savona in 1414. He died in 1484. In 1471 he succeeded Paul and became pope. He kept this office until 1484. He was expected to be a reformer, but political difficulties became a hindrance. His struggle with the French monarchy over the control of the church in France was complicated when Louis XI tried to replace Ferdinand I of Naples with a Frenchman. After the

Pazzi conspiracy in 1478, a quarrel with Lorenzo de' *Medici became critical when it was discovered that one of the instigators was Girolamo Riario, Sixtus' nephew, and many believed the pope had prior knowledge of the plot. Afterward he went to war with Florence. Overall the behavior of his favored nephew was disgraceful. Sixtus was, however, a capable administrator of the city. He founded the Sistine Chapel, was an important benefactor of the Vatican Library, and did much to beautify and improve Rome. His work in the newly built and reorganized Vatican Library included appointing a new director, the humanist Platina. Pope Sixtus IV is usually shown in a Renaissance armchair upholstered in velvet and studded with brass-headed nails. Platina kneels before him, a long cloak flowing from his shoulders.

Example: Melozzo da Forlì, 1474–1477, Pinacoteca, Vatican, Rome.

SIZE. Size is a term used in painting for highly purified glue or gelatine, but the word may be used in reference to any glue. Cennino Cennini, the Italian writer and artist (born 1370), mentions the preparation of size in his craftsman's handbook *Libro dell' Arte*. According to this account, size is prepared from parchment waste by soaking it in water and heating it. The purpose of size is to fill the porous surface of canvases and wooden panels to provide a smooth *ground for the priming or painting. Also, certain water-color techniques use size as a *medium. See GOUACHE.

SLOTH. See SEVEN DEADLY SINS.

SOFT STYLE. A style of *painting found mainly in Germany near the end of the fourteenth and beginning of the fifteenth centuries is known as the "Soft Style." It is characterized by gentle and soft rhythms, as in flowing drapery, and by a playful sentiment. The beautiful Madonnas or *Schöne Madonnen playing with her Child are the principal subjects. *Woodcuts and sculpture display the style better than painting.

Example: Wilton Diptych, 1400–1410?, National Gallery, London.

SOLOMON RECEIVES THE QUEEN OF SHEBA. See QUEEN OF SHEBA BRINGING GIFTS TO SOLOMON.

SOTTO IN SÙ. The Italian phrase *sotto in sù* means "from below upward." The term is used to describe extreme foreshortening. This extreme illusionistic representation may show figures on a ceiling so foreshortened as to seem actually floating above the spectator. The term "frog perspective" is sometimes used to indicate such *perspective. The Italian Renaissance painter Andrea Mantegna (c. 1431–1506) developed the first completely illusionistic *sotto in sù* in his *Camera degli Sposi* (1474) in the Castello as a memorial to the *Gonzaga family. Their portraits on the walls seem to the spectator to be in an extension of the space of the room, while on the ceiling is a *fresco of a balcony with figures

looking down under an open sky into the room. The idea was exploited by Raphael and Antonio Correggio, but was not fully developed before the baroque.

SPECULUM HUMANAE SALVATIONIS. A medieval textbook of Christian typology, the *Speculum Humanae Salvationis* demonstrates how the *Passion and Incarnation of *Christ had been prefigured in Jewish legend, secular history, and the Old Testament. The first *Speculum* was probably written at Strassburg in 1324 by a Dominican friar, Ludolph of Saxony. During the Renaissance a French prose version was made in 1448 by the canon of Lille, Jean Mielot, and it was later translated into English, Dutch, German, and Czech. Not only did the translations prove that it was popular, it was issued as a *block book and used in tapestry, sculpture, stained glass, and painting throughout Europe.

An illustrated *Speculum* is usually arranged so that there are four pictures at the head of the page when one opens the book: the antitype (Christ as foreshadowed by prophecies) and the types (legends, stories, and histories that had foreshadowed Christ). Eight introductory pictures of the *Creation and *Fall of Man, the *Fall of the Rebel Angels, and the Flood (see DELUGE) precede the types and antitypes. The New Testament history is introduced in the third chapter by illustrations of the Immaculate Conception and Birth of the Virgin Mary (see MARY, SAINT) and followed by the childhood and Passion of Christ to the *Ascension and *Pentecost; following these are the after-life and death of the Virgin, her intercession (see INTERCESSION OF THE VIRGIN MARY) for man, Christ's mediation with the Father, the *Last Judgment, the horrors of *hell, and the wonders of heaven. The *Speculum* concludes with three chapters of 208 lines illustrating the Seven Sorrows (see PRESENTATION IN THE TEMPLE) and the Seven Joys of the Virgin Mary and the Seven Hours of the Passion.

SPOLVERO. The word *spolvero* is Italian for "fine dust." The *spolvero*, a kind of supplementary *cartoon, was used to preserve the cartoon for the guidance of assistants working on a final painting. It was pricked through and pounced with charcoal dust and because of this it is doubtful whether any remain. One example could be a drawing of Andrea Mantegna's *Madonna della Vittoria*, Ducal Palace, Mantua. The painting itself dates 1495–1496 and is in the Louvre.

SPRING. See PRIMAVERA.

STABAT MATER DOLOROSA. *Stabat Mater Dolorosa* is Latin for "There stood the grieving mother" the words that begin Jacopone da Todi's famous thirteenth-century poem in which he describes the anguish of the Virgin Mary (see MARY, SAINT) as she watched her son's *Crucifixion.

STANZA (pl. Stanze). *Stanza* is the Italian word for "room." *Stanze* are the suite of rooms in the Vatican decorated by Raphael during the Renaissance.

STAR OF THE SEA. A title given to the Virgin Mary (see MARY, SAINT), "Star of the Sea," from the Latin *Stella Maris*, is the meaning of the Jewish form of Mary's name, Miriam. During the early Renaissance a star was often shown on the shoulder of Mary's cloak.

Example: Duccio, *The Annunciation of Mary's Death*, detail of the *Maestà Altarpiece*, 1309–1311, Opera del Duomo, Siena.

STATIONS OF THE CROSS (Way of the Cross, Via Dolorosa). The Stations of the Cross is a series of fourteen scenes from the *Passion of *Christ that depict the places on Christ's route through the streets of Jerusalem. These scenes are placed around a church and devotions are held before them. The first subjects of the stations are devoted to scenes on the Road to Calvary (see CALVARY): Christ Falls under the Weight of the Cross (three times); a Meeting with the Virgin; with Saint *Simon and Cyrenian, and with Saint *Veronica (the woman who wiped the sweat from Christ's face—his image was left on her cloth). The next subjects are Christ stripped of his garments, the Nailing to the Cross, the *Crucifixion, Christ in the arms of the Virgin (the Pietà), and the *Entombment. The Stations of the Cross are found in many churches and are often located down both sides of the nave or central area of the church where the worshipper sits or stands while listening to the celebration of the *Mass. They are depicted in both painting and sculpture.

STEPHEN, SAINT. Stephen is a Greek name, Stephanos. Also used frequently are Esteban, Spanish, and Etienne, French. Stephen was one of the seven deacons whom the *apostles ordained for the sacred ministry. He was the first martyr for the Christian faith. The Acts of the Apostles tell his story in the sixth and seventh chapters. Here it states that he did great wonders and miracles among the people. Unfortunately those of the old faith were angered by his words. He was arrested and brought before the Sanhedrin, the Jewish legislative council in Jerusalem. Stephen accused them of having murdered the Messiah whose coming their prophets had foretold. On testimony of false witnesses he was accused of having spoken blasphemous words against *Moses and God and with declaring that Jesus would destroy the temple and change the customs derived from Moses. His reply, which is his celebrated sermon found in Acts 7:2–56, so angered the authorities that he was taken out of the city and stoned to death. It was unlawful for the Sanhedrin to put anyone to death without permission from the Romans, but Stephen's death was evidently the result of an uncontrollable outbreak. Stephen's sermon and death mark the transition of Christianity from its earliest Jewish form to its extension among the gentiles. Sources say he died the year of the *Ascension of *Christ, on the third of August A.D. 36. Stephen is most often depicted as a young man, beardless, in the costume of a deacon (the *dalmatic). His particular attributes are the stones, which were the instruments of his martyrdom. He holds them in his hand or they rest on his head and shoulders or lie on a book or at his feet or in a fold of his robe. Sometimes they

are stained with blood. He may hold a censer in his left hand and the martyr's palm in his right hand.

Example: Vittore Carpaccio, late fifteenth century, Philbrook Art Center, Tulsa, Oklahoma.

STIGMATA. Marks corresponding to the wounds on *Christ's feet, hands, and side are known as the "stigmata" (pl. for stigma). These wounds have sometimes appeared supernaturally on the bodies of exceptionally religious persons as a consequence of prolonged meditation and religious transport. The most frequently depicted stigmata are Saint *Francis of Assisi and Saint *Catherine of Siena.

Example: Giovanni Bellini, *Saint Francis in Ecstasy*, c. 1485, The Frick Collection, New York.

STIGMATIZATION OF SAINT CATHERINE. Saint *Catherine of Siena, a fourteenth-century Christian mystic and member of the *Dominican order, is said to have received the *stigmata in 1375. Her intense religious experience occurred at Pisa. According to legend she was at prayer in a chapel in Sta. Christina when she beheld a vision of rays descending upon her from the wounds in the body of the crucified *Christ. Rendered unconscious, she discovered upon waking that her hands, feet, and side were imprinted with the stigmata. Catherine is shown kneeling before a crucifix or fainting into the arms of two sisters as she receives the marks on her body. It seems that the five wounds were visible only to herself until after her death.

Example: Domenico Beccafumi, c. 1518, Pinacoteca, Siena.

STIGMATIZATION OF SAINT FRANCIS. Saint *Francis of Assisi, founder of the Franciscans, received the *stigmata in 1224, two years before his death. This climax of his life was reached after forty days of prayer and fasting at his mountain retreat on the Mounte della Verna (Mount Alverna). During this withdrawal from the world he had a vision of a *seraph. In the center of the vision was the figure of the crucified *Christ, from whom he received the wounds of the *Crucifixion. He is usually shown with his vision hovering in front of him. Francis' is the first known appearance of the stigmata, one of the best certified as genuine, and the only one that is celebrated liturgically by the western church (September 17).

Example: Jean Bourdichon, *Book of Hours of Frederick II of Aragon* (Ms. lat. 10532, fol. 370), illumination, 1501–1504, Bibliothèque Nationale, Paris.

STRADA, JACOPO. Jacopo Strada, or de Strada, was a Mantuan art dealer, amateur architect, numismatist, and amateur engineer. He was court counselor and antiquarian to Emperor Maximilian II and temporarily served the elector of Bavaria. He became a business partner and good friend of the Renaissance painter Titian. In Titian's portrait Strada's adventurous personality is reflected. He is shown as a young man, bearded and wearing a fur cape. Strada's success in life

is symbolized by items included in the portrait. The golden chain and the sword characterize the court counselor; the statuette of a nude *Venus and the fragmentary torso and bronze figurine, the court antiquarian; the books placed on the cornice over his head, the scholar; the coins, the numismatist. Strada is shown holding the nude Venus, which is a small replica of Praxiteles' *Aphrodite Pselioumene* (Venus Putting on Her Necklace), as though attempting to persuade a prospective buyer.

Example: Titian, 1567–1568, Kunsthistorisches Museum, Vienna.

STRAPWORK. A design that resembles pierced, rolled straps of leather or interlacing is known as "strapwork." It was first developed in the 1530s by the Italian painter Giovanni Rosso Fiorentino and his school at Fontainebleau (see FONTAINEBLEAU, FIRST AND SECOND SCHOOLS OF).

STUDIA HUMANITATIS. Essentially the Renaissance humanists were rhetoricians interested in Greek and Latin literature, grammar, history, and ethics. These subjects constituted the *studia humanitatis*.

SUDARIUM (Vernicle). An image of the face of *Christ painted on a cloth and used as an aid to devotion is known as a "sudarium." The original sudarium was the cloth with which Saint *Veronica wiped the sweat from Christ's face as he was carrying his cross to *Calvary. When she removed the cloth she found that the image of his features had become miraculously imprinted on the cloth. Today it is preserved as a holy relic in Saint Peter's in Rome. Usually the cloth is shown being held by two *angels.

Example: Albrecht Dürer, *Angels Holding the Sudarium*, engraving, 1513.

SUICIDE OF SAUL. See SAUL AND DAVID.

SULTAN MOHAMMED II (Muhammad the Conqueror). Mohammed II, son and successor of Murad II, was an Ottoman sultan from 1451 until 1481. He is considered the founder of the Ottoman Empire (Turkey). This Moslem ruler moved his capital from Adrianople to Constantinople and restored the city by settling the populations of other conquered towns there. It was during his rule that Justinian's church of Hagia Sophia (Holy Wisdom) became a mosque. Mohammed II was a patron of education and an accomplished linguist as well as a great military commander. The Italian Renaissance artist Gentile Bellini painted numerous portraits for the sultan while living at his court in Constantinople in 1479 and 1480. Bellini used a combination of Renaissance and Oriental elements that reveal the sultan as an intelligent, well-educated man with a rather long nose wearing his turban.

Example: Gentile Bellini, 1480, National Gallery, London.

SUPERBIA. See SEVEN DEADLY SINS.

SUPPER AT EMMAUS. According to the *Gospels, *Christ appeared several times to his disciples and others after the *Resurrection. One appearance occurred on the road to Emmaus, a village about seven miles from Jerusalem. The topic Supper at Emmaus is the sequel to the Road or Journey to Emmaus. According to Luke 24:13–32, two disciples, Cleopas and one unnamed, were on their way to Emmaus when they were joined by Christ. They did not recognize him, but when they reached Emmaus and he indicated that he would continue on his way, they pressed him to stay, mentioning that the day was nearly over. So he went in to stay with them and when he sat down to eat he took bread, said the blessing, broke it, and gave some to them. They recognized him immediately and he disappeared from their sight. The two disciples are usually shown seated at the table with Christ in the center in the act of breaking the bread. The awareness of his identity is on their faces and sometimes on the faces of other guests and servants who might be included. The emblem of the pilgrim during the Middle Ages was the cockleshell. Some artists show it fastened to the shirt of one of the disciples.

Example: Jacopo Pontormo, 1525, Uffizi Gallery, Florence.

SUPPER IN THE HOUSE OF LEVI. See FEAST IN THE HOUSE OF LEVI.

SUPPER IN THE HOUSE OF THE PHARISEE (Christ at Supper with Simon the Pharisee). The story of *Christ in the house of the Pharisee is told in Luke 7:36–50. While Christ was having supper with the Pharisee, a woman who lived a sinful life, who is identified with Saint *Mary Magdalene, entered the room and stood by Jesus' feet crying and wetting his feet with her tears. In some representations Mary Magdalene is shown kneeling devoutly kissing Christ's feet, her mantle slipping from her head to reveal the luxuriant hair of the repentant sinner. It is interesting to note that during the Renaissance the date of a work can nearly be gauged by the extent to which her hair gains exposure from beneath the mantle and the color in its transformation from drab brown, to auburn, to blond, like spun-gold. She usually wipes his feet with her hair and then kisses and anoints them. Christ told those at the table that the woman's action proved her love, which made her worthy to be forgiven her sins. Judas Iscariot (see PACT OF JUDAS) protested the waste of the precious oil of myrrh (John 12:4–6) that the Magdalene used and may be depicted with an expression of scorn or anger.

Example: Attributed to Cenni di Francesco, 1370–1375, Vatican, Pinacoteca, Rome.

SUPPORT. The wooden panel, canvas, paper, or other solid substance on which a painting is executed is its support.

SUSANNA AT THE BATH (Susanna and the Elders). According to the Apocryphal story, Susanna was a fictional heroine whose innocence triumphed in the end over evil. She was the beautiful wife of a prosperous Jew, a citizen of Babylon. Her virtue was as great as her beauty, but because of her beauty, two elders of the community secretly desired her and determined to seduce her together. It was her habit to go into her garden to bathe. One day the two men hid in the garden and, as she was about to bathe, completely naked and with her maids gone, they sprang out of hiding and demanded that she give herself to them. They threatened that unless she submitted to them both they would swear publicly that they had discovered her in the act of adultery with a young man, a crime for which she would face the penalty of death. In spite of their threats Susanna refused their advances and cried out for help. The two elders, thwarted, carried out their threat. She was brought to the place of judgment on the false charge, found guilty, and condemned to death for her sin. Just as she was being led away to her execution, a young man by the name of Daniel insisted that she had not been tried in a fair manner. Daniel cross-examined the elders by separating them from each other. In this manner he caused them to give conflicting evidence, thus proving that both were lying and that Susanna was innocent. In the end Susanna was exonerated and the two elders were condemned to death. In early Christian art Susanna was a symbol of the saved soul. Her chastity was seen as a prefiguration of the Virgin, and the story of her acquittal was used during the Middle Ages to represent *Justice. From the Renaissance onward, however, artists chose to depict Susanna at her bath and used the topic as an opportunity for the portrayal of the female nude in an erotic setting with lurid connotations. Susanna's name in Hebrew means lily, the symbol of purity. She is usually shown nude, although she may be dressed and having only her feet washed. The elders are usually barely visible peeking out from behind trees. Some artists include the stoning of the elders (the fate Susanna would have met).
 Example: Albrecht Altdorfer, 1526, Alte Pinakothek, Munich.

SYLVESTER RESUSCITATING TWO DECEASED ROMANS (Saint Sylvester Reviving Two Slain Men). During the reign of Constantine the Great (see CONSTANTINE AND SAINT HELENA), Sylvester was pope from 314 to 335. According to legend, the emperor was baptized by Sylvester (see BAPTISM OF CONSTANTINE). The story of Sylvester reviving two dead Romans is told in the *Golden Legend*. Some of Constantine's priests came to him one day and told him of a dragon in a cave that was killing more than three hundred men daily with its breath. When the emperor reported this to Sylvester, the saint promised to render the dragon harmless. The priests, in turn, promised that if he did this they would be converted to Christianity. When Sylvester began to pray, the Holy Ghost appeared to him and told him what to do. He was to enter the dragon's pit without fear and take two priests with him. He was to say these words: ''The Lord Jesus, born of a Virgin, crucified and buried, then risen from the dead, shall one day come to judge the living and the dead; and thou,

Satan, await his coming in this place." Then Sylvester was supposed to bind its jaws with a cord and seal the knot with a ring bearing the mark of the cross. Sylvester took the two priests and did these things. While coming out of the pit he found two magicians who had followed him to see if he really dared to confront the dragon. They were dead, overcome by the breath of the dragon. Sylvester revived them, and they were converted on the spot. The two men are shown lying on their backs, then suddenly alive and kneeling before Sylvester in thankfulness. (This before-and-after depiction is typical of fourteenth-century miracle paintings.) The dragon is shown with its jaws clamped and Sylvester and the priests emerge from the cave (usually shown as a pit in the ground).

 Example: Maso di Banco, c. 1340, Bardi di Vernio Chapel, Sta. Croce, Florence.

SYLVESTRINE ORDER. Saint Sylvester Gozzoline founded the Sylvestrine order in 1231 at Montefano. The order, though under the Benedictine rule, was much stricter in practice in regard to abstinence and poverty. See BENEDICTINE ORDER.

SYMBOLS OF THE FOUR EVANGELISTS. See EVANGELISTS, EVANGELIST SYMBOLS.

T

TABITHA. See PETER: THE RAISING OF TABITHA.

TAKING OF CHRIST. See BETRAYAL.

TELEMACHUS. See ULYSSES AND PENELOPE.

TEMPERA. The term "tempera," which has borne various meanings in connection with *painting, really means any type of *binder that will serve to "temper" powder color and make it workable. Until the late fifteenth century the most popular technique of painting was egg tempera, in which case pigments were mixed or "tempered" with egg. The earliest Italian treatise on painting was *Il Libro dell'Arte* written by Cennino Cennini c. 1390. This treatise contains most of our knowledge of the early tempera technique. The process of painting with egg-yolk was described by Cennini as being used chiefly for painting executed on wood panels prepared with *gesso. The mixing of the pigments in egg-yolk was done beforehand because the paint film dries almost instantaneously, and it is very tough and permanent. The yellowness of the egg has small effect on the color, though Cennini mentions it. He said that town hens produced the best and palest yolks, and that darker yolks were best for the flesh color of old people. It is interesting to note that pale yolks are preferred today. Tempera dries several tones lighter than the wet paint, and this demanded not only knowledge of the material, but great certainty of purpose. Tempera is not easy to handle, the colors are few, and it is, as it was during the Renaissance, very difficult to blend. Possibly this is one reason why some form of drying oil was used. The oil would form a rich and transparent film that could be used to modify the semiopaque layer. This oil *glaze was probably used to shade off

silver leaf or burnished gold, and it could be from this mixture that the whole technique of *oil painting developed. After appearing in Europe in the twelveth or early thirteenth century, tempera painting was the most important technique for panel painting until the fifteenth century, when it gradually gave way to oil painting.

TEMPERANCE. See VIRTUES.

TEMPLE OF EPHESUS. One of the greatest ancient Greek cities of Asia Minor, Ephesus was located south of Izmir in what is today western Turkey. In its day the city became a leading seaport; its wealth was proverbial. In the middle of the sixth century B.C., a large temple was built there for the worship of a native nature goddess who was equated with the Greek Artemis (*Diana). The temple was burned down in the fourth century B.C., but rebuilding was started before Alexander the Great took Ephesus in 334. In 113 it was taken by the Romans and they called the temple of Artemis, the temple of Diana, then one of the Seven Wonders of the World. In the year A.D. 262 Ephesus was sacked by the Goths, and the temple was destroyed.

 Example: School of Rimini, *Collapse of the Temple of Ephesus*, first half of the fourteenth century, Sant' Agostino, Rimini.

TEMPLE OF MARS. See EXORCISM OF THE DEMON IN THE TEMPLE OF MARS.

TEMPTATION (Disobedience of Man). The story of the temptation in the garden of Eden is taken from Genesis 3:1–7. *Adam had been warned on pain of death not to eat the fruit of the Tree of the Knowledge of Good and Evil. According to Genesis, the snake, the most cunning animal that God had made, asked the woman, ''Did God really tell you not to eat fruit from any tree in the garden?'' And she told the snake that she and Adam could eat the fruit of any tree in the garden except the tree in the middle of it. They were not even to touch it. If they did they would die. The snake told Eve that they would not die, that God told them that because he knows that when you eat the fruit, you will be like God and know what is good and what is bad. She noticed how beautiful this tree was and how good its fruit would be to eat. She also pondered upon how wonderful it would be to become wise. She took some of the fruit and ate it. Then she gave some to her husband, and he also ate it. As soon as they had eaten it, they were given understanding and realized that they were naked; so they sewed fig leaves together and covered themselves. The tree is usually a fig or an apple. The snake is twined round its trunk or is standing beside it. Sometimes it has a woman's head and even a torso. It may be standing, in which case it has four legs and feet like a lizard's. Adam and Eve are shown standing beside the tree. Eve either plucks the fruit or holds it. If she has already

taken a bite, she is offering it to Adam. They are both shown nude except for their fig leaves.

Example: Masolino, c. 1424–1425, Brancacci Chapel, Sta. Maria del Carmine, Florence.

TEMPTATION OF CHRIST (Temptation in the Wilderness). The story of the temptation of *Christ is told in Matthew 4:1–11; Mark 1:12–13, and Luke 4:1–13. After Jesus had been baptized by Saint *John the Baptist, he fasted in the wilderness for forty days and forty nights. At the end of that time he was tempted three times by the devil. The devil appeared to him saying, "If you are the Son of God, command that these stones be made into bread," and Jesus replied, "Man shall not live by bread alone, but by every word that comes out of the mouth of God." The devil tempted him a second time by taking him to the top of the temple in Jerusalem. There he told Jesus to cast himself down, assuring him that if he were the Son of God, the *angels would save him. Jesus resisted again saying, "Thou shall not tempt the Lord thy God." And finally, the devil took Jesus to the top of a mountain overlooking the kingdoms of the world, which he offered as a bribe if Christ would forsake God and worship Satan. To this Jesus answered, "It is written, Thou shall worship the Lord thy God, and Him only shall thou serve" (Matt. 4:1–11). Works of art during the Renaissance may show any one of these three scenes. The devil is usually in the form of a dark, nearly black angel who stands before Christ. Christ may point his finger at him as if saying, "Get thee hence, Satan."

Example: Duccio, from the back predella of the *Maestà*, 1308–1311, The Frick Collection, New York.

TERRACOTTA. Clay baked to become hard is known as *terracotta*, which is the Italian word for "baked earth." Figures and architectural ornaments are made of this material and have been since very early times. During the Renaissance terracotta flourished for the *bozzetti* (sculptor's sketches), but it was also the favorite *medium for wall-tombs, plaques, and images, and became a substitute for the expensive *bronze and marble used less frequently. Luca della Robbia applied white and colored enamels to his terracotta sculpture in the early 1440s. His work was an innovative form of architectural decoration, but the technique was also used for free-standing sculpture.

TERRIBILITÀ. The Italian word for "terribleness" is *terribilità* and was sometimes used to describe the austere, tragic grandeur of Michelangelo's art and, by extension, any art with these same qualities.

THADDEUS, SAINT. See JUDE, SAINT.

THEATINE ORDER. The Theatine order, also called the Society of Clerk Regular, was founded jointly in 1524 by Giovanni Carafa (later Pope Paul IV), and Saint *Cajetan. A new model of behavior was presented with an emphasis

on extreme austerity, a strong emphasis on Eucharistic devotion and prayer, and a devotion to pastoral work.

THIEVES ON THE CROSS. An account of the two thieves (criminals or bandits in the New English Bible) who were crucified with *Christ is found in all four *Gospels. The names of the two thieves, Dismas and Gestas (good and bad) are taken from the Apocryphal Gospel of Nicodemas. *Crucifixion among the Romans was a form of capital punishment used only on slaves or on other persons who had committed the most heinous crimes; the ordinary Roman citizen was exempted from it by law. Thus the two thieves condemned to this method of punishment were not Roman citizens, and both had committed robbery. Artists distinguished between the impenitent and penitent thief following Luke 23:39–41. One of the criminals hanging there hurled insults at Christ saying, "Aren't you the Messiah? Save yourself and us." The other thief, however, rebuked him saying "Don't you fear God? You received the same sentence He did. Ours, however, is only right, because we are getting what we deserve for what we did; but He has done no wrong." The good thief is always placed on Christ's right (which in art is always the "good" side), and the bad thief is always placed on Christ's left. The good thief is shown composed and resigned to his fate whereas the other thief is always shown in agony. Many early Italian Renaissance artists depicted the thieves nailed to their crosses, while northern artists tended to show the thieves tied. The two thieves are shown nailed or tied to a T-shaped *crux commissa. Some artists show them blindfolded. John 19:32 tells how the soldiers broke the legs of the thieves to hasten their death. "So the soldiers went and broke the legs of the first man and then of the other man who had been crucified with Jesus." The thieves may be shown with wounds on their legs, sometimes one on each leg, sometimes two, or the soldiers may be in the act of wounding them. Some artists omit this, especially in Italy.

 Example: Master of Flémalle (Robert Campin), *Thieves on the Cross and Resurrection, Entombment Triptych,* c. 1415–1420, Collection of Count Antoine Seilern, London.

THOMAS, SAINT. See DOUBTING THOMAS.

THREE AGES OF MAN. See AGES OF MAN.

THREE AGES OF WOMAN AND DEATH (Allegory of Human Vanity). The idea of a woman preoccupied with herself, which is considered a *vanitas* allegory, usually shows a beautiful young woman viewing herself in a mirror, which she holds in one hand. With her other hand she arranges her long, flowing hair. A veiled *cupid (the concept of the cupid covered by a veil is a medieval symbol of lust) may be seated below her. Death holds the other end of the cupid's veil with one hand and with the other holds up an hour-glass (the attribute of

death and of father time) behind the unsuspecting woman. An old, withered woman enters the scene from the left and attempts to stay Death's hand.

Example: Hans Baldung Grien, 1509–1511, Kunsthistorisches Museum, Vienna.

THREE GRACES. The handmaidens of several goddesses and the personification of grace and beauty are known as the Three Graces. Artists often depict them as attendants of *Venus. According to Hesiod (*Theogony* 905) their names were Aglaia, Thalia, and Euphrosyne. The three are typically shown in a group with the two outer figures facing the spectator and the one in the middle facing away, although there are variations, especially by Renaissance artists. They were shown so-grouped in their antique form and copied thus. They are usually nude or scantily clothed, or their drapery is transparent. They were seen as the three phases of love by fifteenth-century Florentine humanist philosophers. One was beauty, which aroused desire, which led to fulfilment. They were also seen as the personification of Chastity, Beauty, and Love.

Example: Germain Pilon, 1559, marble, Louvre, Paris.

THREE MARIES AT THE SEPULCHRE (Three Maries at the Tomb). The three Maries, or holy women at the sepulchre, are described in Matthew 28:1–8; Mark 16:1–8; Luke 24:1–11, and John 20:1–9. The holy women who were the first to discover the empty tomb are mentioned by all the *Gospels; however, little agreement exists as to who they were. Matthew, for example, says, ''Mary Magdalene and the other Mary went to look at the tomb''; Mark says, ''Mary Magdalene, Mary the mother of James, and Salome bought spices to go and anoint the body of Jesus''; Luke says, ''Sunday morning the women went to the tomb.'' John says it was Saint *Mary Magdalene alone who went to the tomb. Over the years it has become customary for artists to depict three women, known as the Three Maries, or *myrrhophores,* bearers of myrrh. Artists usually show a stone sarcophagus from which the lid has been removed. Roman soldiers may still be asleep somewhere near or directly in front of it. An *angel may seem to bless the women as they stand or kneel.

Example: Adam Dumont, c. 1450, Museum Boymans-Van Beuningen, Rotterdam.

TIARA. The pope's triple crown, surmounted by the cross and orb, is known as the papal tiara. Although it is the emblem of sovereign power, it has no sacred character and is never worn at liturgical functions.

TIBURTINE SIBYL. See AUGUSTUS AND THE TIBURTINE SIBYL.

TITULUS. The Latin word for ''inscription'' is *titilus.* It is the label often placed above the head of the crucified *Christ which bears the letters INRI, the abbreviation of ''Jesus Nazarenus Rex Judaeorum,'' or ''Jesus of Nazareth, King of the Jews'' (John 19:19–20). This was the notice that Pontius Pilate (see CHRIST BEFORE PILATE) wrote and had placed at the top of Jesus' cross.

TITYUS. In Greek mythology Tityus was the son of earth, a giant who tried to rape the mother of *Apollo (Leto) and *Diana and was punished in Hades. His liver, thought to be the seat of the passions, was eternally torn and eaten by two vultures and continuously renewed as he lay stretched out, pegged to the ground. The story of Tityus appears in Virgil's *Aenead* 6:595–600 and Ovid's *Metamorphosis* 4:457–458. During the Renaissance Tityus was a symbol of the enslavement of the body by sensual passion and of the hopeless suffering of one who loves in vain. He is usually depicted bent and suffering.

Example: Michelangelo, black chalk drawing, 1532, Windsor Castle.

TOBIAS AND THE ANGEL (Tobias with the Archangel Raphael). The story of Tobias, a book probably written in Aramaic in the second century, is manifestly a moral tale, and not serious history. Tobias is that biblical book placed after Nehemiah in the Western canon but not included in the Hebrew Bible and placed in the *Apocrypha in the Authorized Version. It tells of Tobit (Tobias in the Vulgate), a certain pious Naphtalite who was a devout Jew in exile who had a son named Tobias. Despite his many good works, the father lost his eyesight while he lay sleeping one day in a field after a sparrow's droppings fell into his eyes and caused an infection that blinded him. Thinking that he would die soon, he asked his son to travel to Media to collect some money owed him. When Tobias looked for a companion to travel with him, he met the archangel Raphael, who appeared as an ordinary person and agreed to accompany him. The pair, along with Tobias' dog, left after a blessing from Tobias' father and his mother, Anna. At the Tigris River, where Tobias took a bath, a giant fish jumped out of the water and would have eaten him, but Raphael ordered him to catch it, which he did. At the archangel's instructions, he set aside the gall, liver, and heart. He was assured that the heart and liver, when burned, would drive off evil spirits and the gall would cure his father's eyes. When they reached their destination Tobias collected the money and then went to stay with a kinsman whose daughter Sara would make a bride for him. Unfortunately Sara was afflicted by a demon who had already killed seven husbands on wedding days before the marriages could be consummated. Tobias, nevertheless, married Sara and exorcized the demon with the aid of the burned fish, the smoke of which put the evil spirit to flight. When they returned to Nineveh, Tobias cured his father's blindness by annointing his eyes with the gall of the fish. Raphael then disclosed his identity. The book ends with a prophecy by the father that Jerusalem would be restored. The story, with its easy style and ideal of benevolence, marriage, and prayer, have made it a favorite. Tobias and the angel are usually dressed as travelers and accompanied by the dog. The giant fish is thought to have been a crocodile whose heart and liver were used in ancient magic to exorcise demons. Artists, however, usually show it as being no larger than a foot or so. In Italy, during the Renaissance, the concept of the guardian *angel was widespread, and the story of Tobias was

often used by a family to commemorate the travels of a son. Tobias would then be depicted in the likeness of the son.

Example: Girolamo Savoldo, 1520s, Borghese Gallery, Rome.

TOMB OF INNOCENT VIII. See WALL-TOMB.

TONDO. *Tondo* is the Italian word for "round." The *tondo*, a circular picture, was popular in Italy during the fifteenth century.

TOUCHET, MARIE. Traditionally known as Diane de Poitiers, Marie Touchet was the mistress of Henry II.

Example: François Clouet, c. 1571, National Gallery, Washington, D.C.

TOWER OF BABEL. The story of the Tower of Babylon is told in Genesis 11:1–9. In the beginning the people of the world had only one language. When they came to a plain in Babylon, they decided to settle there. They said, "Let's bake bricks and build ourselves a city and a tower that reaches the sky." For this presumption God confused their language so that they no longer understood one another and scattered them all over the earth so that they stopped building the city. Nimrod, a legendary conqueror of Babylon in the second millennium B.C., was supposed to have supervised the construction of the tower. Some read this account as an etiological story on the diversity of speech and also a reminiscence of the "ziggurat," a stepped pyramid found in some Sumerian cities of Mesopotamia. Artists usually show a tower being constructed.

Example: Pieter Bruegel, 1563, Kunsthistorisches Museum, Vienna.

TRAFFIC IN INDULGENCES. In the Roman Catholic church an indulgence is the pardon of temporal punishment due for sin. Indulgences may be full remission of all temporal punishment, or they may be partial. The idea of indulgences can be traced back to ancient times when public penance was imposed. During the Renaissance Martin *Luther protested against the sale of indulgences because he felt the practice was being abused. Finally he came to reject the teaching altogether. When the Council of Trent met in 1562 the decision was made to render the buying and selling of indulgences unlawful. Before this, however, the selling of indulgences became increasingly more popular as funds for the rebuilding of Saint Peter's in Rome were needed. Men are usually shown in lines handing over piles of coins to men of the Church.

Example: Jörg Breu the Elder, woodcut, sixteenth century, Staatsbibliothek, Berlin.

TRANSFIGURATION OF CHRIST. An account of the Transfiguration of *Christ is told in Matthew 17:1–13; Mark 9:2–13; and Luke 9:28–36. The word "transfiguration" denotes the visible change in the personal appearance of Jesus when he manifested his divine nature to the disciples Peter (see PETER, APOSTLE AND SAINT), *James the Greater, and Saint *John the Evangelist

and Apostle. He took them up a mountain, and although the name of the mountain is not designated, some believe that it was Mount Tabor in Galilee. It may also have been one of the foothills of Mount Hermon. Here Jesus took on an unusual radiance and nonearthly appearance. His garments became shining white and there appeared with him the prophets *Moses and Elijah, symbols of the Old Testament Law. On the site of the Transfiguration, Peter offered to build three shrines: one for Jesus, one for Elijah, and one for Moses. As Peter spoke, however, a bright cloud overshadowed them and a voice came out of the cloud saying, "This is my Son, whom I have chosen—listen to Him" (Luke 9:35). The *apostles fell down to the ground in great humility. Moses and Elijah are shown as grey-bearded old men. Moses usually holds a tablet of the law, or, in early Renaissance paintings, has rays of light sprouting from his head. Peter, usually in the center, has a grey beard, and John is easily identified because of his youthfulness. The scene that followed the next day may be shown in the lower half of the picture and may separately show, by way of contrast, the large crowd that met Jesus and the three disciples when they went down from the hill. This was intended to show man's powerlessness when separated from God. The disciples were engaged in an argument with the Jewish scribes, and a father begged Jesus to cure the "spirit attacks" his son had that caused him to foam at the mouth (Luke 9:37–40). During the Renaissance the Feast of the Transfiguration was instituted in the West. It had been fostered by the Carmelites, whose traditional founder was Elijah.

Example: Raphael, 1517, Pinacoteca, Vatican, Rome.

TRANSPORT OF THE BODY OF SAINT MARK. The story of Saint *Mark, one of the four *Evangelists, is found in the *Golden Legend*. Mark met his martyrdom under the rule of Nero, who began his reign in the year 57. When he was dead, after being dragged through the streets of Alexandria, the pagans prepared to burn his body. As they set about their task, a hail storm suddenly caused them to retreat. But because of the roaring thunder and flashing lightning, they left Mark's body untouched. The Christians, seeing this, carried it away and buried it in his church. Men are usually shown reverently carrying the body while other individuals flee the storm. Lightning is in the dark sky and the entire scene has the force of a great storm. See DISCOVERY OF THE BODY OF SAINT MARK and MARK FREEING A CHRISTIAN SLAVE.

Example: Tintoretto, 1562–1566, Accademia, Venice.

TRECENTO. The word *trecento,* which means "three hundred" in Italian, is used to designate the fourteenth century.

TREE OF LIFE. From very early times the tree was worshipped as a sacred object inhabited by a god. During the early Renaissance *Christ was depicted hanging, not upon the conventional cross, but upon a tree, the symbolic Tree of Life, also known as the mystical Tree of the Cross. This particular tree grew

alongside the Tree of Knowledge in the Garden of Eden. Above Christ's head a white pelican, a symbol of the sacrifice of Christ on the cross, is shown piercing her breast to feed her young with her own blood. Below the cross are the Virgin Mary (see MARY, SAINT) and Saint *Mary Magdalene with attendants and holy men. The fruits of the Tree, medallions seemingly hanging from it, contain scenes from Christ's life. To Christ's right are the *Stigmatization of Saint Francis and a scene from the Life of Saint Louis of Toulouse (see LOUIS OF TOULOUSE CROWNING ROBERT OF ANJOU KING OF NAPLES). To Christ's left are Saint *Benedict in the Desert and *Feast in the House of Levi. Below, a *Last Supper scene, with Judas (see PACT OF JUDAS) on the opposite side of the table, spreads across the width of the *fresco.

Example: Taddeo Gaddi, c. 1340–1350, Refectory, Sta. Croce, Florence.

TRIBUTE MONEY (Tribute to Caesar). The story of the tribute money is told in Matthew 22:15–22; Mark 12:13–17; and Luke 20:20–26. During his ministry in Judea, when *Christ was teaching in the temple at Jerusalem, the Pharisees plotted to trap him and lay him open to accusation by the Roman authorities or by those Jews who resented paying taxes to the Roman emperor. They sent some of their disciples and some members of Herod's party to ask Jesus whether he thought it was against their law to pay taxes to the Roman emperor or not. Christ, aware of their plan, pointed to the effigy of the emperor on a coin and told them to pay to the emperor what belongs to the emperor, and pay to God what belongs to God. They were silenced with his reply. On the basis of Christ's words no charge could be placed against him. On another occasion, when Christ and his *apostles went to Capernaum, some of the people there who received tribute money went to Peter (see PETER, APOSTLE AND SAINT) and asked him if his master paid tribute. Christ, knowing of this, told Peter to go to the sea and take up the first fish his hook brought up, open its mouth, find a piece of money there and take it to them for "Me and thee" (Matt. 17:27). Some artists show only two figures, Christ and the Pharisee, who holds the coin. Others show a broad scene with several figures surrounding Christ whose finger points upward signifying "Render to God the things that are God's." Also, Christ may be surrounded by the twelve apostles and the tax-collector. Peter may be shown crouching at the water's edge taking the silver coin from a fish's mouth.

Example: Masaccio, c. 1425, Brancacci Chapel, Sta. Maria del Carmine, Florence.

TRINITARIAN PIETÀ. God the Father is shown wearing papal dress and the papal *tiara supporting the dead *Christ in his arms. They float in heaven with *angels who carry the instruments of the *Passion. A dove, the Holy Ghost, the third Person of the *Trinity, hovers above.

Example: Albrecht Dürer, woodcut, 1511.

TRINITY. The word "trinity" is from the Latin *Trinitas* meaning three-foldness and is used to indicate a fundamental doctrine in Christianity by which God is considered as existing in three persons, Father, Son, and Holy Ghost, all coequal,

coeternal, and indivisible, of the same substance. The doctrine takes its authority from Matthew 28:19, where the three persons are mentioned in the baptismal formula, and was defined very early by Augustine in the *De Trinitate*. The word does not appear in Scripture, but several verses in the New Testament support the doctrine. For example, in 1 Corinthians 12:4–6, Saint *Paul correlates the Spirit with God. In Matthew 11:27 and Luke 10:22 the Father and Son are brought together; in Matthew 12:32 and Luke 12:10, the Son of Man and the *Holy Spirit are joined. Most Christian teachers consider the Trinity to be a mystery, that is, its nature cannot be fully understood or known by human intelligence. For this reason it is known as a truth of revelation. In Renaissance art the Trinity was represented in two principal ways. Importance was placed on the Unity of the Godhead or the Three Persons of the Trinity were represented. In the latter depiction, the Father, Son, and Holy Ghost may appear separately or together, depending on the topic portrayed. Usually the God is emphasized. God the Father reigns over the creation of the world; Christ the Son endures the torment of the *Passion; and the Holy Ghost illumines the church. God the Father is shown as an old man, usually with a long beard and perhaps with a triangular halo (used only in representations of the Trinity, or God the Father). He may be situated behind and somewhat above Christ, who is on the cross. He may hold each end of the crosspiece (patibulum) in his hands or a book or the globe. He may wear the papal tiara and be clad in papal dress. God the Son may be shown seated at the right hand of the Father as the judge of the living and the dead. Christ is usually shown as younger than his Father in devotional paintings. He is also shown as mature, bearded, showing his wounds, and with bare feet; he may be represented as a child, either with his mother, or even, although rarely, alone. Since the Christ Child represents the Incarnation, he may carry the symbols of his Passion to emphasize the relationship between his Incarnation and his sacrifice for man. Rarely he may be depicted as a lamb, and even more rarely as a lion. His most popular symbol in Early Christian *painting, the fish, apparently had become obsolete by the Renaissance.

Example: Masaccio, 1428, Sta. Maria Novella, Florence.

TRIPTYCH. See POLYPTYCH.

TRIUMPH. Roman triumphs were processional entries into Rome, an official honor bestowed by the Roman senate on a victorious general and under the empire confined to the emperors themselves. The triumph took the form of a procession through the streets of Rome, in which the victor was carried on a beautifully decorated car drawn by several white horses. During the Renaissance the Italian love of public spectacle revived the triumph. Allegorical and mythological triumphal scenes became popular, and the theme eventually came to be used for its didactic possibilities. Renaissance artists known for their paintings of triumphs were Albrecht Dürer, Hans Holbein, and Andrea Mantegna.

TRIUMPHAL ARCH FOR MAXIMILIAN. Maximilian I, 1459–1519, was Holy Roman emperor and German king from 1493 until 1519. He was the son and successor of Holy Roman Emperor Frederick III. Elected king of the Romans in 1486, he increasingly assumed a share of the imperial duties until his father's death. Maximilian I was one of the most important European sovereigns of his period. He made his family, the Hapsburgs, dominant in sixteenth century Europe. A well-planned marriage with Mary of Burgundy acquired for him Burgundian lands in the Netherlands and France in 1477. It was necessary to defend them from France for many years, which he did, and by treaty in 1491 he secured the Hungarian and Bohemian successions for the Hapsburgs. He built a complex system of alliances over the years and greatly strengthened his dynasty's position in Europe. The Triumphal Arch for Maximilian, a tribute to his power, is divided into sections: (1) three gateways, which are dedicated to Honor (in the middle), Praise (left), and Nobility (right); (2) the middle tower over the main gateway, which contains the genealogical tree of the emperor and is flanked by fifty-seven escutcheons; (3) the deeds of Maximilian in twenty-four scenes above the two gateways with twelve compartments on each side showing historical scenes from the emperor's life, plus twelve half length portraits of the kings of Rome, of Italy, and of the Roman Empire from Caesar to Sigismund on the left side, and twelve half length portraits of contemporary princes on the right side; (4) busts of emperors and kings on the left and of kinsmen on the right (with two outside the columns); (5) the two corner towers have eleven subjects. Ornament is in abundance. The arch was a monumental project that required the work of an architect, a master designer, an iconographer, and an entire company of craftsmen for nearly three years. The finished arch consisted of 192 *woodcut prints fitted together to make one large print—a triumphal arch 11 feet high and 10 feet wide made entirely of paper. Maximilian had, it seems, an unquenchable ambition to be glorified like Ceasar. Since his budget did not match his aspirations, instead of ordering a real triumphal arch like those built for the emperors of Rome, he commissioned Albrecht Dürer to design a paper one. It was completed in 1515. Dürer also made a sketch from life of the emperor on June 28, 1518, at Augsburg. Today the drawing is in the Albertina, at Vienna. It was from this sketch that Dürer did the original for his woodcut, *Portrait of the Emperor Maximilian,* completed c. 1519.

TRIUMPH OF CAMILLUS. Marcus Furius Camillus, a Roman hero who died c. 365 B.C., has always been remembered as the saviour and refounder of Rome after its occupation by Gauls in 387 B.C. Modern historians do not accept in full the account of his victories because his exploits were later exaggerated by tradition. In any case, Camillus levied an army, overran the Gauls, recovered the booty they had stolen, and successfully opposed the suggestion that the population left in Rome should be taken nine miles away to the city of Veii, which he had captured himself in 396 B.C. In *Lives* Plutarch adds to the accounts told by Livy in his *History of Rome.* It is from Plutarch that artists took the

subject for their paintings of Camillus' triumph. The story is a good example of the Roman sense of *justice. It seems that when the Romans were attacking Falerii the master of the local school brought the children in his care to the Roman camp and asked if they couldn't be used as hostages for handing over the city. Camillus, furious at the man's treachery, sent the children back and whipped their schoolmaster before them. This scene is frequently depicted. Other scenes show Camillus riding on his triumphal car, surrounded by barbarian captives, trophies, and standards with lictors or Roman officials bearing fasces (a bundle of rods bound about an ax with projecting blade, carried before Roman magistrates as a symbol of authority).

Example: Francesco Salviati, 1550s, Sala dell' Udienza, Palazzo Vecchio, Florence.

TRIUMPH OF DEATH. During the Renaissance, pictorial representations of death were common. The *Dance of Death, or *Danse macabre,* originally a fourteenth-century morality poem, was a dialogue between death and persons of all classes from the pope down. A traditional representation was the meeting of the three living and the three dead, a topic that had been depicted often in the later Middle Ages yet still held fascination for Renaissance man. The three living are splendidly dressed noblemen who, along with their friends and attendants, suddenly come upon three open coffins while hunting one day. Each coffin is occupied by a corpse, one still bloated, the next half-rotten, and the third a mere skeleton. Serpents and worms crawl over all three. Even the horses and hunting dogs draw back in disgust while one nobleman holds his nose at the horrible stench. On the opposite side beautiful young ladies and gentlemen sit in a shaded grove conversing intimately, playing music, and paying no attention to the approach of Death, a hideous, white-haired hag who nears them on bat wings and swinging the axe with which she will cut them down. Between the hunters and the merrymakers is a heap of Death's recent victims, all beautifully dressed, above whose corpses demons carry away their helpless souls. Above all this horror are hermits who contemplate, work, and read. The hermit drinks milk furnished by a doe deer. The message seems to be that the only escape from the horror of death is a life in the wilderness.

Example: Francesco Traini, mid-fourteenth century, Campo Santo, Pisa.

TRIUMPH OF HERACLIUS OVER CHOSROES. See BATTLE OF HERACLIUS AND CHOSROES.

TRIUMPH OF MORDECAI. The story of Mordecai is told in the Book of Esther. Esther (see ESTHER AND AHASUERUS), an orphan, had been brought up by her cousin, Mordecai, who had adopted her as his daughter. After King Xerxes (Ahasuerus) had made Esther his queen, Mordecai was appointed to an administrative position in the court. Both were Jewish and Mordecai had warned Esther not to tell anyone. In the meantime, when he learned that two of the palace guards were plotting to assassinate King Xerxes, he told Esther, who

then told the king. Both men were hanged. Soon a man named Haman (see DEATH OF HAMAN) was named to the position of prime minister. The king ordered all men to show their respect for him by kneeling and bowing to him. Everyone did, except Mordecai. He then admitted that he was a Jew and could not bow to Haman. When Haman learned of this, he made plans to kill every Jew in the entire Persian Empire. The king, after hearing his plot, gave him permission to carry it out. Mordecai asked one of Esther's servants to take her a copy of the proclamation, explain the situation to her, and have her go and plead with the king and beg him to have mercy on her people. Esther sent a message back to Mordecai telling him she could not see the king without being summoned on pain of death, and when Mordecai received it he sent her this warning: "Don't imagine that you are safer than any other Jew just because you are in the royal palace" (Esther 4:13). Esther decided to see the king, and when she did he received her. He told her she could have anything she desired, but instead of asking her favor then, she invited the king and Haman to a banquet. After her banquet she invited them to still another banquet planned for the following day. Meanwhile, Haman built a gallows and planned to ask the king to have Mordecai hanged on it. That night, however, the king could not sleep and had the official records of the empire brought and read to him. He heard the account of how Mordecai had uncovered a plot to assassinate him and asked how this man had been honored. He was told that nothing had been done. Haman entered the courtyard at this time intending to ask the king to have Mordecai hanged. The king, however, said to him, "There is someone I wish very much to honor. What should I do for this man?" (6:6). Haman thought that the king wanted to honor him. So he answered,

"Have royal robes brought for this man. Have a royal ornament put on your own horse. Then have one of your highest nobleman dress the man in these robes and lead him, mounted on the horse, through the city. Have a nobleman announce as they go, 'See how the king rewards a man he wishes to honor.' " (6:7–9)

The king told Haman to hurry and get the robes and the horse and provide these honors for Mordecai the Jew. Haman did these things. At the second banquet, Esther revealed everything, and Haman was hanged on the gallows that he had built for Mordecai. Mordecai is shown being led through the city streets on the king's horse. People lean from balconies and wave to him.

Example: Veronese, 1556, Ceiling, S. Sebastiano, Venice.

TRIUMPH OF THE CHURCH. The word "church" has several origins: Middle English, *chirche,* from Anglo-Saxon *circe,* and from Greek *kyriakon,* "the Lord's house." An aggregation of Christian believers, living and dead, the church was founded and headed by Jesus *Christ. Various divisions recognize the church militant (the living), the church triumphant (the saints of heaven), and the church suffering (the dead in purgatory). Some divisions define the church as the communion of saints who truly believe in Christ, in which the

*gospel is rightly preached and the sacraments properly administered recognizable by four points. It is Catholic (universal), apostolic (having continuity with the *apostles), holy (producing holy lives), and one (united). During the Renaissance, the church, as most individuals in the west knew it, underwent tremendous changes. As early as the late fifteenth century reforms so excellent were drawn up that if put into effect they might have saved the church from both the Reformation and the Counter-Reformation. The reforms, at first deferred from day to day, were finally never undertaken. The Triumph of the Church, therefore, is a subject popular during the early Renaissance. Being concerned with religious life on earth, heaven, and one of the monastic orders, such as the *Dominican order, the triumph becomes a great statement showing humanity finding its way to heaven. In the fourteenth century the most impressive church, even though incomplete (it lacked a dome) until the early fifteenth century, was the Cathedral of Florence. Some artists used it to typify the church on earth, and it is always shown with a dome few believed would ever exist. In the Triumph, the pope usually occupies a section in front of the cathedral with a cardinal and a bishop on his right and an emperor and a king on his left. Sheep, symbolizing the Christian flock, gather obediently at his feet. The world is shown outside the fortress of the church where heretics are admonished. Worldly figures are also shown making music, making love in the shrubbery, dancing in the fields, and enjoying the fruits of the trees. From these sins, mankind can be rescued only by the sacrament of Penance. Heaven is shown above the church, the entrance guarded by Saint *Peter (see PETER, APOSTLE AND SAINT), who stands before the splendid golden gates. *Angels crown the little souls as they march through the heavenly gates. Rejoicing saints, some recognizable by their symbols, are crowded behind the gates. Finally, floating far above it all is Christ himself, who holds the New Testament and the key to heaven. Below him the Apocalyptic lamb is guarded by symbols of the four *Evangelists, and on both sides angelic cohorts praise the eternal.

 Example: Andrea da Firenze, c. 1350, Spanish Chapel, Sta. Maria Novella, Florence.

TROJAN WAR. In Greek mythology, the Trojan War was the war between the Greeks and the Trojans, the people of Troy. The legend is probably, according to some historians, the real war (c. 1200 B.C.) between the invading Greeks and the people of Troy, possibly over trade rights through the Dardenelles. In legend, history, or partial history, the city of Troy was besieged for nearly ten years and finally taken. The strife began after Paris, a Trojan prince, abducted Helen (see ABDUCTION OF HELEN), the wife of Menelaus of Sparta. Menelaus demanded her return, and the Trojans refused. After this Menelaus persuaded his brother Agamemnon, leader of the Greek armies, to lead an army against Troy. The troops gathered at Aulis, led by the most courageous of all Greek heroes—Achilles, Diomed, Odysseus, Patroclus, Nestor, and the two warriors known as Ajax. So important did the mission become that Agamemnon sacrificed his daughter Iphigenia to Artemis, one of the twelve goddesses of Olympus.

(During the war the gods of Olympus themselves took sides and controlled the destinies of the warriors.) After all the preparations for war had been made, the fleet set sail for Troy and for the next nine years the Greeks did battle with Troy's surrounding cities and countryside. The city itself, was not only commanded by Hector and other sons of the royal household, but also was well fortified and thus held out. The Greeks, seeing that they would not be able to take the city, finally decided to build a wooden horse, that was hollow and large enough to hold a group of warriors. Meanwhile, the other Greeks were seen setting sail for home, leaving behind only the horse and Sinon, who persuaded the Trojans to take the giant horse within the city walls. *Cassandra vainly tried to warn the Trojans against the wooden horse. Also, the Trojan priest Laocoön warned the citizens of Troy not to bring the Greek's wooden horse into the city. The Greeks, before leaving, had caused the story to be circulated that the horse was an offering to the goddess Minerva, whose temple was within the walls of Troy. Laocoön, while officiating at the altar of *Neptune, was killed, along with his two sons, by two huge snakes who had come from the sea. Frantic by this apparent sign of Minerva's displeasure, the Trojans dragged the horse into the city. That night the Greeks returned, their warriors crept out of the horse, opened the city gates, and Troy was finally destroyed. The sources for the story are Virgil's *Aeneid* and Homer's *Illiad*. Although it was retold by writers of late antiquity and in thirteenth and fourteenth century medieval romances, the topic is rare in Renaissance art. Artists show Agamemnon in splendid armor facing Achilles. The Greek ships may be visible in the background. Nestor, the oldest of the Greek chieftains, who unsuccessfully attempted conciliation, may be shown wearing armor. The most familiar scene of the war, the episode of the wooden horse, is extremely rare.

Example: Noël Jallier, *The Trojan War,* 1549, Château of Oiron, Deux-Sèvres.

TROMPE L'OEIL. The French term *trompe l'oeil* means "deceive the eye." A painting that has the ability to deceive the eye as to the material reality of the objects depicted is known as trompe l'oeil. The purpose of the work may be simply decorative. Some historians use the term in a derogatory sense when designating skillful paintings that lack artistic interest. The genuine trompe l'oeil isn't necessarily a work of shallow depth, because its subject matter is limited to surfaces that lie in or near the picture plane. A good example might be a postage stamp or a low *relief sculpture. In depictions of objects of greater depth, the eyes easily detect the absence of parallax. However, the deception can be made to work if the trompe l'oeil can be viewed from only one angle. Probably the earliest Renaissance example of trompe l'oeil was painted by Giotto. Giorgio Vasari records that when Giotto was still a young man in Cimabue's workshop, he once painted on the nose of one of the figures Cimabue was working on, a fly that was so lifelike that when the master returned to carry on with his work he tried several times to brush it off with his hand under the impression that it was real before he realized his mistake.

TROPHY. In antiquity victory memorials took the form of the arms and armor of an enemy hung on the branches of an oak tree arranged in such a manner as to resemble a human figure; these were later hallowed and put within a shrine. During the Renaissance the armor motif was used on tomb sculpture and *reliefs as a kind of trophy.

TRUMEAU. An architectural term, the *trumeau* is a central mullion supporting the tympanum (pediment) of a doorway.
 Example: Claus Sluter, 1391–1397 Portal of the Chartreuse de Champmol, Dijon.

TUSCAN SCHOOL. The term "Tuscan School" is a collective name for the Schools of Florence (*Florentine School) at Lucca, Pisa, Arezzo, and Siena.

TYPOGRAPHY. The art of printing with movable types is described as "typography." Preceded by the production of *woodcuts and the consequent development of the *block book, the introduction of metal types in the fifteenth century brought about a radical transformation in printing. No one actually knows where, when, or by whom this type of printing was first invented. The discovery is, however, attributed to Johann Gutenberg of Mainz. On the other hand, a certain Laurens Janszoon Coster of Haarlem has also been credited with it.
 Established by c. 1440–1450, its first piece of printing, an indulgence, was printed at Mainz in 1454. By 1456 the first edition of the Bible was issued at Mainz, assumed by some to have been printed by Gutenberg. It is called the *Gutenberg Bible*. Because a copy attracted the attention of Cardinal Mazarin, it is known also as the *Mazarin Bible*. It is also known as the *Forty-two Line Bible* (from the number of lines in a column of its page). The art of printing spread rapidly during the Renaissance so that by 1500 presses were set up in more than seventy towns south of the Alps. Early printed books of the fifteenth century closely resemble manuscripts and are known as "incunabula," but by 1500 and the establishment of the numerous new presses, typography had nearly freed itself from the influence of the manuscript. The sixteenth-century book, as distinct from most incunabula, generally has a title page with the date, the name of its author, and the address of the bookseller by whom it was published. The sixteenth century also saw the introduction of small compact type, which replaced the use of type that imitated script. The new books were reduced to portable and convenient dimensions. An excellent sixteenth-century example is the 1568 edition of the *Bishops' Bible* issued by Richard Judge which contained copper-plate portraits.

U

ULYSSES AND PENELOPE (Ulixes and Penelope). Ulysses is the Greek Odysseus. In Greek mythology he was the son and successor of King Laertes of Ithaca (modern Leucadia), husband of Penelope, and father of Telemachus, one of the heroes of the *Trojan War. As a leader of the Greek forces during the Trojan War noted for his cunning strategy, he was courageous, enterprising, and sensible. He was chosen with Phoenix and Ajax to take Agamemnon's offer of reconciliation to Achilles. In post-Homeric legend he was, however, depicted as a lying and evil man. In fact, he avoided having to fight in the Trojan War by feigning madness. Later he was exposed by Palamedes, whom he later revengefully caused to be executed. Palamedes had placed Ulysses' infant son Telemachus in the path of an advancing team. Numerous legends of Ulysses' wanderings, some of which stem from pre-Homeric times, have been treated successfully not only in art, but in literature as well. The Renaissance artist Piero di Cosimo painted scenes from the *Odyssey,* and the heroic concept of Ulysses is reflected in a character in Shakespeare's *Troilus and Cressida*. Penelope was the faithful wife of Ulysses and mother of Telemachus. Overall, she is considered as wise and prudent. When left in Ithaca she was pressed by local nobles to remarry but managed to successfully stave them off for three years by saying she had to finish weaving a shroud for her father-in-law Laertes; this she unraveled every night. Finally she was betrayed by one of her maids and had to finish it. When Ulysses had been gone for twenty years and Telemachus had gone in search of him, Penelope found she had to offer herself to any of the suitors who could string Ulysses' giant bow and shoot through a row of double-headed axes. Ulysses, by this time, came home, and disguised as a beggar, took the bow and killed the suitors. He and his wife were then reunited. Penelope is usually shown

seated at her loom surrounded by suitors who appear to gesture impatiently. Close by her maids spin and wind bobbins. Telemachus may be in close proximity. Ulysses' bow and quiver may hang on the wall, and a ship may be seen in the distance bringing him ashore.

Example: Francesco Primaticcio, c. 1545, Toledo Museum, Ohio.

UMBRIAN SCHOOL. Umbria is a mountainous area in the heart of Italy. Traditionally when one speaks of Umbrian art one uses words such as "sweetness," or "softness." In the fifteenth century the district became known because of this school of painting. Fra Angelico and Domenico Veneziano had worked in the area and their inspiration gave rise to the graceful flowery style of Benedetto Bonfigli, Bartolomeo Caporali, and finally, under the influence of Piero della Francesca, the art of the greatest Perugian painters, Bernardino Pintoricchio and Perugino, the teacher of Raphael. Such was the success of the style that it affected the *Florentine and Roman Schools, and through the influence of an Italian goldsmith of Bologna, Francesco Francia the Bolognese. By 1540, when the papacy annexed Perugia, the Umbrian School had ceased to be influential.

UNDERPAINTING. The term for preliminary layers of paint that are later covered by solid paint (impasto), scumbles, or *glazes is known to painters as "underpainting." During the Renaissance most paintings were built with a number of layers. *Tempera painting, very popular during the early Renaissance, followed this general pattern. After a design had been sketched on the *ground, light and dark areas were indicated by a wash of green earth color known as *terre verte* over which the other colors were laid, very light in the beginning, but enriched by more layers if needed. On the other hand, *oil painting, probably used first by the Flemish masters and followed by Italian painters, may have been used over tempera that had been used for the underpainting. Michelangelo's *Entombment,* c. 1495, today located in the National Gallery, London, is a good example of this. The main areas of light and dark are shown in *terre verte,* and the standing figure on the left has the robe painted in tempera. Tempera may also have been used by the Venetians as an underpainting.

URSULA, SAINT (It. Orsola). Ursula was a fifth-century legendary saint born in Brittany, the daughter of the Christian king Theonestus. Ursula appears especially in Italian and German Renaissance art, her story often told in narrative scenes. According to legend, she was extremely beautiful and intelligent. This brought many suitors to her door, but she refused to marry until Agrippus, the pagan king of England, sent ambassadors to ask her hand in marriage to his only son Conon. Ursula consented to the marriage but told her father she would marry Conon on three conditions, that she fully expected to be refused. First, she said she must have ten virgins as her companions, and that each of these must have a thousand attendants, also virgins. She requested a thousand

handmaidens for herself. Second, she required Conon to accompany her on a pilgrimage to Rome and allow three years in which to visit the shrines of the Christian saints. Finally, she insisted that her future betrothed and all his court must become Christians, for she would not marry a heathen. The ambassadors were so impressed with her beauty and wisdom that Conon and his father accepted all the conditions. Eleven thousand virgins were brought together to form Ursula's retinue, and Conon joined her for the trip to Rome. At Rome Pope Ciriacus baptized Conon in the name of Etherius and decided to accompany them on their way home. On their return they stopped in Cologne and Ursula lay in bed and dreamed of her crown of martyrdom. An *angel is usually shown entering her bedroom with the morning sunlight to bring her the palm of her approaching martyrdom. When Cologne is besieged by the Huns, Etherius and the virgins are killed, the virgins only after many unsuccessful attempts have been made by the Huns to ravish them. The Huns' barbarian leader, noting Ursula's unusual beauty, decided to spare her. When he asked her to marry him she dismissed him with a gesture whereupon he drew his bow and drove three arrows through her heart. Some accounts say he ordered his men to shoot her full of arrows. Ursula is usually shown holding two or three arrows, or she is standing before an archer who has an arrow aimed at her heart. The Cathedral of Cologne may be in the background.

Example: Hans Memling, *Chasse of Saint Ursula,* gilded and painted wood, 1489, Hospital of Saint John, Bruges.

V

VEHICLE. A word that is synonymous with *medium, vehicle is a liquid used to bind powdered color to make paint or to thin thick or stiff paint.

VELATA, DONNA. Donna Velata, meaning "veiled woman," is possibly the famous Fornarina, the "baker's daughter," recorded by Giorgio Vasari.
 Example: Raphael, c. 1513, Pitti Gallery, Florence.

VELATURA. An Italian word, *velatura* is used when referring to the technique of building up a painting with layers of paint and especially interminable *glazes to tone down colors and to enrich the work with a depth of tone in which numerous colors, lights, and darks seem miraculously suspended. Titian is known to have said, *"Trenta, quaranta velature!"* or "Thirty, forty glazes!" and it is possible that he used that many.

VENETIAN SCHOOL. Venice, founded in the fifth century, was a city that grew great under the patronage of Byzantium and Venetian art. Dominated by early Christian forms, the Venetian mode was to perpetuate those forms within the tradition of Italian art itself. When Gentile da Fabriano went to Venice in 1408, he brought with him Gothic painting in its newest form—a rich, delicate, decorative style easily blended with an east European style. But even more noteworthy was the influence of Andrea Mantegna, particularly his severe *perspectives and sculptural forms (see SOTTO IN SÚ and IN SCURTO). Later, it was Giovanni Bellini who gained from Mantegna's art and turned it into that concord of light with space, and that harmony of figure with landscape which was to, in the end, distinguish Venetian painting. And it was Bellini who, above

all, established the predominance of color, especially in his late works, as an element of composition. This is the feature that is characteristically Venetian.

VENUS. Originally an obscure Italian deity, Venus, whose name meant "charm" or "beauty," was identified by the Greeks as Aphrodite through the cult of Aphrodite on Mount Eryx in Sicily, which had been founded by Aeneas after the death of his father Anchises. After 217 B.C. Venus Erycina had a temple in Rome and took on all the associates and functions of Aphrodite. She was especially important in the recognized state cult because the Julian family claimed descent from Aeneas, the son of Aphrodite. Here she is known as Venus Genetrix, the mother and creator of all living things. She became, as Genetrix, the center of Sandro Botticelli's *Primavera*. The mother of *Cupid, she is attended by the *Three Graces. Her attributes are numerous, giving artists a wide selection. She may have a pair of swans or doves, either of which may pull her chariot; dolphins and the scallop shell, both recalling her birth from the sea; her tools for kindling love, a flaming torch and her magic girdle. Both the myrtle, evergreen like love, and the red rose, stained with her blood, are sacred to her. Her typical pose is the recumbent. She may also be shown nude in a formalized standing pose, in which case the pose probably originated in the religious statuary of antiquity. The *Venus Pudica,* or Venus of Modesty, stands with one hand covering the pubic area, while the other covers the breasts. She was also known as *Venus Victrix,* bringer of victory; and *Venus Verticordia,* protector of feminine chastity.

Example: Titian, 1538, Uffizi Gallery, Florence.

VENUS ANADYOMENE. The word *Anadyomene* means "rising." Venus Anadyomene is the title used for Venus rising or born from the sea. It was first used by the Hellenistic artist Apelles for a painting, now lost, in Cos. She is usually shown nude holding a seashell or standing on a large shell floating on the sea. See BIRTH OF VENUS.

Example: Jacopo Sansovino, bronze, before 1527?, National Gallery of Art, Washington, D.C. (Mellon Collection).

VENUS AND CUPID. According to tradition *Cupid was the son of Venus. During the Renaissance the education of heroes and gods was a popular theme. Since it reflected an interest in the revival of classical learning, Venus was often shown educating Cupid. She may be shown taking his arrows away from him or with him across her knee, her raised hand holding a bunch of roses with which to strike him. She may be shown teaching him to read along with his teacher Mercury. One fable tells how Cupid, when only an infant, was stung by a bee while trying to steal a honeycomb. He ran to his mother and may be shown standing tearfully beside her holding part of a honeycomb while bees buzz around him. She may simply be depicted teaching him to walk, in which case she holds

one of his arms to steady him. He carries his bow in his other hand and his quiver full of arrows is strapped over his shoulder. See CUPID AND PSYCHE and EXPOSURE OF LUXURY.

Example: Jan Gossart, 1521, Musées Royaux des Beaux-Arts, Brussels.

VENUS AND MARS. See MARS AND VENUS.

VENUS AND THE LUTE PLAYER. The goddess *Venus is shown about to be crowned by her son *Cupid. She usually reclines on a couch before a parapet and is gazing toward something unknown. She holds a type of shepherd's pipe, and other musical instruments are scattered about. A curly-headed youth in typical fifteenth-century costume plays music for her and looks in her direction. A curtain parts behind them to reveal a shimmering glade where *nymphs dance to music of their own.

Example: Titian, late 1550s, Metropolitan Museum of Art, New York.

VENUS, CUPID, FOLLY, AND TIME. See EXPOSURE OF LUXURY.

VENUS PUDICA. See VENUS.

VENUS TAKING LEAVE FROM ADONIS. See ADONIS.

VENUS VICTRIX. See VENUS.

VENUS WITH CUPID AS A HONEY THIEF. See VENUS AND CUPID.

VERNICLE. See SUDARIUM.

VERONICA, SAINT. The Apocryphal *Gospels of Nicodemus tell the legend of the woman named Veronica who came forward and took her veil, or a linen handkerchief, and wiped the sweat from *Christ's brow as he was bearing his cross to Calvary. Miraculously the likeness of his face became imprinted on the cloth. The name Veronica means true image, *vera icon.* According to the *Golden Legend,* Veronica said, "As Jesus was always travelling about to preach, and I could not enjoy His presence, I once was on my way to a painter to have the Master's portrait drawn on a cloth which I bore with me. And the Lord met me in the way, and learning what I was about, pressed the cloth against His face, and left His image upon it" (p. 214). The cloth, preserved in Saint Peter's in Rome as a holy relic, is known as Veronica's veil. Veronica is usually shown holding out the cloth, which bears the picture of Christ wearing the crown of thorns, or the cloth may be held by two *angels. As an allusion to her eastern origin, she may wear a turban. Although she appears frequently in art, Veronica is not listed in official calenders of saints. See SUDARIUM.

Example: Master of Flémalle (Robert Campin), c. 1430–1434, Städelsches Kunstinstitut, Frankfurt.

VERTUMNUS AND POMONA. The story of this Italian god and goddess, the protectors of orchards, gardens, and the ripening fruit, is taken from *Metamorphoses* 14:623–697. Pomona, according to the legend, was the only *nymph who did not care for the wild forests. She loved only fruits and orchards, and her greatest delight was in grafting and pruning and everything that the gardener does. Alone with her beloved trees, she shut herself away from men. Being especially lovely, the god Vertumnus sought to woo her. He tried to enter her presence in disguise, now as a clumsy herdsman, now as a rude reaper, or a vine-pruner, but in vain. One day, after devising a better plan, he came to her disguised as a very old woman, so that it did not seem unusual to Pomona when after complimenting her orchard he said to her, "But you are far more beautiful," and kissed her as no old woman would have done. Naturally Pomona was startled and so he stopped kissing her and sat down opposite an elm tree. A great vine loaded with luscious purple grapes grew over the tree. He said, "How beautiful they are together, and how different they would be apart, the tree useless and the vine flat on the ground unable to bear fruit. Are you not like such a vine? You turn from all who desire you. You will try to stand alone. And yet there is one—listen to an old woman—who loves you more than you know—you would do well not to reject Vertumnus. You are his first love and will be his last. And he too cares for the orchard and the garden. He would work by your side." He went on to tell her how *Venus had shown that she disliked hard-hearted maidens and then told her the unhappy story of Anaxarete, who had disdained her suitor Iphis, until in sad agony he hanged himself from her gatepost. Venus then turned the heartless girl into a stone figure. "Be warned," he told her, "and yield to your true lover." Then he dropped his disguise and revealed himself to her in his true shape, the radiant, resplendent god. Pomona yielded and from that day on her orchards had two gardeners. Vertumnus may be depicted as the reaper and the herdsman and the old woman in the same painting. Pomona is shown nude and sometimes the old woman is bent over her, perhaps with a hand on her shoulder. She may be seated under a tree with a cornucopia or a basket of fruit beside her. She may hold a branch or a pruning knife. The tree may have the grape vine growing upon it. Ovid extended the idea of the tree and the grape vine metaphorically: the tree is the steadfast husband to whom the wife may cling for support.

Example: Jacopo Pontormo, 1520–21, Villa Medici, Poggio a Caiano.

VIA DOLOROSA. See STATIONS OF THE CROSS.

VICES. The seven vices, frequently paired with the *Virtues, usually include Avarice, Folly, Gluttony, Inconstancy, Injustice, Pride, and Unchastity. The allegorical depiction of the virtues and vices derives from a long tradition taken

up by the early church, which used them to teach a moral lesson. The virtues and vices were represented in constant conflict. See PSYCHOMACHIA.

VICISSITUDES OF THE BOY JOSEPH. See JOSEPH, THE STORY OF.

VICTOR, SAINT. Victor, rarely seen in Renaissance art, was a standard bearer for the Theban Legion (so-called because its members were from the city of Thebes), better known as the Holy Legion. The captain of this legion, Saint *Maurice, led his 6,666 soldiers to defend innocent Christians against the emperors Diocletian and Maximian, whose aims were to ultimately destroy the Christian faith. The Holy Legion was slaughtered, except for a certain number, around the year 280. According to the *Golden Legend,* as the emperor's soldiers were dividing the booty and eating together, an old man named Victor passed by, and they invited him to join the celebration. He inquired of them how they could have a party in the midst of so many thousands of slaughtered men scattered everywhere about them. Someone shouted to Victor that these men had died for the Christian faith; the old man said that he would have counted it a blessing to be put to death with them. Discovering that he was a Christian, they attacked him and tore him to pieces. Victor is usually shown as a young man with a closely cropped beard, which is the same color as his hair, reddish brown. He usually holds a cross as an allusion to the fact that he died for *Christ.
 Example: Duccio, *Saint Victor,* front panel of the *Maestà Altarpiece,* 1308–1311, Museo dell 'Opera del Duomo, Siena.

VICTORY. The goddess of Victory, "Nike" in Greek, and "Victoria" in Latin, known to the ancient Greeks and Romans, was the messenger of the gods, a kind of *angel who appeared from above to crown the victor in a contest of poetry, athletics, or arms. She was personified as a winged female figure, and her Roman image was the source of early depictions of the angel in early Christian art. Rarely represented in the Middle Ages, Victory was revived by artists in the Renaissance. At this time she was shown bestowing a crown, usually a palm branch and a laurel. She may also be surrounded by, or reclining on, a pile of armor and weapons of war, while a defeated enemy lies bound at her feet. Fame, found in the company of the illustrious dead and occasionally the living, may be her companion. Fame's attribute during the Renaissance was a trumpet, and she, too, may hold a palm branch, the symbol of victory.
 Example: Bartolommeo Ammannati, marble, c. 1540, Bargello, Florence.

VINCENT, SAINT. Vincent was a third-century Spanish Christian martyr. Born at Huesca, he died at Valencia c. 287 under the reign of the Emperors Diocletian and Maximian. Vincent became deacon to Saint Valerius, the bishop of Saragossa. His martyrdom, a series of horrible ordeals, was recorded by Saint Augustine and is found in the *Golden Legend.* When first thrown into prison, he was nearly starved to death, then stretched upon the rack, and his limbs were

broken. Vincent is recorded as saying, "This is what I have at all times desired!"(p.115). He was whipped and, before being grilled, iron rakes were driven into his sides. It is said that he mounted the grill of his own accord. When he was dead a great stone was tied to his corpse, and it was thrown into the sea. But the body of Vincent would not sink. It floated away and was rescued by a devout Christian woman who, with the help of others, gave it a solemn burial. Vincent usually wears a deacon's *dalmatic and is depicted as a young man who, like Lawerence, (see MARTYRDOM OF SAINT LAWRENCE) carries a gridiron, his instrument of martyrdom. He may hold a whip, and a millstone alludes to the one tied round his body when it was cast overboard. A bunch of grapes alludes to his patronage of viticulturists.

Example: Nuno Goncalves, *Saint Vincent Altar,* c. 1465–1467, Lisbon Museum.

VIRGIN ADORING THE CHILD. See MADONNA AND CHILD.

VIRGIN AND CHILD. See HOLY FAMILY.

VIRGIN APPEARS TO SAINT LUKE. The Virgin Mary (see MARY, SAINT), usually holding the Infant *Christ, appears to Saint *Luke in a vision. She is shown standing behind him as he writes the *Gospel. The ox, his symbol, is nearly always present somewhere in the picture. If he is not writing the Gospel, he is drawing the Virgin, and she may give him direction by pointing out certain things. Luke is the patron saint of painters. See LUKE PAINTING THE VIRGIN.

Example: Hermen Rode, from the *Altarpiece of the Guild of Saint Luke,* exterior left wing, 1484, Sankt-Annen-Museum, Lubeck.

VIRGIN IN GLORY. The Virgin in Glory, one of the many majestic depictions of the Virgin and Child that can be seen through many centuries of religious art, first became widely diffused in the West in the seventh century. By the fifteenth century the Virgin appears as the Apocalyptic woman, with the clouds and sun behind her in a brilliantly radiating circle and the crescent moon at her feet (a symbol of her chastity). She is seated on a wide bench that seems to levitate above the heads of Saint Peter (see PETER, APOSTLE AND SAINT), recognizable by his keys (a gold and a silver (or iron) key symbolize, respectively, the gates of heaven and hell) and Saint Augustine shown holding his attribute, a heart, the symbol of religious fervor. A *donor may be present, kneeling in an attitude of worship.

Example: Master of Flémalle (Robert Campin), *Virgin in Glory, with Saint Peter, Donor, and Saint Augustine,* c. 1428–1430, Musée Granet, Aix-en-Provence.

VIRGIN MARY. See MARY, SAINT.

VIRGIN WITH THE SISKIN. The Virgin is shown with the *Christ Child who has a siskin. The bird, perched on Christ's arm, which gives its name to the picture, is a finch and, like the goldfinch, which pecks thorns, may refer to

the crown of thorns. Christ's death is implied by the lilies offered by Saint *John the Baptist, from which the Infant Christ recoils.

Example: Albrecht Dürer, 1506, Staatliche Museen, Gemäldegalerie, Berlin-Dahlem.

VIRGO INTER VIRGINES. The Virgin Mary (see MARY, SAINT) is shown seated amongst other virgins and *angels. The virgins read, and the angels play musical instruments. The Child in the Virgin Mary's lap may hold a bunch of grapes as a symbol of the eucharist.

Example: Gerard David, *Virgin and Child with Saints,* 1509, Musée des Beaux-Arts, Rouen.

VIRTU, VIRTUOSO. The Italian *virtu,* from the Latin *virtus,* meaning "excellence," became the current mode in Italy during the sixteenth century. Conte Baldassare *Castiglione's treatise on etiquette, social problems, and intellectual accomplishments, *Il Cortegiano,* published in 1528 and translated into English as *The Courtier,* specified *virtu,* or excellence, as one of the qualifications of the ideal courtier. Certain men of the time sought to achieve these standards.

VIRTUES. The principal Christian virtues were divided into three theological virtues of faith, hope, and charity (1 Corinthians 13:13), and four cardinal virtues of temperance, *justice, fortitude, and prudence. The latter were listed by Plato in the *Republic* (4:427) as the virtues necessary for the citizens of an ideal city-state. The *Fathers of the church adopted them for Christians. See PSYCHOMACHIA and VICES.

VISCONTI, BERNABO. A tyrant of Milan, Bernabo Visconti (1323–1385) was constantly at war with the pope because of intrigues and territorial ambitions. His nephew, Gian Galeazzo Visconti, had him arrested and he died in prison.

Example: Equestrian monument by Bonini da Campione, c. 1363, Museum of Sforza Castle, Milan.

VISION OF ANNE. See ANNUNCIATION TO ANNE.

VISION OF CONSTANTINE. Constantine the Great, c. 280–337, gained power as Roman emperor after defeating the emperor Maxentius at the Battle of the Milvian Bridge on the Tiber (see BATTLE OF CONSTANTINE AND MAXENTIUS). According to Eusebius' *Life of Constantine* (1:27–32), Constantine had a dream the night before the battle. In his dream he saw a cross in the sky and heard a voice tell him, "In hoc signo vinces," —"By this sign shalt thou conquer." The emperor usually is shown asleep upon his bed, the curtains parted so that he may be seen. A servant sits on a bench beside him and two guards may stand somewhere in the room. They are not aware of the *angel that has appeared over them.

Example: Piero della Francesca, from the *Legend of the True Cross,* probably 1453–1454, S. Francesco, Arezzo.

VISION OF JOACHIM. See MEETING AT THE GOLDEN GATE.

VISION OF SAINT AUGUSTINE (Saint Augustine in His Study, Saint Augustine and the Child with the Spoon). Saint Augustine of Hippo, who lived between the years 354 and 430, was a Christian saint and extremely influential theologian. During the Renaissance a legend that became very popular appeared concerning Saint Augustine and it remained a favorite with artists during the sixteenth and seventeenth centuries. It tells of Augustine walking by the ocean and thinking of the *Trinity. As he walked he saw a child who had made a deep hole in the sand and, with only a seashell, was trying to fill the hole with water. When the saint told the child of the futility of what he was doing, the child told him: "No more so than for the human intelligence to fathom the mystery you are meditating" (Hall, *Dictionary of Subjects and Symbols in Art,* p. 36). Augustine is shown dressed in his episcopal robes. If he is shown by the ocean he may sit on a rock, an open book on his knees, or he may stand in front of the child. If he is shown in his study, he is seated at his desk, an open book in his hand. The accoutrements of his study are typically Renaissance in kind. The clock, geometrical treatise, and armillary sphere are all tokens of the intellectual life of a Renaissance scholar. He gazes reverently upward and clutches his breast with his right hand. Monica, his mother, may be shown kneeling in prayer, and, if the subject is treated devotionally, the Virgin and *angels appear overhead. The child, symbolically standing for *Christ, may be depicted as an angel.
 Example: Sandro Botticelli, c. 1480, Chiesa d'Ognissanti, Florence.

VISION OF SAINT BERNARD. A Cistercian monk and theologian, Saint Bernard of Clairvaux was totally devoted to the Virgin *Mary (see MARY, SAINT). According to the *Golden Legend,* one day when the saint was feeling so ill and exhausted that he could barely hold his pen, the Blessed Virgin came to strengthen him. Artists show Mary as a heavenly vision, touching nothing earthly with her feet or hands. She may be borne by *angels or accompanied by them as she stands before Bernard. He is shown young and beardless, wearing the white habit of the *Cistercian order. Other monks may be seen in the background, since the setting is usually on the outside of the monastery. See BERNARD, SAINT.
 Example: Filippino Lippi, c. 1485–1490, Church of the Badia, Florence.

VISION OF SAINT EUSTACE. See EUSTACE, SAINT.

VISION OF SAINT JEROME. *Jerome, one of the four Latin (Western) *Fathers of the church, lived for four years as a hermit in the Syrian Desert after experiencing a vision of *Christ. Sometimes he imagined he heard the trumpets

sounding the *Last Judgment. Also, during this time of severe asceticism he experienced hallucinations, which he described in one of his letters as being sexual in nature. He tells how he endured these torments by beating his breast with a stone until the fever passed. Jerome, customarily depicted as a philologist and theologian among the books and papers of his study, forever working on his translation of the Scriptures, is shown among the rocks of the Egyptian desert. Here, stripped to his undergarment so that one can see his lacerated breast, Jerome stands, rock in hand, gazing toward heaven. Above him and two female saints (possibly Saint *Mary and Martha) floats the *Trinity, Father holding sacrificed Son, and Holy Ghost in the form of a dove. Below Christ's chest are two child seraphim. Jerome's lion stands behind him, and his cardinal's hat is on the ground before him.

Example: Andrea del Castagno, c. 1454–1455, S. Annunziata, Florence.

VISION OF SAINT JOHN THE EVANGELIST. Saint *John the Evangelist and Apostle was one of the first to be called to follow *Christ. He, along with the other disciples, was present at the *Ascension of Christ. He is usually shown viewing the scene in a vision in which the Twelve Apostles are seated in pairs that form a circle. Christ, in the center, ascends into heaven.

Example: Antonio Correggio, 1520–1524, Dome, San Giovanni Evangelista, Parma.

VISION OF SAINT MARTIN. Martin of Tours, a Christian saint, was the founder of the first monasteries in France. He is shown in his bed asleep. *Christ, attended by *angels has appeared beside his bed as if in a dream. See MARTIN, SAINT.

Example: Simone Martini, c. 1328, Lower Church of S. Francesco, Assisi.

VISITATION. The story of the visit of Saint *Mary to her cousin Saint *Elizabeth is told in the Bible, Luke 1:39–56. Shortly after the *Annunciation, Mary went away to a town in the hill country of Judea. There she went into Zechariah's house and visited Elizabeth, who recognized her as being the "Lord's mother." Elizabeth, the mother of Saint *John the Baptist, was then in her sixth month of pregnancy. At this time Mary sang her song of praise (Luke 1:46–56). She stayed about three months with Elizabeth and then went back home. The topic may form part of a series, together with the Annunciation, *Joseph's Doubt, and the *Nativity and is found also as a separate topic. Before the Renaissance artists depicted the two greeting each other formally with a bow, but during the Renaissance they are often shown in the act of embracing. Usually the scene is an open area before the house of Zechariah. Elizabeth is usually portrayed as an older woman in contrast to a youthful Mary. The two women may be alone or others, both men and women, may be included in the scene.

Example: Fra Angelico, on the predella of the Cortona *Annunciation* after 1428, Diocesan Museum, Cortona.

VULCAN. See FORGE OF VULCAN.

VULGATE. The Latin version of the Bible prepared by Saint *Jerome at the end of the fourth century A.D. is known as the "Vulgate."

W

WALL-TOMB. A wall-tomb is a type of funerary monument that may consist of an aedicula (a shrine framed by two columns supporting an entablature and pediment) enclosing a sarcophagus. Wall-tombs existed before the Renaissance and increased in elaboration and changed in style during that period. Development began as early as the thirteenth century in Italy. The Gothic tabernacle form was elaborated with more sculpture, which sometimes included the Virgin and Child and *angels. By the late fifteenth century a new pattern for papal tombs was set by Antonio and Piero Pollaiuolo (brothers who ran a workshop in Florence at this time). Their tomb of Innocent VIII included a statue of the living pope together with his recumbent effigy on the sarcophagus. Wall-tombs increased in complexity and design until a culmination was reached by Michelangelo in his Medici Chapel Tombs, 1519–1533, San Lorenzo, Florence.

WALNUT OIL. An oil used in *painting, walnut oil is one of the earliest and probably the most popular *medium in the first stages of the development of *oil painting.

WASH. The technical term for a layer of transparent water-color or diluted ink is known as ''wash.'' It is spread evenly over a wide area so as to show no strokes of the brush. Cennino Cennini, the fourteenth-century Italian writer and artist, gave instructions for reinforcing a pen drawing with the brush. The technique seems to have been a type of deliberate spotting and was frequently used. During the course of the Renaissance the brush-work became looser. Leonardo, for example, was known to use a very free method suggesting shadows and forms by the depth and shape of the wash. By the sixteenth century, the practice of preparing the wash in two tones and using both simultaneously, the

one being variously shaded with the other, seems to have become nearly a discipline.

WATCHING OF THE RODS. The Presentation and Watching of the Rods are scenes in the narrative cycle in the life of Saint *Mary, mother of *Christ. According to the *Golden Legend* when the Virgin was in her fourteenth year, the high priest announced that all virgins who were reared in the temple should return to their homes and be given in marriage. Mary said she could not do this because she had dedicated her service to God, and she had vowed her virginity to God. When all the priests met to discuss the matter, a voice told them that all the marriageable men of the house of David who were not yet married should each bring a branch (rod) and lay it upon the altar, and that one of the branches would burst into flower and upon it the *Holy Spirit would come to rest in the form of a dove, according to the prophecy of *Isaiah, and that he to whom the branch belonged would be the one chosen to be the husband of Mary. Joseph was among the men who came, but placed no branch upon the altar because of his advanced years. Thus, as the priests watched the branches, nothing such as the voice of God had predicted took place. The high priest again counseled with God, who explained that he alone to whom Mary should be married had not brought his branch. Joseph, being thus discovered, placed a branch upon the altar, and immediately it burst into bloom, and a dove came from heaven and perched on it. In the Presentation of the Rods, the young men are shown approaching the altar, each with a rod. The high priest stands behind the altar. Later, they watch the rods stacked upon the altar. They are all on their knees.
 Example: Giotto, 1305, Arena Chapel, Padua.

WAY OF THE CROSS. See STATIONS OF THE CROSS.

WAY TO CALVARY. See BEARING OF THE CROSS.

WEDDING AT CANA. The story of the Wedding at Cana, a town in Galilee, is told in John 2:1–11. Jesus, his mother, Saint *Mary, and the disciples were attending a wedding there and Jesus' mother told him that they were out of wine. Jesus told the servants to fill six stone water jars (each large enough to hold between twenty and thirty gallons) with water. They filled each jar to the brim, and Jesus told them to draw some water out and take it to the man in charge of the feast. They took him the water, which had turned into wine, and he tasted it. The Wedding at Cana is recounted only in the *Gospel of Saint John and is the first of the seven miraculous signs told in that Gospel. This topic was rare until the fifteenth century. During the Renaissance, however, it became, like the *Last Supper, a topic for refectories. *Christ is shown seated in the central section of a table, while the guests are standing and seated on both sides of him. The action, though, is usually centered on the man in charge of the feast tasting the wine. The bride and groom may wear crowns, or it may be impossible to

distinguish them from the other guests. Mary may be seated to Christ's right. In some versions, Christ may appear a second time, somewhere at the side, where He is blessing the six stone water jars.

Example: Paolo Veronese, 1563, Louvre, Paris.

WEDDING OF CUPID AND PSYCHE. See CUPID AND PSYCHE.

WISDOM. During the Renaissance Wisdom is usually personified by Minerva, the Roman goddess of wisdom and the arts, who was identified with the Greek Athena. She is shown wearing a helmet and armor and carries a shield and spear, and is thus distinct from Prudence (see VIRTUES), who has a snake and a mirror. Wisdom becomes secularized in Renaissance allegory and in the shape of Minerva has her owl and olive branch. *Cupid may offer her a book.

Example: Jacopo della Quercia, marble from the Fonte Gaia, 1414–1419, Palazzo Pubblico, Siena.

WISE AND FOOLISH VIRGINS. A parable from the New Testament, Wise and Foolish Virgins is about ten maidens going to a wedding, each of whom carries a lamp. The bridegroom, however, is late, and by the time he arrives, five of the maidens, who did not bring oil for their lamps, find that they will not light. These maidens are not allowed to attend the wedding. During the late fifteenth century, the wedding was understood to represent the Kingdom of God; arrival of the bridegroom was interpreted as the Second Coming of *Christ; admission to the ceremony seen as the *Last Judgment. Therefore, those maidens who were prepared with oil were called Wise Virgins and admitted to the wedding. Those who were not, the foolish, impious virgins, were denied entrance. The wise virgin is shown with long, flowing hair holding her lamp upright with a high flame burning. She wears a broad smile on her face. The foolish virgin has her head covered, and she holds her lamp upside down, a look of regret on her face.

Example: Martin Schongauer, series of ten engravings, c. 1480–1490, New York Public Library Prints Division.

WITCHES. Witches were thought to be those individuals who had supernatural powers and exercised them mainly for evil purposes through the use of sorcery, satanism, enchantment, and black magic. Witchcraft in Europe can be traced back to the pre-Christian, pagan cults. After the advent of Christianity, however, the church became particularly hostile to witchcraft. The result was a spread of witch lore and in some cases fear and mass hysteria. The persecution of supposed witches began early in the thirteenth century. Trials, convictions, and executions became common all over Europe and by the end of the Renaissance had reached a peak. Nude women are usually shown sitting under a tree at night in the process of concocting a brew that bursts forth from the pot. Another witch may ride on a flying goat above them holding a smoking pot on a long stick.

Example: Hans Baldung Grien, chiaroscuro woodcut, 1510.

WOLFGANG, SAINT. Born c. 930, Saint Wolfgang came from a Swabian family. As a young man his parents sent him to the abbey of Reichenau, on an island in Lake Constance. Here he met a young nobleman named Henry whose brother was the bishop of Wurzburg. The bishop had set up a school in Wurzburg, and Henry persuaded Wolfgang to accompany him to the new school, where he was admired. In 956 Henry was elected archbishop of Trier, and again when he had to move he took Wolfgang with him. In Trier Wolfgang became a teacher in the cathedral school, came under the influence of a monk named Ramuold, and worked for the improvement of religion in his diocese. In 964, when the archbishop died, Wolfgang was appointed director of the school of the monastery. Saint Ulric, bishop of Augsburd, soon had Wolfgang ordained as a priest and sent to Pannonia to preach the *Gospel to the Magyars. Soon, however, he was recommended to the Emperor Otto II as a person fully qualified to fill the seat of Regensburg (Ratisbon), which was vacant. In 972 on Christmas Day he was consecrated as bishop of Regensburg. He was canonized in 1052, and his feast day is kept in many dioceses of central Europe and also by the Canons Regular of the Lateran because he restored the canonical life for his clergy. Saint Wolfgang is usually shown dressed as a bishop. He wears the liturgical hat of bishops, the *mitre, and the front of his cope (a large cape fashioned in the form of a half circle and considered the richest and most magnificent of ecclesiastical vestments) is fastened with a morse (brooch). He holds in his left hand a crosier, the pastoral staff of a bishop which is regarded as the symbol of mercy, firmness, and the correction of *vices.

Example: Michael Pacher, Altarpiece of Saint Wolfgang, carved, painted, and gilded wood, 1471–1479, Church, Sankt-Wolfgang, Austria.

WOODCUT. The oldest method for making prints is the woodcut. The ancient Egyptians and Babylonians used the woodcut for impressing *intaglio designs into unpressed bricks. The Romans used the process for stamping symbols and letters. Basically the artist draws a design on the flat side of a wood block. After deciding which parts of the picture he wants in white, he cuts these away with a knife and gouges. The design that will be printed in ink is left standing up in *relief. The surface of the block is then covered with ink and a sheet of paper placed upon it. When pressure is applied to the back of the paper, either by hand or in a press, the design transfers to the paper and an impression is made in reverse of the original design. Almost any wood is suitable, although pear, sycamore, and cherry are among those most frequently used. Because the design must be cut through the fibres of the wood with a sharp knife, subtlety is difficult, although not unattainable. Most of the early woodcuts are chiefly bold drawing. During the Renaissance the various stages of the woodcutting and *printing process were carried out by different individuals, most anonymous except for the book-printers who became well known. Also during this time an increase in the technical skill of the cutters occurred. Nevertheless, the technique as a reproductive *medium failed due to the various complex techniques the times

demanded. Cross-hatching, for example, which was an easy demand to place upon the line engraver, was difficult for the woodcutter, who had to cut row upon row of lozenges, working with rather clumsy tools upon a somewhat recalcitrant surface. The task could become rather inartistic and laborious. Even so, many exquisite designs were cut in the north by Albrecht Dürer, who carried the style to such a fine height that the woodcut nearly took on the characteristics of painting.

Example: Dürer, seven woodcuts for *The Great Passion*, c. 1497–1500.

WORSHIP OF THE GOLDEN CALF. The story of the worship of the golden calf is taken from Exodus 19; 20; 32:1–24; and 37. While *Moses was on Mount Sinai receiving the two tablets of stone on which the Ten Commandments were written, the Israelites asked Aaron, the elder brother of Moses, to give them idols to worship. Aaron collected their gold earrings, melted them, poured the gold into a mold, and made a golden calf. The people all agreed, "This is our God." Aaron built an altar in front of the calf and announced a festival to honor the god. The next day sacrificial animals were brought, some to burn and some to eat. They sat down to a feast that turned into an orgy of drinking and sex. God told Moses to hurry and go back down because the people, whom he had led out of Egypt, had sinned. He told him about the golden calf and threatened to destroy them all. But Moses was able to change his mind, and he went back down the mountain carrying the two stone tablets with the Commandments written on both sides. When Moses came close enough to see the festivities, he became furious. He threw down the tablets and broke them. He took the golden calf that they had made, melted it, ground it into fine powder, and mixed it with water. Then he made the people of Israel drink it. Later he returned to Sinai and received new tablets from God. Recognizing the Israelites' need of a tangible object to worship, he had built a covenant box, the Ark of the Covenant. The Commandments were put inside. Groups of merrymakers are usually shown eating and drinking. Farther back Moses, holding the tablets, may be shown descending from the mountain.

Example: Lucas van Leyden, c. 1525, Rijksmuseum, Amsterdam.

WRATH. See SEVEN DEADLY SINS.

Y

YOUTH OF MOSES. See MOSES.

Z

ZECHARIAH (Zachariah). Author of the Book of Zechariah, eleventh in order of the Minor Prophets, Zechariah (Hebrew spelling of his name), with the connivance of King Joash (also Jehoash) of Judah, was stoned to death for his public rebuke of idolatry. According to 2 Chronicles 24:20–22, Zechariah was sent to the people who had stopped worshipping in the temple and had begun to worship idols and the images of the goddess Asherah. The people, however, refused to listen to the prophet. He told them that because they had abandoned God, so God had abandoned them. Upon the orders of King Joash, the people stoned Zechariah in the temple courtyard. His violent death was familiar to succeeding generations, and he was the last of the righteous men thus martyred. Zechariah is usually shown as an old man with a long beard holding a book from which he reads his famous prophecy: ''Here is a man named the Branch; He will shoot up from the ground where He is and will build the temple of the Lord'' (6:12).

Example: Michelangelo, Sistine Chapel Ceiling, 1508–1512, Vatican, Rome.

ZENOBIUS, SAINT. See MIRACLE OF SAINT ZENOBIUS.

ZEUS. See JUPITER.

ZUCCONE. Nickname for an unidentified prophet figure, Zuccone actually means ''pumpkin-head'' or ''big squash.'' Zuccone has even been called ''baldy.'' The marble figure seems to be skin and bone under rough heaps of cloth draped over his shoulder that make do as a cloak. He seems to gaze ahead, proclaiming a rule of righteousness and peace. In his hand is a scroll held by a

strap. The bald head is left rough and unfinished and a stubble on the chin is shown by only a few marks.

Example: Donatello, 1423–1425, on the Campanile, Florence (now in Museo dell 'Opera del Duomo, Florence).

Appendix:
List of Artists

Abbate (Abati), Niccolò dell' (c. 1512–1571), Italian

Alberti, Leone Battista (1404–1472), Italian

Aldegrever, Heinrich (1502–1560), German

Altdorfer, Albrecht (1480–1538), German

Altichiero da Zevio (c. 1330–c. 1395), Italian

Ammannati (Amannati), Bartolommeo (1511–1592), Italian

Angelico, Guido di Pietro (Fra Giovanni da Fiesole or Fra) (c. 1400–1455), Italian

Antonello da Messina (c. 1430–1479), Italian

Arnolfo di Cambio (c. 1245–c. 1302), Italian

Avanzo, Jacopo (14th cent.), Italian

Baldinucci, Abate Filippo (1624–1696), Italian

Baldung-Grien, Hans (c. 1484–1545), German

Bandinelli, Federico (Baccio) (1493–1560), Italian

Barna da Siena (active c. 1350–1356), Italian

Barocco (Baroccio), Federico (c. 1530–1612), Italian

Bartolo, Domenico di. *See* Domenico di Bartolo

Bartolommeo, Fra Baccio della Porta (1475–1517), Italian

Bazzi, Giovanni Antonio (Il Sodoma). *See* Sodoma, Il

Beccafumi, Domenico di Pace (1486–1551), Italian

Beham, Bartel (1502–1540), German

Beham, Hans Sebald (1500–1550), German

Bellechose, Henri. *See* Malouel, Jean

Bellini, Gentile (c. 1429–1507), Italian

Bellini, Giovanni (c. 1430–1516), Italian

Bellini, Jacopo (c. 1400–c. 1470), Italian

Berlinghiero, Bonaventura (active c. 1215–1242), Italian

Bertoldo di Giovanni (c 1420–1491), Italian

Bertram of Minden, Master. *See* Master Bertram

Bologna, Giovanni (da) (Giambologna, Jean de Boulogne) (1524–1608), Flemish

Bondol, Jean de (Hennequin or Jean de Bruges) (active 1368–1381), Flemish

Bonfigli, Benedetto (c. 1420–1496), Italian

Bonino di Campione (active 1357–1388), Italian

Bosch, Hieronymus (c. 1450–1516), Flemish

Botticelli, Sandro (c. 1444–1510), Italian

Bourdichon, Jean (1457–1521), French

Bouts, Dirk (Dierick) (c. 1420–1475), Dutch

Bregno, Andrea (1421–1506), Italian

Breu, Jörg, the Elder (c. 1475–1537), Austrian

Broederlam, Melchior (active c. 1381–1409), French

Bronzino, Agnolo (Il) (1503–1572), Italian

Brosamer, Hans (c. 1500–1554), German

Bruegel, Pieter I, the Elder (c. 1525–1569), Flemish

Brunelleschi, Filippo (1377–1446), Italian

Campin, Robert. *See* Master of Flémalle

Caporali, Bartolomeo (c. 1420–1509), Italian

Carpaccio, Vittore (c. 1460–c. 1523), Italian

Carracci, Annibale (1560–1609), Italian

Castagno, Andrea del (c. 1421–1457), Italian

Cellini Benvenuto (1500–1571), Italian

Cenni di Francesco (active 1370–1375), Italian

Cennini, Cennino (c. 1370–1440), Italian

Christus (Cristus), Petrus (c. 1420–1472), Flemish

Cimabue, Giovanni (c. 1240–1302), Italian

Cione, Nardo di (Orcagna, Arcagnolo) (c. 1308–1368), Italian

Clouet, François (c. 1510–c. 1572), French

Clouet, Jean (c. 1485–1540), French

Correggio, Antonio Allegri (1494–1534), Italian

Cosimo, Piero di. *See* Piero di Cosimo

Cossa, Francesco del (c. 1434–c. 1477), Italian

Cousin, Jean, the Elder (c. 1490–c. 1561), French

Cozens, Alexander (c. 1717–1786), English

Cranach (Kranach), Lucas, the Elder (1472–1553), German

Daddi, Bernardo (c. 1290–c. 1349), Italian

David (Davitt), Gerard (c. 1460–1523), Flemish

Domenico di Bartolo (c. 1400–1447), Italian

Domenico Veneziano (c. 1400–1461), Italian

Donatello, Donato di Niccolò di Betto Bardi (c. 1386–1466), Italian

Dosso Dossi (Giovanni di Niccolò de Lutero) (c. 1480–1542), Italian

Duccio di Buoninsegna (active 1278–1319), Italian

Dumont, Adam (active c. 1450), Flemish

Dürer, Albrecht (1471–1528), German

Engelbrechtsz, Cornelis (1468–1533), Flemish

Eyck, Hubert van (c. 1370–1426), Flemish

Eyck, Jan van (c. 1390–1441), Flemish

Fabriano, Gentile da. *See* Gentile da Fabriano

Filarete, Antonio Averlino (c. 1400–c. 1465), Italian

Filippino Lippi. *See* Lippi, Filippino

Fiore, Jacobello del. *See* Jacobello del Fiore

Fiorentino, Rosso. *See* Rosso Fiorentino

Firenze, Andrea da (Andrea Bonaiuti) (active 1243–1277), Italian

Foppa, Vincenzo (c. 1427–c. 1515), Italian

Forlì, Melozzo da. *See* Melozzo da Forlì

Fouquet, Jean (c. 1420–c. 1480), French

Fra Angelico. *See* Angelico, Guido di Pietro

Fra Filippo Lippi. *See* Lippi, Fra Filippo

Francesca, Piero della. *See* Piero della Francesca

Francesco, Cenni di. *See* Cenni di Francesco

Francia, Francesco Raibolini (c. 1450–1517), Italian

Froment, Nicolas (c. 1425–1483), French

Gaddi, Taddeo (c. 1300–c. 1366), Italian

Geertgen tot Sint Jans (c. 1465–c. 1495), Dutch

Gentile da Fabriano (c. 1370–1427), Italian

Ghiberti, Lorenzo (c. 1378–1455), Italian

Ghirlandaio, Domenico del (1449–1494), Italian

Giorgione (Giorgio Barbarelli) (c. 1478–1510), Italian

Giotto (Giotto die Bondone) (1266/1267 or 1276–1337), Italian

Giovanni da Udine (Giovanni di Francesco Ricamador) (1487–1564), Italian

Goes, Hugo van der (c. 1440–1482), Flemish

Goncalves, Nuno (active until 1480), Portuguese

Gosaert (Gossart), Jan (c. 1478–1535), Dutch

Goujon, Jean (c. 1510–c. 1566), French

Gozzoli, Benozzo di Lese (1420–1497), Italian

Graf, Urs (c. 1485–1528), Swiss

Grünewald, Matthias (c. 1475–1528), German

Hesdin, Jacquemart de. *See* Jacquemart de Hesdin

Holbein, Hans, the Elder (c. 1465–1524), German

Holbein, Hans, the Younger (1497–1543), German

Housebook Master. *See* Master of the Housebook

Huber, Wolf (c. 1490–1553), Austrian

Isenbrandt, Adriaen (d. 1551), Flemish

Jacobello del Fiore (1394–1439), Italian

Jacquemart de Hesdin (c. 1384–1411), French

Jallier, Noël (active 1549), French

Konrad (Conrad) von Soest (early 15th cent.), German

Leiferinxe, Josse. *See* Master of St. Sebastian

Leyden, Lucas van. *See* Lucas van Leyden

Limbourg brothers, Pol, Jehanequin (Jan), and Herman (active c. 1380–c. 1416), Flemish

Lippi, Filippino (c. 1457–1504), Italian

Lippi, Fra Filippo (c. 1406–1469), Italian

Lochner, Stephan (d. 1451), German

Lomazzo, Giovanni Paolo (1538–1600), Italian

Lombardo, Antonio (c. 1458–c. 1516), Italian

Lorenzetti, Ambrogio (active 1319–1347). Italian

Lorenzetti, Pietro (c. 1280–c. 1348), Italian

Lotto, Lorenzo (c. 1480–1556), Italian

Lucas (Hugensz) van Leyden (1494–1533), Dutch

Mabuse, Jan de. *See* Gossaert, Jan

Malouel, (Maelwel, Maleuel), Jean (d. 1419), Dutch

Mantegna, Andrea (c. 1431–1506), Italian

Marmion, Simon (active 1449–d. 1489), French

Martini, Simone (Simone di Martino) (c. 1283–1344), Italian

Masaccio (Tommaso Guidi) (1401–c. 1428), Italian

Maso di Banco (active 2d quarter of 14th cent.), Italian

Masolino da Panicale (Tommaso di Cristoforo Fini) (1383–c. 1447), Italian

Master Bertram (active 1367–1387), German

Master Francke (active 1st half of 15th cent.), German

Master of Alkmaar (equated with Cornelis Buys) (died before 1524), Dutch

Master of Flémalle (equated with Robert Campin) (1378–1444), Belgian

Master of 1402 (active early 15th cent.), French

Master of Moulins (active c. 1480–c. 1499), French

Master of René of Anjou (late 15th cent.), French

Master of St. Cecilia (active before 1304), Italian

Master of St. Giles (active c. 1500), Flemish

Master of St. Sebastian (equated with Josse Leiferinxe) (active 1493–1508), French

Master of the Housebook (active 1475–1500), German

Master of the Middle Rhine (active c. 1410), German

Master of the Munich Taking of Christ (active 1464–1579), German

Master of the Ovile Madonna. *See* Ugolino-Lorenzetti

Master of the Rohan Hours (active 1st half of 15th cent.), French

Master of the St. Barbara Legend (active 1470–1500), Flemish

Master of the St. Francis Cycle (active early 14th cent.), Italian

Master of Wittingau (Master of the Třeboň Altarpiece) (active until c. 1420), Bohemian

Melozzo da Forlì, Michelozzo degli Ambrogi (1438–1494), Italian

Memling (Memlinc), Hans (c. 1430–1494), German-born/Flemish School

Messina, Antonello da. *See* Antonello da Messina

Metsys (Matsys, Massys), Quentin (c. 1466–1530), Flemish

Michelangelo Buonarroti (1475–1564), Italian

Michelozzo Michelozzi (Michelozzo di Bartolommeo) (1396–1472), Italian

Moretto, Giambattista (Alessandro Bonvicino, Il) (c. 1498–1554), Italian

Nanni d'Antonio di Banco (c. 1384–1421), Italian

Oostsanen, Jacob Cornelisz van (1470–1533), Dutch

Orcagna. *See* Cione Nardo di

Orleans, Girard d' (active 1356–1359), French

Orley, Bernard (Barent) van (c. 1491–1542), Belgian

Pacher, Michael (c. 1435–1498), Austrian

Paolo di Giovanni (Paolo di Giovanni Fei) (active 1372–1410), Italian

Parmigianino (Parmigiano), Francesco Mazzola (Il Parmigianino) (1503–1540), Italian

Patinir, Joachim (1475–1524), Flemish

Pencz, Georg (c. 1500–1550), German

Perugino (Pietro di Cristoforo Vannucci) (c. 1445–1523), Italian

Peruzzi, Baldassare (1481–1536), Italian

Piero della Francesca (de'Franceschi) (c. 1420–1492), Italian

Piero di Cosimo (c. 1462–1521), Italian

Pilon, Germain (c. 1535–1590), French

Pintoricchio (Pinturicchio) (Bernardino di Betto di Biago) (c. 1454–1513), Italian

Piombo, Sebastiano del. *See* Sebastiano del Piombo

Pisanello, Antonio (Antonio Pisano) (c. 1395–c. 1455), Italian

Pisano, Nicola (c. 1220–c. 1284), Italian

Polack (Pollack), Jan (d. 1519), Polish

Pollaiuolo, Antonio del (c. 1429–1498), Italian

Pollaiuolo, Piero del (1443–1496), Italian

Pontormo, Jacopo da (Jacopo Carucci) (1494–1557), Italian

Pourbus, Frans I (the Elder) (1545–1581), Flemish

Primaticcio, Francesco (1504–1570), Italian

Pucelle, Jean (c. 1300–1355), French

Quercia, Jacopo della (c. 1374–1438), Italian

Raphael (Raffaello Sanzio) (1483–1520), Italian

Riccio, Andrea Briosco (c. 1470–1532), Italian

Robbia, Luca della (c. 1400–1482), Italian

Rode, Hermen (active c. 1485–1504), German

Rohan Master. *See* Master of the Rohan Hours

Roman painter (Anonymous) (15th cent.), Italian

Rosselli, Cosimo (1439–1507), Italian

Rosso Fiorentino, Giovanni Battista di Jocopo (Il) (1495–1540), Italian

Rubens, Peter Paul (1577–1640), Flemish

Salviati, Francesco de' Rossi (Cecchino) (1510–1563), Italian

Sangallo, Aristotile da (1481–1551), Italian

Sansovino, Andrea (c. 1467–1529), Italian

Sassetta (Stefano di Giovanni) (c. 1400–1450), Italian

Savoldo, Giovanni Girolamo (active 1508–after 1548), Italian

Schongauer, Martin (1430–1491), German

Scorel (Schoorel), Jan van (1495–1547), Italian

Signorelli, Luca (c. 1441–1523), Italian

Sluter, Claus (active c. 1380–d. 1406), Dutch

Sodoma, Il (Giovanni Antonio Bazzi), (1477–1549), Italian

Soest, Conrad (Konrad), van. *See* Konrad van Soest

Tintoretto (Jacopo Robusti) (1518–1594), Italian

Titian (Tiziano Vecellio [Vecelli]) (c. 1488–1576), Italian

Traini, Francesco (active 1321–1363), Italian

Tura, Cosimo (Cosmé) (c. 1430–1495), Italian

Uccello, Paolo (1397–1475), Italian

Udine, Giovanni da. *See* Giovanni da Udine

Ugolino-Lorenzetti (Ovile Master and Master of the Fogg Nativity) (d. 1378), Italian

Vasari, Giorgio (1511–1574), Italian

Veneziano, Domenico. *See* Domenico Veneziano

Veronese, Paolo (1528–1588), Italian

Verrocchio, Andrea del (1435–1488), Italian

Weyden, Roger van der (Roger de la Pasture) (c. 1399–1464), Flemish

Witz, Konrad (Conrad) (c. 1400–1445), German

Bibliography

Antal, Frederick. *Florentine Painting and Its Social Background*. London: Kegan Paul, 1948.

Apollodorus. *Bibliothēkē*. Translated by J. G. Frazer. Cambridge, Mass.: Harvard University Press, 1921.

Apuleius, Lucius. *The Golden Ass*. Translated by Jack Lindsay. Bloomington: Indiana University Press, 1962.

————. *Metamorphoses*. Translated by R. Graves. Baltimore: Penguin, 1950.

Benesch, Otto. *Art of the Renaissance in Northern Europe*. Rev. ed. London: Phaidon, 1965.

————. *German Painting from Dürer to Holbein*. Geneva: Skira, 1966.

Berenson, Bernard. *The Drawings of the Florentine Painters*, 3 vols. 1938. Reprint. Chicago: University of Chicago Press, 1970.

————. *Italian Painters of the Renaissance*. London: Phaidon, 1968.

Blunt, Anthony. *Art and Architecture in France 1500–1700*. 2d ed. Harmondsworth, England: Penguin, 1970.

Bonaventura, Saint. *The Little Flowers, the Mirror of Perfection, and the Life of St. Francis*. New York: Dutton, 1963.

Borsook, Eve. *The Mural Painters of Tuscany*. London: Phaidon, 1960.

Burckhardt, Jacob. *The Civilization of the Renaissance in Italy*. 1867. Reprint. New York: Harper & Row, 1958.

Butler, Alban. *Lives of the Saints*. 5 vols. New York: P. J. Kennedy and Sons, 1956.

Castiglione, Baldassare. *The Book of the Courtier*. Translated by George Bull. Harmondsworth, England: Penguin, 1983.

Chastel, André. *The Age of Humanism*. New York: McGraw-Hill, 1964.

Conway, William M. *The Van Eycks and Their Followers*. 1921. Reprint. New York: AMS Press, 1979.

Cuttler, Charles P. *Northern Painting from Pucelle to Brueghel*. New York: Holt, Rinehart & Winston, 1968.

Decker, Heinrich. *The Renaissance in Italy: Architecture, Sculpture, Frescoes*. New York: Viking, 1969.

De Wald, Ernest T. *Italian Painting, 1200–1600*. New York: Holt, Rinehart & Winston, 1961.

Diodorus Siculus. *Library of History (Bibliotheca Historica)*. 12 vols. Cambridge, Mass.: Harvard University Press, 1933–1967.

Dixon, Laurinda, S. "Bosch's 'St. Anthony Triptych'—an Apothecary's Apotheosis." *Art Journal* 44, no. 2 (1984): 119–131.

Edgerton, Samuel Y., Jr. *The Renaissance Rediscovery of Linear Perspective*. New York: Harper & Row, 1976.

Einem, Herbert von. *Michelangelo*. London: Methuen, 1976.

Encylopedia of World Art. 15 vols. New York: McGraw-Hill, 1959–1968, revised 1972.

Eusebius Pamphilus. *History of the Church*. Translated by G. A. Williamson. New York: Dorset Press, 1965.

————. *Life of Constantine*. London: Ancient Ecclesiastical Histories, 1650.

Ferguson, George. *Signs and Symbols in Christian Art*. New York: Oxford University Press, 1967.

Ferguson, Wallace K. *The Renaissance*. New York: Henry Holt, 1940.

Freeberg, Sydney J. *Painting of the High Renaissance in Rome and Florence*. 1961. Reprint. New York: Harper & Row, 1972.

Fremantle, Richard. *Florentine Gothic Painters from Giotto to Masaccio: A Guide to Painting in and near Florence*. London: Martin Secker and Warburg, 1975.

Frielaender, Max J. *Early Netherlandish Painting*. New York: Praeger, 1967.

————. *From Van Eyck to Bruegel*. 3d ed. London: Phaidon, 1969.

Gadol, Joan. *Leon Battista Alberti: Universal Man of the Early Renaissance*. Chicago: University of Chicago Press, 1969.

Godfrey, F. M. *Early Venetian Painters, 1415–1495*. London: Tiranti, 1954.

Good News Bible. American Bible Society: Collins World, 1976.

Hale, John R. *Italian Renaissance Painting from Masaccio to Titian*. New York: Dutton, 1977.

Hall, Edwin, and Horst Uhr. "Aureola super Auream: Crowns and Related Symbols of Special Distinction for Saints in Late Gothic and Renaissance Iconography." *The Art Bulletin* 67, no.4 (1985): 567–603.

Hall, James. *Dictionary of Subjects and Symbols in Art*. New York: Harper & Row, 1974.

Hamilton, Edith. *Mythology*. New York: New American Library, 1953.

Hammond, N.G.L., and H. H. Scullard, eds. *The Oxford Classical Dictionary*. 2d ed. Oxford: Oxford University Press, 1978.

Harris, William H., and Judith Levey, eds. *The New Columbia Encylopedia*. New York: Columbia University Press, 1975.

Hartt, Frederick. *History of Italian Renaissance Art*. New Jersey: Prentice-Hall, Inc., 1969.

Hauser, Arnold. *The Social History of Art*. vol. 2. New York: Vintage Books. 1951.

Hays, Denys, ed. *The Renaissance Debate*. European Problem Studies, New York: Holt, Rinehart & Winston, 1965.

Helton, Tinsley, ed. *The Renaissance: A Reconsideration of the Age*. Madison: University of Wisconsin Press, 1964.

Herodotus. *History*. Translated by A. de Sélincourt. Baltimore: Penguin, 1954.

Hesiod. *Theogony*. New York: Oxford University Press, 1978.

Hibbard, Howard. *Michelangelo*. New York: Harper & Row, 1974.

Hind, Arthur M. *History of Engraving and Etching from the Fifteenth Century to the Year 1914*. 3d rev. ed. New York: Dover, 1963.

————. *An Introduction to a History of Woodcut*. New York: Dover, 1963.

Holt, Elizabeth B. *A Documentary History of Art*. Vol. 1. 2d ed. Garden City, New York: Doubleday, 1957.

Homer. *The Illiad*. Translated by Robert Fitzgerald. New York: Anchor Press, 1974.

Huizinga, Johan. *The Waning of the Middle Ages*. 1924. Reprint. New York: Doubleday/ Anchor, 1970.

Huyghe, René, ed. *Larousse Encyclopedia of Renaissance and Baroque Art*. New York: Prometheus Press, 1964. Reprint. Hamlyn/American (paperbound), 1976.

Kurth, Willi, ed. *The Complete Woodcuts of Albrecht Dürer*. New York: Bonanza Books, 1946.

Langer, William L., ed. *An Encyclopedia of World History*. 5th ed. Boston: Houghton Mifflin Co., 1972.

Lassaigne, Jacques, and Delevoy, Robert. *Flemish Painting*. New York: Skira, 1957.

Leonardo da Vinci. *Treatise on Painting (Trattato della Pittura)*. 2 vols. Translated by A. Philp McMahon. Princeton: Princeton University Press, 1956.

Levey, Michael. *A Concise History of Painting From Giotto to Cézanne*. Praeger World of Art Series. New York: Praeger, 1962.

Livy. *History of Rome*. Translated by Moses Hadas and Joe P. Poe. New York: Modern Library, 1962.

Longaker, Jon, D. *Art, Style and History*. Glenview, Ill.: Scott, Foresman, 1970.

Maginnis, Hayden B. J. "Pietro Lorenzetti: A Chronology." *The Art Bulletin* 66, no. 2 (1984): 183–211.

Mâle, Émile. *Religious Art*. New York: Noonday Press, 1959.

Marle, Raimond van. *The Development of the Italian Schools of Painting*. 19 vols. 1923– 1938. Reprint. New York: Hacker, 1970.

Mather, Frank J. *Western European Painting of the Renaissance*. New York: Cooper Square Publishers, 1966.

Meiss, Millard. *Painting in Florence and Siena after the Black Death*. Princeton: Princeton University Press, n.d.

More, Thomas. *Utopia*. Translated by H.V.S. Ogden. New York: Appleton-Century-Crofts, 1949.

Murray, Linda. *The High Renaissance and Mannerism*. New York: Oxford University Press, 1977.

————. *The Late Renaissance and Mannerism*. London: Thames & Hudson, 1967.

Murray, Peter, and Linda Murray. *The Art of the Renaissance*. London: Thames & Hudson, 1974.

————. *A Dictionary of Art and Artists*. New York: Penguin, 1976.

Myers, Bernard Samuel, ed. *Encyclopedia of Painting: Painters and Painting of the World from Prehistoric Times to the Present Day*. 3d rev. ed. New York: Crown, 1970.

New Testament. New York: World Publishing Co., n.d.

Osborne, Harold, ed. *The Oxford Companion to Art*. Oxford: Oxford University Press, 1978.

Ovid. *Fasti*. Translated by James George Frazer. Cambridge, Mass.: Harvard University Press, 1976.

————. *Metamorphoses*. Translated by A. Golding. 1567. Reprint. New York: Macmillan, 1965.

Panofsky, Erwin. *Early Netherlandish Painting*. Cambridge, Mass.: Harvard University Press, 1953.

————. *The Life and Art of Albrecht Dürer*. 4th ed. Princeton, N.J.: Princeton University Press, 1971.

————. *Meaning in the Visual Arts*. New York: Doubleday, 1955.

————. *Problems in Titian*. New York: New York University Press, 1969.

————. *Renaissance and Renascences in Western Art*. New York: Harper & Row, 1969.

Partner, Peter. *Renaissance Rome, 1500–1559: A Portrait of a Society*. Berkeley: University of California Press, 1977.

Pater, Walter. *The Renaissance: Studies in Art and Poetry*. Edited by Donald L. Hill. Berkeley: University of California Press, 1980.

Philostrates the Elder. *Imagines*. Book 1. Translated by A. Fairbanks. Cambridge, Mass.: Harvard University Press, 1931.

Philostrates the Younger. *Imagines*. Book 2. Translated by A. Fairbanks. Cambridge, Mass.: Harvard University Press, 1931.

Plato. *Republic*. Translated by Desmond Lee. 2d ed. Baltimore: Penguin, 1955.

Plutarch. *Lives*. Vol. 12. Translated by Arthur Hugh Clough. Ontario: P. F. Collier and Son Corp., 1909.

Pope-Hennessy, John. *An Introduction to Italian Sculpture*. 3 vols. 2d ed. New York: Phaidon, 1970–71.

————. *Italian High Renaissance and Baroque Sculpture*. 3 vols. Greenwich, Conn.: Phaidon, 1963.

————. *Sienese Quattrocento Painting*. New York: Oxford University Press, 1947.

Puyvelde, Leo van. *The Flemish Primitives*. London: Collins, 1948.

Radice, Betty. *Who's Who in the Ancient World*. Baltimore: Penguin Books, 1973.

Reau, Louis. *French Painting in the Fourteenth, Fifteenth, and Sixteenth Centuries*. New York: Hyperion Press, 1939.

Richter, Gottfried. *Art and Human Consciousness*. Translated by Burley Channer and Margaret Frohlich. New York: Anthroposophic Press, 1985.

Ruskin, Ariane. *Art of the High Renaissance*. Discovering Art Series. New York: McGraw-Hill, 1968.

Russell, Francis, and eds. *The World of Dürer 1471–1528*. New York: Time Inc., 1967.

Seymour, Charles. *Sculpture in Italy, 1400–1500*. Baltimore: Penguin, 1966.

Stechow, Wolfgang, ed. *Northern Renaissance Art, 1400–1600*. Englewood Cliffs, N.J.: Prentice-Hall, 1966.

Stubblebine, James, ed. *Giotto: The Arena Chapel Frescoes*. New York: Norton, 1969.

Varagine, Jacobus de. *The Golden Legend*. Translated by Granger Ryan and Helmut Ripperger. 1941. Reprint. New York: Arno Press, 1969.

Vasari, Giorgio. *The Lives of the Most Eminent Painters, Sculptors, and Architects, 1550–68*. 4 vols. New York: Dutton, 1963.

Venturi, Lionello. *The Sixteenth Century: From Leonardo to El Greco*. New York: Skira, 1956.

Venturi, Lionello, and Rosabianca Skira-Venturi. *Italian Painting: The Creators of the Renaissance*. 3 vols. Geneva: Skira, 1950–1952.

Virgil. *Aeneid*. Translated by Robert Fitzgerald. New York: Random House, 1983.

Waetzold, Wilhelm. *Dürer and His Time*. Enl. ed. London: Phaidon, 1955.

Wallace, Robert, and eds. *The World of Leonardo 1452–1519*. New York: Time Inc., 1966.

Werkmeister, William H., ed. *Facets of the Renaissance*. New York: Harper & Row, 1963.

White, John. *Art and Architecture in Italy, 1250 to 1400*. Baltimore: Penguin, 1966.

Wilenski, Reginald H. *Flemish Painters, 1430–1830*. 2 vols. London: Faber & Faber, 1960.

Williams, Jay, and eds. *The World of Titian 1488–1576*. New York: Time Inc., 1968.

Wölfflin, Heinrich. *The Art of the Italian Renaissance*. New York: Schocken Books, 1963.

—. *Principles of Art History*. New York: Dover Publications, 1950.

Index

About the Author

IRENE EARLS teaches advanced placement art history to academically gifted high school students. Her doctoral dissertation "Napoleon III as a Patron of Architecture" recently won second place in the *Prix Prosper Merimee*, an international competition. Translated into French, it is now being published in Paris. The author of several articles in scholarly journals in the United States and in France, she received her Ph.D. in the history of art from the University of Georgia.